THE
WORLD
BENEATH

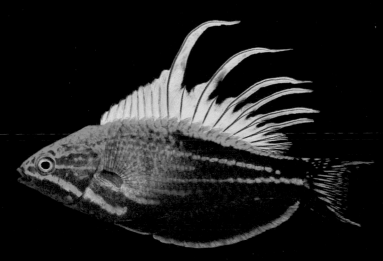

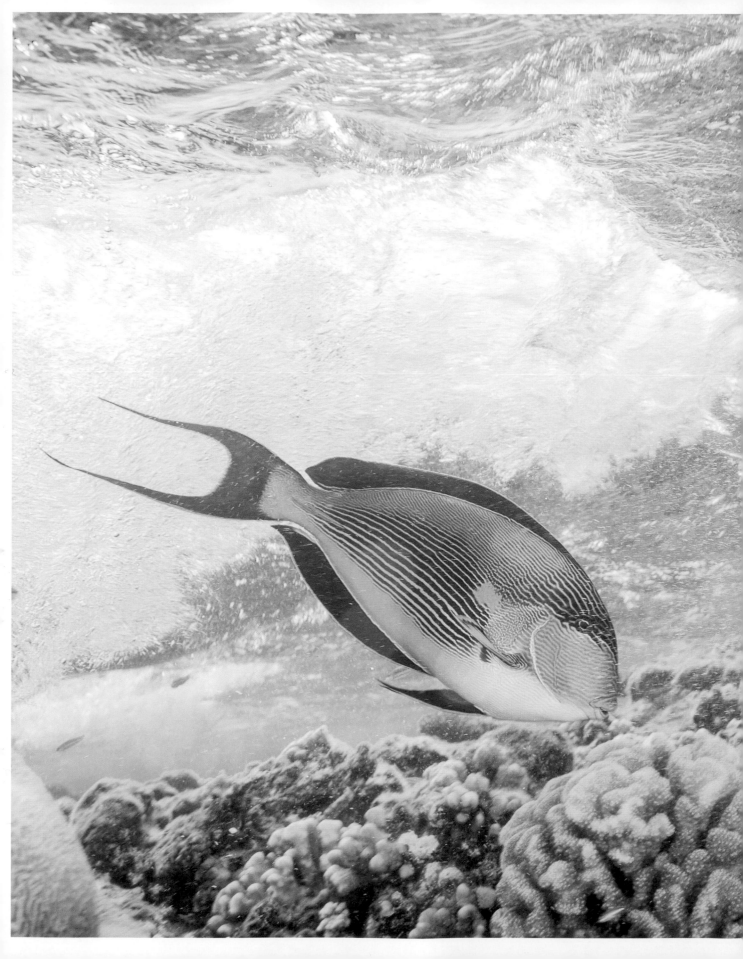

THE
WORLD
BENEATH

The Life and Times of Unknown
Sea Creatures and Coral Reefs

DR. RICHARD SMITH

APOLLO
PUBLISHERS

This Page: The tailspot coralblenny is found only
around Raja Ampat and nearby Halmahera Island.
Raja Ampat, West Papua, Indonesia.

Front Cover and Page 1: Displaying male blue
flasher wrasse. Raja Ampat, West Papua, Indonesia.

Pages 2–3: Arabian surgeonfish
feeding on algae in the surge in the Red Sea Egypt.

Back Cover: Spawning barrel sponge.
Tubbataha Reef, Sulu Sea, Philippines.

For my father.

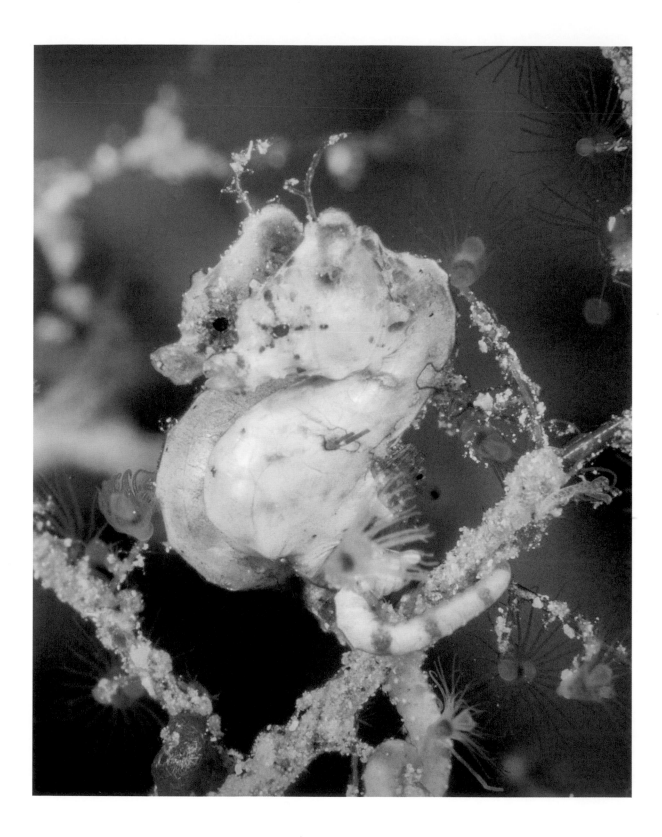

CONTENTS

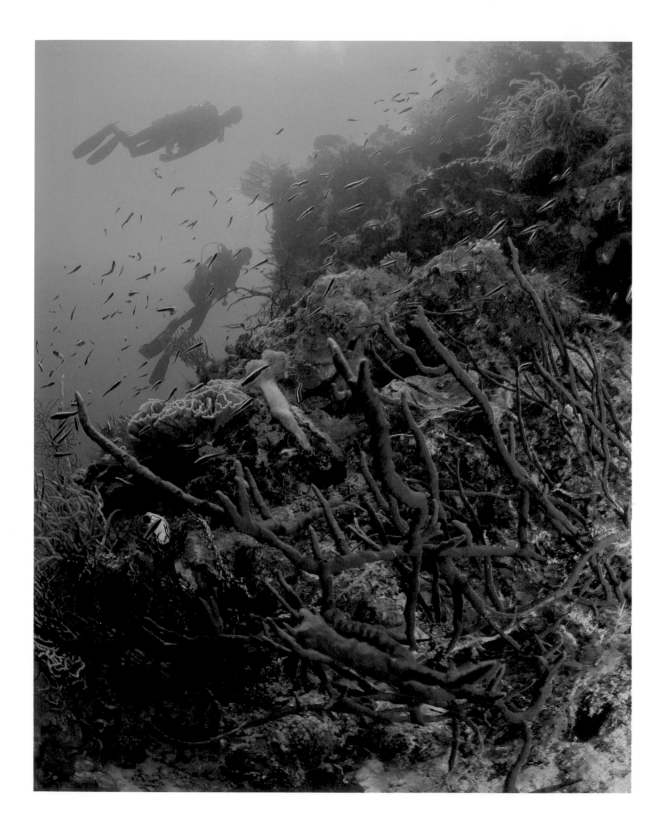

The World Beneath

CHAPTER 1:

DIVING IN

In the declining early evening light forty-five feet beneath the surface on a remote Indonesian coral reef, a tiny seahorse strangles another with its tail. Just three-quarters of an inch long, the diameter of a one-cent coin, and perfectly camouflaged against the windshield-sized fan-like gorgonian coral they inhabit, these creatures have a penchant for the dramatic. For my PhD research I spent six months watching and recording the antics of these mysterious and diminutive fish, collecting data on their biology and conservation—the first recorded observations of their social and reproductive behaviors. Denise's pygmy seahorses had only been recognized by science four years previously, in 2003. Like other behaviors that occur on coral reefs every day, these skirmishes have presumably been happening for millennia. We just didn't know to look for them.

Most of us hear about coral reefs and see them on nature documentaries, but unless we're lucky enough to experience such awe-inspiring ecosystems firsthand, it can be hard to appreciate their intricacies. Exploring a tropical rain forest, you drip with sweat in a supersaturated and oppressive atmosphere waiting to spot an animal. A bird might call in the distance, the insect at your feet might unleash its high-pitched whine, and, perhaps, if you're very lucky, and extremely patient, something larger might barrel toward you from the undergrowth. On a healthy coral reef, you can glimpse activity and life wherever you happen to look. Dozens of fish busy themselves with their daily commutes and travails.

In one hour on an Indonesian reef you will likely see over one hundred

OPPOSITE: A red sponge and divers. Wakatobi, Sulawesi, Indonesia.

PAGE 6: Pair of courting Pontoh's pygmy seahorses, described in 2008. Wakatobi, Southeast Sulawesi, Indonesia..

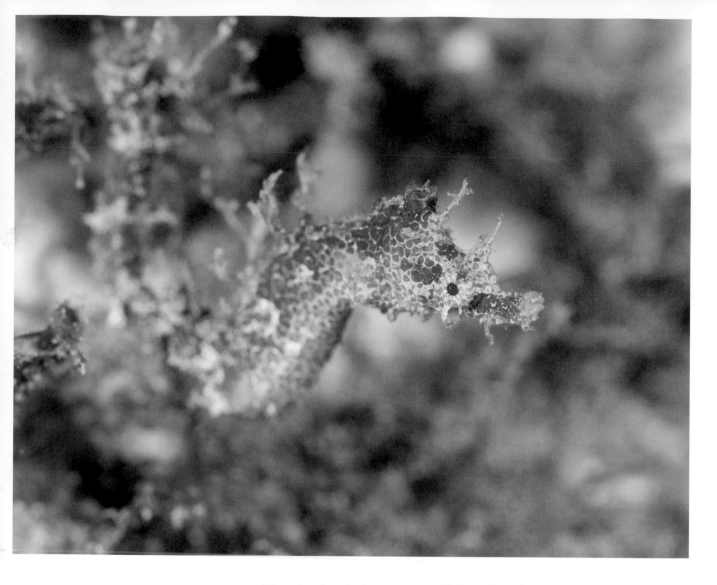

ABOVE: Undescribed species of pygmy pipehorse from New Zealand. Northland, North Island, New Zealand.

multihued and multiform species of fishes, if not double that—scrupulous cleaners, eccentric lovers, steadfast parents. The nervous cometfish pokes its marionette of a tail out of a hole, attempting to convince you it's a menacing moray eel. Inches from your mask, a small but assertive damselfish warns you not to swim any closer to its precious algal farm. You may not know the names of all of them, but you are mesmerized: immersed in the hustle and bustle of their daily rituals.

Coral reefs continue to surprise and delight. My work has taken me all over the globe and introduced me to coral reefs in twenty-three countries. I have seen fish that wouldn't even stretch across a dime and others that are longer than two London buses. I have seen vibrant and bustling coral gardens that stretch as far as the eye can see and I have captured the first photograph of creatures that have never before been pictured alive. Elsewhere in the ocean, I have come face to face

with a warty file snake deep among the roots of a mangrove forest in Indonesia, photographed animals and behaviors in Japan that were still unknown to science, and spent hours scouring an algal-covered rock face to find an unnamed relative of the seahorse in New Zealand. My aim in this book is to share some of my passion and wonder for coral reefs and the astounding variety of creatures that call them home, while allowing those who aren't lucky enough to experience this wonderful ecosystem firsthand a window under the waves.

For a long time, coral reefs have fascinated mankind. Charles Darwin mused about how these eclectic ecosystems could flourish in crystal-clear tropical waters where there are next to no nutrients to fuel their growth. Today we hear about them in the news—often, articles bemoaning their loss due to devastating coral bleaching. When corals become stressed by environmental changes, such as warmer waters, they expel their symbiotic intracellular algae, leaving them ghostly white in appearance. Coral bleaching has killed millions of corals over the past two decades. Children learn about coral reefs as well, namely through the popular (though scientifically free-willed) animated coming-of-age film, *Finding Nemo*. I credit the film for this even though its makers didn't include some of the most fascinating aspects of anemonefish biology in the story line. If the film were true to life then after the untimely death of Nemo's mother, his father would have transitioned into a female and another sexually reproductive male would have taken his place.

The reef is a biological powerhouse, full of fantastical creatures with amazing stories to be told. For my godson Joey's birthday, I made a huge print of an untouched coral reef vista that I took in West Papua, Indonesia, to put on his bedroom wall. When I was a child in a rural British village, I spent hours poring over a map of the globe on my friend's wall; this had a profound effect on my view of the world. I hoped I might inspire Joey, the way I was inspired, that I might foster within him a wonder of the natural world. With so many kids growing up without a tangible connection to nature, it is ever more important for us to celebrate its splendor.

For those lucky enough to dive or snorkel on a coral reef, the first time is as overwhelming as it is memorable. Imagine the European explorers as they came across the first coral reefs. As early natural historians and biologists began to explore coral reefs, they would have been struck by the stark differences between Caribbean, Red Sea, and Indo-Pacific reefs and the temperate Atlantic and Mediterranean ecosystems they were used to. Initially, of course, the extent of

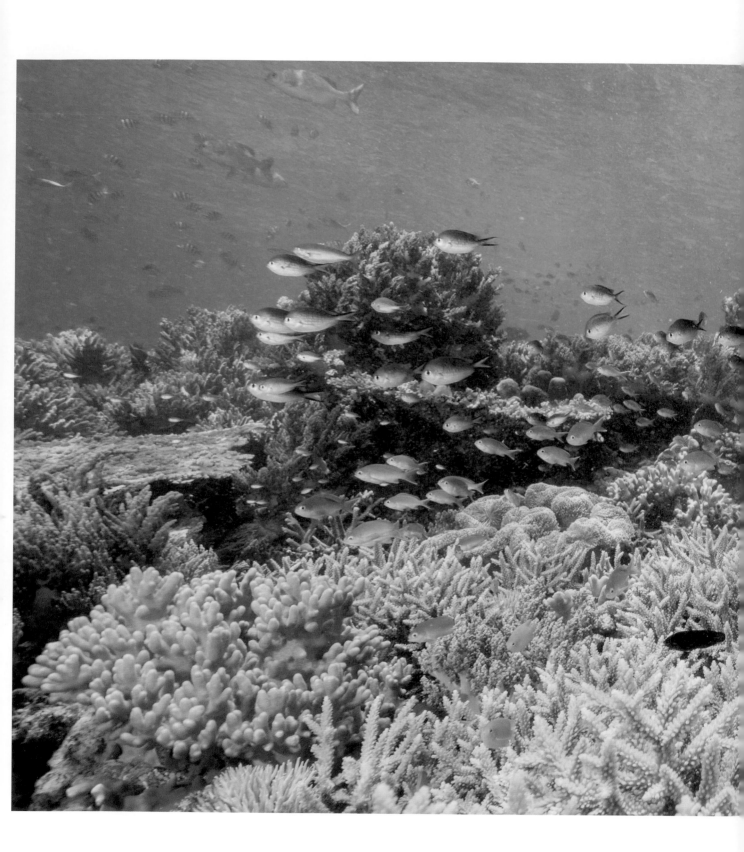

The World Beneath

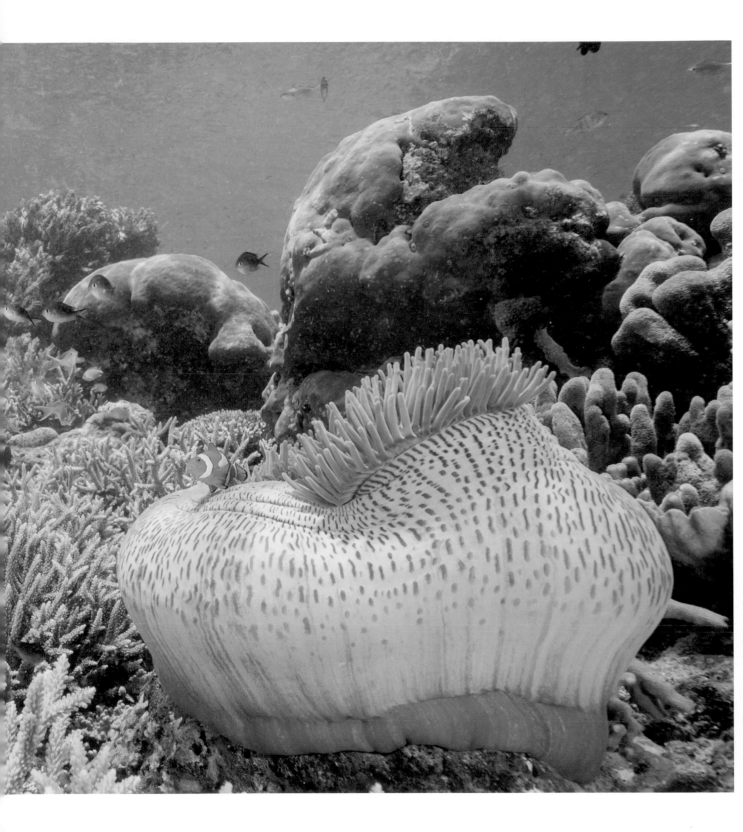

Diving In

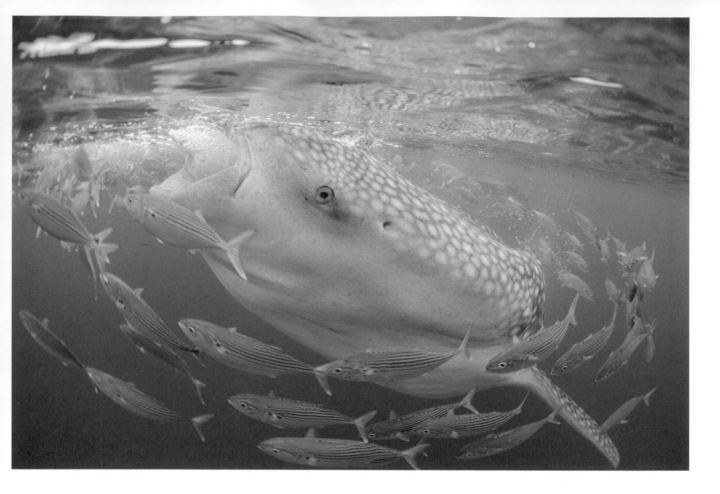

an explorer's interest in coral reefs lay in the reefs' ability to wreck their vessels. Despite all the modern technology that we now possess, there are still unchartered waters that can scuttle ships. Only a few years ago, I was on a boat that narrowly avoided disaster after encountering an unchartered reef in a remote corner of Papua. I looked over the side of the ship and could clearly see the tiny damselfish on the reef below; they were so close.

Growing up in England, albeit the most landlocked part, I felt a deep connection with the sea, and I can relate to the wonderment of those early explorers. My connection with it began when my father took me to rummage around tide pools, or rock pools as we call them, on the British south coast. I spent hours hunting between the seaweeds for beadlet anemones, periwinkles, limpets, and the odd hermit crab or shrimp. The life in tropical tide pools tends to be less abundant due to the extremes of heat that the animals must endure in the blazing sun, but if you explore beneath the surface, the differences between coral reefs and temperate seas immediately become clear. So far, more than eighteen hundred different reef fish species have been found and recorded on the reefs of the Raja Ampat Islands,

located off the island of New Guinea, in Indonesia's West Papua province—compared to three hundred around the British Isles. Each reef is different too; while many of the Atlantic fishes are extremely widespread, almost every Indonesian island has its own unique assembly of creatures.

We are living through a revolutionary period in the timeline of coral reef exploration; suddenly, for the first time, scuba allows us to get to know a reef intimately. Citizen scientists, not only academics, are contributing enormously to our understanding of this world. Any motivated healthy adult can get certified within a week to dive down to one hundred feet below the surface and, with a little experience, spend an hour submerged. With the advent of accessible recreational scuba training, we are the first generation that has been able to freely explore the underwater realm. We are diving into and cataloging the Coral Triangle, the region of Southeast Asia where the world's richest coral reefs reside, ones that have never been explored before. I have been among the first group of divers to explore a certain coral reef—outer space is not the only place where we can "boldly go where no man has gone before." And as a direct result of expanding our horizons into unchartered corners of the sea, we are discovering a wealth of new species.

You might have thought that scientists have documented almost the whole diversity of the Earth, but particularly in the oceans; this couldn't be further from the truth. In my twenty-three-year dive career, fish identification books have doubled in size as people push boundaries in terms of what they look for and where they look. This expansion has yet to peak. I recently worked on the scientific description of a new species of pygmy seahorse from Japan; it was hiding in plain sight and not far from Tokyo, the world's most densely populated metropolitan area. I know of at least one more new species of pygmy seahorse waiting in the wings. The same is true of almost any group of sea animals you care to choose. With so few taxonomists, there are great queues of species that continue to go about their daily lives, but are yet to be formally named or studied.

The complexity of coral reefs is often multilayered and elaborate; while we tend to focus on the prominent corals and fishes vital to the reef's functioning, they make up just a fraction of the overall number of species. We turn a blind eye to things we consider boring, insignificant, or ugly, such as worms, sponges, sea cucumbers, and parasites. But they are absolutely fascinating in their own right if we spend a little time considering their natural history. I am drawn to animals that are easily overlooked or ignored, and I use underwater photography to share their

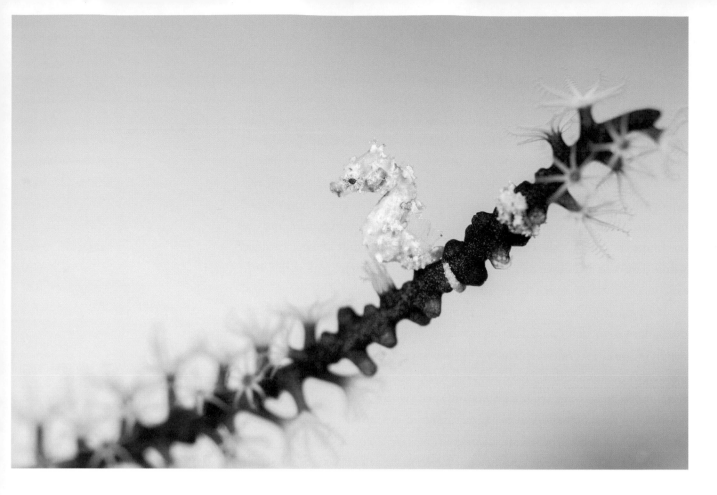

beauty—hopefully imparting a greater sense of appreciation to people who haven't been able to see these animals firsthand.

It's unsurprising that some of the tiniest reef inhabitants are poorly known, but even some of the biggest, most conspicuous, and most charismatic are reluctant to reveal their secrets. In 1986, only 320 whale sharks, the world's largest fish, had ever been recorded alive; today we know of aggregations of 420 individuals in just a few square miles.[1] We still don't know for sure where these behemoths go to mate or give birth. We don't know where juveniles spend their formative years; we don't even know where all the biggest female whale sharks live. Another shark, the megamouth, the world's third largest, wasn't even discovered until 1976. We still have fewer than one hundred recorded sightings of the species and know next to nothing about its biology and ecology.

One phenomenon that we must be aware of when it comes to coral reefs, and natural ecosystems in general, is shifting baselines. The first humans to see coral reefs would most likely have experienced them in their pristine state, but sadly our actions take their toll on the health of an ecosystem. Over the years, declines in

ecosystems can be masked by perception of what a natural ecosystem looks like, with each generation, our view of how a coral reef should look and function shifts slightly. In 1997, I was lucky enough to catch a brief glimpse of the Maldivian coral reefs before they were completely devastated by coral bleaching. A diver visiting the reefs today might not be aware of the changes that have taken place and consider what they see at face value. The current, depleted state of the reef becomes that person's baseline. With such widespread bleaching affecting the world's reefs, one wonders if the next generation may think of their damaged state as the new normal and have a different concept of what a pristine coral reef looks like.

Night diving isn't my favorite pastime but seeing a new creature certainly is. Descending into the darkness down an undulating and jagged reef wall in the most remote corner of West Papua, I was looking for a fish that at that time wasn't yet named and that I knew would be very hard to find. Unlike the pygmy seahorses that I studied for my PhD research, which live on gorgonian sea fans, Satomi's pygmy seahorse hops about the reef from gorgonian to hydroid to soft coral. Beyond not knowing exactly where to look for the fish, it is difficult to track the creature because it measures no longer than half an inch in length and is only active as night falls. My dive guide friend Yann Alfian had spotted one for the first time weeks before, so he was eagerly taking me back to try and find it again. Not wanting to disturb these tiny animals with our bright flashlights, we covered all but a fraction of our beams, revealing only a tiny shard of illumination onto the reef. We searched and searched to no avail, but after half an hour, Yann's little beacon of light finally shined on a tiny seahorse swimming from one frond to another. There is no sense of scale or perspective underwater, but I was amazed at how nature has condensed all the organs needed for life into such a miniscule package. This fish has a brain, gills, and a heart; males get pregnant and brood their young. I ended the dive elated to have observed one of the smallest backboned animals on the planet.

It is impossible to be jaded by the spectacle of a coral reef: the natural world just keeps giving. Throughout this book, I aspire to share a little of my passion for the many creatures and little-known organisms that call coral reefs their home. I hope you can learn how this intricate ecosystem functions while gaining an appreciation for its surprising, beguiling, and charming residents.

OPPOSITE: The world's smallest seahorse, Satomi's pygmy seahorse, described in 2008. Raja Ampat, West Papua, Indonesia.

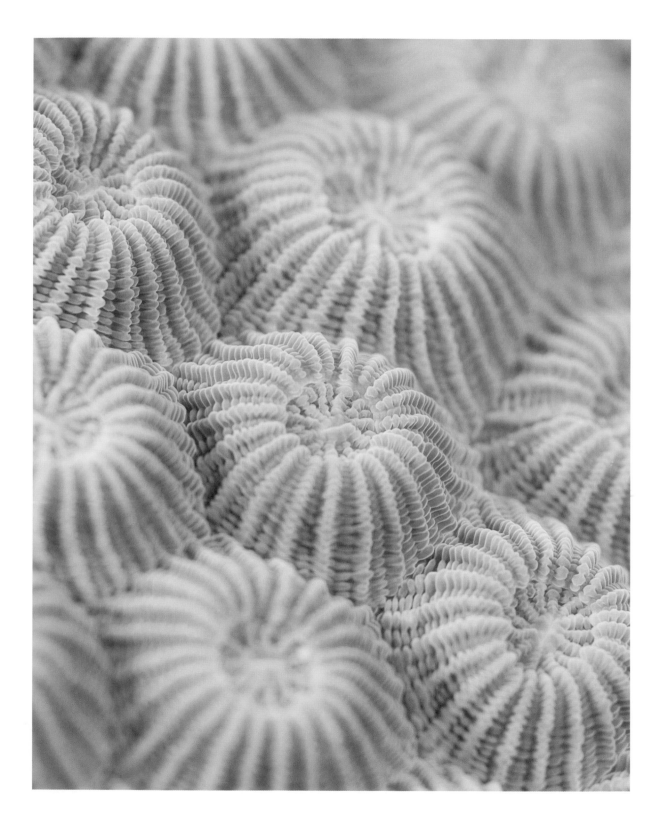

The World Beneath

CHAPTER 2:

HOW THE
REEF WORKS

We begin our story with a humble jellyfish-like creature in the Triassic period, some 240 million years ago. After the great Permian Extinction—some ten million years before the Triassic—almost wiped the Earth clean of life, marine creatures were beginning, again, to find their feet.[2] In the wake of this tumultuous period, life seized the opportunity to expand and reclaim the Earth. During the Triassic, the first ancestral scleractinian corals appeared;[3] today, we know their kin as hard or stony corals. They shared the seas with enormous and menacing dolphin-like dinosaurs, called ichthyosaurs; lobe-finned fish very similar to the coelacanth, a six-foot-long fish that was long-believed extinct and famously rediscovered by Marjorie Courtenay-Latimer in 1938; feathery crinoids, ancient plant-like relatives of the sea star; and many other groups that still populate coral reefs today.

The domination of coral reefs in today's shallow tropical seas is due to the symbiotic relationship between scleractinian corals and unicellular algae, called zooxanthellae. This special ecological relationship allows corals to finesse their metabolic processes of respiration, metabolism, and waste product management, improving their growth rates and allowing them to supercharge their deposition of calcium carbonate. Early stony corals were small and solitary—it took millions of years before this symbiosis enhanced them into becoming true reef builders.[4] However, many of the families of stony corals we see today are

OPPOSITE: Several individual coral polyps. Solomon Islands.

very old, having originated in the middle to late Jurassic period, one hundred and fifty million years ago.

Corals are living animals, although they may not fit our preconceived notion of what defines an animal. These tiny relatives of the sea anemone and jellyfish are sessile creatures, permanently attaching themselves to the seafloor, somewhat like a plant. The living parts of the coral are very simple, soft-bodied animals called polyps. For many colonial corals, each polyp is just a few millimeters across; solitary polyps, however, such as those of mushroom corals, can sometimes be almost a foot in diameter.

Each polyp comprises a single opening surrounded by a ring of tentacles. The tentacles are covered in specialized stinging cells, called nematocysts, which help to harpoon and trap passing food particles. Internally, most of the polyp is a simple stomach, the single opening acting for both ingestion and excretion. The living polyp sits atop a protective calcium carbonate structure, the coral's deposit, which has been key to them becoming such prominent ecosystem engineers.

The vast majority of a coral colony comprises the dead skeleton structure beneath, which is blanketed with a very thin layer of living tissue comprised of many individual polyps. A colony of individual polyp clones can have hundreds of thousands of polyps. They are connected to one another by a thin band of living tissue. Thousands of individual coral colonies, constituting many species, make up a reef.

DARWIN'S PARADOX

While vivid blue tropical seas may draw vacation-goers in droves, the same crystal-clear waters aren't as inviting to marine organisms. In the ocean, truly crystal clear water lacks the nutrients that can be exploited to sustain life. Nutrients in the water column, the stretch between the surface and ocean floor, are usually highlighted by the presence of plankton, which add a noticeable hue. Plankton is the term used for a diverse array of miniscule organisms that float or drift in the open ocean and are largely transported by the whim of currents. The term "Darwin's Paradox" refers to the conundrum that Charles Darwin himself highlighted: coral reefs are oases in the desert of the blue ocean.[5]

Corals are only able to flourish and grow in these nutritionally deficient waters thanks to the symbiotic relationship shared between single-celled algae,

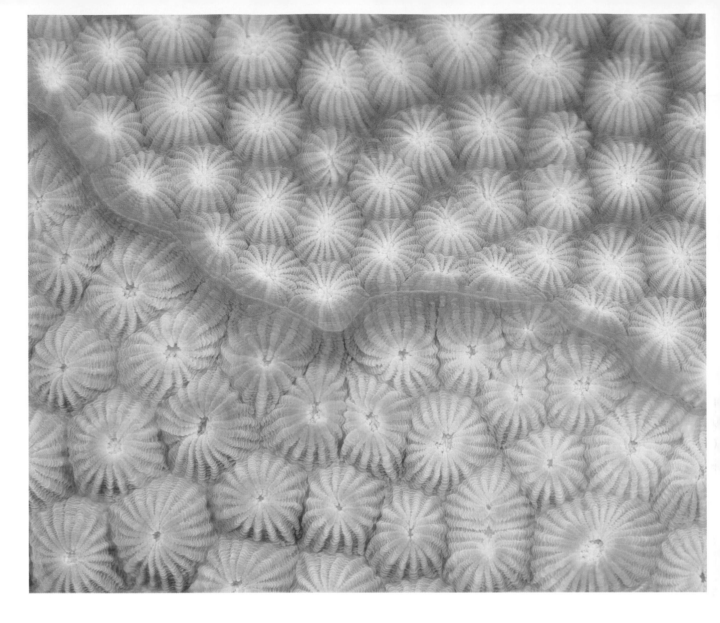

zooxanthellae, which live within their tissues. Symbiosis means that both parties benefit from the relationship; in this case there are advantages for both the coral animals and the zooxanthellae. Zooxanthellae form colonies within the safe, soft tissues and tentacles of the coral polyps, where they harness the sun's light to photosynthesize and produce sugars. These sugars fuel the corals and allow them to sustain unparalleled growth, compared to their relatives that don't harbor such algae. In return, the corals supply zooxanthellae with their metabolic waste products that the algae then use to fuel photosynthesis. Corals do still need to supplement the nutrition provided by the algae, so at night the polyps swell and they feed on passing plankton using their stinging tentacles.

ABOVE: The meeting of two distinct coral colonies. Cenderawasih Bay, West Papua, Indonesia.

This extremely tight cycling of nutrients means that very little goes to waste and corals are able to direct significant energy into reef building. Coral polyps deposit calcium carbonate at varying rates—some of the most prolific branching species can grow seven inches in a year—although four to six inches is more common. On the other hand, the slower growing boulder-shaped forms may grow by just a few millimeters per year.[6] Over thousands of years this symbiosis has been responsible for the world's largest biogenic structure: the fourteen-hundred-mile-long Great Barrier Reef located off the coast of Queensland, Australia. Without this symbiosis, calcium carbonate deposition and coral growth in the tropical shallows would be negligible, and reefs as we know them would not exist.

ZOOXANTHELLAE: HAVES AND HAVE NOTS

Corals have benefitted enormously from hosting intracellular zooxanthellae, and some other creatures have followed suit. Other immobile reef organisms, like sponges, sea anemones, and certain soft corals, also benefit from a relationship

The World Beneath

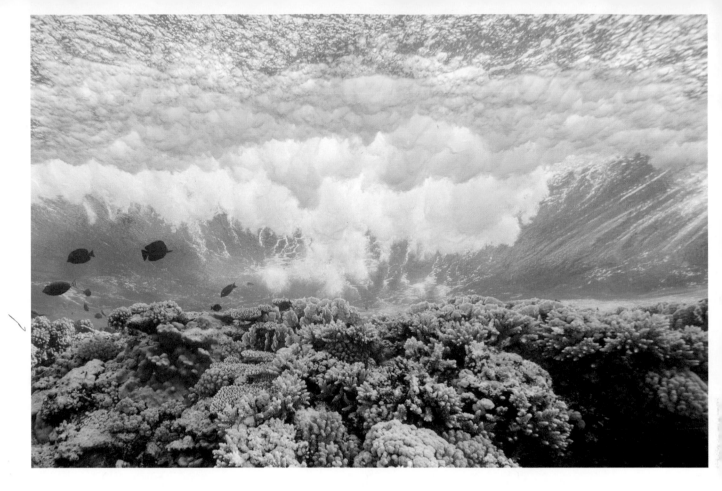

with these algae, as do certain mollusks. On land, we are familiar with slugs and snails, but in the oceans, mollusks are much more diverse. In addition to the tens of thousands of species of gastropods (slugs and snails), other well-known groups of ocean mollusks include cephalopods (octopuses, squids, and nautiluses), bivalves (such as clams and oysters), and chitons (unusual plated slug-like animals). Giant clams and a number of sea slugs have zooxanthellae living within their tissues.

One genus of sea slugs, *Phyllodesmium*, has a stronger relationship with the algae than most. These slugs are covered in cerata, which are thin, finger-like protrusions that cover the back of the animal. Cerata house the digestive glands of the slug, and zooxanthellae reside within the cells of these glands. The sea slug obtains the zooxanthellae from its food: beige soft corals found in shallow water. Each species of *Phyllodesmium* has selective tastes, and its camouflage reflects the type of coral that it prefers to feed on, rendering them almost invisible while feeding. The slugs can sit and feed leisurely on the coral with very little risk of predation, while also supplementing their nutrition through the photosynthesis of the zooxanthellae within their cells.[7] I have even spotted

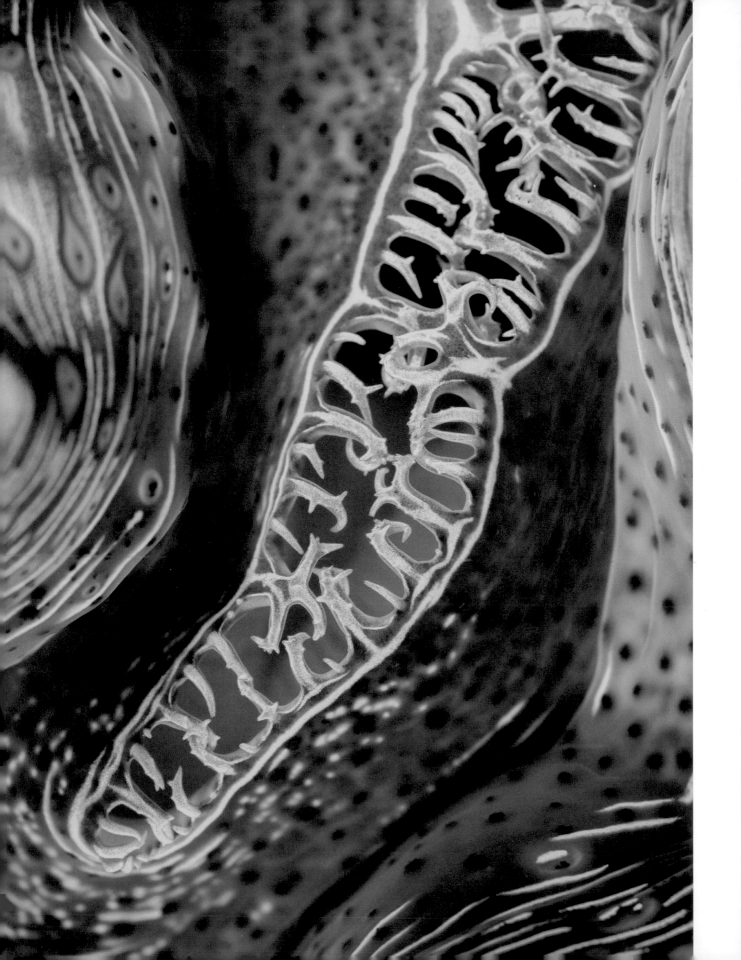

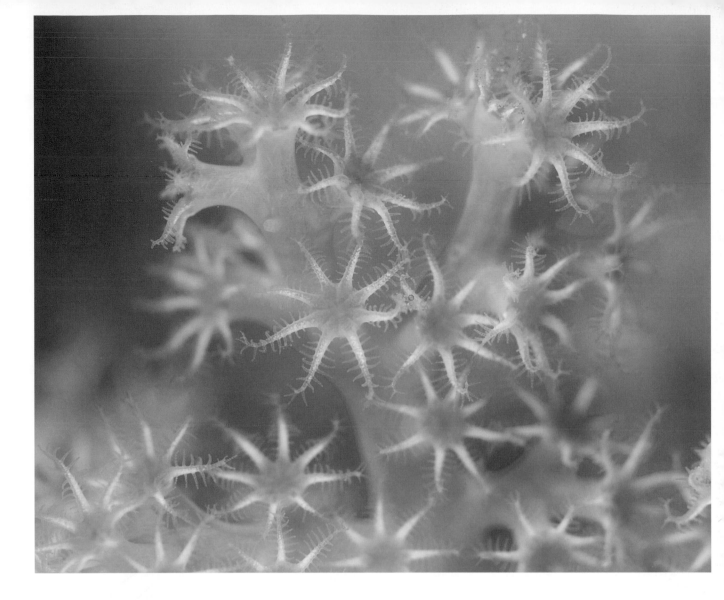

a particularly large species, *P. longicirrum*, hanging out in the open on the reef with the casual air of a sunbather soaking up the sun's rays.

Not all corals contain zooxanthellae, and it tends to be simple to tell which ones do. Zooxanthellae typically have a beige coloration, so corals containing these algae tend to be beige. Non-zooxanthellate corals (those corals without intra-cellular algae) tend to be much brighter in color. Most of the bright colors you might associate with coral reefs come from organisms that do not have symbiotic algae. These animals obviously do not benefit from contributions of a symbiont; however, as they do not require access to sunlight (a key ingredient in Darwin's Paradox), these corals are not as limited in where they can grow. They will often proliferate inside large overhangs or caves that receive little natural light.

ABOVE:: Detail of non-zooxanthellate soft coral polyps. Raja Ampat, West Papua, Indonesia.

OPPOSITE: Detail of a giant clam's mantle. Great Barrier Reef, Australia.

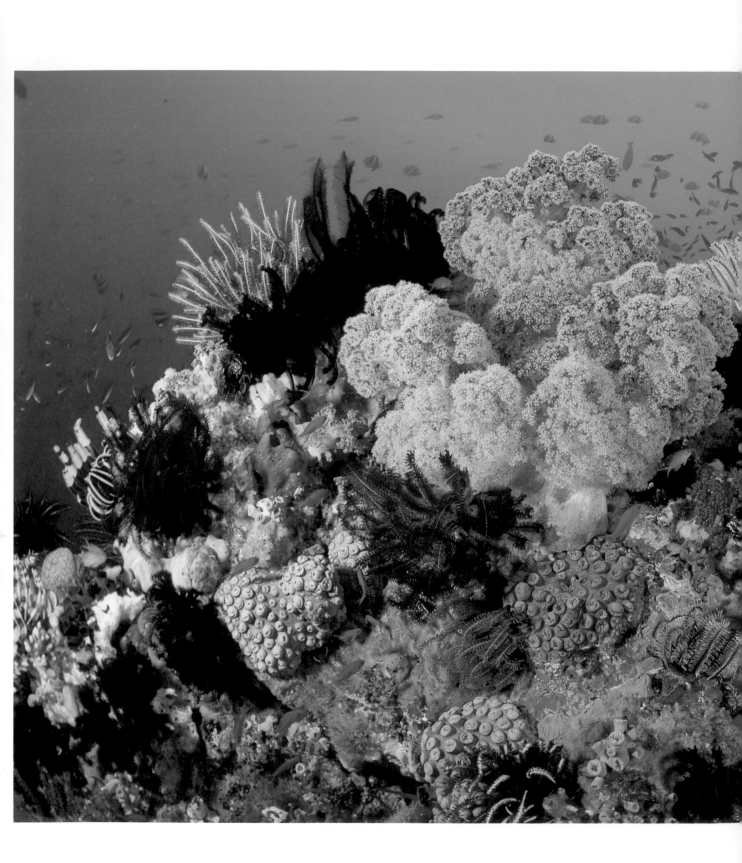

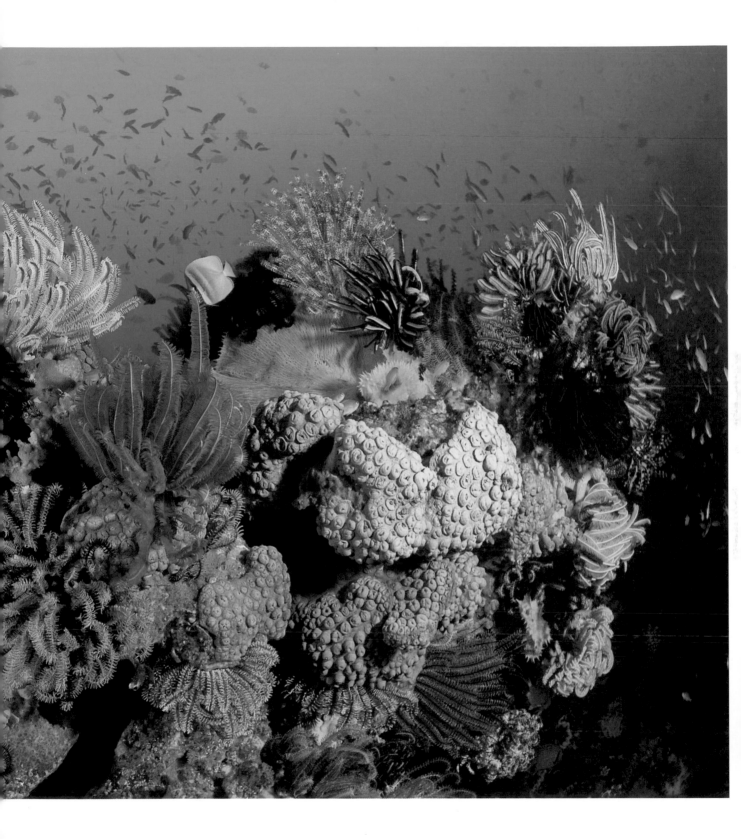

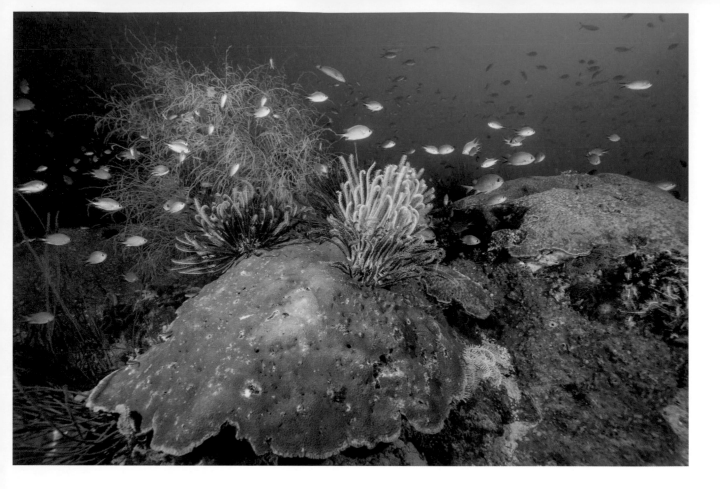

Rather than deriving nutrition from their symbionts, non-zooxanthellate corals mostly filter feed and usually situate around parts of the reef where nutrient-rich currents hit. Nutrient-rich water tends to be rather murky, which explains why—in that setting—the vibrant colors of soft corals, sponges, and other filter feeders truly come alive.

Triton Bay in West Papua, Indonesia, experiences localized seasonal upwellings of cool, nutrient-rich water that turn the existing water into a green soup. The first time I dived there, descending with a little hesitation into the eerie water, I wasn't sure what to expect. When I reached the seafloor I was taken aback by the profusion of growth and riot of color. Without having to compete with light-loving corals, other organisms had been able to proliferate. Soft corals in reds, pinks, yellows, and purples covered every inch of the reef. In an illogical contradiction, most color exists in the gloom.

Soft corals do not produce a ridged calcium carbonate skeleton like hard corals do; rather their structure is based on a mesh of tiny calcareous rods, known as "spicules." During the parts of the day when currents aren't flowing, soft corals

shrink, forming small spiky balls. As currents begin to pick up, they swell and expose their polyps, which can then begin to trap plankton from the passing water. These corals, which live without zooxanthellae, are also found in the deep, lightless sea where individual colonies grow extremely slowly for thousands of years. Twenty thousand feet below the surface, in water of 30 degrees Fahrenheit, life continues at a slower pace. Without the volatile climatic conditions experienced in shallower waters, the corals here have created rich but fragile ecosystems that are home to their own unique fauna.

WHERE CORALS GROW

With the symbiotic coral-algal powerhouse facilitating growth of corals in clear tropical seas, few other organisms in this habitat are able to compete. However, corals do have specific environmental requirements; where these are not met they can be outcompeted by other organisms that are more tolerant of the particular conditions. On the whole, corals have a few basic ecological requirements to maintain meaningful reef building growth.

Warm water is fundamental to coral growth. Corals generally have a tolerance for waters between 70 and almost 90 degrees Fahrenheit; in winter, they can briefly endure temperature dips to 65 degrees. Because of this, most reefs fall within the latitudes of 30 degrees north and south; however, in some parts of the ocean the reefs might extend slightly farther toward the poles. Certain globally important currents assist in extending the reach of warmer waters beyond these latitudes, for example the major Pacific equatorial currents that flow separately in the northern and southern hemispheres. In the southern hemisphere, the South Equatorial Current is driven by winds across the central Pacific and strikes the Great Barrier Reef off the coast of Queensland, Australia; it then flows from there in a southerly direction as the East Australian Current. As the East Australian Current flows southward, it carries warm waters from the equator that can ultimately reach as far as Tasmania. This was the current that Nemo used to travel from the Great Barrier Reef in the north to Sydney in the south in *Finding Nemo*. Without the East Australian Current, the waters off Sydney, for example, would be significantly cooler and many organisms would have their southern ranges much farther north. Over recent decades, this current has been strengthening and extending farther south, pushing the geographic ranges of some organisms in a southerly direction.[8]

OPPOSITE TOP: Robust coral growth enduring crashing waves. Egyptian Red Sea.

OPPOSITE BOTTOM: Huge and elaborate coral growth can take many decades or even centuries to grow. Egyptian Red Sea.

I have seen firsthand how this extension of the warm East Australian Current has had an unfortunate impact on the historically cool waters of southern Australia. In 2011, I visited the Tasman Peninsula in southeast Tasmania to dive the giant kelp beds. Much like the famed kelp beds of California, these giant algae form huge dense and towering forests. These kelp beds were known as being similarly impressive as their northern Pacific counterparts, and it was the only time I have had the chance to experience this amazing ecosystem. The kelp beds were previously so dense and widespread as to allow commercial harvesting but have gradually dwindled over the years. I dived one of their last real strongholds, Waterfall Bay, in southeast Tasmania—where colorful weedy seadragons and a wide variety of other unique creatures exist.

Having been so amazed by this aquatic jungle, I returned six years later, eager to share the spectacle with some friends. To my utter dismay, I was told that kelp had disappeared almost entirely from Tasmania since my last visit, due to the extension of the East Australian Current. Although Tasmania may seem like a remote wilderness, the area is suffering some of the most extreme impacts of climate change on the planet.[9] It is among the top 10 percent of places on Earth for extreme ocean warming, heating at four times the global average, with no sign of this deadly trend abating.[10] The reason for the kelp's disappearance isn't only the influx of warm water. The long-spine urchin, a mainland native, has migrated with the warmer waters, extending its range four hundred miles south over the past forty years.[11] A voracious herbivore, the urchin eats juvenile kelp and prevents it from establishing. The loss of the kelp is thought to have directly impacted at least 150 species associated with the forests.[12]

Looking at global patterns of coral reef distributions, you find coral reefs in unexpected places. Conversely, you might not find a reef in a place where you would expect one. On the west coast of the tropical Americas, an area where you might expect coral reefs to flourish, they tend to exist only in isolated patches, measuring just a few hectares in size.[13] Imagine the Galápagos Islands, which, at the equator, seem to occupy the perfect coral comfort zone. However, aside from a few scattered and species-poor reefs at Darwin Island in the far north, corals in the Galápagos remain few and far between. While Indonesia, for example, boasts well over five hundred hard coral species, the Galápagos hosts just twenty-two.[14] The lack of corals is largely due to unsuitably cool water that bathes the islands. Despite their equatorial location, it is not uncommon for the Galápagos Islands

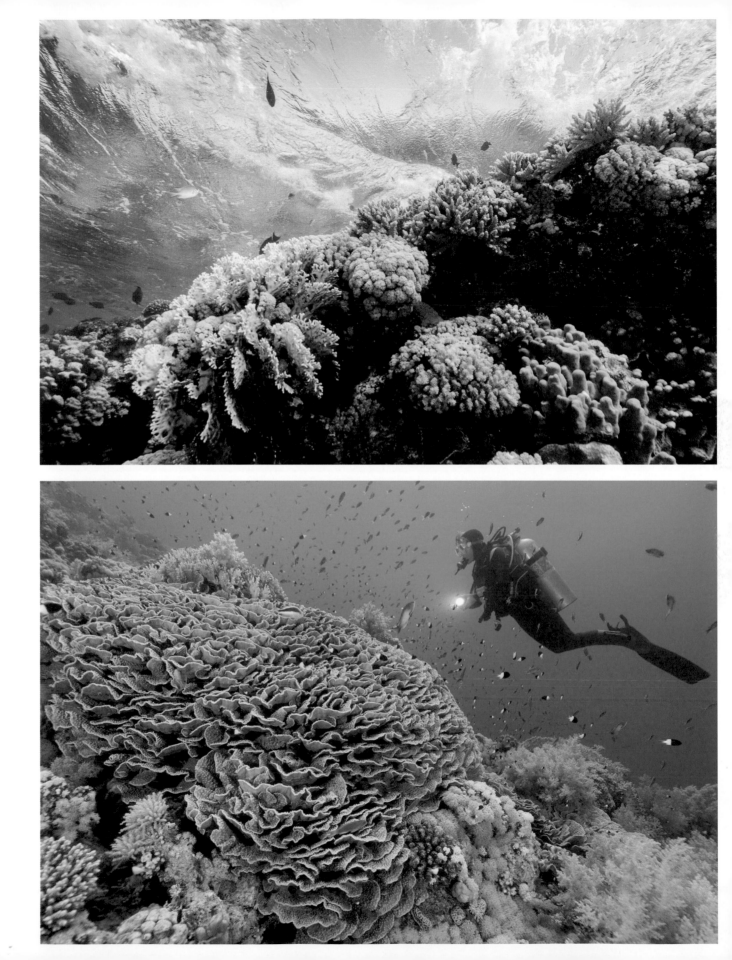

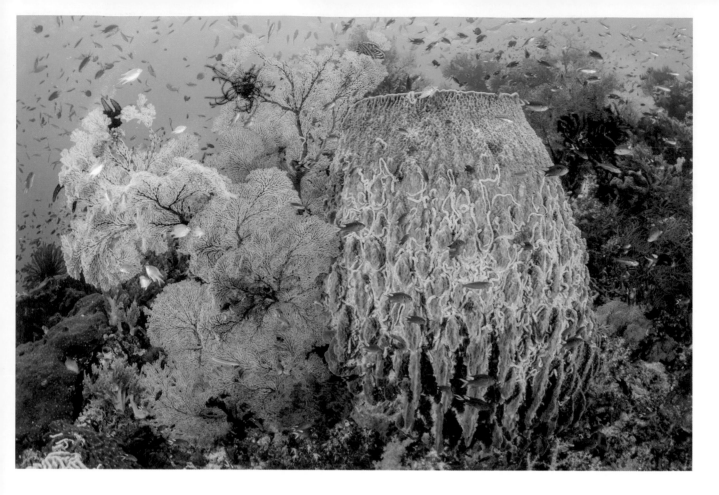

to experience waters between 50 and 60 degrees Fahrenheit, which is far too cold for corals to thrive. The cool, nutrient-rich water originates in the deep ocean and is brought to the surface in a process known as "upwelling." There are various locations around the globe where similar upwellings bring cool water to the surface, in all cases inhibiting the growth of coral, thus limiting the potential extent of coral reefs.

For optimal growth, corals also need constant salinity, which the large bodies of the ocean provide. It follows then that in coastal areas, large river outflows of fresh water inhibit coral growth. Reefs do not occur near the mouths of the Mississippi, Amazon, and Ganges rivers; the huge volumes of fresh water decrease salinity, and the high levels of sediment loads prevent sunlight from penetrating very far through the water column. The murky sediments in the water from the surface down to the seafloor do not permit sufficient penetration of light, thereby limiting necessary photosynthesis. Conversely, water with too high salinity can also pose a threat to coral growth, if it passes a certain threshold. The Red Sea, a substantial inlet of the Indian Ocean west of Saudi Arabia, is one of the saltiest life-supporting bodies of

The World Beneath

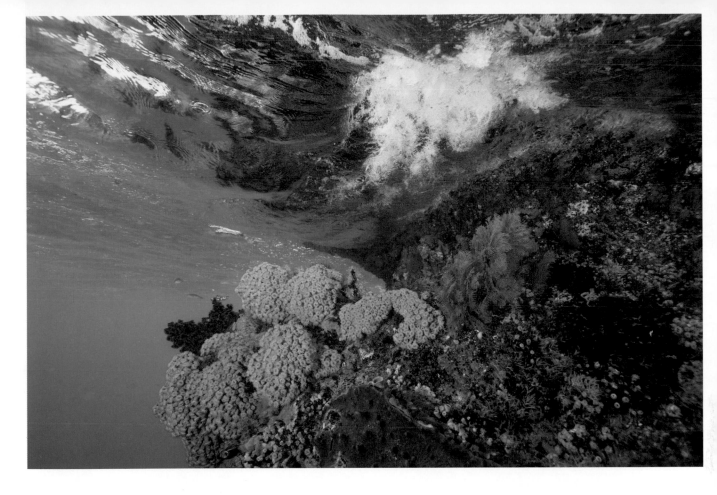

water on Earth and lies at the upper limits of coral's salinity tolerance. Due to the high salinity, when I dive in the Red Sea I have to wear an extra couple of kilos of weight on my equipment to be able to descend in the water column.

Finally, corals require ample sunlight for optimum growth. They must attach to a hard surface within sufficiently shallow depths to allow for ample light penetration. New coral reefs can't simply open up shop in the middle of the ocean: they can only grow around islands or existing atolls, a ring-shaped coral reef. The maximum depth that light can penetrate clear water for coral growth hovers at around 160 feet, and most of the open ocean is far deeper. But what of the reefs that punctuate the remote recesses and vast stretches of deep blue sea? Charles Darwin theorized that coral atolls formed in the open ocean of the Pacific through a series of stages; first, corals settled around ancient volcanoes as fringing reefs hugging the coasts. Then, as the volcanoes began to sink and erode into the seafloor, their former coastlines receded. The reefs grew farther from these shores and became barrier reefs guarding lagoons, which filled the new distance between corals and coasts. Ultimately, the volcano cones succumbed to the depths of the ocean, but

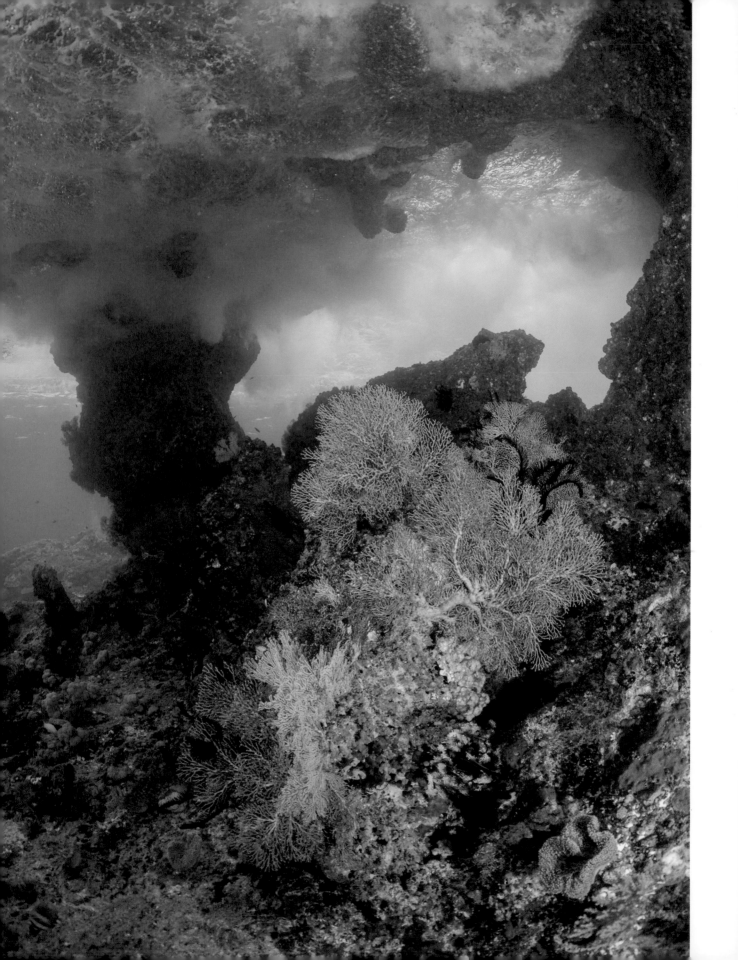

the corals remained: growing toward the light and leaving remote atolls that are scattered throughout the open ocean.

Because of the rich tapestry of life on coral reefs and the different environmental conditions that shape them, each ecosystem is unique. Through my experiences of diving around the world, I have become familiar enough with the reefs that I can tell exactly where a picture was taken by the composition of sessile invertebrates growing there (that is, if the fish don't give it away). Sessile invertebrates are those animals such as corals, sponges, bryozoans (an ancient lineage of small filter-feeding invertebrates), and tunicates (a common marine invertebrate with an important role in the evolution of back-boned animals) that permanently attach to the seafloor or reef to grow.

With so many sessile invertebrates vying for space on the reef, there is fierce competition among them. It is clearly not in an organism's best interests to have other species settle directly next to it and possibly overtake it, so these reef dwellers have evolved ingenious modes of self-protection. Some soft corals and sponges release chemicals into the water, which inhibit the settlement of other sessile invertebrates directly around them.[15] Inhibition of one species by another to impede growth or prevent settlement through the release of chemicals into the environment is known as "allelopathy." The larvae of other invertebrates detect the chemicals, called allelochemicals, and avoid them.[16] If they settle in the proximity of an allelopathic organism, they could be killed by the chemicals.

One of my favorite places in the world to dive is Raja Ampat. Here, every single inch of the reef is covered in growth of some sort, and the growth continues to within inches of the water's surface. I spent an entire two-week dive trip exploring these islands without straying thirty feet below the surface—pretty unusual, given that a recreational dive certification allows you to dive to one hundred feet. The shallows of Raja Ampat, which means "Four Kings" in Indonesian and refers to the four large islands that comprise the area, are full of hard coral growth, as well as the growth of various sessile invertebrates. Most of these islands were produced by ancient coral reefs; over time, ocean erosion has whittled away at their bases, leaving the islands with mushroom-like topographical forms. This erosion is so extreme that in some places the coastline of the islands is undercut by fifteen feet or more. Underneath the mushroom-like overhangs, light cannot reach the substrate, the hard base on which organisms live, so light-loving corals aren't able to grow. In their place, the corals that would ordinarily only be found in deeper

OPPOSITE: Huge waves crashing through an archway. Raja Ampat, West Papua, Indonesia.

water appear in three-feet-deep water. Multihued sponges, gorgonian sea fans, soft corals, whip corals, and black corals cover the rock, while the waves bubble under the overhang above.

While the composition of coral reef communities varies hugely between locations, the characteristics of the corals themselves can be extraordinarily plastic too. The same species of coral can be variable in its growth shape depending on the local conditions. In deeper water, where light is at a premium, corals grow differently than those of the same species in shallow water. Likewise, in very protected areas, a branching coral is more likely to grow with a fragile, spindly appearance than in an exposed site, where branching coral will be more likely to have a squatter and more robust growth form that can tolerate a battery of waves and storms.

Perhaps, as land-living animals, we mistakenly believe that the vibrant, polychromatic nature of reefs likens them to the colorful but ephemeral annual flowers that we see in the garden, rather than ancient and enduring redwood forests. Giant clams and anemones may both live for more than one hundred years;[17] even anemonefish could live up to ninety years at the extreme end of current estimates;[18] some large hard coral colonies could be eight hundred years of age.[19] These timescales are important to bear in mind when we consider the conservation of coral reefs and how long it takes for them to recover following damage.

The substrate that exists between the attachment site of sessile invertebrates is potentially as important as the rest of the community due to the other organisms that call it home. Herbivory, or feeding on plants, is a very important ecological process that builds communities both on land and in the water. On coral reefs, herbivores play a vital role in maintaining the status quo of the reef by grazing on the turfs of algae that grow constantly on rock surfaces. The many species of herbivorous fishes and invertebrates keep busy, dining

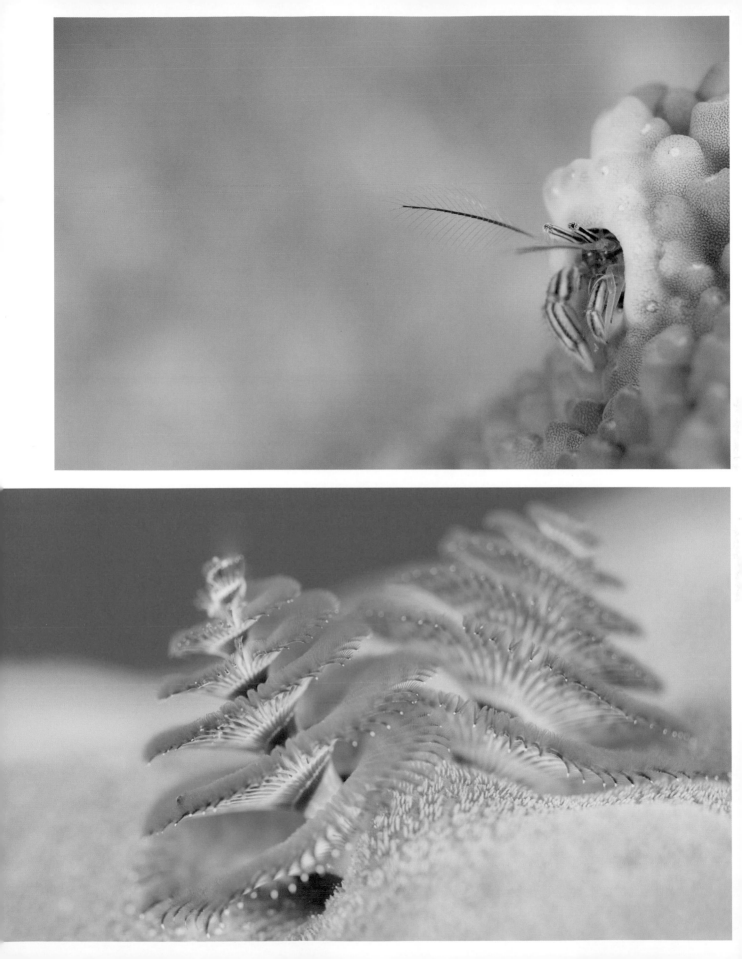

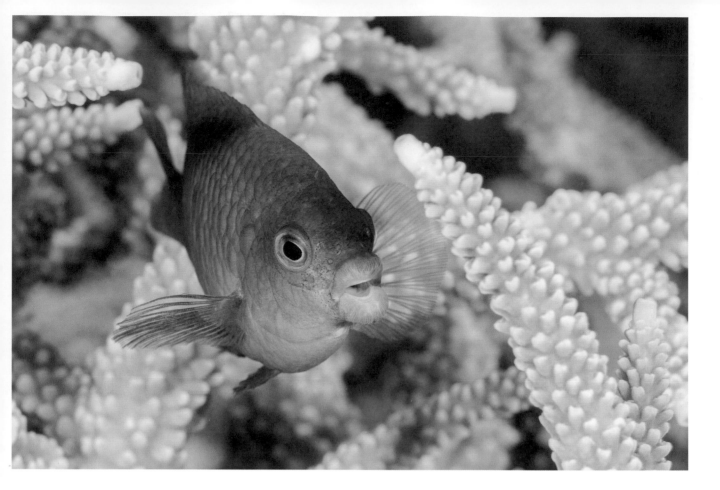

on 90 percent of the algae produced each day. Without this constant grazing pressure, algae can grow large and tough and ultimately reach a size unpalatable for most herbivores. If the herbivores falter in their efficacy and allow the algae to mature, the entire ecosystem can irreversibly shift from coral to algal dominance. Overfishing of herbivores such as parrotfishes can have a wide-ranging impact as a result. Only one species of unicorn fish seems to have a penchant for these large macroalgae, and the balance of the reef's ecology rests on the appetite of this humble fish.[20] As this illustrates, each species plays its own unique role in the ecology of the reef. It is therefore critical to maintain and conserve the full gamut of coral reef species to ensure that all the reef's vital ecosystem processes are accounted for, and no single part claims a monopoly.

CORAL HOMES AND CORALLIVORES

The physical framework of corals provides three-dimensional structures on the reef for creatures to live in or hide in and can also serve as food for many species to

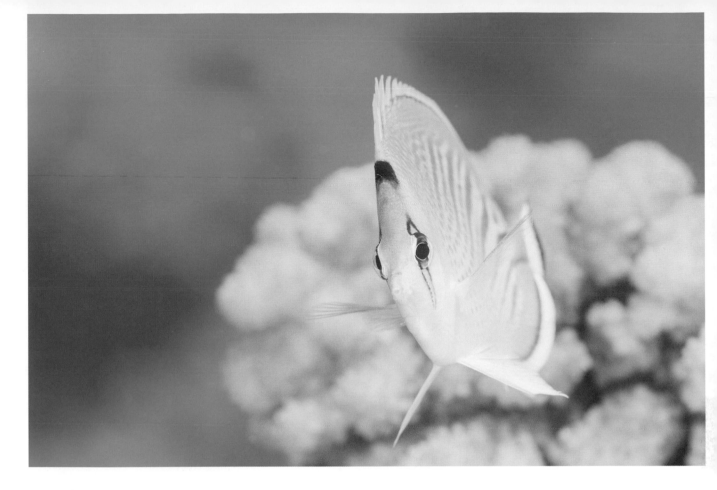

live on; the deceased skeletons of hard corals even bequeath a foundation for the next generations of corals to grow on.

Coral hermit crabs are one of the species that exploits corals as a home. Instead of carrying around shells for protection like their non-reef counterparts, coral hermit crabs cozy up in small holes in the coral, filter feeding with specially adapted arms and never departing their safe havens. Likewise, Christmas tree worms depend entirely on corals providing them places to burrow, shelters from which to extend their filter-feeding bristles to trap passing plankton.

Corallivores, those organisms that feed on corals, are easily spotted on healthy coral reefs. I became fixated with one corallivore in particular: a damselfish called the big-lipped damsel. I had only ever seen pictures of the fish and was having a hard time finding them in the wild. Finally, while diving a small marine reserve in the southern Philippines, I spotted one of these superficially unspectacular fish by chance in a rich coral garden. I identified it by the quick glimpse I caught of its preposterously large lips as it fed on a branching coral. These lips are so large that they're surely the true inspiration for the inflated Hollywood "trout pout."

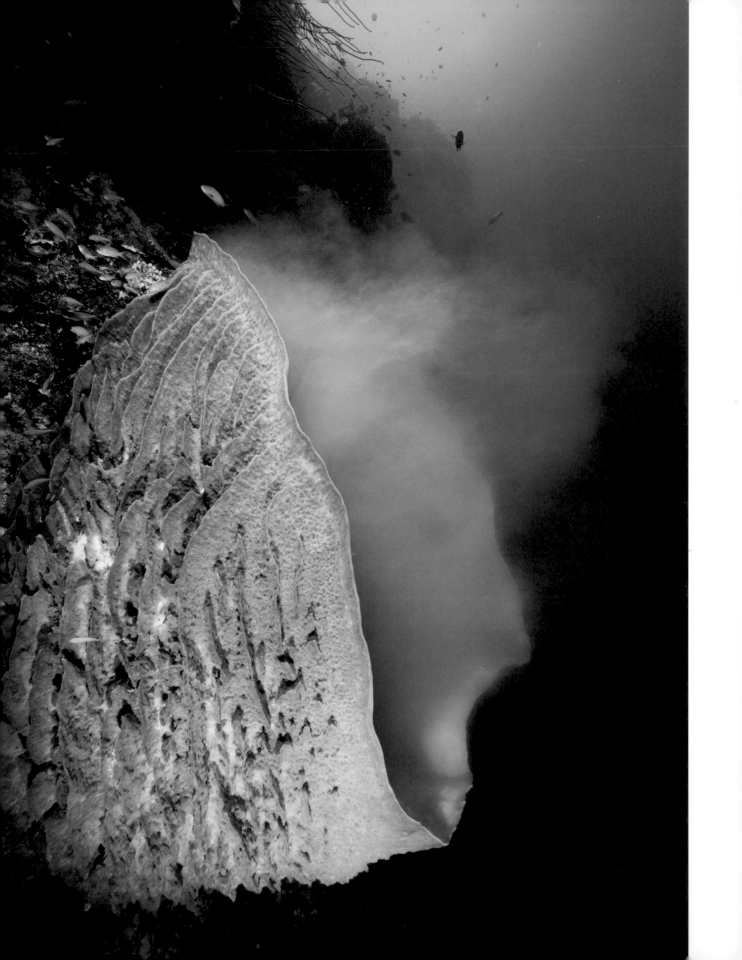

However, these lips serve a purpose, as does everything in nature. After finding more of these fish a year later in West Papua, I spent an hour or so watching their antics and confirmed the function of the lips. These fish are obligate corallivores, and rather than utilize the approach of the dainty butterflyfish that pluck one polyp at a time, the damselfish instead completely denudes the surface of the coral of tissue, their sensitive flesh meeting the sharp coral skeleton beneath. Their voluptuous lips protect them from cutting and tearing their skin against these edges.

The most well-known of specialist corallivorous fishes must be the butterflyfish, which are ubiquitous and conspicuous members of coral reef communities around the world. Because most butterflyfish completely rely on healthy and diverse coral assemblages, they quickly respond to changes in coral health and abundance by moving location; in extreme cases of ecosystem degradation, they can die. In the early 1980s it was suggested that butterflyfish could act as indicators of coral health, as they are easy to survey and changes in their populations are easy to document.[21] It would be much more difficult to survey corals directly as they are so numerous and can be very hard to identify. Butterflyfish can be quite picky about their favored food sources, so their population fluctuations also help to highlight changes within specific coral groups. They are also territorial, and the density at which they will tolerate other butterflyfish is directly related to local food supplies. Therefore, these coral reef staples can tell us how many species of coral are present in an area, as well as their density.

SPAWNING

One evening in mid-November, after spending the twilight hour making observations on the social behavior vswam up into a cut in the reef full of corals, sponges, and crinoids. There was an excitable energy in the water, and before long I started to notice a few little white specks lifting off a coral. Very quickly, several corals and even a crinoid began spawning, releasing great clouds of sperm and eggs. It was magical to witness this event firsthand. The crinoid appeared almost on fire as a smoke of gametes were released. The coral took a subtler approach, releasing visible individual large gametes into the water.

This type of reproduction is known as "broadcast spawning," or "mass spawning." Most corals and other animals that are permanently stuck to the reef release

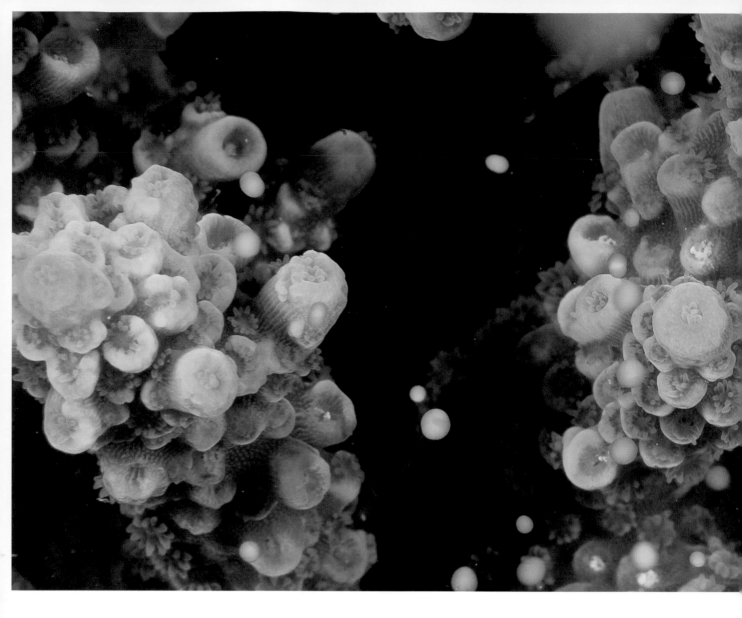

their sperm and eggs into the water in this way, where fertilization and development then occur externally.[22] Mass broadcast spawning is one of the greatest natural spectacles on Earth since most of a given reef's organisms are synchronized to spawn on one or a few nights per year, turning the water surface into a noticeable slick due to the density of the spawn. Most species in a given area tend to spawn on the same evening, although there may be other evenings throughout the year where conditions suit the spawning needs of other species. Mass spawning of different species may be an adaptation to overwhelm predators and prevent them from taking too much of a toll on the reproductive potential of a single species. Interestingly, researchers have found that spawning just several hours apart on

the same day is enough to prevent coral colonies from cross-fertilizing, and this may lead to reproductive isolation and the evolution of different species.

Mass coral spawning typically occurs a few nights after a full moon. Environmental cues remain vital in enabling one hundred-plus species of corals and other organisms to orchestrate their spawning on the exact same evening of the year, with each species typically utilizing just a four-hour window in which to spawn. Various environmental cues such as day length and luminance from the moon appear to allow the creatures to synchronize with other members of their own species.[23] Other organisms plan their schedules around the same yearly cycle to exploit the coral spawning. Whale sharks make great migrations from across the Indian Ocean to coincide with the spawning at Ningaloo Reef in Western Australia, as the spawn significantly contributes to the sharks' annual dietary intake. The tourism industry has also developed around the regularity of the spawning and the shark's arrival.

SESSILE INVERTEBRATES

A huge variety of sessile organisms, in addition to corals, occupy the hard substrates of reefs, including sponges, bryozoans, tunicates, gorgonians, sea anemones, and corallimorphs (large disc-shaped animals, superficially similar to sea anemones). Some of these organisms are so ancient that they haven't shared a common ancestor since the times of the very earliest animal life on Earth.

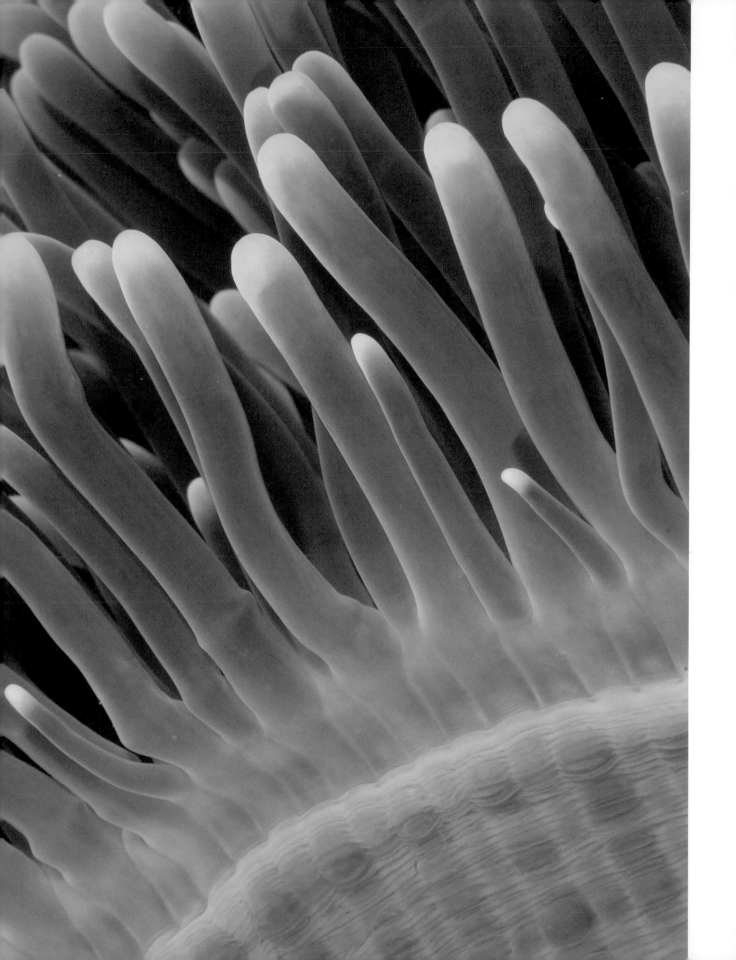

Sponges, one example, are very simple animals that draw water in through their sides using tiny whip-like cells to create a current. Recent research on sponges has found that they may be the missing link that helps to transfer organic matter in the water column into a form that the reef's inhabitants are able to consume, filling in another missing part of Darwin's Paradox.[24] The cells in a sponge's filtering system have a very high turnover rate, producing a consumable detritus for reef creatures. In the Caribbean, sponges are more abundant and species-rich than corals and have a huge variety of important roles on the reef, even physically cementing the whole structure together. Some sponges have zooxanthellae, like corals, whilst others have bacteria that help to fix nitrogen into a form that they can use in growth.

Many other organisms attached to the reef contribute to the diversity of coral reefs. The Anthozoa, which includes not just the corals, but also a wide variety of their relatives such as gorgonians, sea anemones, and corallimorphs are very diverse. Some of these are solitary and consist of a single polyp, such as sea anemones and corallimorphs, which are both known for their noxious stinging tentacles. Gorgonians are considered to be a type of soft coral, and like their closest relatives, do not produce a calcium carbonate skeleton. Gorgonians are largely defined by their fan-like shape, which gives them their common name, the sea fan. Some gorgonians grow to be the size of a car; others form bush-like shapes. Often, the only way to identify them at a species level is to view them under microscopic magnification.

Tunicates, sometimes also known as "ascidians" but more commonly known as "sea squirts," are prevalent on most coral reefs though they are generally small and largely ignored. Sea squirts are simple animals that have a single inhalant and single exhalent opening, where water flows in and out to be filtered of nutriment. One of the most interesting aspects of their biology is that they are the most foundational living relative of the vertebrates. Vertebrates are one of the great branches in the tree of life and include those animals—humans, fish, amphibians, birds, and other mammals—that have a backbone. The link between tunicates and vertebrates has been shown through genetic analysis as well as identification of some very early key features of backboned animals seen in tunicate's tadpole-like larval forms.[25] It's amazing to consider that these tiny gelatinous sea squirts could have given rise to all backboned life on Earth.

OPPOSITE: Sea anemone tentacle detail. Wakatobi, Sulawesi, Indonesia.

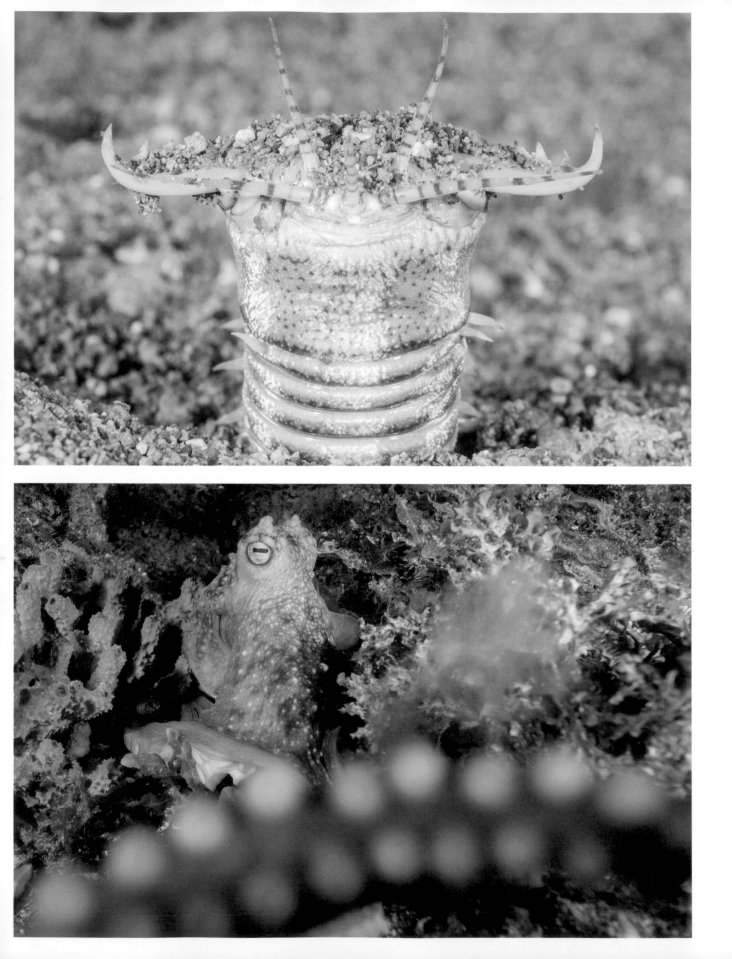

UNSEXY BEASTS

In addition to the many sessile invertebrates that are fundamental for coral reef ecosystems that remain rooted to the reef, there are of course many active and mobile invertebrates too. Mollusks, crustaceans (a group of arthropods that includes many familiar species such as lobsters, crabs, barnacles, and terrestrial pill bugs), echinoderms (an evolutionarily distinct group of animals that includes sea stars, urchins, and crinoids), and polychaete worms (a branch of worms with noticeable bristles) are some of the most easily spotted, but they rarely come up when people think about the biological diversity of coral reefs.

Worms might be the least appreciated of reef animals, but their role in breaking down coral rock is important for the background functioning of the reef. Feather duster worms filter food from the water and tend not to leave their burrows, but other polychaete worms are much more active. Fireworms scurry about, confident that their irritating bristles will ward off predators. Another worm that appears fearless is the Bobbit worm. Named in honor of the infamous incident in which Lorena Bobbitt cut off her husband's manhood as he slept and then threw it out of the car window into a field, these terrifying worms emerge from the sand during the night and stand upright with a pair of enormous pincers held open so they're ready to pounce on any unsuspecting fish. They can reach ten feet in length and are a nightmarish predator for small reef fish. You certainly wouldn't want to complete your one hundredth dive at night where these worms are found, since the one hundredth dive is traditionally done in the nude and the worm may get confused.

Mollusks are another group that features prominently on coral reefs. There are many sessile forms, such as giant clams and oysters, but also many mobile groups including thousands of species of sea slugs, snails, little-known groups such as the many-plated chitons, and, of course, the cephalopods. Mollusks are an extremely species-rich group, with 80 percent of mollusks belonging to the class *Gastropoda*, which includes all snails and slugs. Clearly, the cephalopods, a group of around eight hundred species containing squids, octopuses, and nautiluses, have evolved in a different direction than the slugs. Nautiluses are a fascinating group of spiral-shell-dwelling free-swimming cephalopods. Of the several thousand known fossil nautiloid species, which were once one of the ocean's dominant marine predators, there are now just a few marginal extant species. Cephalopods have evolved to be some of the most intelligent animals on the reef; certainly, the most intelligent

OPPOSITE TOP: Bobbit worm waiting to ambush its prey. Anilao, Luzon Island, Philippines.

OPPOSITE BOTTOM: A playful Maori octopus, the world's third largest species of octopus, attaining 22 lbs in weight. South Australia.

PAGE 48:

1: Nudibranch (*Aegires villosus*). Anilao, Luzon Island, Philippines.

2: Nudibranch (*Favorinus mirabilis*). Sangeang Island, Indonesia.

3: Nudibranch (*Caloria indica*). Raja Ampat, West Papua, Indonesia.

4: Nudibranch (*Glossodoris stellatus*). Raja Ampat, West Papua, Indonesia.

5: Nudibranch (*Nembrotha kubaryana*). Solomon Islands.

6: Nudibranch (*Tambja tentaculata*). Raja Ampat, West Papua, Indonesia.

PAGE 49:

7: Nudibranch (*Chromodoris* sp.). Hachijō-jima, Japan.

8: Nudibranch (*Miamira alleni*). Anilao, Luzon Island, Philippines.

9: Nudibranch (*Halgerda willeyi*). Hachijō-jima, Japan.

10: Nudibranch (*Sakuraeolis nungunoides*). Sangeang Island, Indonesia.

11: Nudibranch (*Okenia kendi*). Lembeh Strait, Sulawesi, Indonesia.

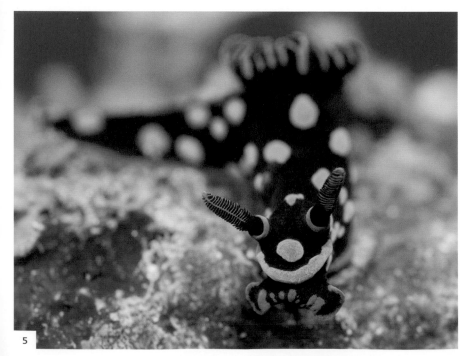

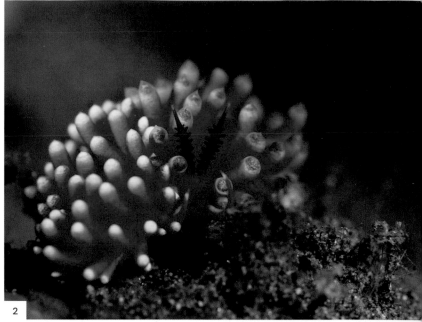

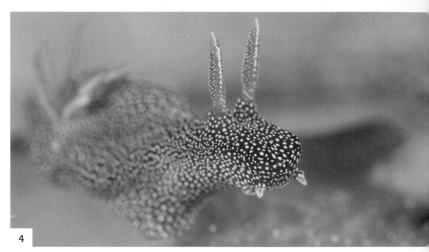

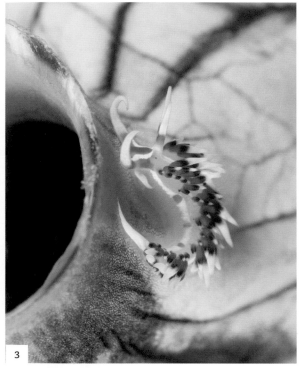

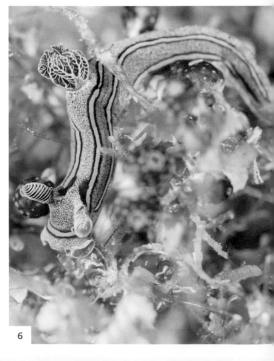

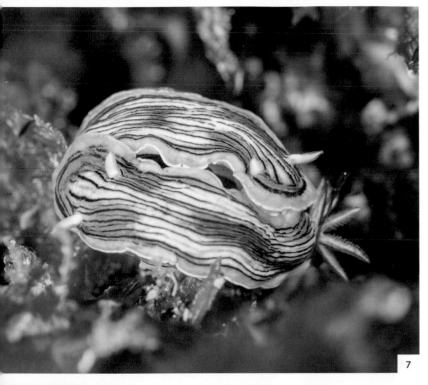

7

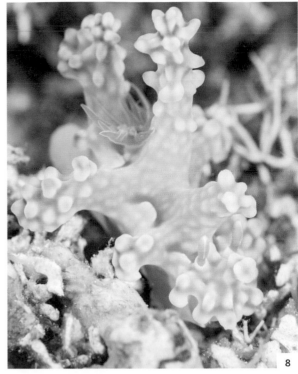

8

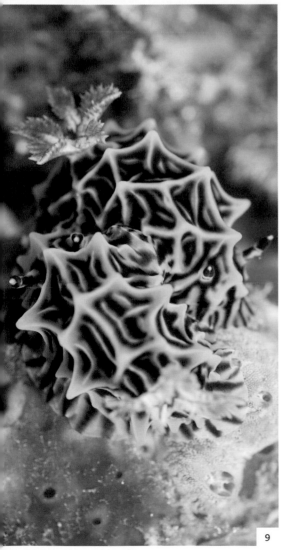

9

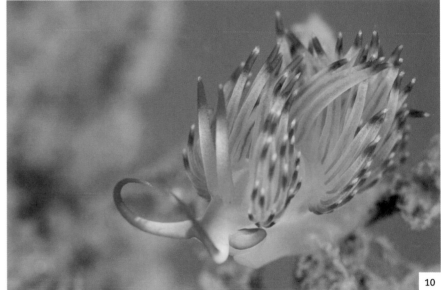

10

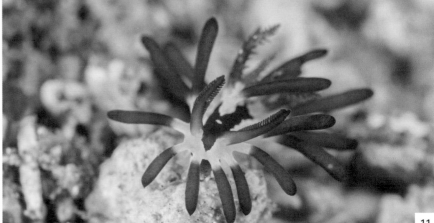

11

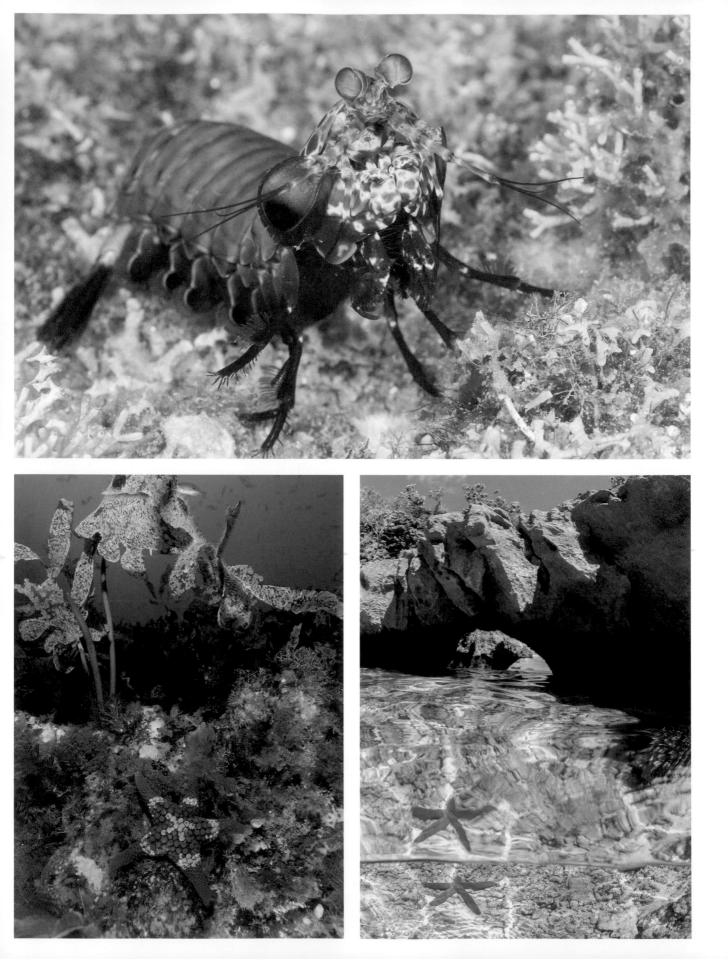

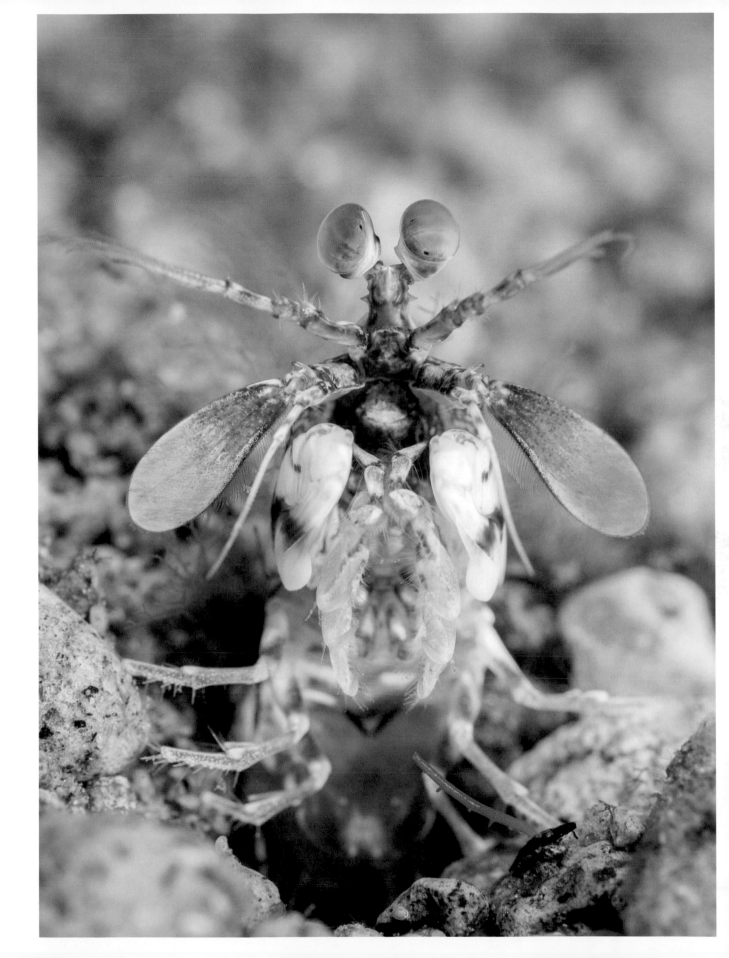

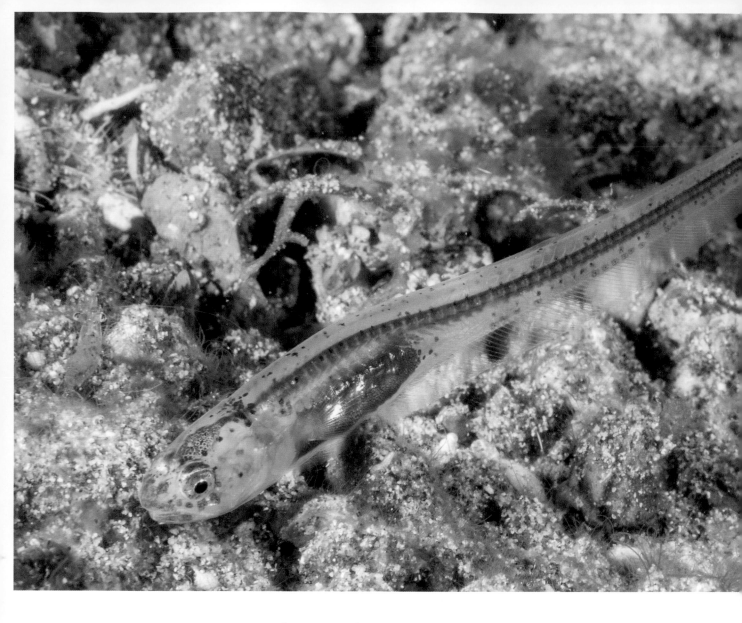

invertebrates. They have highly developed nervous systems and brains as large as some equivalent-sized vertebrates, which have afforded them unparalleled learning and memory.

Also among the reef's active invertebrates are the arthropods, segmented animals whose more familiar members include insects, spiders, and centipedes. In the oceans, arthropods are equally diverse and include crustaceans such as crabs and lobsters, as well as the little-known pycnogonids, known as "sea spiders," and horseshoe crabs. The sea spiders and horseshoe crabs are unusual and ancient branches of the group, rarely seen and minimal actors in coral reef ecology. The crustaceans, however, are a very important group, both in their

The World Beneath

free-living forms and as parasites, as we'll learn in a later chapter. Barnacles, the familiar white mottling seen within the splash zone of the rocky shore or on the chins of whales, are nonetheless unexpected members of the crustaceans, and more recognizable as crustaceans in their larval form; as adults they remain cemented to the rock and rely on filter feeding. Shrimps, lobsters, mantis shrimps, and many types of crabs are very common on coral reefs and range in size from tiny species almost invisible to the naked eye to huge lobsters.

Echinoderms are the final group of dominant invertebrates and are entirely marine. They are simple and ancient animals with five main classifications: the crinoids, sea stars, brittle stars, urchins, and sea cucumbers. Among these various groups, echinoderms play a very significant role on coral reefs. Urchins furiously graze away algae; crown-of-thorns sea stars form plague proportions that can wipe out entire coral reefs; and sea cucumbers feed on the bacteria that cover sand grains. Echinoderms also provide homes for a huge array of other organisms. One of the most shocking examples is the pearlfish that lives inside the body cavity of sea cucumbers. They are a rod-like transparent fish that emerge from the cucumber's anus at night to feed, and they pop back in during the day to hide inside the rarely predated echinoderm.

Coral reefs are composed of organisms from some of the most disparate branches from across the tree of life, all wrapped up in one ecological hodge-podge. It is due to these long-diverged branches of life that coral reefs are considered to have higher levels of diversity than tropical rain forests, with many of a reef's organisms dating back hundreds of millions of years.

PAGE 50, TOP: Peacock mantis. Dumaguete, Negros Island, Philippines.

PAGE 50, BOTTOM LEFT: *Nectria saoria* sea star. Tasmania, Australia.

PAGE 50, BOTTOM RIGHT: Blue sea star in the shallows. Raja Ampat, West Papua, Indonesia.

PAGE 51: Pink-eared mantis. Dumaguete, Negros Island, Philippines.

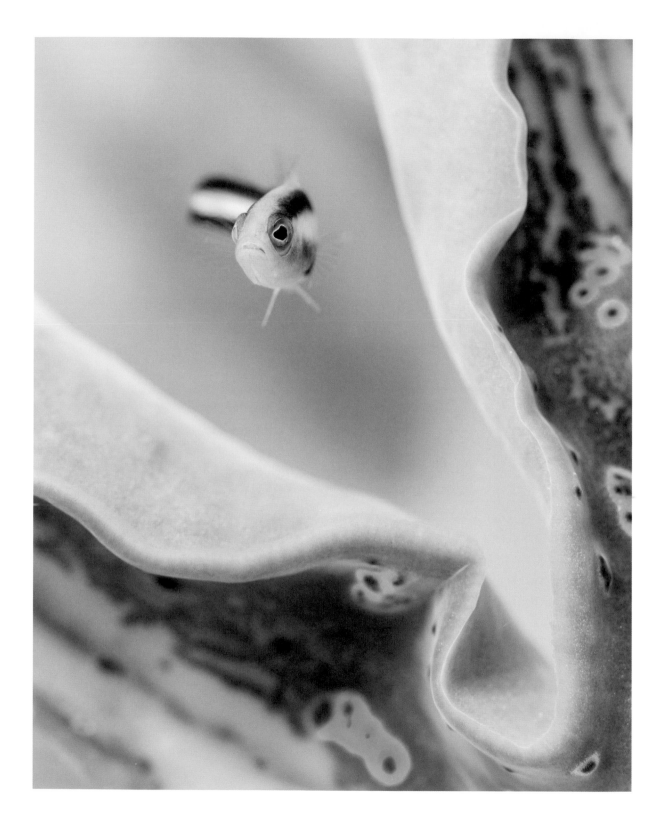

The World Beneath

CHAPTER 3:

THE CORAL TRIANGLE

Huge clouds of damselfishes in hues of gray, yellow, and baby blue pulse in and out of the protection of the field of branching corals that stretches before me. Trevallies, small relatives of the tuna, burst from out of nowhere to try and snag one of these wary but tasty treats. Several blacktip reef sharks slowly cruise above the sharp coral, paying no attention to either myself or their potential prey. I turn my attentions from the reefscape and look down at the smaller animals around me. A pair of ring-tailed cardinalfish, a species-rich group of small reef fishes, is below, the male's mouth full of rusty orange eggs. The reef is busy. Every glance reveals a new branch from the tree of life. Not just fish and corals, but sea stars, tunicates, whip corals (whip-shaped corals range in length from a few to ten feet and can be solitary or form small bushes), and sailors' eyeballs—a silvery marble-like alga—all buzzing, all contributing to the cornucopia of life.

Often dubbed the "rain forests of the sea," coral reefs contain outstanding natural diversity, packed full of vibrant animals that capture the imagination. They accommodate some of the highest densities of animals on earth and more species than any other marine habitat. Although coral reefs are widespread throughout the tropics, they cover only a small area of our planet: a space smaller than the state of Texas, covering a measly 0.1 percent of the Earth's surface.[26] While the structure and composition of coral reefs appear superficially similar regardless

of their location, the number of coral reef–associated species varies considerably depending on where you are in the world.

Tropical rain forests and coral reefs are the pinnacles of biodiversity of life on Earth. Rain forests cover an area twenty times that of all the coral reefs, and host more individual species than coral reefs, but they have fewer groups of species at higher taxonomic levels. It is easy to find organisms living side-by-side on a reef which are so ancient that they last shared a common ancestor during the Precambrian era, more than six hundred million years ago. The kind of diversity found on coral reefs is far greater than that found on land, or indeed anywhere else on the planet. Some species found there today date back to millions of years before the appearance of dinosaurs; cnidarians (the group containing jellyfish, corallimorphs, and corals), echinoderms, sponges, and bryozoans (ancient lattice-like invertebrates) are just a few of the better-known ancient phyla common on coral reefs.

It seems improbable that an ecosystem as limited in geographic extent as coral reefs should host as many as several million species. Estimates of the total number of coral reef species worldwide range between six hundred thousand and nine million.[27] [28] The only area that competes with coral reefs for high marine biodiversity is the deep sea, largely due to the huge extent of deepwater habitat around the globe. Rain forests compare to coral reefs in many ways, where corals and fish become analogous to the forest's trees and birds. Both of these tropical ecosystems rely on living organisms—trees and corals, respectively—to produce the structurally complex habitat that provides vital food and shelter. Both also shelter many inhabitants that are extremely specialist, with these relationships coevolving over many millennia.

Anemonefish are just one example of a habitat specialist that lives on coral reefs. All anemonefish live exclusively with anemones; some can choose between ten possible anemone hosts, while some can only live with a single anemone species. Such specific habitat requirements allow many species to peacefully coexist with one another, each inhabiting its own specific niche. The number of these habitat specialists seems almost endless. Each type of animal seems to have another that lives with it or on it; in fact, new species are still being discovered, having previously been hidden in the bustle of the reef.

The World Beneath

CENTER OF DIVERSITY

Although coral reefs as a whole accommodate huge numbers of species, the number of species that a specific reef harbors depends hugely on where it is located in the world. Just as the Amazon forest is richer than forests in Europe, for example, some reefs are more dynamic than others. Patterns of variety and population of coral reef species around the world aren't uniform; for instance you could count as many species of fishes in a single Philippine bay as you could in the entire Caribbean.

In the nineteenth century, British biologists Sir Alfred Russel Wallace and Charles Darwin pioneered the study of animals' distributions on land. However, it wasn't until the mid-1950s that scientists began to investigate patterns of biodiversity in the oceans. One particular area of outstanding marine biodiversity has since become known by conservationists as the "Coral Triangle." The area is relatively small in global terms, just 1 percent of the Earth's surface, but it boasts the world's richest marine biodiversity.[29] It includes parts of the waters of six countries: eastern Indonesia, the Philippines, Sabah (a state of Malaysia), East Timor, Papua New Guinea, and the Solomon Islands.

Approximately 60 percent of all Indian Ocean and Mid- to Western Pacific (Western Indo-Pacific) reef fish species, and 37 percent of all the world's reef fishes, are found in the Coral Triangle.[30] The same area, equal to 1.5 percent of ocean surface, accommodates 76 percent of all known hard coral species.[31] Due to a lack of research, it is impossible to estimate the proportion of other reef-living animals that are found within the Coral Triangle, but evidence suggests that they are similarly high. Beyond the six core Coral Triangle countries, Australia, Japan, Taiwan, Palau, Vanuatu, Fiji, New Caledonia, and the Federated States of Micronesia each has at least one thousand reef-associated fish species (those fish that spend part of their lives living on coral reefs) in their waters; while high, their numbers still fall significantly below the numbers of the triangle countries.

A renewed interest in ichthyological research around the Coral Triangle made it the focus of exploration and conservation efforts in the late 1990s. As a result, it has been the source of many of the newer coral reef species discoveries over recent decades. Although the total area of the Coral Triangle is small, there is plenty of habitat variation in it. In fact, by studying coral distributions in the Coral Triangle, scientists have identified sixteen ecoregions, each ecologically distinct from the others.[32]

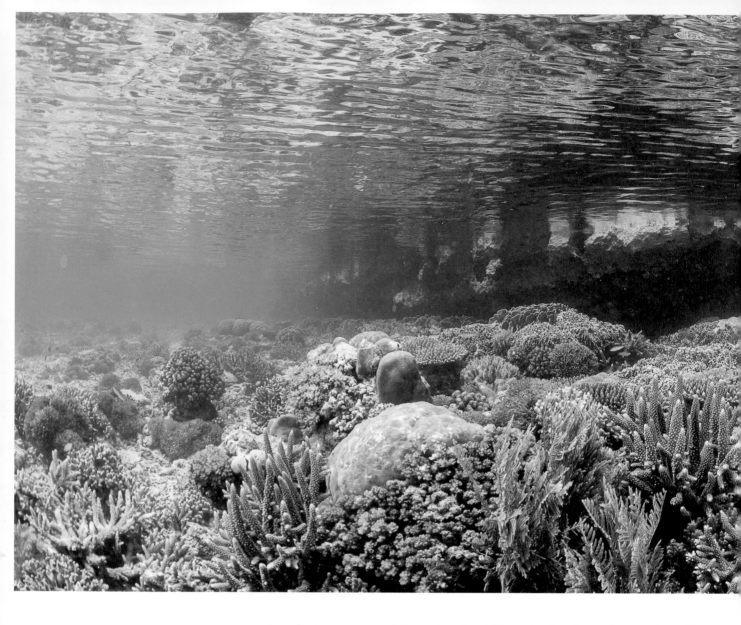

The farther you travel from the Coral Triangle, the fewer the number of fishes, corals, and other organisms living on coral reefs you'll find. This can be mapped as isobars of diversity with their focal point centered on the Coral Triangle. This pattern is generally found both from the equator toward the poles and in westerly or easterly directions. The Red Sea, for example, has significant coral structures but noticeably lower hard coral diversity, with just 240 species in the northern section compared to six hundred or so in the Coral Triangle.[33] Red Sea fish life, too, although abundant, is much less diverse. Likewise, Hawaii has coral reefs, but the number of species that inhabit them is much lower than in the Coral Triangle. These patterns of coral reef biodiversity show us that

The World Beneath

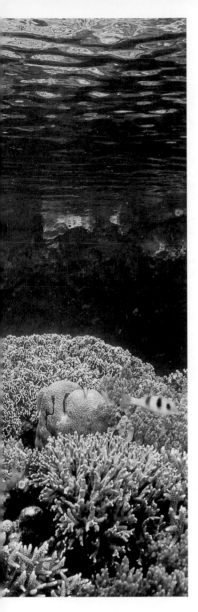

the Coral Triangle has the richest reefs. Further inspection shows that within the Coral Triangle there is one area that stands out as an epicenter of biodiversity.

HEART OF THE CORAL TRIANGLE

In the remote western part of the island of New Guinea, one of the most continually rewarding areas for new species discovery remained obscured from the rest of the world until the mid-1990s. Dutch explorers named the peninsula Vogelkop, meaning "bird's head," due to its shape, and while today its formal name is Doberai, it's often called the Bird's Head Peninsula. It consists of three main areas: Cenderawasih Bay to the east, Raja Ampat to the west, and Triton Bay to the south. This region is the true heart of the Coral Triangle and the epicenter for global marine biodiversity. Of the Coral Triangle's 605 hard coral species, 574 of them have been recorded here; some reefs support 280 species per hectare.[34] By comparison, there are around one hundred hard coral species in the entire western Atlantic and Caribbean. Raja Ampat, to the west of the Bird's Head, officially has the world's highest coral diversity with 553 species present.[35] This is incomparable across the world's oceans and makes the area hugely important in terms of conservation.

Europeans first explored Raja Ampat in the 1800s. It is in this region that Sir Alfred Russel Wallace spent time collecting bird skins he could sell to fund his research expedition. Scientists of Wallace's era were preoccupied with species distributions on land and largely ignored the oceans. However, in the early to mid-1800s when Europeans, including Wallace, were exploring Bird's Head, they noted and named many common reef fishes, including widespread Indo-Pacific species such as bluefin trevally, blacktip reef sharks, and semicircular angelfish. After this initial flurry of activity, the outside world largely forgot the peninsula.

OPPOSITE TOP: Caitlin's dottyback, described in 2008. Cenderawasih Bay, West Papua, Indonesia.

OPPOSITE BOTTOM: Maurine's demoiselle, described in 2015. Cenderawasih Bay, West Papua, Indonesia.

This twist of fate was probably its saving grace. When modern scientists began to explore the area centuries later, they found a wilderness full of rich, pristine reefs and previously unknown species.

Two ichthyologists who have made a particularly huge contribution to the documentation of the fishes in Bird's Head are doctors Gerry Allen and Mark Erdmann. I had the pleasure of diving with the dynamic pair in 2013 as they continued their exhaustive inventory of the Bird's Head reefs. Dr. Allen made some of the first modern underwater scientific observations of Raja Ampat in 1998 and has returned many times in subsequent years. By 2009, when they published their *Check List* of species, they had recorded 1,511 reef fishes.[36] They have now passed the eighteen hundred species mark and are still counting. Raja Ampat is bathed by various currents that pass through the Indonesian archipelago and into the Pacific, bringing nutrient-rich waters through the area. In addition, Raja Ampat has a huge variety of habitat types, which seems to encourage a greater number of species to inhabit them, positively impacting the high diversity of this region.

One of the wildest locations on the planet that I have ever visited is unquestionably Cenderawasih Bay on the north coast of Indonesian Papua. Thickly forested mountains tumble into the expansive, still waters. Small villages dot the bay, and visitors must respect the local ownership of these untouched waters and receive permission from the villagers to dive the sites. On my first visit to the location, I was required to have a local national park ranger stay aboard my liveaboard vessel to aid in these exchanges. Whether it was an honest mistake, a village he should have been avoiding, or a miscommunication, I don't know—but as we tucked into our lunch after the dive, we heard a ruckus outside. We dashed out to discover four bare-chested Papuans brandishing machetes, anger bursting from their eyes. They were livid that we hadn't asked permission to dive the site; after all, as they saw it, we were effectively trespassing. It took some time to explain the misunderstanding and return calm. Thankfully a cold Coke isn't easy to come by in these remote corners of the planet and they were somewhat placated by our supply. They had paddled several miles from their village, travelling in a dugout canoe, so we gave them some fuel to express our apologies, since their supply had long since run dry.

Cenderawasih Bay is a marine biologist's dream. It is a rare example of a location that illustrates evolution by isolation. Also known as "allopatric speciation," Darwin saw this as the most common source of new species creation in terrestrial animals. In the same way that the Galápagos Islands are isolated from the mainland

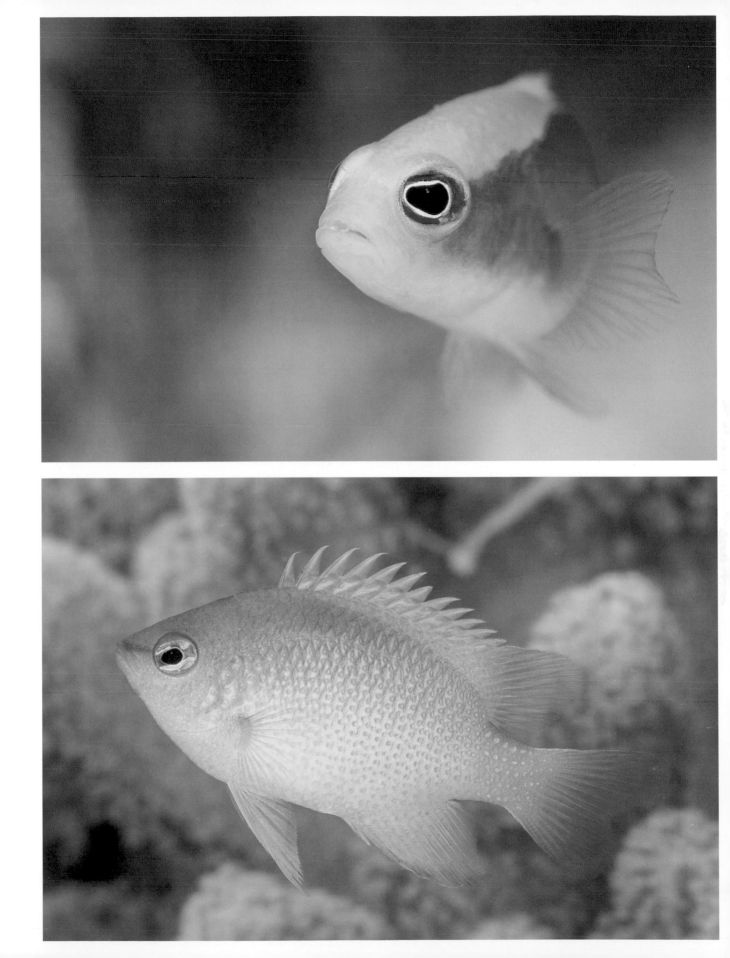

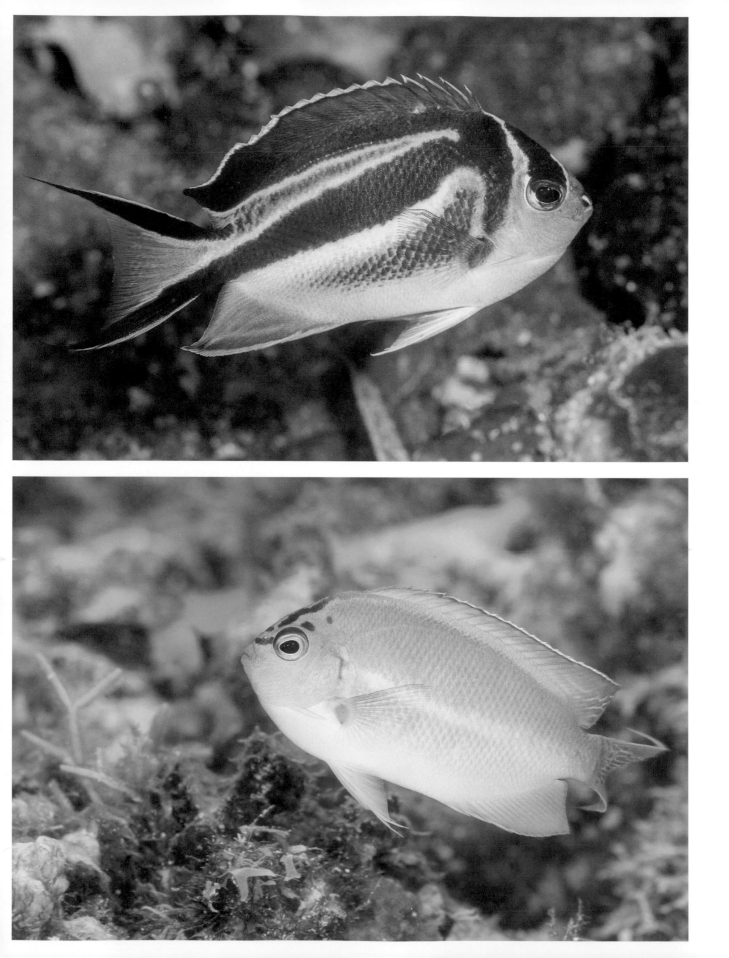

and species evolve there to suit the local conditions, Cenderawasih provides an almost self-contained ecosystem allowing for high levels of endemism. Endemism means that an organism is unique to a defined geographic region, in this case Cenderawasih Bay; although, it would also be true to say that these animals are endemic to Indonesia. The huge bay covering almost one and a half million hectares was isolated from the Pacific Ocean when large landmasses drifted across its mouth between two and five million years ago.[37] These landmasses may not have created a complete physical barrier, but they were significant enough to alter currents in and out of the bay. Without this flow through, populations inside became separated from those outside the bay and over time adapted to the conditions they found themselves in within the bay.

Diving in Cenderawasih Bay is a strange experience. While the reefs are ostensibly the same as many in Raja Ampat to the west, the inhabitants are largely alien. Bright blue and white Price's damselfish, pink and yellow Caitlin's dottybacks, and beige and yellow Maurine's demoiselles are all ubiquitous here, but found nowhere else on Earth. Farther down the reef slope, the stunning Cenderawasih fairy wrasse inhabits rich coral areas at sixty feet below the surface. The shocking yellow streak and black blotches on the male's side allow divers to spot the beauties from a fair distance away. It's amazing that these fish remained in obscurity until 2006 when scientists first explored the bay. Previously, none of these fish were known to Western science. There are at least fourteen species of reef fishes known only from the bay, which is many more than you would expect from such a small area, with many sure to join them as it is explored further.

While exploring the limits of recreational diving at around ninety feet, another quirk of the bay is revealed. The topographical structure of the bay means there are limited areas where the reef gently slopes into the abyss; instead, shallow slopes give way quickly to deeper drop-offs. Over the course of several ice ages, where the water level drops and subsequently rises thousands of years later, the shallow coral reef habitat was repeatedly lost and many species went locally extinct. When sea levels rose again, the lack of connectivity with areas outside the bay meant that the vacant niches couldn't be filled by migrants. It seems that deepwater species instead seized the opportunity to fill some of these niches and moved up into the shallows. As a result, while diving in Cenderawasih it is possible to see fishes such as the alluring ornate angelfish, Randall's anthias, and the Burgess butterflyfish in water much shallower than they are found in elsewhere in the world.

OPPOSITE TOP: Female ornate angelfish. Cenderawasih Bay, West Papua, Indonesia.

OPPOSITE BOTTOM: Male ornate angelfish. Cenderawasih Bay, West Papua, Indonesia.

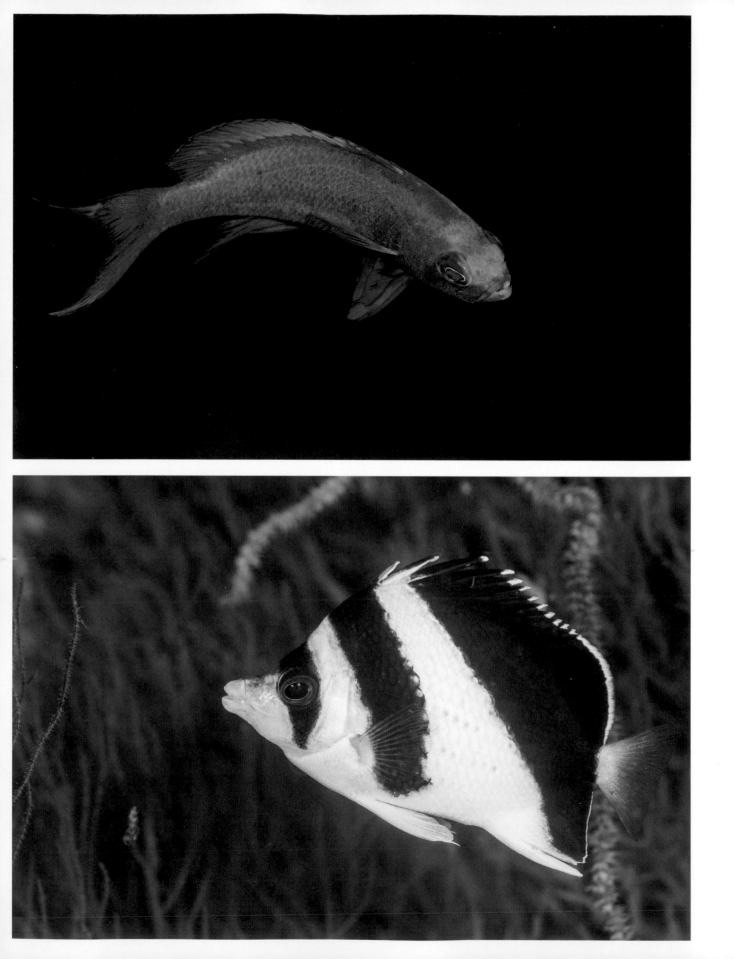

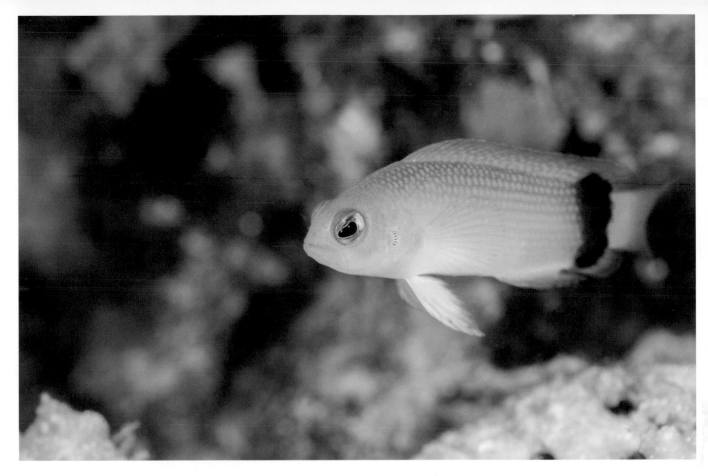

The final area of the Bird's Head trio is Triton Bay. Located southeast of Raja Ampat on the south coast of Papua, this area has been revealed as another region rich in endemic species. In 2006 scientists mounted an exploratory expedition and found many new and indigenous species, such as Jamal's dottyback, Nursalim flasher wrasses, and a unique walking shark. The leading theory that most likely explains the high levels of endemism around Triton Bay relates to the two large freshwater rivers that flow into the ocean to the north and south of the bay. In a similar way to the landmass-blocked mouth of Cenderawasih, the freshwater from the rivers acts as a barrier to the marine organisms in the bay. Trapped within by these walls of unsuitable habitat, the animals within evolved to suit local conditions.

The walking sharks, or epaulette sharks, are an intriguing group found around the coast of New Guinea and northern Australia. As their common name suggests, their preferred method of locomotion is walking rather than swimming. They use adapted pectoral fins to crawl around in the reef shallows to hunt for their prey. As they live in shallow water and won't swim across deep water or unsuitable habitat, they can easily become cut off. As a result, at least six species of walking shark have evolved around the coastline of New Guinea.[38] Each of the three areas of the Bird's

ABOVE: Jamal's dottyback, described in 2007. Triton Bay, West Papua, Indonesia.

OPPOSITE TOP: Male Randall's anthias. Cenderawasih Bay, West Papua, Indonesia

OPPOSITE BOTTOM: Burgess butterflyfish. Cenderawasih Bay, West Papua, Indonesia.

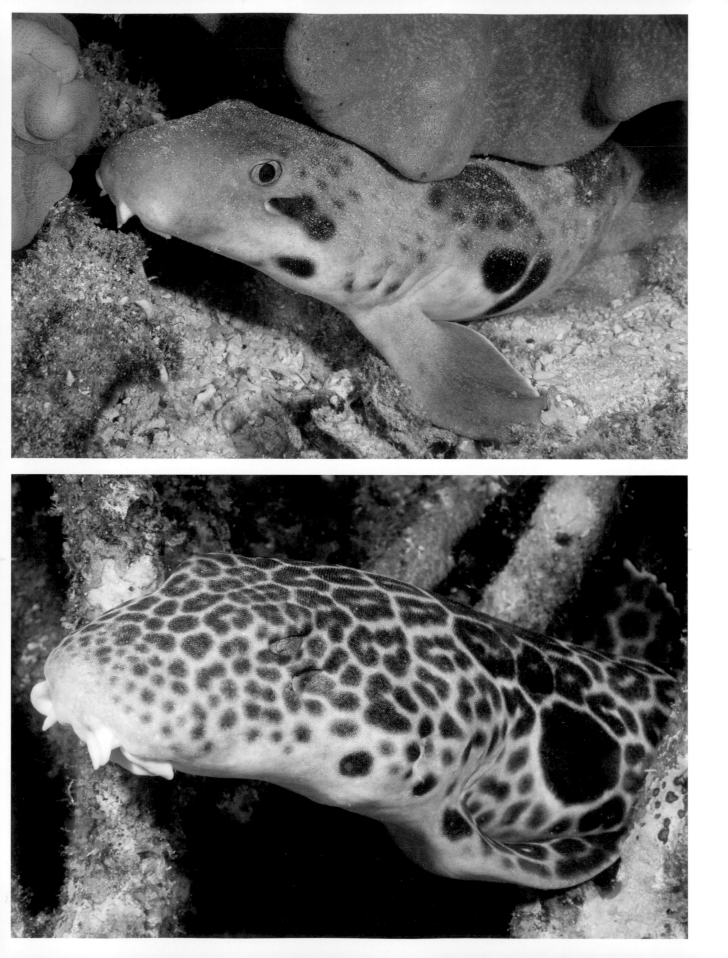

Head has a unique species of walking shark and there are another three in Papua New Guinea to the east. It is not beyond the realms of possibility that more species may be discovered along the New Guinean coast as scientists explore it further.

I have made some of my most unexpected discoveries and observations in the Bird's Head region and experienced the bounty of the coral reef in its full splendor. I have been surrounded by such thick schools of fish that I could not even glimpse my dive buddy a few feet away. I have seen the biggest fish in the sea, the enormous whale shark, in both Cenderawasih and Triton Bays and one of the world's smallest fish, Satomi's pygmy seahorse, in Raja Ampat. This is truly a special corner of the world.

OPPOSITE TOP: Raja Ampat walking shark. Raja Ampat, West Papua, Indonesia.

OPPOSITE BOTTOM: Milne Bay walking shark, described in 2010. Milne Bay, Papua New Guinea.

BELOW: Male Galapagos pike blenny displaying. San Cristobal, Galapagos Islands.

OUTSIDE THE CORAL TRIANGLE

Travelling outside the Coral Triangle, and to the periphery of the ocean's coral realm, reveals reefs with their own special assemblages of creatures. When compared to the Coral Triangle these reefs can seem relatively poor in terms of species richness, but each of the different area adds to the overall richness of coral reefs globally. The limited coral reefs of the Galápagos Islands, for instance, have one-tenth the

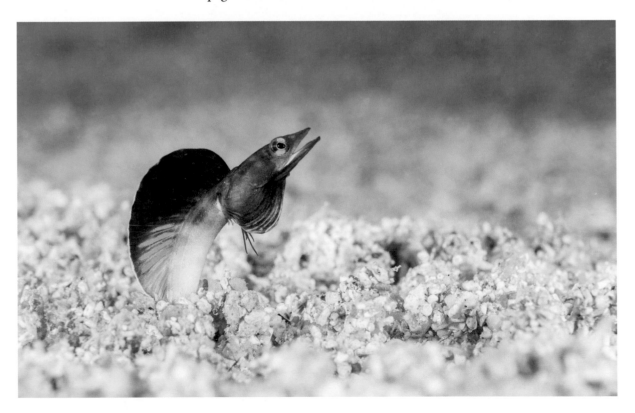

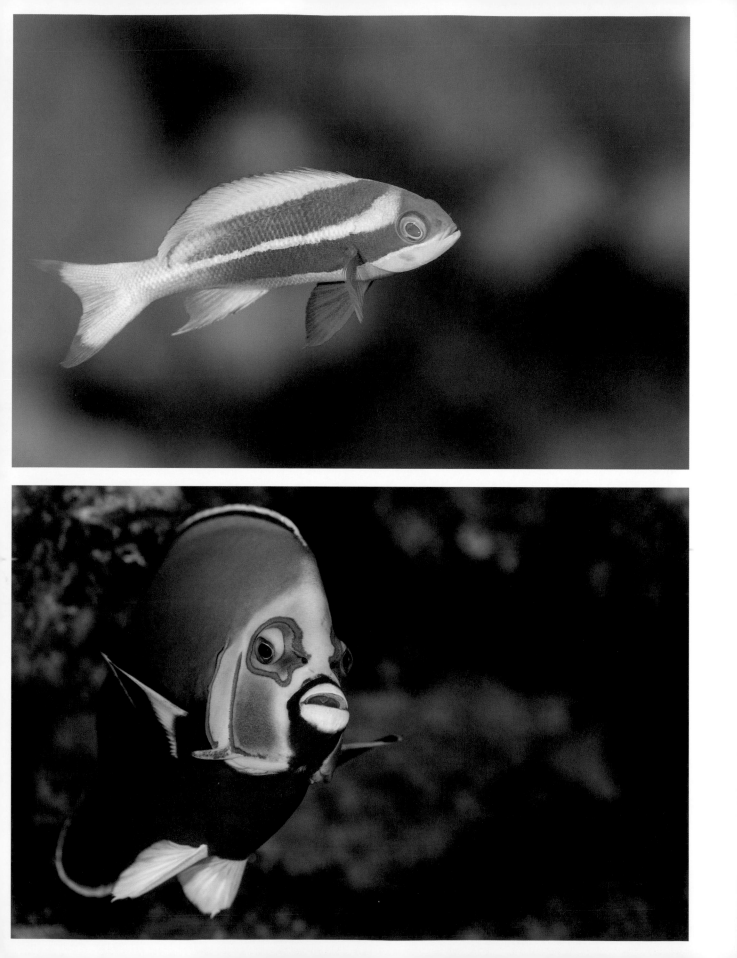

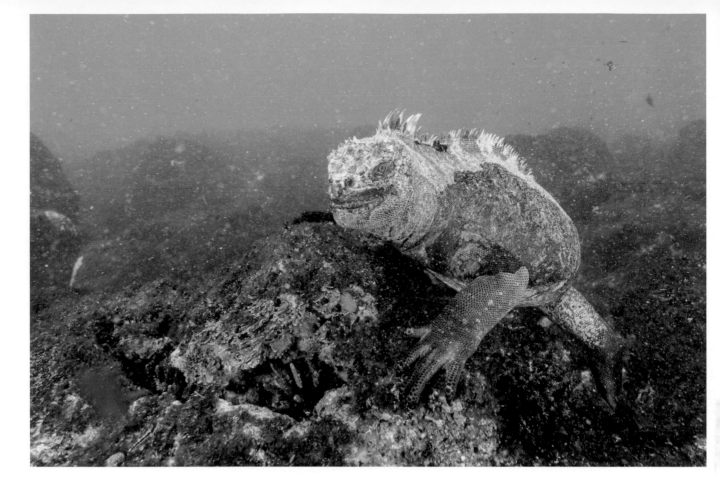

number of species as their counterparts in the Coral Triangle, but these peripheral reef locations tend to have many unique and indigenous organisms. Almost 20 percent of the marine life in Galápagos is found nowhere else on Earth. The areas with the highest numbers of such endemics are found at various isolated eastern Pacific islands, as well as Baja California, a Mexican state just south of California; Hawaii; Galápagos; the Red Sea; and Oman.[39] Despite their high proportions of indigenous species, these areas all have far fewer total numbers of species than the Coral Triangle, which is blessed with both amazingly high biodiversity and many endemic species.

The more I have explored coral reefs around the world, the better my appreciation of the world's varied reefs and how each has its own unique defining attributes. For instance, clouds of bright orange anthias fish, exuberant coral growth, and impossibly blue waters are instantly recognizable as a Red Sea reef. The Red Sea is an area of extreme contrasts. The average rainfall there is less than one centimeter per year, and barely a plant grows on the exceptionally arid land beside it. But the parched and dusty land spills abruptly into the azure sea, which bustles

ABOVE: Marine iguana feeding on algae. Fernandina Island, Galapagos Islands.

OPPOSITE TOP: Red Sea anthias. Egypt.

OPPOSITE BOTTOM: The conspicuous angelfish is found only on the subtropical reefs of central east Australia, New Caledonia, and east to Lord Howe Island. Lord Howe Island, Australia.

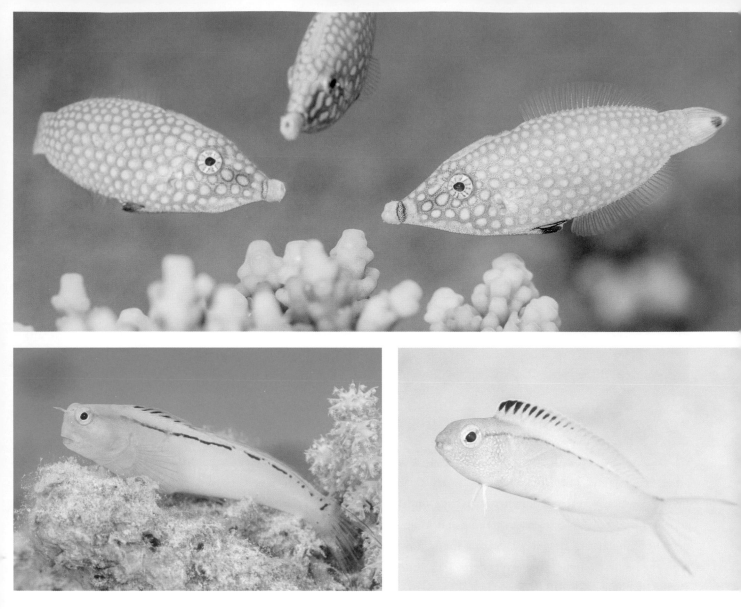

with life more colorful than a painter's palette. Rather than being hindered by the desolate terrestrial landscape, the coral reefs of the Red Sea are shaped by the conditions above. The dazzling blue water is a result of the very limited rainfall, and without freshwater influx hindering their growth, the corals fringe around the land's contours almost exactly.

What I most enjoy about diving the Red Sea is that 13 percent of its fishes are found nowhere else on earth.[40] Over the past several million years, as sea levels have fluctuated, the Red Sea has been cut off by a land barrier at its southern reaches. It is one of the saltiest bodies of water on Earth and its high salinity drives the evolution and adaptation of its inhabitants. Huge clouds of tiny reddish anthias

fish are endemic to the region; striking sunrise dottybacks and vivid orange and green spotted longnose filefish that putter about feeding on coral polyps are also indigenous.

Another fascinating example of evolution that exists in the Red Sea is the venomous fang blenny of the genus *Meiacanthus,* whose relatives have been found throughout the world's reefs. They are quick to bite and potential predators know to avoid them, so they can largely go about their business on the reef without fear of attack. They hold a privileged position and have attracted other envious fishes wishing to exploit the situation. The Red Sea's fang blenny is an endemic species and has a unique coloration of a blue head, black stripe, and yellow rear half of the body. Red Sea predators know to avoid these colors, so it makes sense that their mimics would need to keep up and copy these colors if they're to successfully pull the wool over their would-be predators' eyes.[41] A harmless blenny of the genus *Ecsenius* mimics the venomous fang blenny, allowing it to feed on algae out in the open during the day without fear of predators. The *Plagiotremus* blenny also exploits the *Meiacanthus*, mimicking the fang blenny's coloration to get close to fish that they themselves prey on. Predators avoid the *Plagiotremus* and its prey species do not fear the *Meiacanthus*, so they don't worry about it being near them, allowing the mimic to approach extraordinarily closely and take a bite of a scale. I find it fascinating that because the model *Meiacanthus* is different in the Red Sea, all its mimics have had to evolve to continue to benefit from mimicking it.

SUBTROPICAL REEFS

Keen to experience another type of reef system, I visited the remote subtropical reefs of the Izu Islands some 180 miles south of Tokyo, in Japan. Unlike the calm and tranquil diving around the sheltered islands of Indonesia, these high-latitude reefs tend to suffer more adverse conditions. To reach the entry point, I had to rappel in full dive gear down a steep ramp into the ocean, toward the crashing waves below. Holding a rope in one hand and my hefty camera in the other, I wondered if I should have just visited the stunning temples of Kyoto and given this a pass. Once I sank safely under the surface, the clear and surprisingly tranquil water revealed a beautiful and peaceful sloping topography. There were very few hard corals, with algae more dominant than would be expected for a tropical coral reef, but lots of sponges, gorgonians, and soft corals.

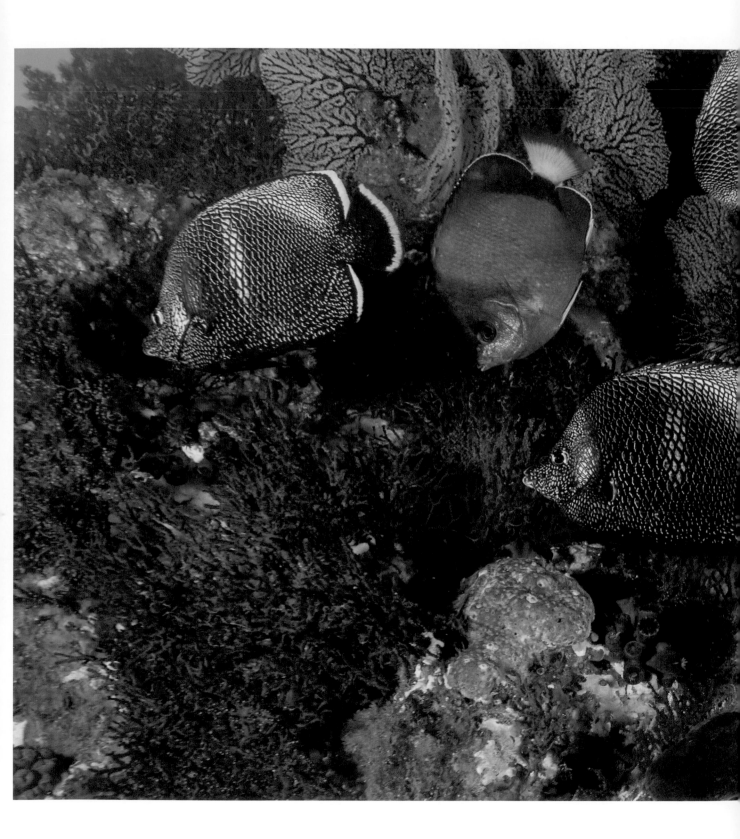

The World Beneath

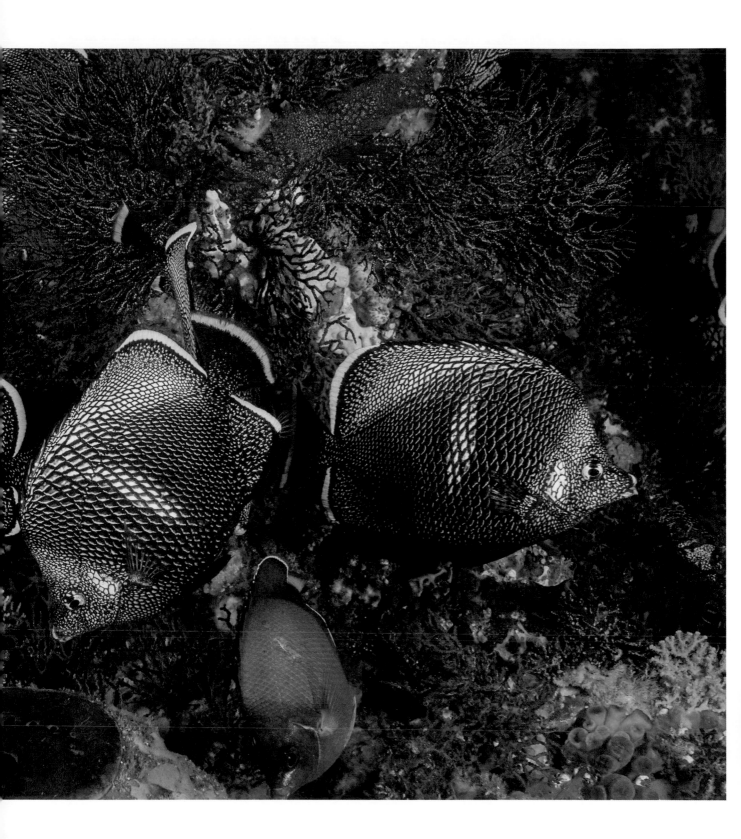

The Coral Triangle

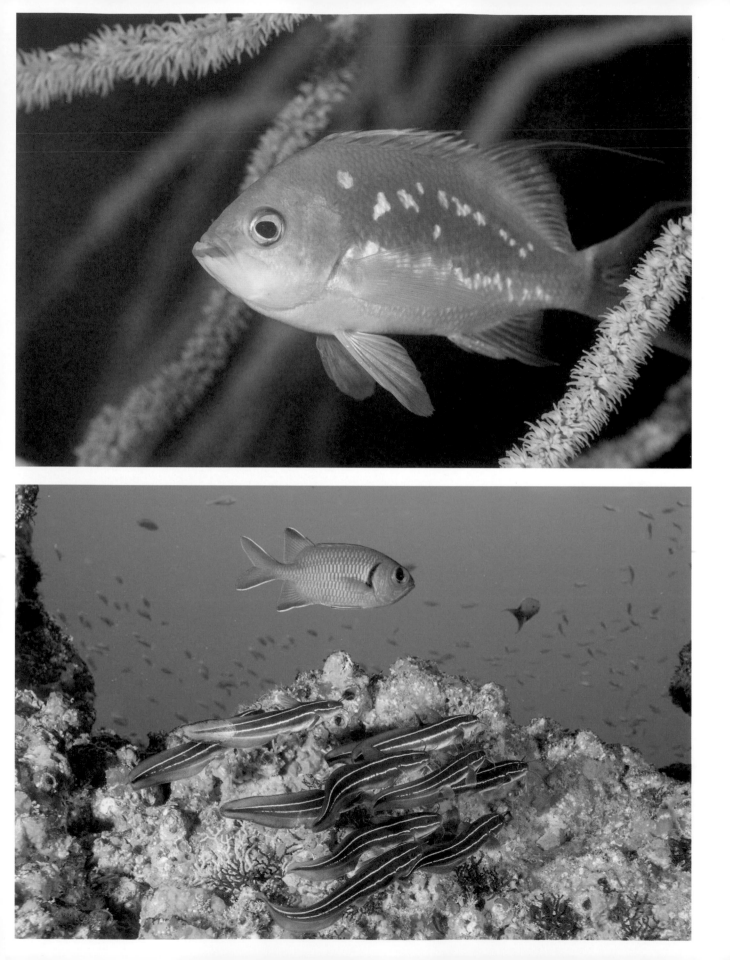

Many quirky creatures call these Japanese reefs home. The yuzen, or wrought-iron butterflyfish, endemic to Japan's Izu and Bonin islands, is stunning with its black-and-white body and a tail of bright daffodil yellow. During my dives, I came across the Japanese swallowtail angelfish, Sakura anthias, Japanese eeltail catfish, and Yatabe blenny—all indigenous to the region. Unexpectedly, I also came across a Bargibant's pygmy seahorse clinging to a gorgonian coral at 110 feet. This find extended the recorded geographic range for the species several hundred miles north from the coral reefs of Okinawa. This vagrant seahorse's presence in these northern reefs implies some of the processes that have resulted in Japan's unique marine life.

Huge ocean-scale currents flow across the Pacific Ocean and split as they strike Australasia. The South Pacific Gyre pushes water across the Pacific in a counterclockwise motion and hits New Guinea, becoming the East Australian Current as it flows southward, down toward Tasmania. The North Pacific gyre heads up toward Japan as the Kuroshio Current. It pushes water from the equator northward toward Japan and is the Pacific's largest current. This current has a significant impact on marine ecosystems, bringing warm water and tropical fishes to where you might not expect them in Japan's northern reaches. This northward flow also has the effect of creating a barrier to fish trying to migrate in a southerly direction. Since they are effectively isolated in Japanese waters, with the current as a barrier to them moving south and cold polar waters in the north, they have evolved into unique forms. As a result, Japanese reefs have many endemic marine species that exist nowhere else on Earth.

WHY THE TRIANGLE

There is no doubt that Japan has fascinating reef inhabitants, but the total number of species I encountered on the trip was dramatically lower than I could have seen on a comparable number of dives in Indonesia. There is some debate about the reason for high biodiversity in the Coral Triangle, but there

PAGES 72–73: Wrought-iron and Japanese butterflyfishes. Hachijō-jima, Japan.

OPPOSITE TOP: Sakura anthias. Izu Peninsula, Japan.

OPPOSITE BOTTOM: Japanese eeltail catfish, described in 2008, and bigscale soldierfish. Hachijō-jima, Japan.

BELOW: Bargibant's pygmy seahorse. Bangka Island, Indonesia.

ABOVE: Yatabe blenny. Izu Peninsula, Japan.

are three leading theories to explain why global patterns of marine richness center in this part of the world.[42] [43]

The first theory to explain the existence of the Coral Triangle as a center of biodiversity suggests that the region is a species factory, with many new species being created there. These go on to boost the overall diversity of the area compared to any other. The southern Coral Triangle has experienced geological instability for at least the past thirty-eight million years.[44] Diving along Indonesia's southern Lesser Sunda island chain, where Bali, Komodo, Flores, and the Alor Islands group are located, illustrates this point. It is not uncommon to see three smoking volcanoes on the horizon as you descend on a dive. One of the largest volcanic eruptions in recorded history, of Mount Tambora, took place here in 1815. The eruption was so big that it caused crops to fail across the world, and the darkened skies reportedly inspired the creation of Frankenstein and Count Dracula. The continually changing geography of the region is thought to have driven the evolution of new species by separating populations from one another and changing the local conditions to which they are exposed.

Given the many millions of years over which evolutionary processes occur, we must remember that we are seeing just one snapshot of the planet as it is today. A map of the Coral Triangle would have looked very different two million years ago. Present-day examples of Cenderawasih and Triton Bays are likely to have been played out many times throughout the geological history of the Coral Triangle. After evolutionary processes have cast their spell on a given bay or stretch of coastline, the new species that evolve there may eventually spread out to the wider Coral Triangle, complementing and enhancing the diversity of the region.

Although evolution by isolation does occur in the marine environment (and I have highlighted several examples here), it is much less common than on land. Sir Alfred Russel Wallace described a theoretical boundary line, Wallace's line, that cuts through Indonesia, and explains the transition between Asian and Australian fauna. To the west of the line sit the large islands of Sumatra, Java, and Borneo, which during ice ages would have been joined to the Asian landmass. Tigers, orangutans, rhinos, and monkeys roam in these Asian forests. To the east of the line they are noticeably absent, replaced instead by various animals we tend to consider as Australian natives, like marsupials and cockatoos, as well as eucalypt trees. The island of Sulawesi sits just to the east of the line, but accommodates an intriguing mix of Asian macaque monkeys, tarsiers, and pigs, as well as Australian cockatoos and cuscus marsupials. The island has a mixed geological origin with parts that have drifted from Asia and others antipodean in origin, but biogeographers continue to argue over the island's faunal origins.

Underwater, Wallace's line has been much less significant in understanding geographical distributions of species. The walking sharks of New Guinea and Australia are limited to unbroken areas of suitable habitat, which explains their distribution, but the vast majority of fishes are not so constrained, with a surprising number of reef fish species found on coral reefs all the way from East Africa to the mid-Pacific. Dispersal across a huge distance was made possible by their larvae, which spend weeks or months floating in ocean currents, allowing them to reach even the most remote reefs.

The pajama cardinalfish is a striking reef fish with red eyes, yellow head, black waistband, and pajama-like spotted rear half. These fish are found all the way from Java in western Indonesia to Tonga in the mid-Pacific. Like almost all cardinalfishes, they are paternal mouthbrooders; the male broods fertilized eggs

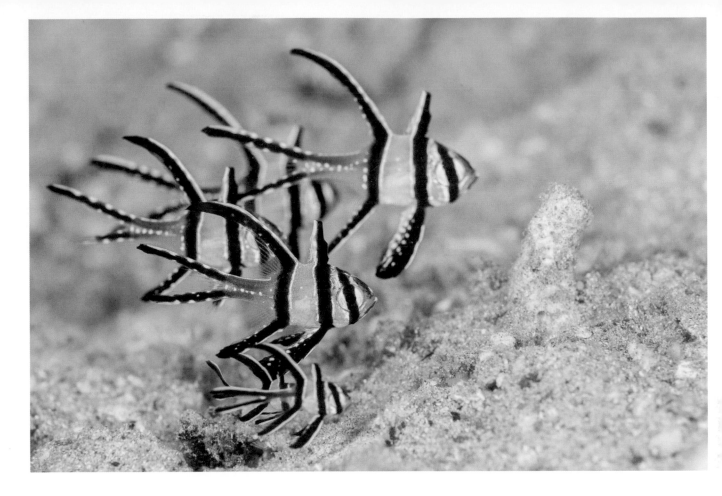

in his mouth until they hatch and the resultant fry, or juvenile fish, float off in ocean currents. In the case of the pajama cardinal, the young spend a relatively extended twenty-four days floating in the water column before settling on a reef. This allows ocean currents to carry them relatively far afield, hence their wide geographic distribution.

A superficially similar cardinalfish offers a good illustrative example to demonstrate the importance of larval pelagic (open sea) duration in a species' distribution. The Banggai cardinalfish is naturally found in a small Indonesian island group just two-thirds the size of Connecticut.[45] It features a stunning combination of black stripes on a white base color, with white-speckled black pelvic, anal, and caudal fins. Unlike the pajama cardinal, the Banggai has a unique approach to brooding. The male holds just forty to fifty large eggs in his mouth, significantly fewer than other cardinals that can brood thousands of much smaller eggs. He broods these for nineteen to twenty days before they hatch, when he retains them for an additional ten days in his mouth.[46] During this extended period of paternal care, the young grow into well-developed, miniature versions of their parents.

ABOVE: Banggai cardinalfish. Lembeh Strait, Sulawesi, Indonesia.

OPPOSITE TOP: Pajama cardinalfish. Wakatobi, Sulawesi, Indonesia.

OPPOSITE BOTTOM: Weedy cardinalfish brooding eggs. Lembeh Strait, Sulawesi, Indonesia.

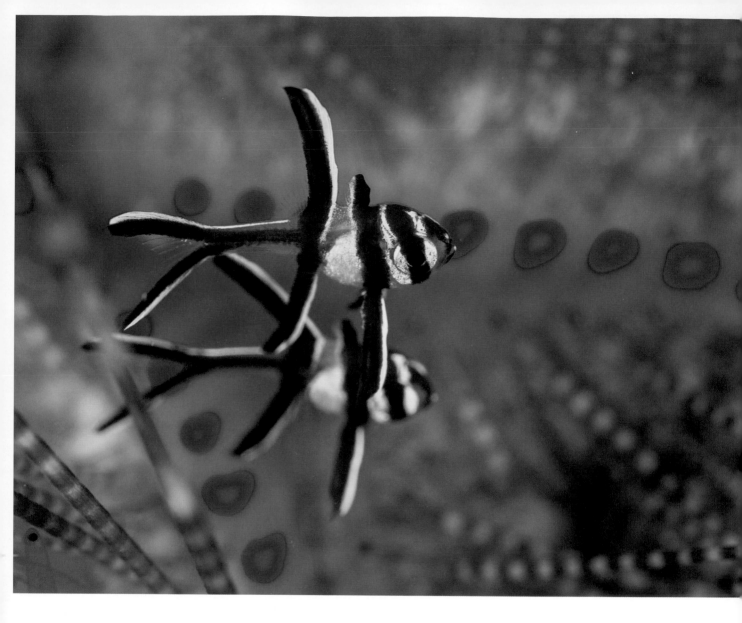

I once spent a dive observing and photographing a brooding male, but was most
intrigued by watching the inquisitive fry jostling for the best vantage point to watch
me from inside their father's mouth. Because of their advanced development, the
Banggai skip the pelagic oceangoing stage of development, and, after gaining their
freedom, immediately form a small school around a protective home such as a sea
urchin, where they shelter among the long spines. The babies are then immediately
committed to the reef; as a result the species hasn't naturally spread beyond the
confines of the Banggai Islands, which are surrounded by deep, unpassable water.

I have been privileged to see the striking Banggai cardinalfish on several
occasions, but I have never been to the Banggai Islands. In the mid-1990s there

was huge demand for these fish in the aquarium trade. They were heavily collected, and in 2000 a small group was discovered in Lembeh Strait, a popular diving location separating the northeast Indonesian islands of Lembeh and Sulawesi. These Banggai cardinalfish are believed to have escaped and naturalized from an aquarium trade consignment. In Lembeh Strait their numbers have since increased exponentially and their population is now abundant. Several years later, most likely released by enterprising scuba professionals, they appeared in northwest Bali, and, in 2017, the first individuals were taken and released near Ambon Island, a diving area in central Indonesia. Without their natural predators, the non-native Banggai's populations have exploded, with potential impacts on native species. It is hard to know the long-term implications of this influx, but you don't have to look hard to find examples of widespread devastation by other invasive organisms. Ironically, the natural populations of these fish in the Banggai Islands have continued to suffer; they have reportedly been reduced by 90 percent through removal for the aquarium trade, and have been listed as endangered and continue to decline in numbers.

The final major explanation for high biodiversity in the Coral Triangle is that the geographic ranges of many species from the Indian and Pacific Oceans overlap within the Asian archipelago, causing higher diversity where they coexist. While the true source of the Coral Triangle's high diversity can possibly be attributed to a convergence of several factors, it mostly boils down to the huge variety of habitat types the islands offer. Varied habitats beget varied organisms.

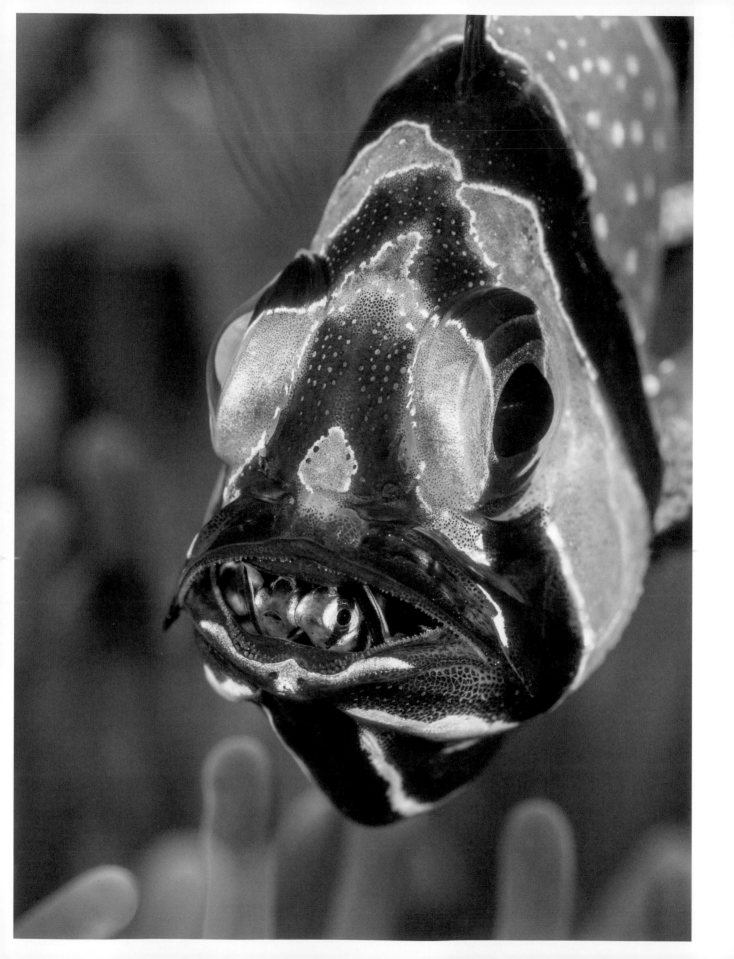

IN OUR HANDS

We know that the world's highest marine biodiversity is in the Coral Triangle, but this wasn't always the case. Major tectonic events over the past fifty million years have shifted the location of the hotspot at least three times over that period.[47] Southwest Europe was once the location of the world's richest reefs. While natural processes like tectonic events can impact the survival of coral reefs and their inhabitants, human activity currently threatens to enact unprecedented changes on the ecosystems.

Given its amazingly high biodiversity, the Coral Triangle's conservation is a global priority. Even today dozens of new fishes, crustaceans, corals, and echinoderms are being discovered on the region's coral reefs—each vital to the mechanics and well-being of their environment. New species can emerge in the most unexpected places. Some have been hiding in plain sight; others have offered only the briefest glimpses into their lives. We have so much more to learn. If we want to meet undiscovered organisms before we lose the chance forever, we must conserve reefs around the world.

OPPOSITE: Male Banggai cardinalfish mouth brooding his fry. Lembeh Strait, Sulawesi, Indonesia.

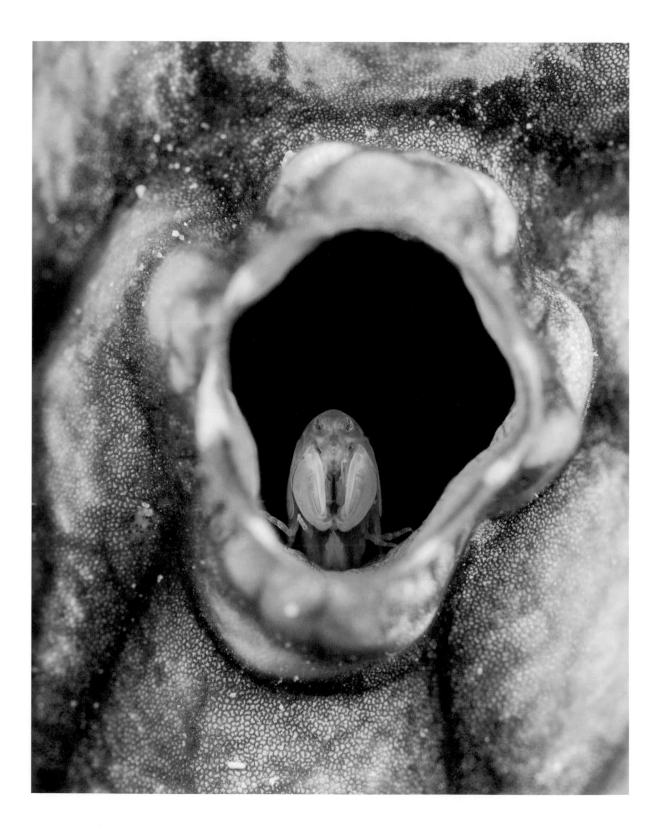

CHAPTER 4:

NEW DISCOVERIES OF THE TWENTY-FIRST CENTURY

Since its inception in 1967, the world's largest recreational scuba diving organization, the Professional Association of Diving Instructors (PADI) has issued more than twenty-five million dive certifications globally and made diving accessible to the general public, making us the first generation to have the freedom to explore the world's shallow seas through scuba. Between the 1950s and 1970s, wet suits, fins, and buoyancy control devices were commercially developed, lending a sense of accessibility to scuba as a hobby. The navy created algorithms and tables that made the bends, or decompression sickness, avoidable by the layman, and scuba diving took off. These technological advances provided the first gateway to this new frontier. Over the past twenty years, PADI has certified almost one million new divers a year.

Suddenly, for the first time, we could freely explore our planet's shallow seas from the surface down to recreational limits of 100–130 feet. Previously, in-person marine exploration was dependent on submersible vehicles, cumbersome early scuba bells, or masks with limited functions. Marine biological surveys were

ABOVE TOP, LEFT TO RIGHT:
Undescribed "velvet" ghost pipefish.
Dumaguete, Negros Island,
Philippines.

Robust ghost pipefish. Lembeh Strait,
Sulawesi, Indonesia.

**ABOVE BOTTOM, LEFT TO
RIGHT:** Rough-snout ghost
pipefish. Dumaguete, Negros Island,
Philippines.

Red phase Halimeda ghost pipefish.
Bunaken Island, Indonesia.

often taken by trawling, using huge nets, or using dynamite that killed fish and
caused their bodies to float up to the surface.

Around twenty-five years ago, there was a consciousness shift within the
recreational diving community. Particularly around the rich coral reefs of the
Coral Triangle, people began to discover fantastical and previously unknown
animals. They also began to push boundaries and eschew coral reefs in favor of
exploring other shallow water habitats in the world's richest seas. In the 1980s
and 1990s, Australian Bob Halstead and American Larry Smith pioneered a new
and unusual type of diving: muck diving. As they explored the sandy slopes and
muddy bottom habitats previously avoided by divers who sought the vibrancy

of coral reefs, Halstead and Smith discovered a huge variety of outlandish and fascinating creatures.

Although muck diving sounds unappealing, the reality is a treasure hunt of sorts. At first glance it might not seem that the featureless muddy bottom provides many spots for an animal to hide, but the small rocks, soft corals, and logs that punctuate the muck attract life like a magnet. Small fishes and juveniles of many species spend parts of their life cycles in places such as these. They seek shelter around the small objects, and this, in turn, attracts ambush predators. With the passage of time, a community develops. The small rocks accrue sea squirts, sponges, and hydroid growth. Then habitat specialists move in. Brightly colored frogfish mimic sponges in a great variety of hues: red, orange, or purple often among them. Different species of ghost pipefishes might choose to camouflage themselves against a leaf, an orange sponge, green *Halimeda* algae, red coralline algae, or a black crinoid. The organisms often begin life in neutral shades and adapt to suit the conditions. In a field of beige, bursts of colors attract divers, although we will learn later that the creatures' vision differs significantly from ours, so likely see things differently. Muck diving first became a phenomenon in the late 1990s and since then the underwater treasure hunt has expanded widely.

BELOW LEFT: Juvenile painted frogfish. Dumaguete, Negros Island, Philippines.

BELOW RIGHT: Diver and robust ghost pipefish. Wakatobi, Sulawesi, Indonesia.

CITIZEN SCIENCE

Muck diving got the ball rolling; recreational divers began to discover hordes of new small cryptic species. Once divers knew where to look and what to look for, they continued to find more. Many of these animals are so small and fragile that they would never have been detected by older collection methods. Dive guides in certain areas, particularly Indonesia and the Philippines, have expert knowledge about where to find specific animals as well as the nuances of their habitat preferences. Since they have seen and found these animals alive in the wild, these guides are much more adept at finding them than scientists who typically go about their taxonomic work in the cold removes of a university or a lab.

I believe that recreational divers can also take some credit for pushing the geographical boundaries of biological exploration, given their inherent desire to expand their horizons and plumb new depths. This drive has increased the number of reefs that are surveyed, even if only in an *ad hoc* citizen science approach. I first visited Papua New Guinea in July 1999. At the time, muck diving had just started to become fairly well-known in the diving community. I had only made around 250 dives at the time and was just starting to wrap my head around the huge diversity of marine creatures we were seeing. I vividly remember a guide returning from a dive with a guest, buzzing about the pygmy seahorses they had just found. The short video clip they showed us depicted a tiny, lumpy, red and pink seahorse on a reddish gorgonian coral. These were the first images I had seen of these animals and they stuck with me. At their largest, these petite fish can reach 1 inch in length; divers had only just begun to realize that they needed to know where to look if they wanted to find these beguiling creatures. It would be another three years before I would see one of these animals myself, and seven before I would begin my PhD research on their biology and behavior.

WHO'S WHO

With the influx of new species being discovered, maintaining processes of formal identification is of critical importance. Even if you are the first to find a new species, you don't necessarily get to choose its name. As has been the case for several centuries, biology rests heavily on the system of binomial nomenclature. The two-name naming system helps to reduce the confusion caused by common names. For instance, *Pterois volitans* has the common names red lionfish, common

lionfish, turkeyfish, and ornate butterflycod, among many others. Its unique two-part scientific name cuts through any potential for confusion and clarifies exactly what species is being referred to.

The International Code of Zoological Nomenclature dictates the way a new species is named, but it is a rather involved process generally relegated to experienced taxonomists.[48] The first stage in naming a new species is the collection of a holotype specimen, which is the specimen identifier for the entire species. The holotype should represent a typical example of the species in question, with all of the key features that distinguish it from other species. Paratype specimens will likely also be collected; these are specimens that offer additional features possibly not present in the holotype. A paratype, for example, may be of a different sex than the holotype, or a juvenile with different features. It may also represent a different color form. The paratypes will help with subsequent identification of the species. Both the holotype and any paratypes must be lodged with a museum, where they are preserved for posterity, to enable scientists to access them if needed in the future.

Next, the taxonomist must craft a written description of the new species and how it differs from other similar and closely related species. The differences can be anatomical, genetic, or behavioral—commonly a combination of all three. Problems can arise due to the subjectivity of whether a find is indeed a new species. There is a huge amount of variation in populations of animals. For example, colors can vary within a species' range. So how do we know if these are distinct species or merely regional variations? In the case of fishes, meristic characters are extremely valuable. These are countable traits, such as the number of fin rays (the rigid fine bones that support the fins) in a certain fin, or the number of scales. Even when a species has been formally named, it may lose its title if new data undermines its status as a distinct species.

As part of a description, the new name is suggested, including the etymology explaining the new name's origins. A scientific name can include elements of not just Latin, but ancient Greek and modern languages as well, however, it must be Latinized and must meet certain linguistic criteria. It is generally deemed vulgar by scientists to name a species after oneself. In recent times naming rights have been auctioned off to fund conservation efforts; some taxonomists also deem this unseemly, but in my opinion scientific funding is so limited that any creative way of generating funds must be explored.

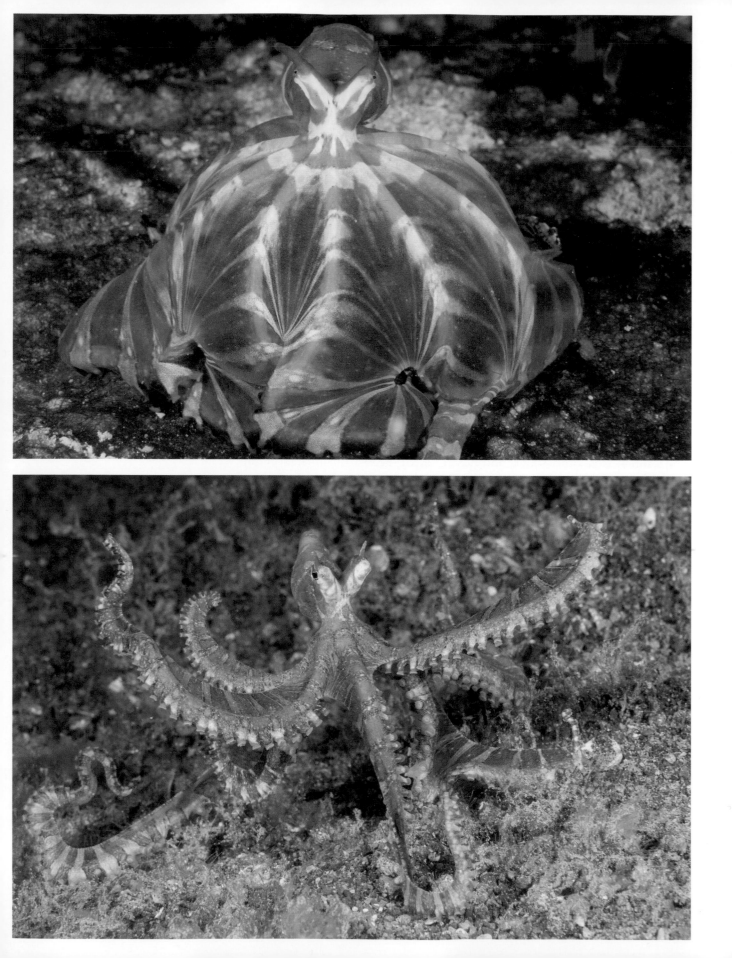

Scientific names are necessarily unique for each species. Any new species will most likely have close relatives, which, if close enough, will share a genus. For example, humans belong to the genus *Homo* and the species *sapiens*. Our close relatives *Homo erectus* and *Homo habilis* were thought to be related closely enough that they should belong to the same genus as us. Further down our evolutionary tree, *Australopithecus* was another genus of hominids to which we are closely related, but *Australopithecus* is considered different enough from us that they aren't included in the genus *Homo*. Each genus can have only one species with a given name, but the same species name can be used by several genera. For example, the species name *cyanopterus* (from the Greek *kyan* and *pteron* meaning "blue spot") is used in the species names *Solenostomus cyanopterus* (robust ghost pipefish) and *Meiacanthus cyanopterus* (bluefin fang blenny).

Sometimes scientists have a little fun with naming a new species. One of my favorite names for a rather excellent octopus, named in 2006, is *Wunderpus photogenicus*. When in print, scientific names must differ from the rest of the text so are italicized when the text is regular or vice versa if the body of the text is italicized. In handwritten form, they are underlined. Convention dictates that the genus name is capitalized, while the species name is written in lower case.

The next step in naming a new species is the publication of the description in an internationally accessible text. Historically this would have been a printed scientific journal, but recently the publication of new species in electronic journals has become permissible. With all the scientific structure and jargon concerned in the naming of a new species, the process is generally carried out by a taxonomist with expert experience with the taxonomic group in question. It is extremely valuable to scientists on the ground if scientific descriptions include as much biological or natural history information as possible. Often, the very taxonomists who write the species description will not have seen a living specimen or the habitat from which it was collected. It is up to the person who collects the specimen to gather this information and pass it along. Many of these species may not be the focus of research again for some time, so it is important to include as much information as possible where it is available.

Despite the huge numbers of species awaiting official description, taxonomy is an underfunded and underrepresented field. Specialist taxonomists could work all hours and never make a dent in the long list of undescribed species. Some groups are so species-rich—with so few specialist taxonomists—that there is a huge

OPPOSITE TOP: Wunderpus octopus using its mantle as a net to hunt, described in 2006. Komodo Island, Indonesia.

OPPOSITE BOTTOM: Wunderpus octopus "walking." Komodo Island, Indonesia.

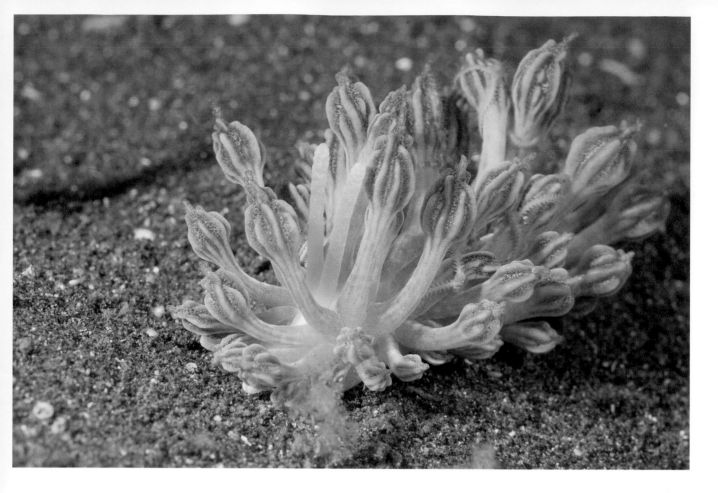

backlog of species awaiting a name. Nudibranchs are a good example of such a group. Relatively few specialists work in the field and eager aficionados exploring the world's oceans discover new species all the time.

LOW-HANGING FRUIT

Nudibranchs are a fascinating and stunning group of animals well-known to divers, but not as well-known outside these circles. This is probably true because they are colloquially known as "sea slugs," although the nickname really doesn't do them justice. They more closely recall butterflies, and are as colorful and varied as the winged creatures. The name "nudibranch" means "naked gill," referring to the gill plume on the backs of many species. They have captured the imaginations of many divers, many of whom make it their life's work to find and record as many nudibranch species as possible. The group is so biologically diverse that we don't have a good grasp of how many species there might be, and, given the continuing deluge of new species, it seems that there are many awaiting discovery. Nudibranchs have

The World Beneath

undergone a huge taxonomic reshuffle over recent years as genetic data has helped to redefine their relationships. Prior to the genetics revolution, their unique radula, or rasping tooth, was used diagnostically in identifying species.

As is true for many budding natural historian divers, nudibranchs were the first group that really caught my attention. I began cataloging and recording all the species I found. The trouble is that the sea slugs can be very similar; a slight divergence in the hue or location of a spot is enough to make a different identification. Early in my dive career, I began taking photos to help with identification. Of course, in those days I was taking film images, so it was weeks or months before I could actually see an image of the animal and be able to figure out its identity. In the meantime, I sketched an image on my dive slate and tried to identify it from there.

My focus has shifted away from nudibranchs, but it provided an excellent impetus to comprehend scientific names, look for well-hidden small species, and improve my macro photography on a slow-moving organism. Even today, I still make the occasional expedition to seek out a particularly stunning or fascinating species. Nudibranchs have some of the most outstanding examples of camouflage in the natural world; therefore, it makes sense that so many have eluded scientific discovery for so long. The remarkable *Phyllodesmium rudmani* was named in 2006, and, to the untrained eye, is indistinguishable from the *Xenia* corals that it feeds upon. The only way I have learned to be able to distinguish the slug from its food source is to closely compare the pinkish coral polyps and the nudibranch's long appendages (cerata). While the coral polyps pulse open and closed to generate flow and trap plankton, the cerata remain static and closed.

Another seemingly impossible feat of nature is the slug *Melibe colemani* that evaded detection until being named in 2012. This slug can reach several inches in length but is transparent, save for a series of taupe interconnecting digestive gland ducts that weave through its body. It lives in association with soft corals and appears to use its hood-like oral veil to pilfer food caught on the corals' polyps. I happened upon three of these mysterious mollusks in Komodo on a night dive. I almost couldn't believe that I was seeing a living animal. It is almost impossible to distinguish the head with eyes, sensory rhinophores, and mouth.

Despite the amount of time I spend in the water, I was astounded to see an undescribed species of *Thecacera* nudibranch in the Philippines recently. I descended to around sixty feet on a rubble slope at an area known as Anilao, a

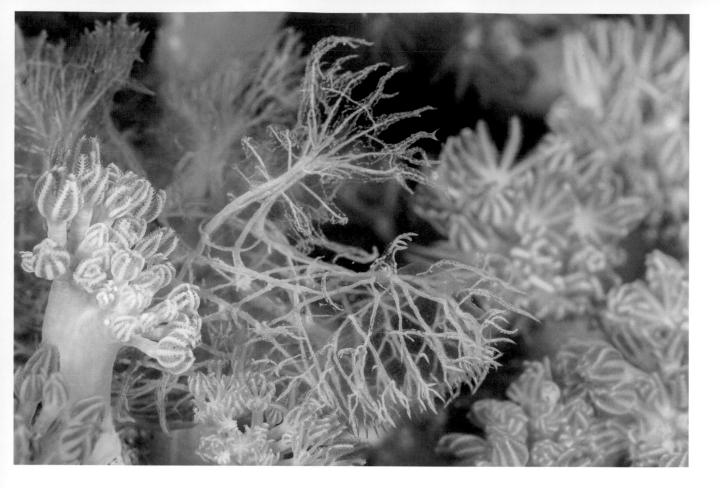

drive of several hours south of Manila on the island of Luzon in the Philippines. There, a neon slug sat feeding on a little mound of algae. The slug was unusual in shape, but typical for the genus *Thecacera*. Two huge filaments stuck out of its back to protect its delicate gills; another two fleshy lobes surrounded its chemosensory purple rhinophores. The body was bright tangerine orange and striped in pattern. I have never seen an image of the species from elsewhere and have never seen one in all my other dives. This slug, like hundreds or thousands of nudibranchs, remains to be named.

A NEW WORLD

Our oceans have revealed more than their fair share of amazing new creatures over the years. The biggest fish in the sea, the whale shark, was first described in 1828, but our knowledge of the oceans has been so lacking that by 1986 only 320 individuals had ever been recorded.[49] As our understanding of the seas has ballooned over the past few decades, we have identified many whale shark aggregation sites

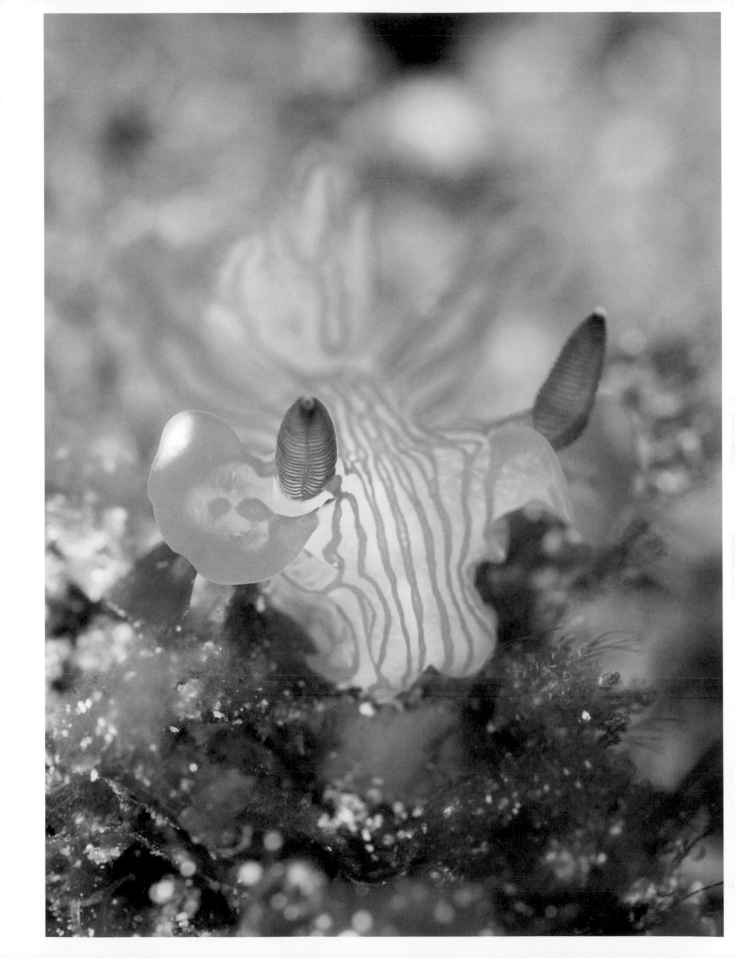

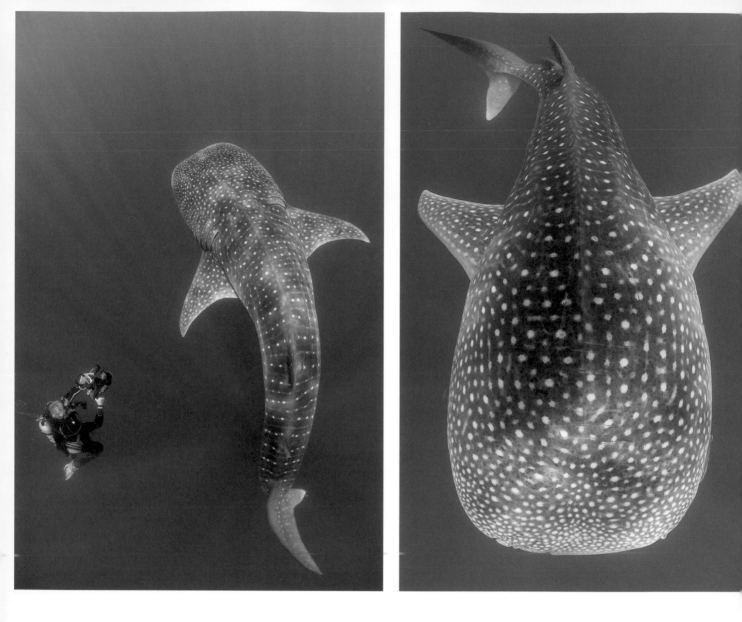

around the world; the densest aggregation being off the Yucatan Peninsula in the Mexican Caribbean, where 420 individuals were recorded in an area of seven square miles. The largest recorded whale shark was sixty-five feet long, twice as long as a London bus, and, at thirty-four tons, three times its weight.

There are very few sharks that attain a total length of more than thirteen feet. Discovered by accident in 1976 by a US Navy research vessel, the megamouth shark can reach a length of more than twenty feet. Over forty years later, just one hundred or so sightings have been made.[50] A filter-feeding shark, like the whale shark and basking shark, megamouths seem to spend much of their time at depths of around five hundred feet, feeding on plankton such as krill (small planktonic

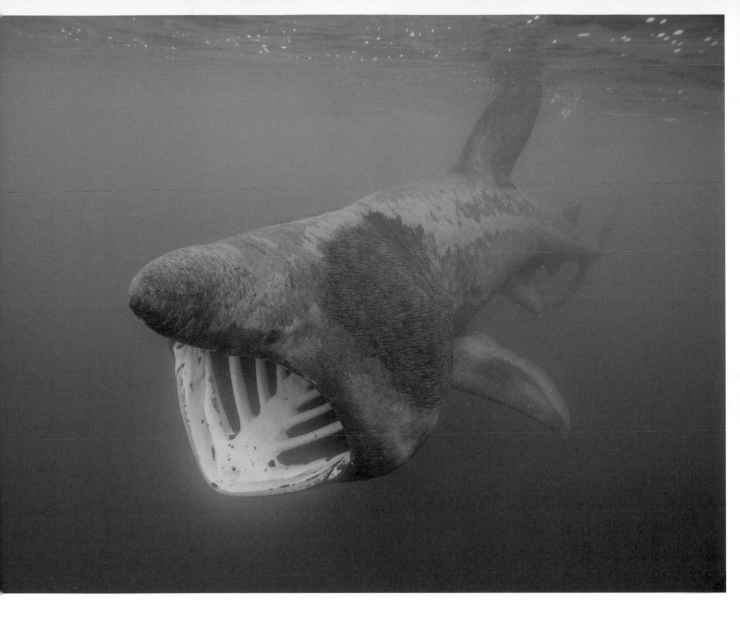

crustaceans); however, at night they follow their prey's vertical migration into forty feet of water. In 2017, a living megamouth was filmed in shallow water by a diver off Komodo. The slow, lumbering fish is uniformly dark gray in color, with a large gummy mouth. In the same way that aggregations of whale sharks have appeared under our noses, as our explorations of the seas continue it is conceivable that the same could happen with the megamouths. If a twenty-foot-long shark could evade detection until so recently, what else might dwell beneath the waves?

As we have been exploring the world's shallow seas since the turn of the twenty-first century, some areas have been particularly rich in terms of new species discoveries. I have been lucky to spend a good deal of my career exploring the

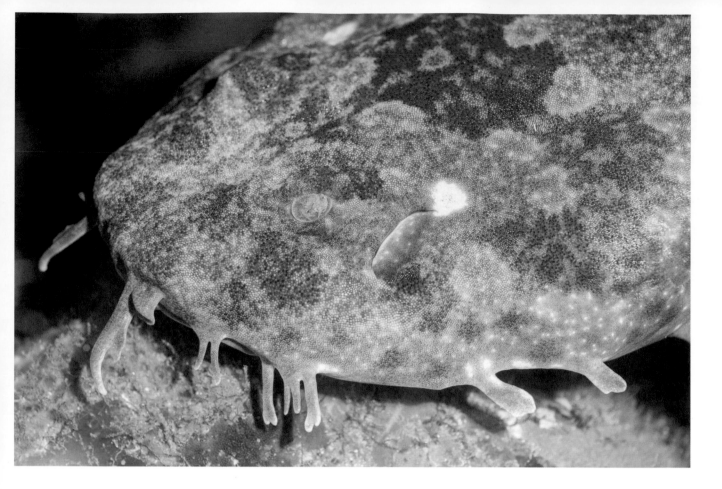

remote corners of Indonesia, one of the richest in terms of new coral reef species and particularly newly discovered fishes, largely thanks to a few ichthyologists who have made this area their focus.

One of my favorite dive locations in Indonesia is the Alor Archipelago in the East Nusa Tenggara province. These islands comprise a volcano chain that stretches along Indonesia's southern coast. On the south coast of Alor Island, where the Indian Ocean floods furiously through the few channels between islands, cool, nutrient-rich water wells up from the depths. The currents can be so strong that even our 190-foot-long vessel was buffeted entirely at their whim. Whirlpools form and the water surface seems to boil as currents collide and conflict with surface winds. Believe it or not, it is a magic place to dive—provided you are careful to dive on a slack tide or in the lee of an island. Since much of the diving happens in upwelled water from deep in the Indian Ocean, it's not unheard of to experience water of 65 degrees Fahrenheit—much cooler than you might expect in the tropics, where 85 degrees Fahrenheit is much more common.

Shivering, and wondering if I might have to cut the dive short, I saw Wendy, my longtime dive buddy, pop her head from behind a huge coral block and beckon me over. There she pointed to a three-foot-long wobbegong shark, nonchalantly sitting on the sand as they sometimes do. Wobbegongs are a fascinating group of ambush predators. They lay motionless on the ocean floor waiting for crustaceans or fish to stray within reach, then suddenly open their voluminous mouths and suck in the prey. Mottled brown in color, wobbegong sharks have a fringe around the mouth to help break up their outline as they lie in wait. Wobbegong sharks of the genus *Orectolobus* are predominantly known from Australia, but here I was in Indonesia clearly looking directly at onc.

Luckily some of my PhD contemporaries were shark researchers and I had met one of the leading shark taxonomists at a conference. After the dive, I quickly sent him an image and he informed me that this was the newly described Indonesian wobbegong shark, which he had named a few years before in 2010, and that my image was one of only a few images of a live Indonesian wobbegong that he'd ever seen. I was diving some five hundred miles east of their previously recorded range

Opposite Top and Bottom:

Undescribed jawfish of the genus
Stalix. Lembeh Strait, Sulawesi,
Indonesia.

too, so the sighting was extremely valuable. Because the holotype and paratype specimens were collected in fish markets, little was known of their natural habitat and colors in life. Such lack of data about the animal's natural behaviors and habitat preferences is typical of new species descriptions and again shows the information that citizen scientist divers can bring to the scientific community.

Another location in Indonesia that has been particularly abundant with new species over the past decades is Lembeh Strait. Lembeh Strait is well-known for its black sand habitats, and is one of the best examples of this kind of habitat in the world, making it a Mecca for muck divers across the world. Among the many new species that are known from the area is the fabled mimic octopus. This fascinating cephalopod was described in 2005 from Bali but is actually fairly widespread in its distribution. They are relatively common in Lembeh, although little is known about their biology. Often all that you will see of the mimic octopus are their tiny stalked eyes peering at you from a black sand dune in the distance. They tend to be shy and disappear as you approach. The best bet for observing them out of their holes is to seek them out at the octopus witching hour, around four or five o'clock in the afternoon, when the sun begins to get low in the sky. At this time of day, they seem much more active and less skittish.

Mimic octopuses are so named for their ability to imitate other creatures. They are said to mimic various toxic fishes, including soles and lionfish, as well as sea snakes, which all have black or brown and white stripes.[51] This mimicry confers an advantage to the octopus in evading its predators. When hunting, the mimic octopus is usually out in open black sandy areas and without anywhere to seek shelter, the ability to mimic these toxic animals is hugely advantageous. Depending on the situation and the type of threat, the octopus choses to mimic the behavior and form of one of these other species.

Since this is the Coral Triangle, there is of course also an animal that exploits the mimic for its own benefit. Jawfish are a group of small unassuming fishes that tend to live in holes with just their heads protruding. In Lembeh, a species of jawfish was found that appears to be new to science; this species is happy to leave its hole and venture out, presumably to hunt. It recently came to light that these jawfish associate with the mimic octopuses.[52] The jawfish hides alongside the octopus and its similar pattern acts as uncanny camouflage. In this way the jawfish can leave the safety of its burrow and travel farther afield to feed, without fear of predators. After all, the octopus can pretend to be a venomous lionfish, and the

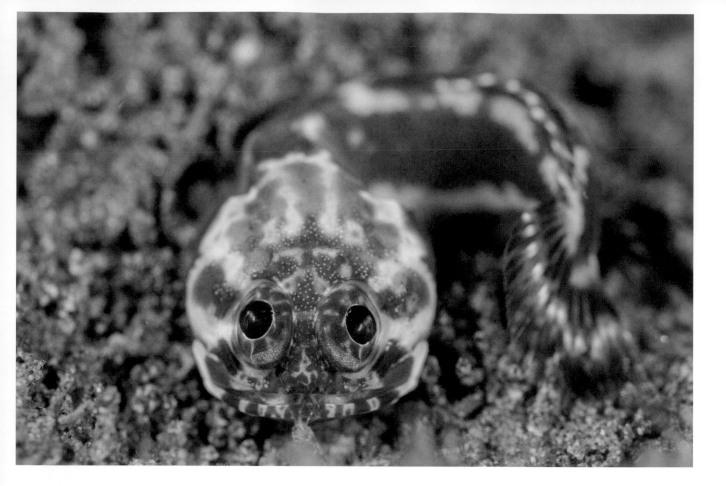

jawfish's black-and-white blotched pattern means that it will blend in seamlessly with the octopus's show. This fish therefore mimics a fish-mimicking octopus—only in the Coral Triangle would something this remarkable evolve. The jawfish and octopus's relationship appears to be opportunistic, but future research may prove such relationships to be more common than we currently realize.

Having seen the not-yet-classified jawfish for myself on a few occasions in Lembeh, I was surprised to see a very similar fish on a night dive in the Philippines. It was similar, but significantly larger, and sitting out in the open in a small hollow in the black sand, much like its relative in Lembeh. I shared the sighting with an expert on this genus and learned that the individual I saw in the Philippines most likely represents yet another new species in this interesting group. Whether it also takes advantage of the mimic octopus when the opportunity arises will require more observation.

There have been many other notable and unexpected new discoveries from the Coral Triangle since the turn of the century. In 2009, divers in Ambon happened upon a very strange frogfish. Frogfishes are commonly identified by a long, rodlike

lure that they cast out from the forehead; it carries a fleshy appendage, or esca, at the end. Depending on the habitat in which the given frogfish is found and the prey it wishes to attract, the esca can be shrimp-like or worm-like in appearance. The frogfish waves the lure in front of its face, and when a hapless fish approaches too closely, the mouth of the frogfish opens wide and in a fraction of a second sucks the prey inside.

The Ambon frogfish is unusual in that it lacks a lure and its face is broad and flat. The psychedelic frogfish, as it is known, has a striking beige or pink pattern and seemingly mimics a sponge or coral. Another unusual feature of its biology is that the eggs are brooded on the side of the animal. Much like juvenile Banggai cardinalfish, the babies are miniature copies of the adults when they hatch, which prevents them from being able to make open ocean crossings, and they are marooned on the island of Ambon. Ordinarily, larval fishes are highly adapted for their early pelagic life: they are tiny, silvery, and fast swimming. The body of an adult has evolved for a more sedentary life on the reef and the challenges and conditions that they face in this environment. Suddenly swimming into the open sea would be suicide for most adult fishes; the same is true for the juvenile fishes that are born as miniature copies of their parents.

The discovery of the psychedelic frogfish caused a frenzy in the diving community, which continues to this day as it remains extremely elusive. Sadly, as can sometimes be the case, the rock-star popularity of an animal can become one of its greatest threats. It draws eager divers from across the globe just to catch a glimpse and take a photo. During a recent visit I made to the region, we were informed that several of the frogfish had recently been seen and we were given detailed location details, which are usually enough for us to find a given creature. Although the frogfish are very well camouflaged, we were a group of some of the best spotters in

ABOVE TOP AND BOTTOM:
Painted frogfish with lure extended.
Dumaguete, Negros Island,
Philippines.

the business and still we hunted for several hours without a sighting. As it happens, the reason we didn't find them was simple: some unscrupulous guides or operators had made tiny cages for the fish, around the reef, for which only they knew the location. When photographers came to see the animal, they would take them right to the fish and release it for photos while obviously not revealing their unconventional methods. Some of our group later found one of these poor frogfish inside a makeshift chicken wire cage obscured by several rocks.

New species can appear in the most unexpected of places. Swimming along a rich coral reef in Raja Ampat, I searched intently for whatever miniature creatures I could find. While it's a great site for Pontoh's pygmy seahorse sightings, something much brighter caught my eye. On the lips of the inhalant siphon of a large *Polycarpa* sea squirt sat a pugnacious looking little crustacean. With scarlet eyes and a bright orange body, he was impossible to miss, despite measuring just a quarter of an inch. To the naked eye, the animal was so small that it was almost impossible to distinguish its features. Luckily, straight after the dive I downloaded my images and under magnification I could tell that it was an amphipod, a type of miniature crustacean, unlike any I had seen before.

ABOVE: Undescribed amphipod in a *Polycarpa* tunicate. Raja Ampat, West Papua, Indonesia.

OPPOSITE: Painted frogfish. Dumaguete, Negros Island, Philippines.

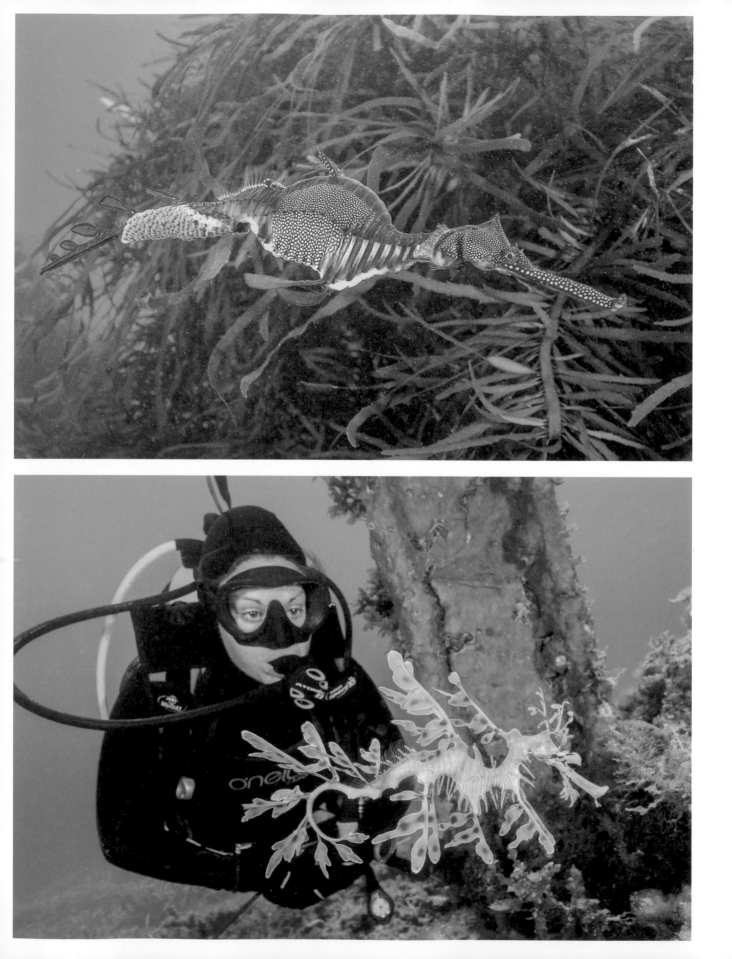

The screen's magnification showed that the amphipod seemed to be threatening me with a pair of mantis-like appendages. I started to trawl the internet for similar species, lacking any notion of the species' identity. Online, I found a similar animal—a new discovery from the very same area, which a year previously, in 2015, had been described by amphipod aficionado Dr. James Thomas. The amphipod was named *Leucothoe eltoni* after the British musician Sir Elton John, a favorite of the article's author.[53] I contacted the author, hoping to make an identification, only to find out that my new friend was not Elton's amphipod, as this lives in a different species of sea squirt. It was possible that I had chanced upon a new species.

Dr. Thomas's explanation of the amphipod's behavior that I had witnessed was fascinating; it was a male guarding the inside of the sea squirt, which housed juveniles and egg-bearing females numbering up to one hundred individuals. In this scenario, the male amphipod positions himself to ward off would-be predators, while filter feeding as water passes by him into the sea squirt. Apparently, this behavior has rarely been recorded—a photographic record again proves invaluable.

ABOVE: A group of undescribed amphipods on a *Nembrotha cristata* nudibranch (sea slug). Alor, Indonesia.

OPPOSITE TOP: Male weedy seadragon carrying a clutch of eggs. Tasmania, Australia.

OPPOSITE BOTTOM: Diver and leafy seadragon. South Australia.

LOOKING ELSEWHERE

Sydney pygmy pipehorse, described in 2004. Botany Bay, Sydney, Australia.

Where other habitats are concerned, there has been a flurry of new discoveries as specialist research divers have gone beyond recreational diving depths and explored slightly deeper waters. Located between one hundred and five hundred feet deep, mesophotic reefs are warm water, light-dependent reefs supporting an array of corals, sponges, and algae in an ecosystem different from that in shallower coral reefs.[54] Many new species have been found here, including a stunning little anthias found in Hawaii named after President Barack Obama. *Tosanoides obama* was described at the end of 2016, having been discovered at a depth of three hundred feet.[55] Like many fishes from this depth zone, it is reddish in hue. However, a more muted mesophotic fish from the Philippines, again with a name inspired by a politician, *Roa rumsfeldi,* was described in 2017. This deep-reef butterflyfish was collected for an aquarium exhibit at the California Academy of Sciences and was at first not recognized to be a different species, but after it was installed in the exhibit, aquarists noted several differences that warranted a new species status.[56] Because these subtleties can

take years to notice in shallow-reef species, many surely remain in obscurity in deeper reefs.

There have been notable discoveries in other areas of the oceans too, not just within coral reefs. These new creatures tend to be characteristically small, well-camouflaged, or deep-water species, although the oceans have often delighted us with surprising and charismatic species over the past couple of years. Southern Australia has more than its fair share of indigenous species due to its remoteness and the influence of ocean currents. Certainly, its most iconic locals are the fabled seadragons. The two species, leafy and weedy, are syngnathids (those fishes related to pipefish and seahorses), measuring between twelve and eighteen inches in length. In 2015 a third type of seadragon was added to the roster: the ruby seadragon. The ruby species was described based on four preserved specimens found in southern Western Australia, but at the time had never been seen alive.[57]

In 2016, an expedition was mounted to observe these mysterious fish in the wild. Two adult ruby seadragons were filmed using a remotely operated minivehicle that carried a low-light camera. They were found in a very different habitat

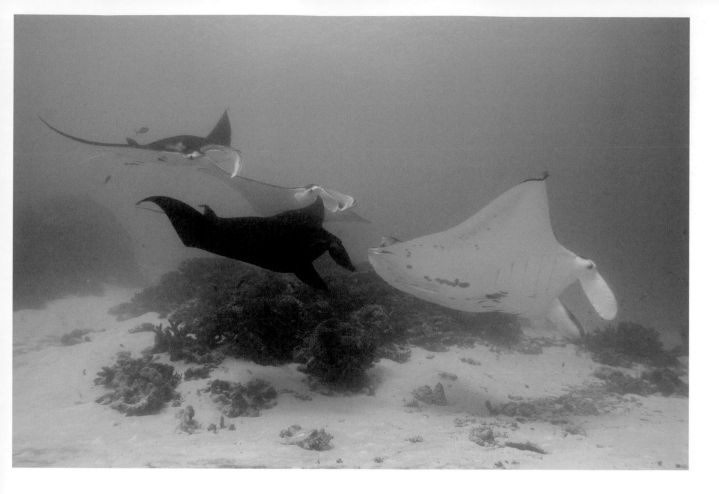

than the two other species, and confirmed suspicions that the ruby remained undiscovered for so long because it inhabits deeper water. The ruby seadragons were found at over 150 feet deep on a sandy bottom with hard substrate and some sponge, gorgonian, and algal growth. Unlike their cousins, they were observed to have prehensile tails. Presumably the surge on the exposed southern reefs that they inhabit can get quite strong when a storm hits, and the prehensile tails allow them to hang on if needed. To date, these animals haven't yet been seen without the help of deep-water ROVs.

Despite being a huge metropolitan city, even Sydney concealed an unknown fish until relatively recently. Ákos Lumnitzer, an avid local diver, discovered the amazingly well-camouflaged Sydney pygmy pipehorse in 1997, just under the Sydney Airport flight path, but it took until 2004 for the species to receive its official name in his honor, *Idiotropiscis lumnitzeri*. It is known only from a short stretch of coast on either side of the city, where the tiny fish (just two inches long) lives obscured among algae along the rocky coastline. It has so many features in common with seahorses that it is possibly one of their closest living relatives.

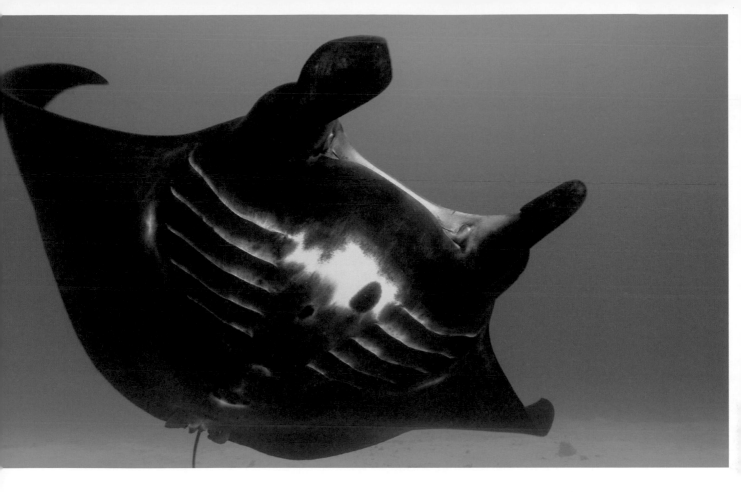

ABOVE: Reef manta belly. Raja Ampat, West Papua, Indonesia.

In late 2015, I was lucky enough to be joined by several local divers who were keen to help me find this little gem. We visited Bare Island, located in Botany Bay, just south of the city center. We did a shore entry, having trudged quite far in the austral summer heat, but quickly began to shiver in the chilly water as we descended. We could only see a very short distance in front of us, so we had to stick closely to each other lest we lose our guides. After a ten-minute swim we reached a rock where I saw my first Sydney pygmy pipehorse. It took me a good few seconds to be able to discern it from the surrounding algae, but then the outline emerged. I have found many pygmy seahorses in my time and they are half the size of the pipehorse, but the pipehorse is harder to spot because it is covered in small tufts of faux alga that make it blend in with the surrounding algae. In my opinion, they are among the hardest to spot of all the diminutive syngnathids

Through syngnathid research colleagues, I heard about a another pygmy pipehorse in New Zealand. The divers who found the new animal initially thought it was a seahorse since they look so similar, but since it is now in the process of being named, it has been identified as a pygmy pipehorse. The New Zealand

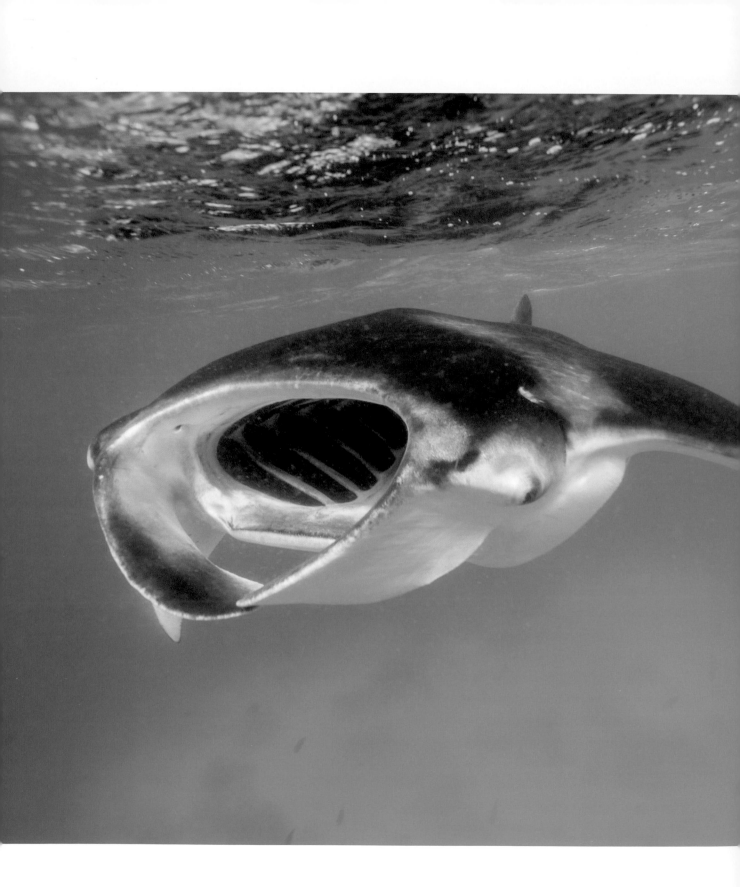

The World Beneath

discovery also helped to clarify the identification of another species, one found in the Seychelles in 2009 and mistakenly named a seahorse when it was in fact a pipehorse. It turns out that it was just a very seahorse-like pygmy pipehorse. The distinguishing features of the two groups weren't entirely clear until the New Zealand pygmy pipehorse came along.

In December 2017, I was in New Zealand and couldn't miss the opportunity to try and see this new pygmy pipehorse myself. It is exceedingly small and cryptic and had only been seen by a handful of people, but I enjoy a challenge. I drove to a remote stretch of coast on the North Island, where the elusive fish had last been spotted, six months before; the local dive shop owners took me to the site and left me to my own devices. After fifty minutes of tossing back and forth in the swell, searching for a tiny fish that's a master of camouflage, I almost gave up; but soon after I decided to press on a little longer. Finally, there it was. The tiny fish grasped a piece of algae and violently swayed back and forth with the surge. With just ten minutes left in my dive, I stayed and savored every last moment of observation. On the next dive I couldn't locate the fish, despite knowing exactly where it had been just an hour before. The next day, however, I managed to find a pair of them in a nearby area. The male was obviously swollen with their brood and the two interacted and hunted while not straying more than a few inches the whole hour I watched them. It was a real honor to see such a rare creature and observe these behaviors before the species even had a name. To date, it still doesn't, but the process is underway.

OPPOSITE: Reef manta filter-feeding. Maldives.

THE GENETIC REVOLUTION

Over the past couple of decades, genetic analysis has become fundamental in naming new species through the advent of relatively inexpensive DNA sequencing technology. It is not always easy to physically differentiate between two groups of animals, so looking at their DNA can often help. It may be that two animals look very similar, but a genetic split is evident. The same is true in reverse, with very different looking animals bearing almost identical genetics. When two species appear superficially identical but do not interbreed and are in fact different species, they are called "cryptic species." These types of species may be more common that we once realized. The danger, of course, is that common widespread species may actually comprise several species, some of which may have small population sizes and be highly endangered without us realizing. Wholesale analysis of coral reef fishes across the Coral Triangle has found that seventy-nine of 141 species analyzed showed hidden genetic diversity.[58] For instance, some localized color variation is common in coral reef fish, and the data showed that in many cases there was significant genetic variation as well as color variation in the species.

One of the most surprising cases of cryptic coral reef-associated species hiding in plain sight occurred in 2009. Until 2009, manta rays, large oceanic rays, were thought to comprise a single widespread species throughout the Atlantic, Indian, and Pacific Oceans. Suddenly researchers realized that the variations that were thought to be natural differences between individuals in fact represented two different species, *Manta birostris* and *M. alfredi*.[59] There are subtle size, color, and morphological differences that distinguish them, confirmed by genetic analysis. DNA analysis showed that the two species split between half a million and one million years ago.[60] In some locations the two species were found living together around the same reefs, but the larger oceanic mantas tend to travel much greater distances than the more site-attached reef species. Oceanic mantas are bigger, measuring up to twenty-three feet across, compared with the smaller reef species measuring up to sixteen feet. In 2017, genetics showed that both mantas actually belong to the broader devil ray group, *Mobula*, so they are now technically known as *Mobula birostris* and *Mobula alfredi*.[61]

Divers have been at the forefront of many of the new discoveries from coral reefs in this millennium, but another way that they have helped to expand our knowledge of the oceans is through citizen science. There are many ways that citizen scientists can add value: primarily through the volume and diversity of data they

can collect, which researchers could never accumulate on their own. Divers have collected information about reefs and their biodiversity through organizations such as Reef Check Foundation and Reef Environmental Education Foundation, and through their submissions of sightings, images, and data sets have helped to establish population sizes and migration patterns of mantas, whale sharks, sand tiger sharks, and even wunderpus octopuses. These species all have unique characteristics, like fingerprints, that researchers have been able to link to individual animals. A simple image of a specific part of the animal allows researchers to track and even determine their ages using previous data. If it weren't for the widespread power of the dive community, it would be unfeasible to gather so much data about these animals.

It has been a real privilege to live during this time of exploration and discovery on coral reefs. I have seen animals and behaviors that no other human has set eyes on. We, as divers, underwater photographers, and citizen scientists, look at the reef in a different way now and this allows us to find many new animals. By travelling to places that most scientists only dream of visiting, divers have recorded a wealth of new species that have previously resided in obscurity in the world's oceans. However, the rate of change on coral reefs through climate change and other anthropogenic disturbances bears a huge impact. I have borne witness to this shift firsthand throughout my scuba diving and scientific careers. The transformation occurring in our oceans obviously makes these new discoveries rather sobering, given that ecosystems are fundamentally shifting before our very eyes.

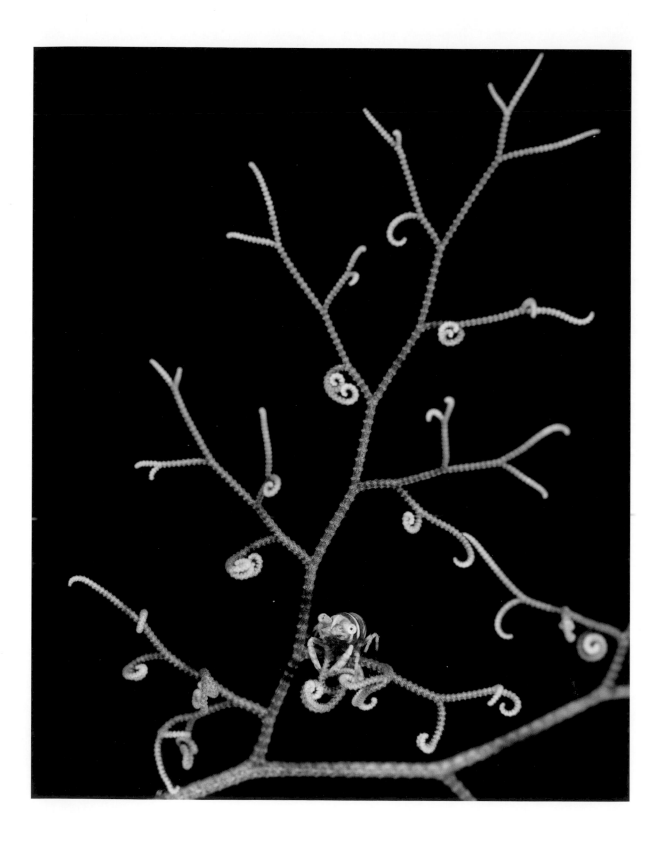

CHAPTER 5:

THINGS THAT
LIVE ON THINGS

Coral reefs are built on the symbiosis between corals and algae; however, this isn't the only close association between different species on the reef. Coral reefs have extraordinarily high biodiversity, and as a result have a huge variety of different types of relationships that take place both within and among species. There are numerous fascinating and beautiful examples of the different kinds of interactions found on the reef, from mutualism (a relationship between two different species where both benefit) and commensalism (a relationship between two different species where one benefits and the other neither benefits nor is harmed) to parasitism (a relationship where one species benefits and another is harmed). Through these relationships, thousands of reef organisms directly rely on one another for their very existence. Specialist species that have a close link with another species are thought to be at higher risk of extinction compared to more generalist species.[62] Some of these associations involve corals, while others exist between species about which we know very little.

Habitat specialists contribute a huge proportion of the overall biodiversity of coral reefs, but the vast majority have yet to be researched by the scientific community. The general lack of knowledge about these habitat specialists—their populations, reproduction, and natural history—makes finding and learning about them difficult, but it's a fantastic task for those who enjoy a challenge.

OPPOSITE: Basket star shrimp. Alor, Indonesia.

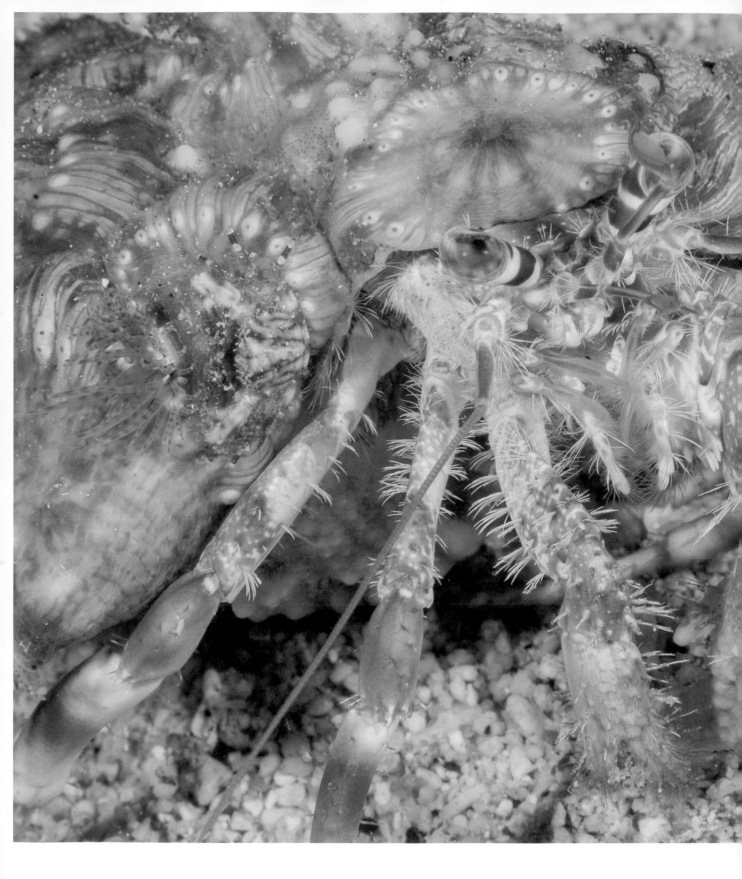

The World Beneath

To my mind, a nondescript little crab epitomizes the astounding biological diversity of coral reefs and the relationships shared between the species. The first I heard about this crab was from some friends, Ned and Anna DeLoach, who had spotted one several months before. The porcelain crab, my friends told me, only lives on the anemones that the hermit crab sticks to its snail shell home and is so small that two could comfortably sit arm-in-arm across a dime. I had seen many hermit crabs over the years; in fact, one of my earliest memories of visiting the seaside in England was to collect hermit crabs on the south coast. Hermits are relatively small and soft bodied, so to protect themselves from predators they live inside the shells of dead snails. When danger approaches, they disappear inside the safety of the shells. Over time, the crab must bid farewell to its starter home and upgrade to more spacious dwellings.

Some hermits renovate their abodes. They stick anemones to the outside of their shells using the anemone's sticky feet as a home security system of sorts. These anemones are a precious commodity; when the hermit crab wants to upgrade its shell to a larger one, it taps the shell in a certain way and the anemones know to release their grip so the hermit crab can then relocate the anemones to their new home. The tiny porcelain crab remains on the anemone and moves with it.

OPPOSITE: Hermit crab with undescribed porcelain crab to the left of the eye. Raja Ampat, West Papua, Indonesia.

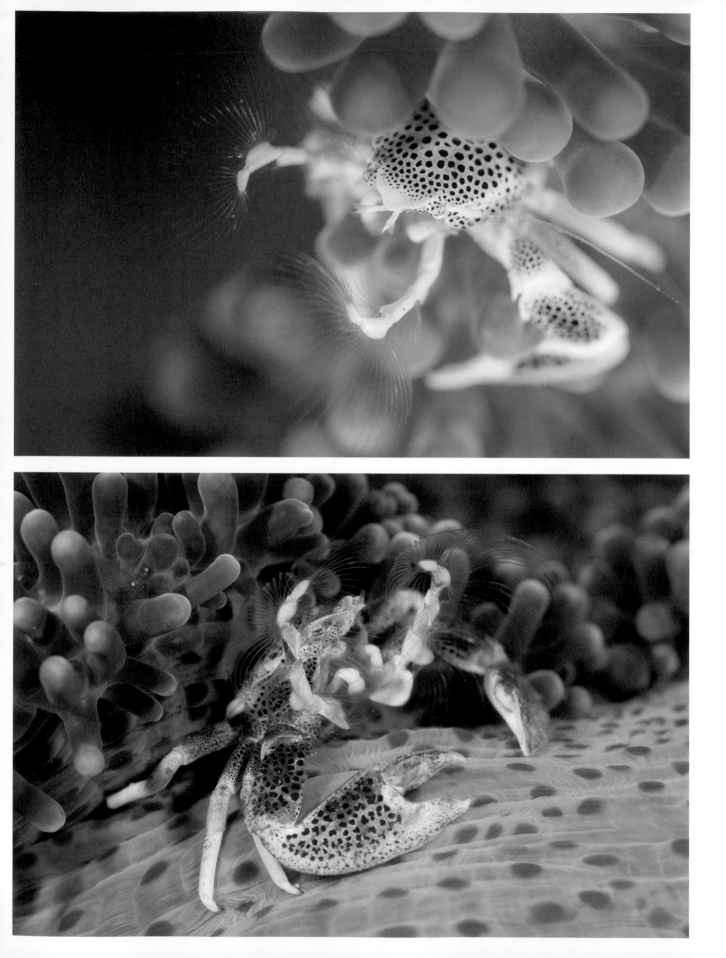

Very little information exists about these porcelain crabs, and few people have ever seen them. Among the various other species of porcelain crab, there is one that shares much larger anemones alongside anemonefishes; these tiny crabs are much more common and well-known and live in pairs on their hosts, where they filter feed. Sometimes, when we have very little information on a rare or newly discovered species, extrapolating as much information as we can from their close relatives is the best we can do in the short term. In the case of this new porcelain crab, I am blown away by the layers of life it displays. To witness a tiny porcelain crab that only lives on the anemones that only live on the dead shells of a snail inhabited by a hermit is really rather special.

THINGS THAT LIVE ON THINGS

Habitat specialists commonly share an association with one of the thousands of species of sessile invertebrates found on a reef, such as corals, sponges, and bryozoans. The strength of the bonds between these animals and the creatures that inhabit them ranges from a mere casual acquaintance to a long-term commitment—spanning from occasional visits for feeding or temporarily seeking refuge to a true lifelong obligate association. An obligate association is a relationship that is constant, where free-living individuals are not normally found, and all stages of adult life must take place on the host, including breeding phases.[63]

In 2015, after many years of searching, I saw my very first giant clam shrimp. *Anchistus demani* was first described in 1922, presumably during the dissection of a giant clam, but as far as I know, live specimens had rarely, if ever, been seen in the wild. I knew of this species from images of preserved shrimp that showed a transparent body covered in blue dots. I incorrectly assumed that they live on the outside of the clam, possibly tucked into crevices on the colorful mantle. I was shocked when I saw an image taken by my friend Juliette Myers. She had happened upon the shrimp quite by accident while absentmindedly glancing inside the body cavity of a clam. Giant clams have two openings: an exhalent hole, where water flows out, and a larger one where water is sucked in and the gills filter plankton. From Juliette's image it was clear that I had assumed incorrectly; the shrimps actually live on the internal gills of the clam.

It became my mission to photograph these shrimps, but the clam's skittish temperament made this a challenge. If a clam senses any unexpected water

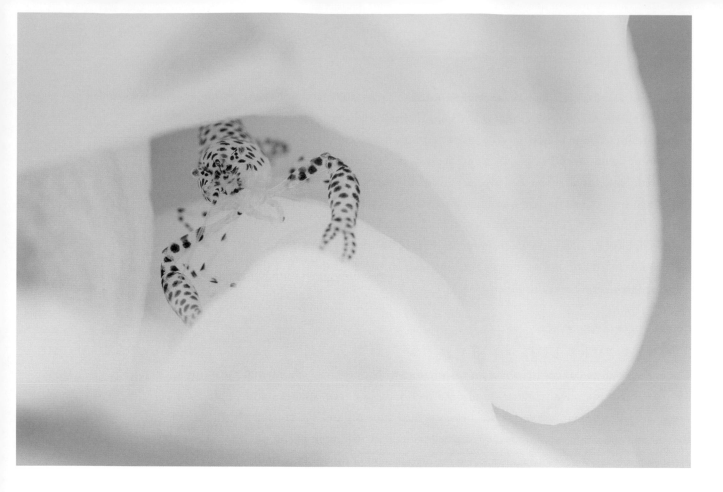

ABOVE: Giant clam shrimp (*Anchistus demani*). Wakatobi, Sulawesi, Indonesia.

movement besides the ordinary currents and waves, it slams shut to protect its soft and vulnerable flesh. My challenge was to find a clam situated in a position that would allow me to peer inside the inhalant opening without having to move around too much and risk engaging its nervous disposition. Fortuitously, I visited Wakatobi Dive Resort, in southeast Sulawesi, a few months later, where Juliette had taken her shot. One of the guides told me exactly where to find the clam and assured me that it was perfectly positioned—I could hang in the blue water and photograph right into the hole where—hopefully—the shrimps could be spotted. I followed his directions to the letter and managed to find and shoot my first giant clam shrimp. Figuring out that the shrimps lived inside these clams was the largest part of the puzzle; since coming to this realization I have seen them in almost all the clams I've had the opportunity to investigate.

I had told some other friends about these shrimps and they became as fascinated as I was. On a trip we made together to West Papua, they happened to look inside a different species: the true giant clam, *Tridacna gigas*, which I had not come across during my hunts. True giant clams are the real behemoths of the

clam world, and have reportedly reached four and a half feet in length. It turns out that these clams host a completely different shrimp, *Conchodytes tridacnae*, distinct from those found in other clams. The shrimp looks very different than the other species too. My friend had images of the bulldozer-like female with a white body, dotted blue arms and legs, and bright red eyes. I tried desperately to observe these amazing animals for myself in the same clam that they had seen them in; however, after three ninety-minute dives, I managed only the briefest glimpse of the smaller male. These animals perfectly illustrate the level of habitat specialization that is found in reef-living animals. Not only are these shrimps only found in giant clams, they are only found in certain species of giant clams and often inhabit the same host for the rest of their life. Thankfully, I have since managed to find a pair of true giant clam shrimps of my own and managed to spend some time photographing and observing their day-to-day activities.

There are costs associated with being an extreme habitat specialist, where just one species of host is inhabited, particularly for those with morphological adaptations to their niche. Because of their adaptations, such as habitat-specific camouflage, they are unlikely to be able to use an alternate habitat as a home should they need to. A more generalist species, on the other hand, can exploit a wider range of places to live. If a generalist is in direct competition with a specialist for its preferred habitat, the generalist tends to be less well adapted and the specialist will dominate. Because of this, most animals have evolved a very narrow niche, or role on the reef. It seems as if every one of the thousands of animals on the reef has a roommate or a hanger-on.

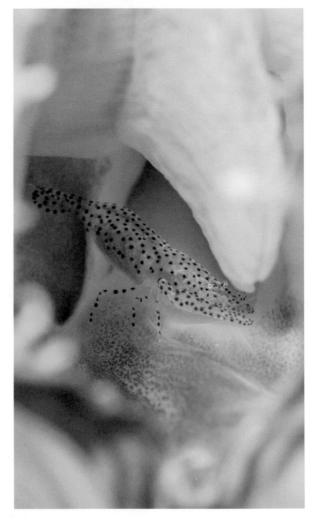

ABOVE: Giant clam shrimp (*Anchistus demani*) with eggs. Raja Ampat, West Papua, Indonesia.

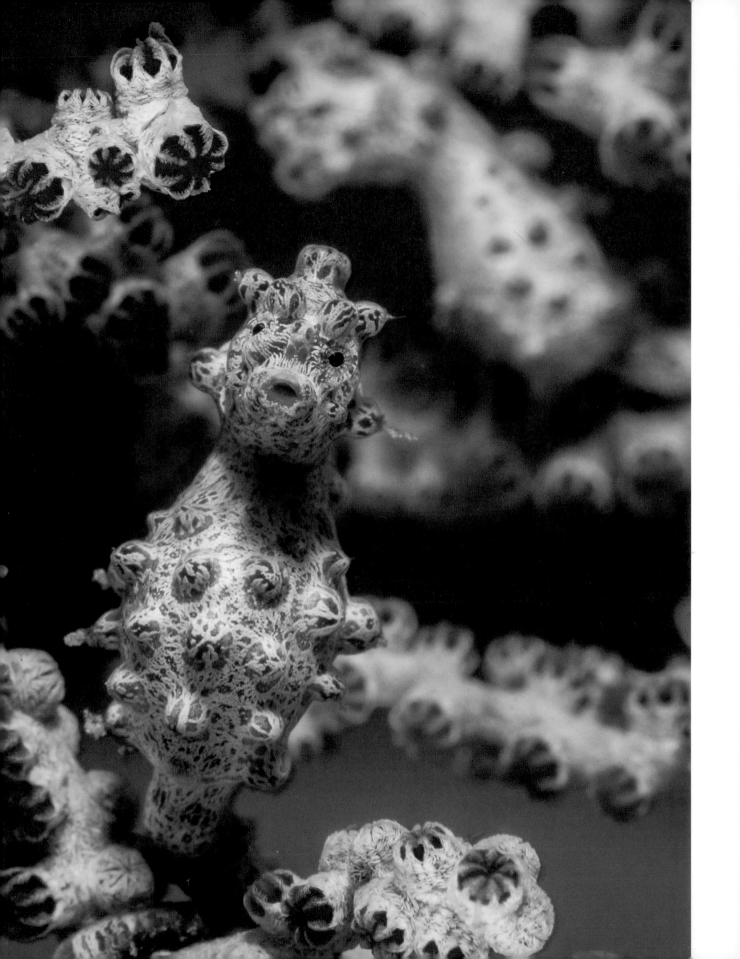

SYMBIOSIS

Symbiosis, the close relationship between two or more species, has three main classifications: commensalism, mutualism, and parasitism, all of which are common on coral reefs. Commensalism is a type of relationship where one individual in the partnership benefits, while the other remains neither positively nor negatively affected (this is considered a 0/+ relationship). Most of the coral reef's habitat specialists are commensals. Take, for instance, two species of pygmy seahorses that spend their entire adult lives on the surface of a single gorgonian coral. The seahorses are less than one inch in length; often, just one perfectly camouflaged pair lives on a single gorgonian—sometimes as large as a sixty-five-inch television screen. They are so tiny that they have no impact, neither positive nor negative, on the gorgonian. The seahorses, on the other hand, benefit positively from the relationship: they have made hearth and home of the animal, feeding on the tiny crustaceans that live on the gorgonian's surface and blending in seamlessly among its polyps.

The second kind of symbiosis found in the animal kingdom is mutualism. In this case, both parties, a host and a symbiont, benefit from the relationship (+/+). There are two kinds of mutualistic relationships: an obligate mutualism where one organism cannot survive without the other, and a facultative mutualism in which each organism can survive independently, but it is more beneficial for both if they remain together. Both types of symbiosis are common on coral reefs. A fascinating example of an obligate mutualism on a coral reef is between the dusky damselfish and an alga, *Polysiphonia*.[64] The damselfish is a farmer, aggressively protecting its patch of reef from other herbivores so its staple food, the *Polysiphonia*, can flourish. The damselfish actively removes other species of algae from its plot, since the alga that it cultivates, while fast growing and palatable, is less competitive than other species. Experimental removal of all other fishes, including the damsel, resulted in other algae taking over the patch within a week due to a lack of weeding. If only the protective damselfish is removed, and other fishes are allowed access, the alga is completely annihilated by other grazers within a few days. What is most amazing is that this species of alga doesn't grow anywhere on the reef outside of the damselfish farms. In addition, the damselfish only eats this alga and no others. Neither species would prosper without the other and so the two have formed an obligate mutualism.

Obligate mutualism also occurs between certain gobies, a large family of small bony fishes, and their partner, the snapping shrimp.[65] The near-blind shrimp is a

hard worker and labors to construct a lovely burrow. The goby is rather lazy, and extremely nervous. A mated pair of these gobies shares a burrow with a mated pair of shrimps, and together they form a strong bond. While the shrimp is digging and constructing the burrow, the fish keeps watch. The entire time, the shrimp stays in touch with the fish using its long antennae, which can feel any subtle movement the fish makes. Like tactile sign language, a certain movement of the tail informs the shrimp to seek shelter in the burrow; another movement instructs the shrimp to stop moving and wait to learn if the coast is clear. If the danger becomes too real, the fish too darts to the safety of the burrow. Research has shown that neither the fish nor the shrimp survive in the absence of the other. Without the shrimp, gobies can't escape predators and hide in the safety of a hole, and without the goby the shrimp are quickly eaten by predators since they can't see them coming.

There are many examples of facultative mutualism on coral reefs, in which it is beneficial to remain in a relationship but it isn't life threatening if the pair takes a break. Take, for example, the interdependency of three different species of Caribbean sponges. Each differs in tissue and skeletal characteristics, and as a result each species is more or less prone to the same environmental hazards, such

BELOW: Gorgonian coral and diver. Ambon, Indonesia.

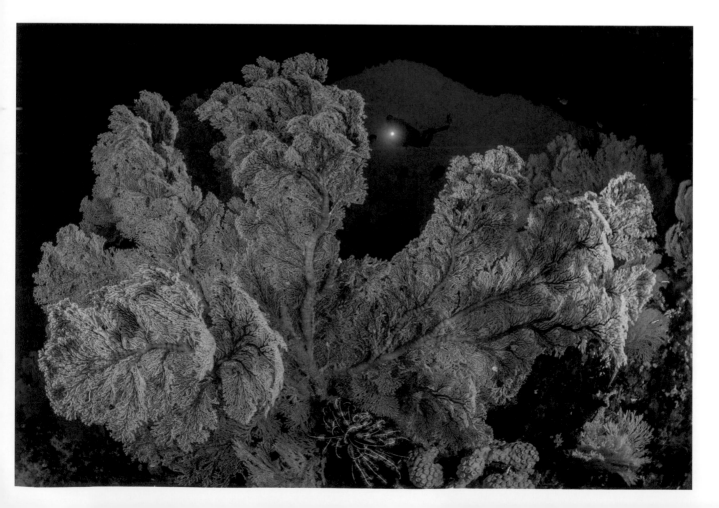

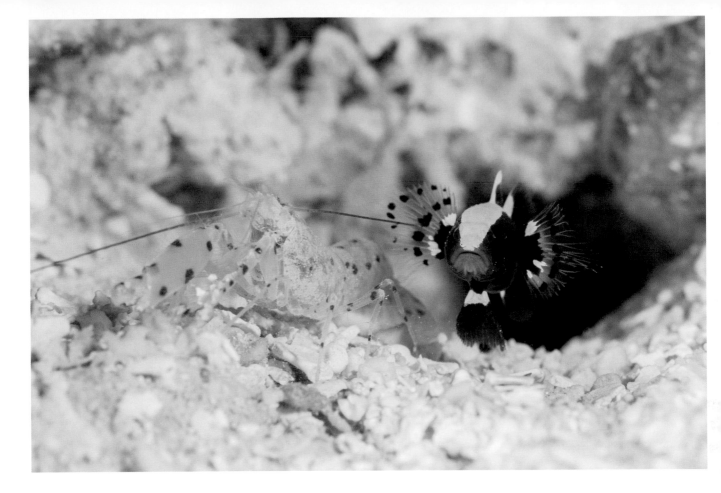

as predation by fish and sea stars, smothering by sediments, and breakage by storm action. Perhaps one is toxic to predators, or one is structurally stronger and confers an advantage during a storm. Exactly how the mechanism works requires further research, but it appears that the three sponges' cooperative growth enhances survival and mitigates environmental hazards for all of them.[66]

Parasitism may be the most common form of symbiosis on the planet, with some researchers speculating that 30 to 50 percent of known animal species are in fact some form of parasite.[67] Even parasites get parasites. The biological definition of this relationship asserts that the parasite benefits and the host suffers (+/−). Parasitism on the reefs will be explored in a later chapter.

COMMENSALISM

While working on my doctoral thesis on the biology of gorgonian-associated pygmy seahorses, I was struck by how little we know about the many common coral reef symbioses and mutualisms. Given how many commensal species reefs

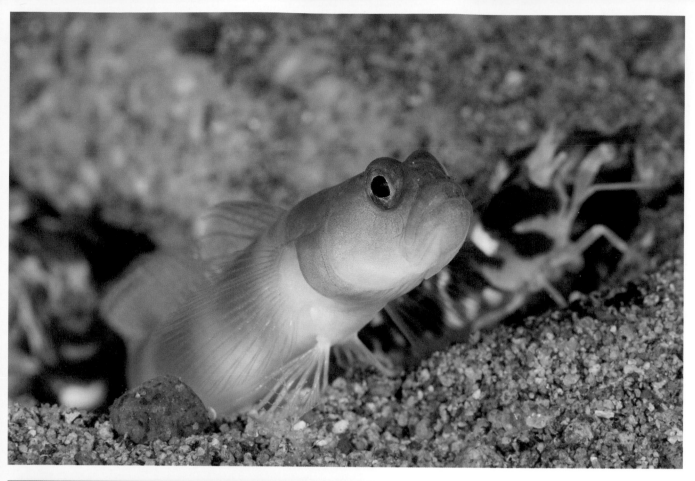

accommodate, and their importance in the overall diversity of coral reefs, it's amazing how little research has been conducted. I was looking for model species to compare to pygmy seahorses and the only comparable commensal species that I could find was the coral gobies of the genus *Gobiodon*.

These colorful gobies are obligate commensals of branching hard corals. Some species are generalist, living with a small number of different coral species and tending to have a body shape that suits living with the different corals. Other species are extreme specialists, living with only one species of coral. The specialist gobies tend to have special adaptations such as long and slender bodies to accommodate denser growth forms of their host coral.[68] Colors of the gobies vary from parrot-like vivid greens with spots and colorful

The World Beneath

patterns, to simple uniform colorations, down to the striking redhead coral goby whose name speaks for itself, depending on which attire best suits their specific host. Due to their habitat specializations, many species of gobies can be found on the same reef. They are a species-rich group; many new species are still being named. Four new species were described in 2014 from the Red Sea alone,[69] with many others known, but not yet described.

Since coral gobies tend to prefer living in just one or a few coral species, they compete intensely for space in suitable corals. Under certain circumstances, it makes sense to avoid this competition by shifting to uninhabited species of coral. Once the shift is made, competition recedes and the goby quickly specializes to the new host; ultimately, the goby diverges and evolves into a new species.[70] Due to the large number of potential coral hosts, these gobies have diversified into a range of new species along the way, each with its own preferred coral host. Not all reefs, however, are the same. Only some will be suitable for a given coral species and therefore some reefs may end up housing many gobies and others none—which directly impacts their populations. Also, the size of an individual coral colony may affect the number of coral gobies that it is able to accommodate, which in

OPPOSITE TOP: Flagtail shrimp goby and pair of snapping shrimps. Dumaguete, Negros Island, Philippines.

OPPOSITE BOTTOM: Redhead coral goby among the branches of a coral. Ambon, Indonesia.

BELOW: Pair of whip coral gobies guarding their eggs. Raja Ampat, West Papua, Indonesia.

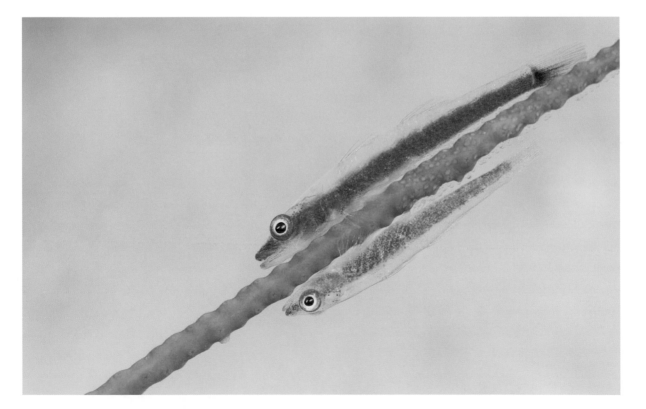

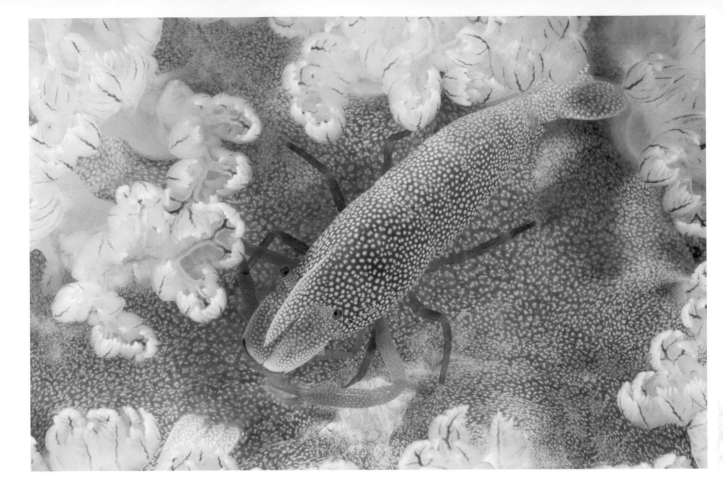

turn influences its social group size. These gobies are just one group of habitat specialists that has received some research focus. It is easy to see how these kinds of mutualistic relationships could substantially add to the species richness on a coral reef but can easily go undetected.

Commensals confer neither benefit nor disadvantage to the host; however, given the commonality of commensal organisms on the reef, substantial benefits to the commensal species must exist. Frequently, the host confers some form of protection to the species. For example, all gorgonians tested so far have been found to possess chemicals that are unpalatable to generalist fishes. In turn, this protection is often passed on to associated organisms, especially if their camouflage does not attract possible predators.

Some reef organisms are more forthright about advertising defenses than gorgonians. The fire urchin, *Asthenosoma varium*, uses its bright and bold colors to alert other organisms to its danger. These urchins are common in some areas and they accommodate a whole variety of commensal organisms that live protected among their spines. Zebra crabs, Coleman and Brock's commensal shrimps, and

ABOVE: Imperial shrimp in the gills of a Spanish dancer nudibranch (sea slug). Wakatobi, Sulawesi, Indonesia.

OPPOSITE TOP: Orangutan crab on a bubble coral. Great Barrier Reef, Australia.

OPPOSITE BOTTOM: Imperial shrimp on a mating pair of *Nembrotha milleri* nudibranchs (sea slugs). Dumaguete, Negros Island, Philippines.

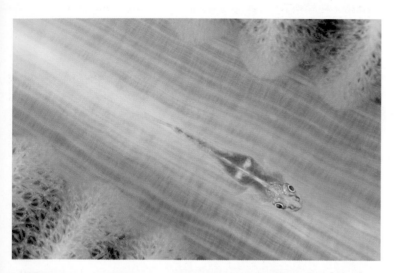

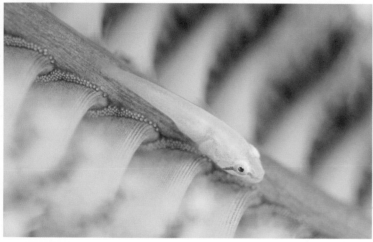

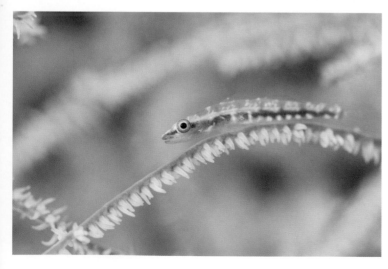

a parasitic fire urchin snail are just a few of the more common symbiotic species. A Coleman shrimp actually goes so far as making a small clearing for itself among the spines. Once settled, they remain in male-female pairs and seem to spend their entire adult lives on a given fire urchin. My own observations suggest that zebra crabs and Brock's commensal shrimps seem less tied to a single urchin and may travel singly on an urchin and then jump to another urchin when they naturally aggregate from time to time.

There are other features of a host that appear to be important to commensal species. A feature of many marine organisms that we rarely consider is their longevity, but this is sure to influence their suitability as hosts. We know that some large coral colonies have been alive since at least the thirteenth century,[71] and some large barrel sponges may have been alive since 300 BC.[72] Even more amazing, in 2009 a deep-water gorgonian colony off Hawaii was dated at 4,265 years, around the same age as the pyramids.[73] Aside from these extremes, some smaller and less well-known reef organisms may well have long lifespans too, such as tunicates and bryozoans, but scientists don't yet know just how long their potential lifespans could be under the right conditions. Clearly, if a host is long-lived, the biology of the commensal is likely to follow suit.

While conducting my PhD fieldwork, I spent a total of six months over a three-year period visiting the same cave on a reef in southeast Sulawesi to record the behavior of pygmy seahorses. During that time, it was striking to me how little the local reef community changed. The whip coral colony to the left of the cave didn't seem to grow or diminish at all over the three years. The small sponges on the wall of the cave also barely changed and even some sea squirts remained.

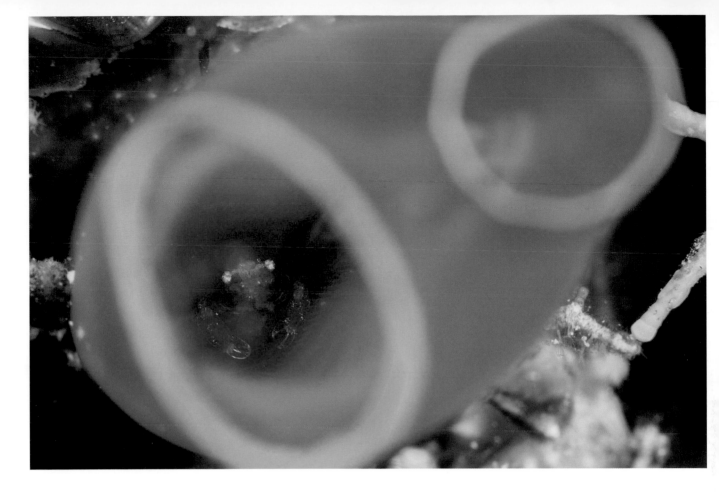

RICH PICKINGS

Crinoids are common coral reef inhabitants that not only have long individual lifespans but have also been on Earth for a long time. They have existed, almost unchanged, for around 450 million years.[74] To put this into perspective, the first dinosaurs appeared around 250 million years ago and our species began walking the plains of Africa around two hundred thousand years ago. In the deep sea, stalked varieties of crinoids, known as sea lilies, open to a three-foot diameter. Smaller mobile forms populate coral reefs; around five hundred species can be found in the world's shallow seas.

There has been relatively little research on the biology of today's living crinoids, despite how common they are. They have no commercial value and do not play much of a role in the ecosystem, which may explain why they have been largely ignored. Crinoids are the most primitive of the five echinoderm classes, other members of this group being sea stars, sea cucumbers, brittle stars, and urchins. At first glance, they are often confused with fern-like plants rather than animals, as they don't have many of the features you would ordinarily think of as animal-like.

ABOVE: Shrimp inside tunicate. Cebu, Philippines.

OPPOSITE TOP: Many-host goby on seapen. Komodo Island, Indonesia.

OPPOSITE MIDDLE: Seapen gobies are a rarely encountered and diminutive species. Sumbawa Island, Indonesia.

OPPOSITE BOTTOM: Black coral goby. Raja Ampat, West Papua, Indonesia.

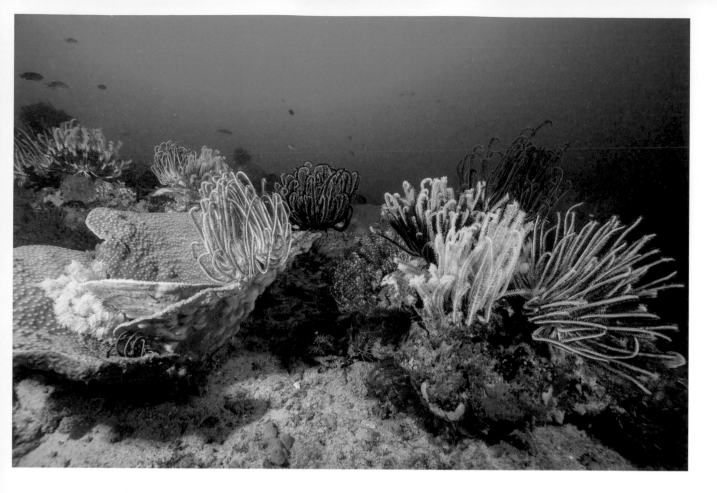

ABOVE: Multiple crinoids. Triton Bay, West Papua, Indonesia.

OPPOSITE TOP, MIDDLE, AND BOTTOM: Oneline clingfish on crinoid. Cenderawasih Bay, West Papua, Indonesia.

Their body structure is comprised of three main parts: the stem or stalked legs, the main body, and the arms. Crinoids have no evident sensory organs such as eyes, nose, or ears. They appear to have no predators to speak of, thanks to their spiky and largely unappetizing physique.

Because of the crinoid's unpalatability and complex external morphology, they make excellent homes for small cryptic animals. As filter feeders, they also make the most of the currents and can swim from one location to another to find the richest currents. This obviously benefits their hitchhikers too. If attacked, crinoids can regenerate lost arms. They may live for more than twenty years, and their stability and longevity make them exceptional homes for commensal organisms. In Taiwan, researchers found that forty out of forty-one crinoids sampled had some type of commensal organism living with them.[75] In Papua New Guinea, 92 percent of crinoids housed symbionts, with an average of eight symbionts per crinoid.[76] In total, they found forty-seven species of symbionts. Five were parasitic, and the rest were commensal. Forty-six of the forty-seven symbionts were obligately associated with crinoids, showing how specialist these animals are.

Crinoids were one of the first hosts that really caught my attention. They are very prominent on the reef, and so fruitful as a hunting ground that they make a perfect starting-off point to begin a search for an intriguing habitat specialist. When hunting for habitat-specific organisms, I have found that knowledge of their preferred host goes a long way in helping find them. One of the first crinoid-associated animals that I became interested in was the crinoid clingfish. These tiny fish live in small, active groups and resemble colorful tadpoles just three-quarters of an inch long. They swim about the crinoid, looking for morsels of food. If currents pick up, they utilize their modified pelvic fins as tiny suction cups. Unlike many other habitat specialists, adults don't appear to spend their life on a single crinoid, opting instead to hop between groups. Sometimes they fight and squabble, which makes them even more exciting to watch. On more than one occasion, while motionlessly hanging in the water watching their antics, I have had one swim over and sit on my camera, hoping to hitch a ride to a new home.

Coral reef crinoids harbor some twenty species of shrimps, in addition to a plethora of other crustaceans including crabs and squat lobsters. There are also pygmy cuttlefish that hide among the crinoid's arms, camouflaged to match, and a not-yet-taxonomically-described brittle star, another type of echinoderm, that clings dearly to the base. Ornate ghost pipefish, masters of camouflage, also live among the crinoids, their bodies covered in fleshy spikes that disrupt their outline among the crinoid's feeding arms. The pattern of this species is also very disjunctive, with their base color matching the color of the host crinoid to optimize their camouflage.

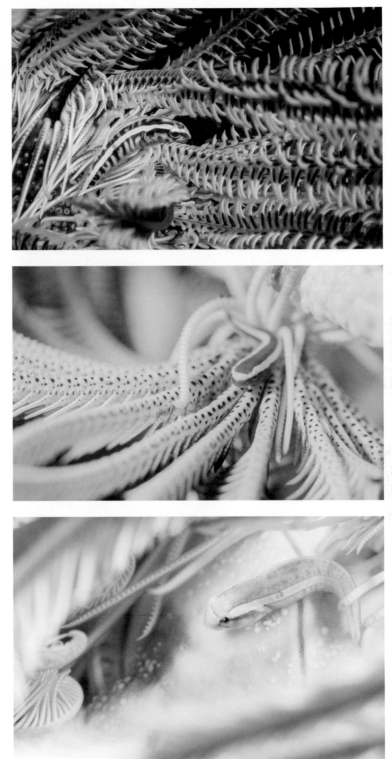

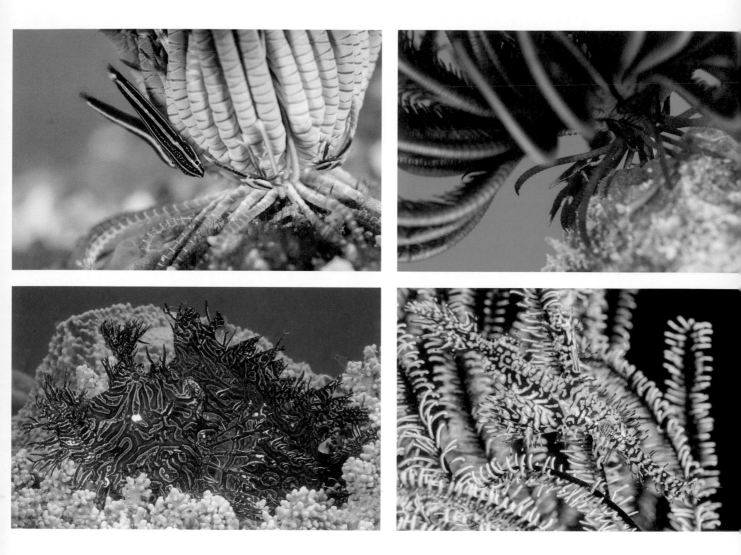

ABOVE TOP, LEFT TO RIGHT:

Twoline clingfish beneath crinoid with
two squat lobsters. Wakatobi, Sulawesi,
Indonesia.

Elegant squat lobster underneath a
crinoid. Great Barrier Reef, Australia.

ABOVE BOTTOM, LEFT TO RIGHT:

Lacy *Rhinopias* scorpionfish mimicking
a crinoid. Milne Bay, Papua New Guinea.

Ornate ghost pipefish camouflaged
against a crinoid. Dumaguete,
Negros Island, Philippines.

Another fish that can be found living alongside crinoids is the stunning juve-
nile form of the Batavia batfish. Adults live off the reef in blue water, but juveniles
remain in protected inshore areas in close proximity to crinoids. While mature
batfish are disc-shaped and golden in color, the young wear a striking zebra-like
façade. With their vivid black-and-white patterns, you might imagine that the
young batfish would draw a predator's attention rather than avoid it; however, the
moment that the fish approaches the crinoid, it seems to disappear in a cloak of
invisibility. Along with the spiky ends on its fins, the patterning allows the fish to
blend in seamlessly.

One last fish that is sometimes found around crinoids on the reefs of the

Coral Sea region of southeast Papua New Guinea, the Great Barrier Reef, and the Solomon Islands is the lacy scorpionfish, *Rhinopias aphanes*. It is a fairly large ambush predator, reaching some ten inches in length. Having seen the weedy and paddleflap *Rhinopias* species, which are generally found on sheltered algae or sandy slopes, I was surprised when I saw my first lacy sitting out in the open on the reef. They mimic the crinoid, with mottled colors and filaments resembling the crinoid's feeding arms. When hapless fish mistake it for a harmless crinoid and swim too close, the scorpionfish strikes.

BROADENING THE SEARCH

The sponge is considered to be the most primitive of all animal groups, significantly older than even the crinoids. They feed through the action of millions of tiny whip-like appendages that stream water into tiny holes in their surface and filter it to find suspended food. Sponges vary widely in size, shape, and color. Some large individual Caribbean barrel sponges are thought to be two thousand years old. Some sponges form small vase-like structures, while others bore into limestone with acid they produce. Given their long history on Earth, it's unsurprising that many organisms associate with sponges, one of my favorites being a tiny crustacean, the hairy squat lobster. This little animal, just big enough to sit on a dime, lives in crevices between the ridges of huge barrel sponges. Since the sponge sucks water through its sides, the lobsters' hairs are likely an adaptation to the sedimentation that flows over the surface of the sponge before entering it. They are bright pink when observed very close up, but the color surprisingly helps with camouflage on the mottled brown sponge.

Another surprising and fascinating denizen of the humble sponge is the eusocial snapping shrimp, which has quite a vivacious social life. Eusociality is well-known on land, with ants, bees, wasps, and termites being examples. It is characterized by cooperative colonies in which most members sacrifice reproduction in order to care for the young or protect the group. In bees, for example, the queen is the sole reproductive member of the colony, and the largely sterile workers and soldiers work away at specialized tasks that assist the colony function. There are just a few known eusocial shrimps, which live inside sponges on tropical coral reefs.[77] Their social structure consists of well-armored males with prominent enlarged snapping claws and a reproductive female. Much like eusocial insects, the males

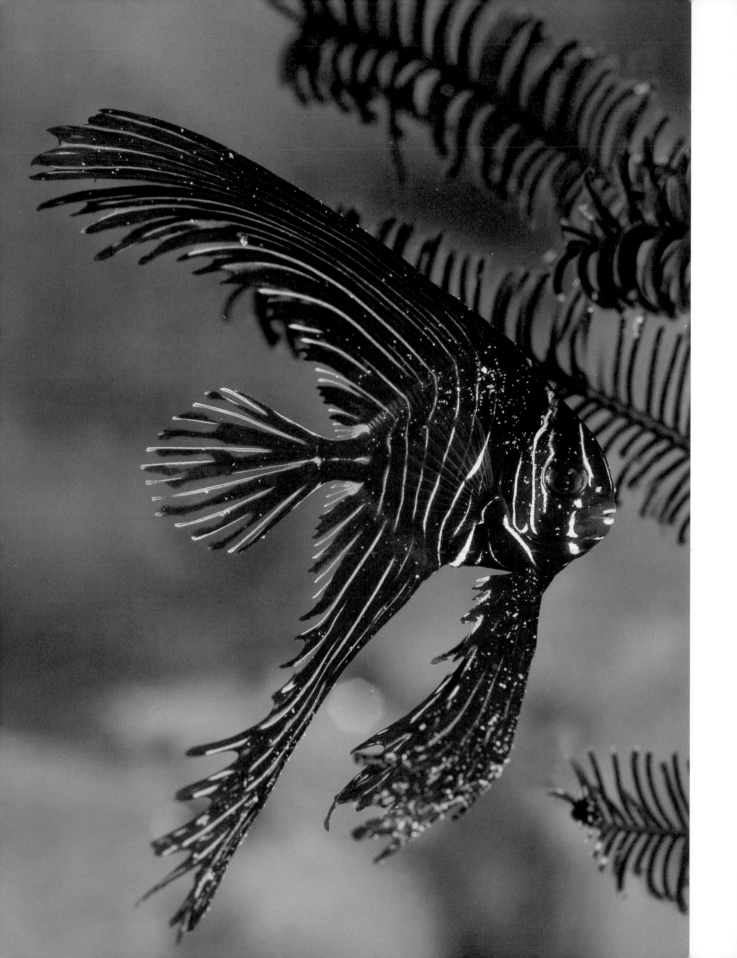

protect a shared social space where the queen and other colony members reside. Competition is fierce for living space in sponges, so it is believed that eusociality evolved in these shrimps to provide a competitive advantage over other species.

FEW AND FAR BETWEEN

The populations of specialist species tend to be smaller than those of generalists. This partly explains why there are so many new specialists still being discovered and why they remain so poorly known. In 2016, a stunning but exceedingly elusive small white goby, less than an inch in length, was named *Sueviota bryozophila*. It is unusual in that it lives exclusively inside colonies of a particular bryozoan species. Bryozoans may look like corals, but they are in fact an ancient branch of animals that split off from all others almost five hundred million years ago. This particular species of bryozoan is pure white, its ribbon-like structure punctuated by small lattice holes. Colonies of the bryozoans are small and could sit comfortably in a child's hand. To help it camouflage, the goby is pure ghostly white with a faint pinkish, blotched pattern that runs over the top of the head and body; this light coloring explains why it went undiscovered for so long. Between 1980 and 2014, 327 new gobies were named,[78] accounting for almost a quarter of new fish discoveries in the Coral Triangle region in this time. Most are less than an inch in size.

The bryozoan goby is currently known only from Indonesia, but given its lifestyle and small size, in addition to the rarity and habitat specificity of its host, it is more than likely found across a larger geographic area. I found a spot in the Philippines where there were many colonies of the particular bryozoan and began to hunt for this diminutive fish. I looked in colony after colony but found none. There were numerous other creatures instead: all undescribed. I saw the pincered arm of a crab hidden deep inside one colony; in another, I spotted a large snapping shrimp; in yet another, a top shell snail grazed on the colony. All these animals were the same white base color with pale pink patches or spots to aid their camouflage. As far as I know, none of these other creatures have yet been named. These bryozoan-loving animals were brought to my attention by my great critter-hunting buddies Ned and Anna, who had been on the trail of the goby for some time. Time will tell if the goby also lives outside Indonesia and what other animals may be found that inhabit this or other species of bryozoan.

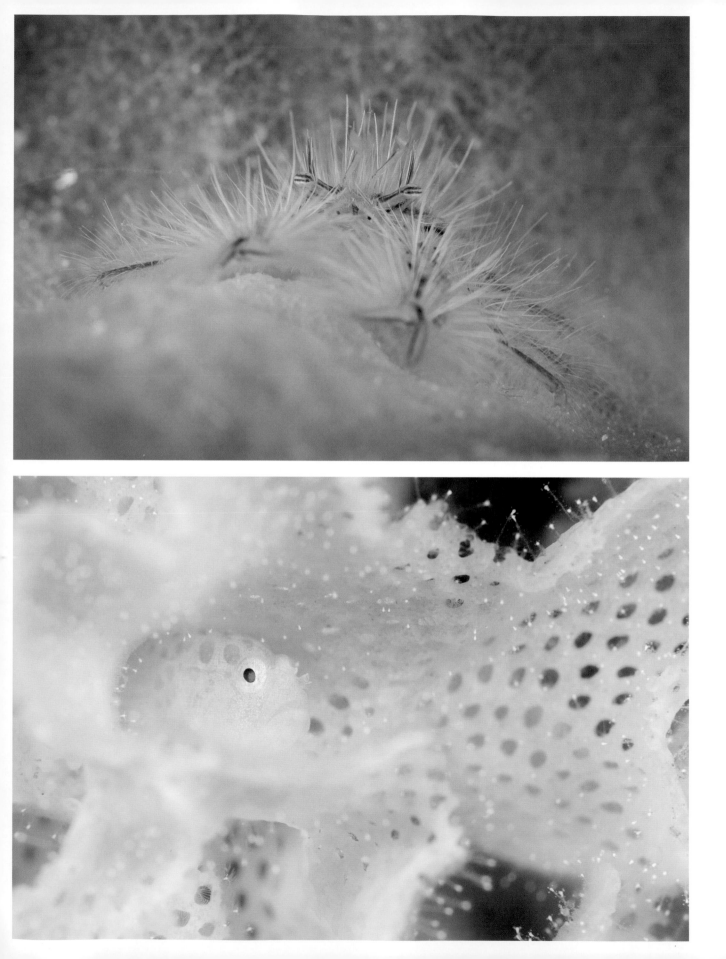

Given that we know how the populations of specialist species are generally much smaller than those of generalist species, it is even more difficult to locate specialist species when the host itself is rare. Leopard anemones are small anemones that live on the surfaces of gorgonians and black coral trees in the tropical Indo-Pacific. They are as large as the tip of the thumb to the first joint and are extremely variable in color, from golden to black and white striped. In 1999, a stunning, eye-catching shrimp was discovered in Japan living on these anemones. I spent the next ten years searching tirelessly for the elusive shrimp.

One day, while swimming along a gloomy wall in a remote northern bay of Raja Ampat in West Papua, searching for some of the peculiar fishes that I had previously found in the bay, I spotted a single leopard anemone growing on a whip coral ten feet below me. Since I was already at one hundred feet, I wasn't keen to go much deeper, but the anemone had piqued my interest. When I spotted a huge female shrimp with an abdomen full of eggs, I was immediately dumbstruck. The anemone had its tentacles withdrawn, making it much easier to spot her perched on top of it. Exactly like the leopard anemone, she was starkly monochromatic in color, patterned with a mosaic of pitch black and vivid white. I began to hunt for her partner, aware that habitat-specific species tend to live in male-female mated pairs. Lo and behold, the male sat hidden in plain sight. He was smaller and more slender, but his body displayed the exact same mosaic pattern. I was diving with some buddies who were surveying fish diversity, so they weren't impressed with my find, adhering to their "no spine, no time" motto. After I explained the rarity of the animals they were keen to return for a look; unfortunately, we had to sail off and leave the spectacular little shrimps to their own devices.

It is not only harmless commensal animals that live on other animals. Due to the danger of smothering and hindering normal feeding and reproductive processes, the reef's sessile invertebrates invariably deploy mechanisms that prevent fouling by other organisms. Some organisms have noxious chemicals on their surface that prevent other organisms from growing. Others occasionally slough their outer skins, like snakes, to rid themselves of any growths. As the victims of fouling create ever-more-elaborate methods of preventing foreign species from taking up residence, their commensal tenants stay one step ahead in this biological arms race. Each host species is likely to differ subtly in its protective mechanisms, which may not exclude just biofouling species (those species that accumulate on the surface of others) but also harmless commensal species.

OPPOSITE TOP: Hairy squat lobster on barrel sponge. Anilao, Luzon Island, Philippines.

OPPOSITE BOTTOM: Bryozoan goby, described in 2015. Ambon, Indonesia.

As seafarers will attest, if humans could harness the antifouling processes by which marine organisms prevent growth on their surfaces, we would save billions of dollars each year. The antifouling paints we use contain toxins that not only kill corals, but also prevent new larvae from settling. Ship strikes on coral reefs not only impart structural damage to the organisms, but the paint that the reef scrapes off the boats can settle and prevent the reef from recovering.[79]

More often than not, habitat specialists have extremely small individual home ranges, since they are so intrinsically linked with their hosts. During my pygmy seahorse research, I tracked the daily movements of one group and found one male that didn't ever stray farther than the area of two large iPhone screens. Even non-habitat specialists can be highly attached to a specific location on the reef. Three species of cardinalfishes in a study were found to remain within one to three feet of their initial settlement site for up to almost a year and a half. Researchers also found that the cardinalfish could find their way home within just a few days after being taken up to 1.2 miles away.[80] Perhaps the propensity of reef animals to inhabit such small areas is exactly the trait that has favored them to become habitat specialists.

Habitat specialization is both a gift and a curse. Specialists generally have little to fear from competitors, but risk extinction at a much higher rate than generalist species. Specialists are less equipped to deal with disturbances generally; the traits they have evolved that make them suit their homes so well make them less inclined to move to another. There is a direct relationship between a species' habitat or dietary specialization and the influence that environmental disturbances can have on their populations. The reliance on another species for existence, therefore, places them at even higher risk of extinction.[81]

As we have discovered, specialists are among the most fundamental contributors to diversity and species richness on coral reefs. We continue to discover new species, even in the better known groups, of which there are few. The severe lack of information we have about these specialists, of course, makes them exceedingly hard to conserve. Furthermore, these specialist species are just one group within the broader diversity of coral reef ecosystems.

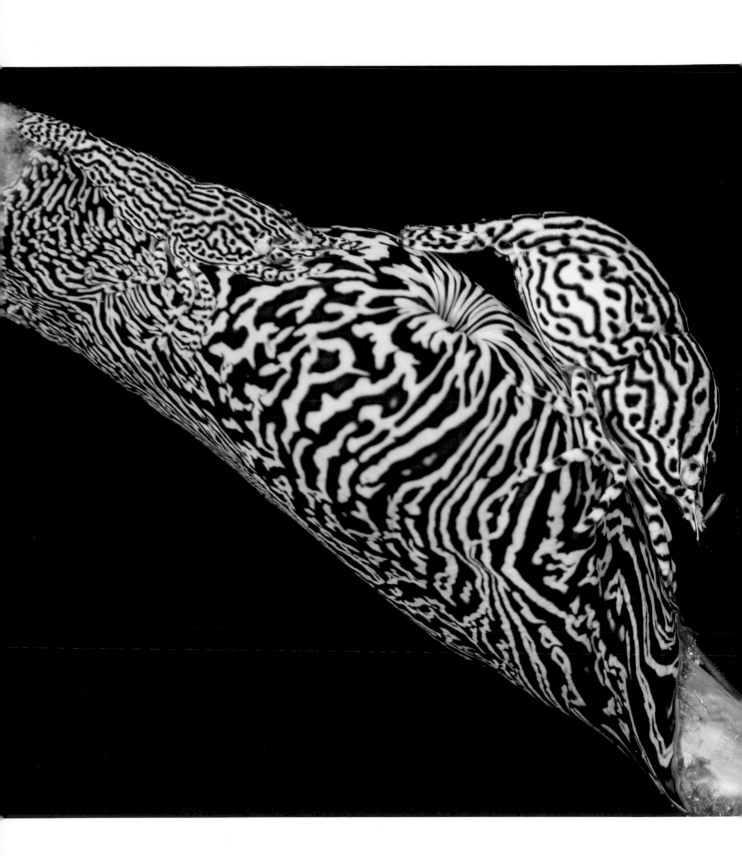

Things That Live on Things

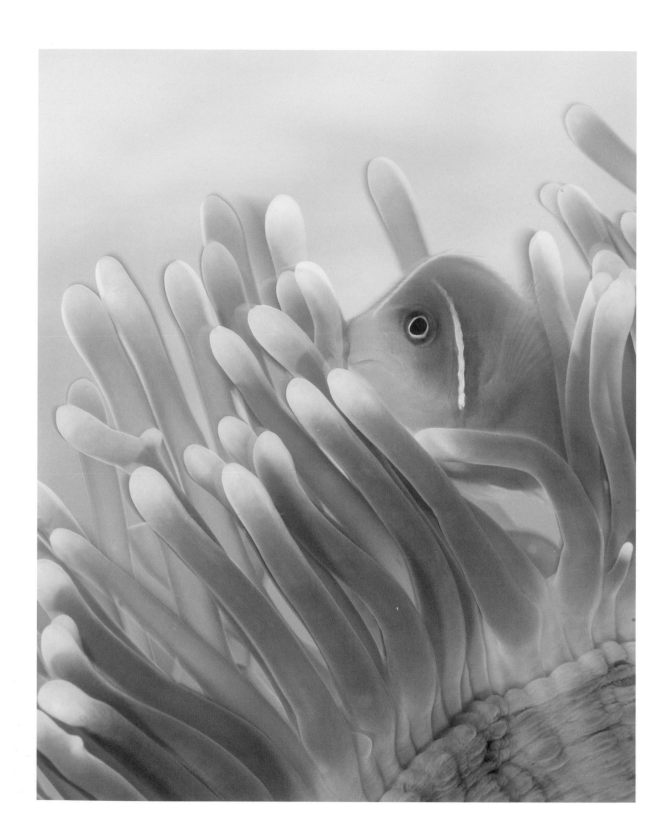

CHAPTER 6:

THE UNSEEMLY WORLD OF ANEMONEFISH

Never has a humble reef creature received such universal recognition as the anemonefish. Thanks to Disney Pixar's *Finding Nemo*, the clownfish and Nemo have become synonymous in children's minds. Nemo became the relatable and loveable icon of the coral reef, hitching a ride on the East Australian Current and forging unlikely alliances during his misadventures. He has certainly been the breakout star of the coral reef, but the reality of an anemonefish's life is very different from the animated artistic interpretation.

In the darkness of the early evening, when the reef's visual predators have turned in, and the month's currents pull at their strongest, a larval anemonefish hatches. It begins life at just three millimeters long, so small that seven of them could stretch nose to tail across a nickel. As soon as the tiny fish breaks free of its egg it can swim. It is transparent and has a large mouth and eyes, and a yolk sack fueling its early movements. The microscopic fish swims away from the rest of the clutch, beginning two to three weeks as a pelagic larva drifting in oceanic currents.

These weeks are important for any young fish and have been of intense interest to marine biologists in understanding their movements between hatching and settling. In finding out how a larval fish orients itself in the ocean and gets back to

the reef, we learn more about how our actions in the oceans are affecting them. It has long been believed that only a few of the fry end up on the reefs close to where they were born, the remainder carried far and wide by currents. Recent research suggests otherwise.

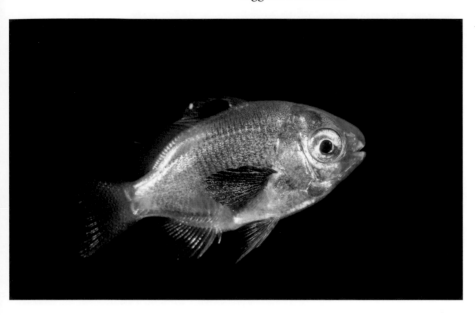

ABOVE: Undetermined larval fish. Hachijō-jima, Japan.

Tracking the movements of one of these microscopic fish in the open ocean for two weeks would be impossible, so scientists have developed ingenious methods to figure out how many return to their local neighborhood. Around the island of Mooréa in French Polynesia, researchers mapped all of the resident anemonefishes.[82] They took a tiny clip from each fish's fin for genetic analysis to create a genetic fingerprint of each individual. (This is a standard scientific method that avoids long-term harm to the animal while gaining fascinating insight into its heritage.) Using this method, the scientists established the genetics of the resident mated pairs of adults. When compared to newly settled fish, they could establish the genetic origin of the new arrivals and determine whether their parents were indeed local or from other reefs. They found that around a quarter to a third of anemonefish end up settling on the same reef as their parents. Despite spending the first two to three weeks of their life in the water column, they may end up just half a mile from where they were born.

Larval fishes are proficient swimmers, rather than simple passive particles subject to the whim of the currents as might be expected for their size. They have been recorded swimming at speeds faster than those of an Olympic swimmer. Experiments have shown that, during late larval stages, some reef fish can swim tens of miles without even eating. Others have been recorded swimming continuously at a constant speed of one kilometer per hour for several days.[83] Local current systems do, however, play a role in retaining larvae around the reef on which they're born. Larval fish to some degree are at the whim of the ocean, but we now know that they make choices in where they end up settling.

The World Beneath

When the time comes and the larva is ready to return to the reef after its infancy in the water column, the fish knows exactly the breadcrumbs it must follow to find its new home. It might seem like a needle in a haystack to us, but reaching the correct microhabitat on the reef is a matter of instinct for a larval fish: anemonefishes cannot survive on a reef without a healthy anemone, so it is vital that they find one. Such a vital part of the life cycle can't be left to chance, and although we don't understand every nuance of the process yet, the continued survival of these species shows that nature has found a way.

By applying Darwin's theory of natural selection, survival of the fittest, we can quickly envisage that those fry that find the perfect microhabitat on the reef will go on to lead successful, healthy lives and produce many young that will inherit their genes. If they were to settle in the wrong microhabitat they would promptly get eaten by predators. This selective pressure will mean that the young with the best ability to find their favored microhabitat will soon dominate in the population. Studies have now shown that the fish hones in on a reef by using a precise combination of visual, acoustic, and chemical cues.[84] As the fish swims toward the reef, a dark shadow appears in the distance. Once the fish is closer, the reef slowly becomes visible; ultimately an anemone comes into focus and the acclimation process begins.

Once an anemonefish reaches a suitable anemone, it must negotiate the delicate process by which it is able to take up residence among the stinging tentacles. An anemone's tentacles help to protect it against would-be predators: each tentacle is covered in stinging cells, known as nematocysts, which fire a poison dart upon impact. Obviously, this is a potential hurdle for an animal that wants to take up residence and has never before come into contact with an anemone. Research has shown that the fish actually produces protective mucus specific to the anemone that prevents nematocysts from firing, thereby rendering the fish immune to the dangers of the anemone. In some cases, there appears to be an acclimation period, during which the fish darts in and out of the tentacles and begins production of the tailored mucus. In other instances, the fish appear innately able to prevent the nematocysts from firing and can immediately move in.[85] This depends largely on the species of anemonefishes and whether it commonly lives with the anemone species in question. Once it has naturalized, the fish will remain with that anemone for the rest of its life, the two organisms' fates inextricably linked.

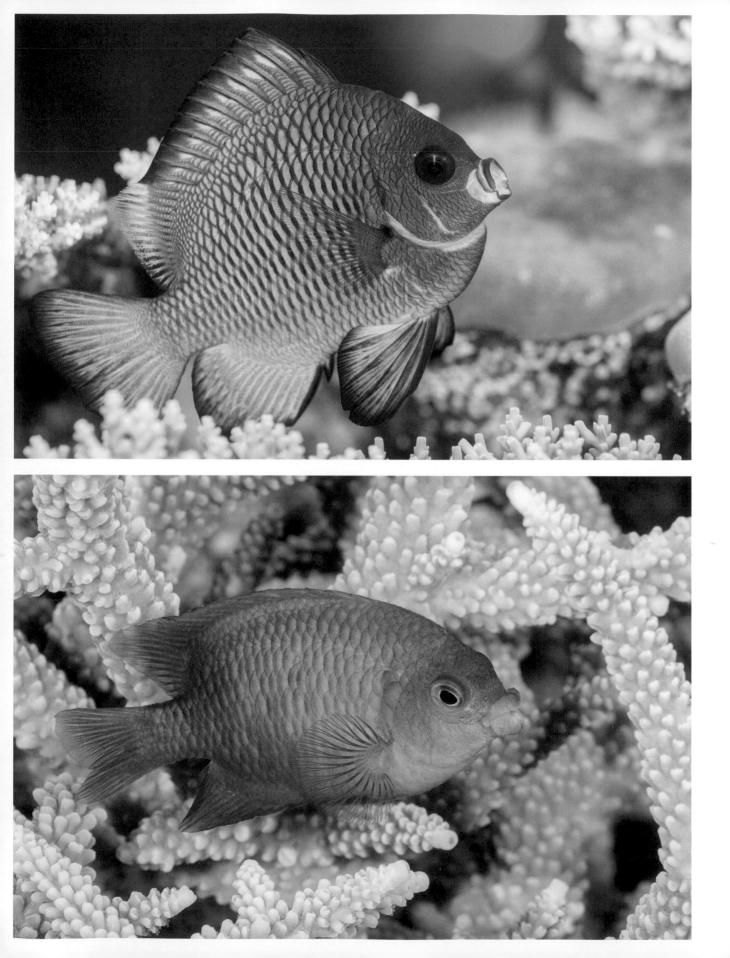

THE DAMSEL

There are more than 380 species of damselfishes, and the anemonefishes are just one highly adapted group of these. The fossil record shows that damsels have been a feature of coral reefs for at least fifty million years.[86] Although each looks slightly different, often with a spot here or there on one of the fins, they tend to be rather drab brown, gray, or mustard in color. They are one of the most species-rich groups on coral reefs but are often overlooked by divers, in favor of the more colorful species. In fact, after the gobies and wrasses (a common and brightly colored family of reef fish), they are the most species-rich of all coral reef fish groups.

OPPOSITE TOP: Fiji variation of three-spot dascyllus. Fiji.

OPPOSITE BOTTOM: Big-lipped damselfish. Raja Ampat, West Papua, Indonesia.

A particularly fascinating damsel species that I had been hunting for the longest time is the big-lipped damselfish. On a large coral-covered plateau in remote West Papua, I finally had the chance to spend some time observing their behaviors, after having had just a fleeting glimpse a few months previously. I had to steal a second look as it dashed in and out of the branching corals, since these are not the easiest fish to identify. Like most reef creatures, they inhabit a very specific niche and as soon as I figured out exactly what it was, I was able to find them quite easily. The big-lipped feeds on certain branching corals in somewhat sheltered areas of the Coral Triangle. It needs stands of healthy shallow hard branching corals to meet its nutritional demands, but where these are present, the damsel is common and great fun to watch. I must admit to overlooking these fish myself, as adults are brown to black and without any gaudy patterns or adornments to catch the eye. However, look a bit closer and what becomes apparent is a pair of enormous juicy lips that might even make Angelina Jolie envious. These act to protect the fish from the coral's sharp and solid skeleton that would otherwise damage the tissue around the teeth.

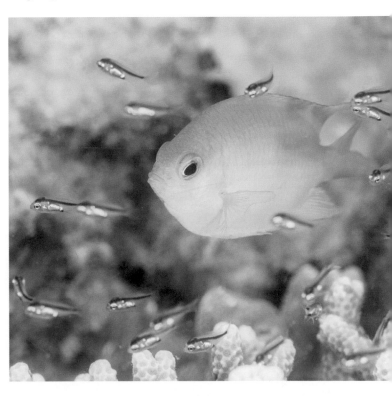

ABOVE: Guardian damselfish with brood of young, described in 1999. Coron Island, Philippines.

Damsels are demersal spawners, which means that they lay their eggs on the sea bottom or attached to hard substrate. In many species the eggs are then guarded, but the degree of care after hatching varies considerably. One genus of damsels, *Altrichthys*, has a particularly fascinating reproductive strategy. I travelled to the

tiny Calamianes group of islands in the central Philippines in order to observe their unique behaviors for myself. Unlike almost all other damsels, which have little to do with their offspring once they hatch, the three species of *Altrichthys* care for their young until they reach almost adult size. I watched groups of guardian damselfish, as they're known, protecting their small cloud of young. Both parents remain close and feed on plankton near their brood, but if would-be predators approach too closely, they aggressively chase them off.

The lack of a pelagic larval phase for these damsels has had an important impact on their biology. In comparison, juvenile anemonefishes are carried away in currents without any form of post-hatching parental care; whereas juvenile *Altrichthys* are too large at the weaning stage to float off in ocean currents without being immediately noticed and eaten by predators. As such, they end up settling in close proximity to where they were born. Deep water and unsuitable habitats act as barriers to the spread of the species, and as a result the Calamian Islands have evolved three distinct species that inhabit different stretches of the islands' coastlines. The third species was added in 2017, having just been discovered in the islands' rarely visited northern reaches. This trio of species, the only members of their genus, are all found in an area half the size of Rhode Island.

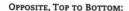

OPPOSITE, TOP TO BOTTOM:

Red and black anemonefish. Solomon Islands.

Spine-cheek anemonefish. Raja Ampat, West Papua, Indonesia.

False clown anemonefish. Raja Ampat, West Papua, Indonesia.

BELOW: Barber's anemonefish, described in 2008. Fiji.

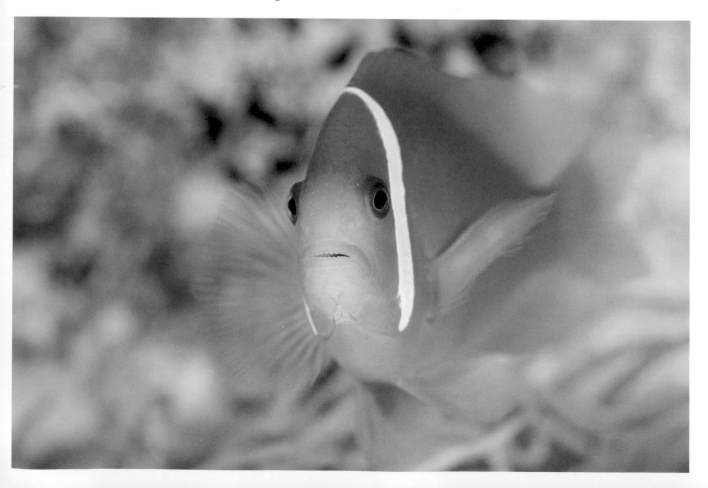

THE ANEMONEFISH AND ITS HOME

I have spent many dives on reefs of the tropical Indo-Pacific watching the antics of anemonefishes. From the Red Sea in the west, where just one indigenous species is found, to Fiji in the east, where one of the newest members of the group was identified in 2010, their dalliances among the anemones' tentacles are mesmerizing. They are willing to chase off animals much larger than themselves (including divers) and they even have individual personalities. It's not hard to see why they were chosen as Pixar's animated protagonist.

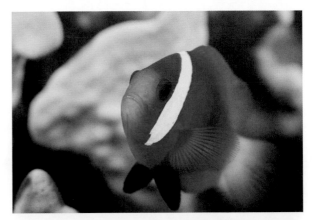

Anemonefishes are arguably the most colorful and intriguing of the damselfishes. Nemo brought the clownfish to prominence, but this is just one of many anemonefish species. It is so named for its bright colors that look like a clown's painted face. Anemonefishes tend to have patterns in shades of orange, yellow, gray, and black, with most having either whitish vertical bands along the body or a dorsal stripe. Thirty species of anemonefishes are found throughout the tropical Indo-Pacific, but none are found in the Atlantic Ocean or the Caribbean or Mediterranean Seas.

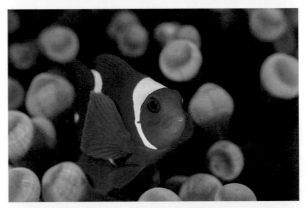

All anemonefishes are obligatorily associated with anemones in the wild, which means that under ordinary circumstances these fishes do not choose to live alone. As such, their numbers and distribution are linked directly with those of their hosts. Host specificity varies widely among anemonefishes, with some restricted to living with just one species of anemone, and the more cosmopolitan anemonefishes able to live with all ten species. Two widespread anemone species boast up to thirteen different anemonefishes able to inhabit them. Typically, just one anemonefish species will inhabit any given anemone at a time, but occasionally two types of anemonefishes will cohabitate. Researchers have found that moderately poisonous anemones accommodate the majority of

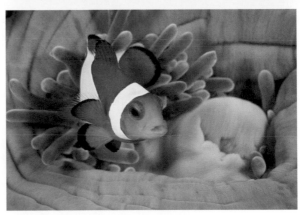

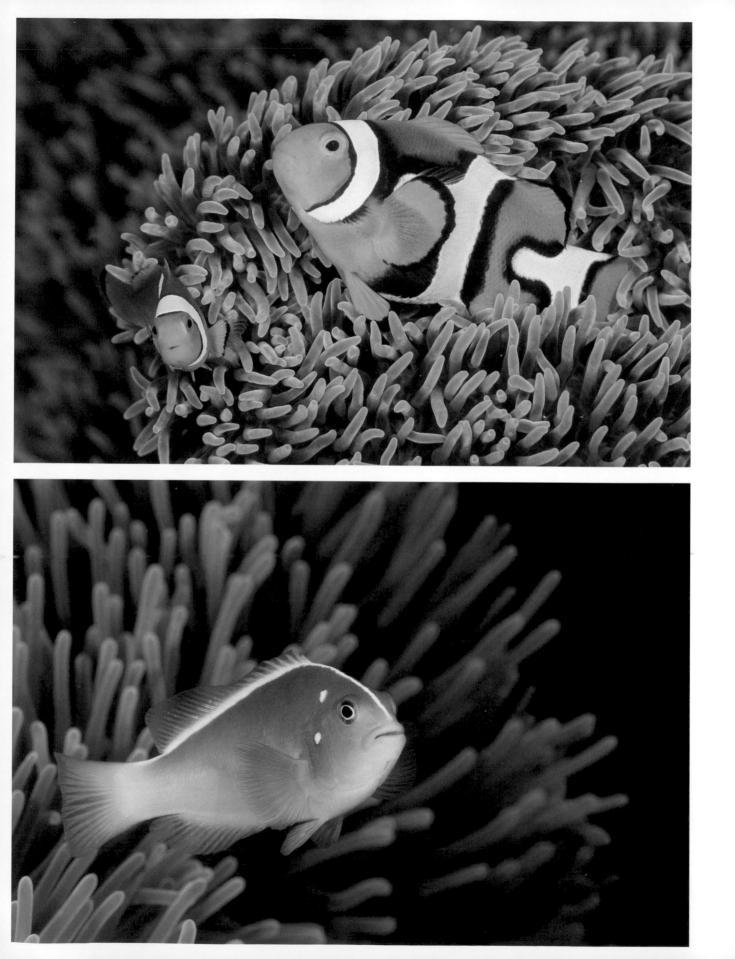

anemonefishes,[87] in addition to other damselfishes and crustaceans that will also opportunistically make them their home. The most and least toxic anemones are generally eschewed by anemonefishes, presumably due to the difficulty of protecting themselves against their toxic stings or the lack of security they confer, respectively.

There is nothing more relaxing than puttering along a shallow reef, absentmindedly watching the fish go about their business. One day on a shallow sandy patch in Bali, Indonesia, I was diving just like this and looking for occasional cryptic critters. I happened upon a large disc-shaped anemone sitting in the open sand with an upturned coconut shell next to it. The shell was covered in a coat of bright orange, and when I went in for a closer look, I swiftly felt a blow to my mask. I looked around but couldn't see anything. Suddenly, I felt another blow and this time, the tangerine orange tail of an anemonefish caught my eye just as it swam away from my face and then turned to look back, ready to attack again. Knowing that the bright orange coating on the coconut shell was a clutch of newly deposited eggs, I backed away in a show of good faith. This wasn't good enough for the new mother; again, the tiny fish subjected me to a barrage of physical assaults.

As I swam off, I could still feel the assault on different parts of my body until I realized that I had actually swum about thirty feet from the anemone. I turned around, and at that exact moment, the anemonefish appeared to realize her mistake. Sheepishly, she sank down onto the sand to seek shelter, afraid. She was so intent on protecting her eggs and anemone host that she had strayed much farther from home than she had intended, probably farther than she had in her entire adult life. I led her back toward the anemone, and once it came into sight, she quickly swam back to nestle in the safety of its tentacles and greet her housemates.

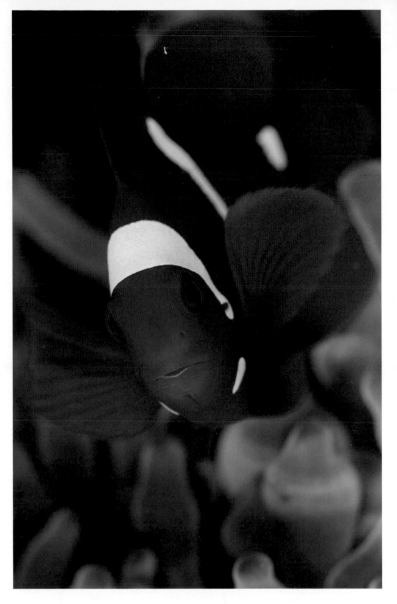

ABOVE: Spine-cheek anemonefish. Raja Ampat, West Papua, Indonesia.

OPPOSITE TOP: True clown anemonefish. Cenderawasih Bay, West Papua, Indonesia.

OPPOSITE BOTTOM: Aberrant skunk anemonefish. Bali, Indonesia.

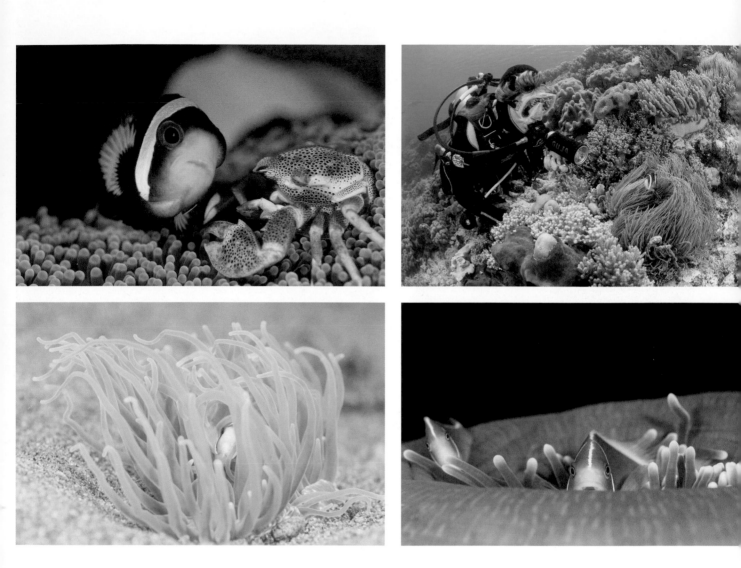

ABOVE TOP, LEFT TO RIGHT:

Anemonefish and spotted porcelain crab. Raja Ampat, West Papua, Indonesia.

Clark's anemonefish and diver. Wakatobi, Sulawesi, Indonesia.

ABOVE BOTTOM, LEFT TO RIGHT:

Anemonefish staking her claim to a small anemone. Sangeang Island, Indonesia.

Pink anemonefish in a balled-up anemone. Raja Ampat, West Papua, Indonesia.

The symbiotic bond shared by the anemonefish and its host anemone is one of the best studied on the coral reef. Early researchers believed that the fish's primary benefit to the anemone was through their waste products that acted as fertilizer for the growth of the anemone. Their waste has been shown to increase growth rates and encourage more frequent asexual reproduction.[88] By feeding on passing plankton, the fish can harness this untapped resource and pass it down to their host. But while this is true, the role that anemonefish carry out that is now believed most beneficial to the anemone is protecting it from specialist predatory reef fishes, such as butterflyfish, that would happily eat the tentacles. My own experience with the anemonefish in Bali illustrates how pugnacious these little fish can be. I have

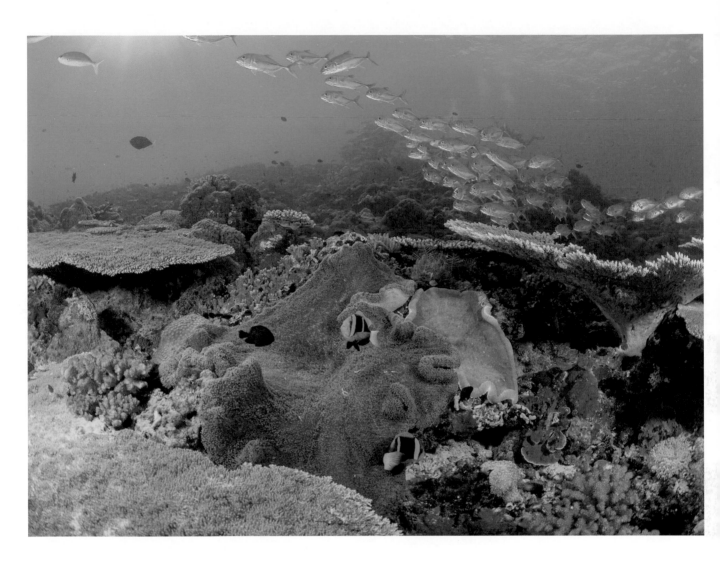

ABOVE: Orangefin anemonefish and bigeye trevally. Solomon Islands.

seen them draw blood from unsuspecting divers. Thankfully, they clock in at just one and a half to four and a half inches long, otherwise diving near them could pose a real danger. Conversely, the anemone's stinging tentacles help to protect the fish from its own predators; they are put off by the potentially lethal weaponry. Without this protection, predators would quickly pick them off.

Like all mutualistic symbioses, the arrangement between anemones and anemonefishes is of significant benefit to both parties. The relationship enhances the growth and survival of inhabited anemones beyond those that live without resident fish. The anemonefish also lives a relatively stress-free life, benefitting from protection from a majority of predators and reduced competition with

The Unseemly World of Anemonefish

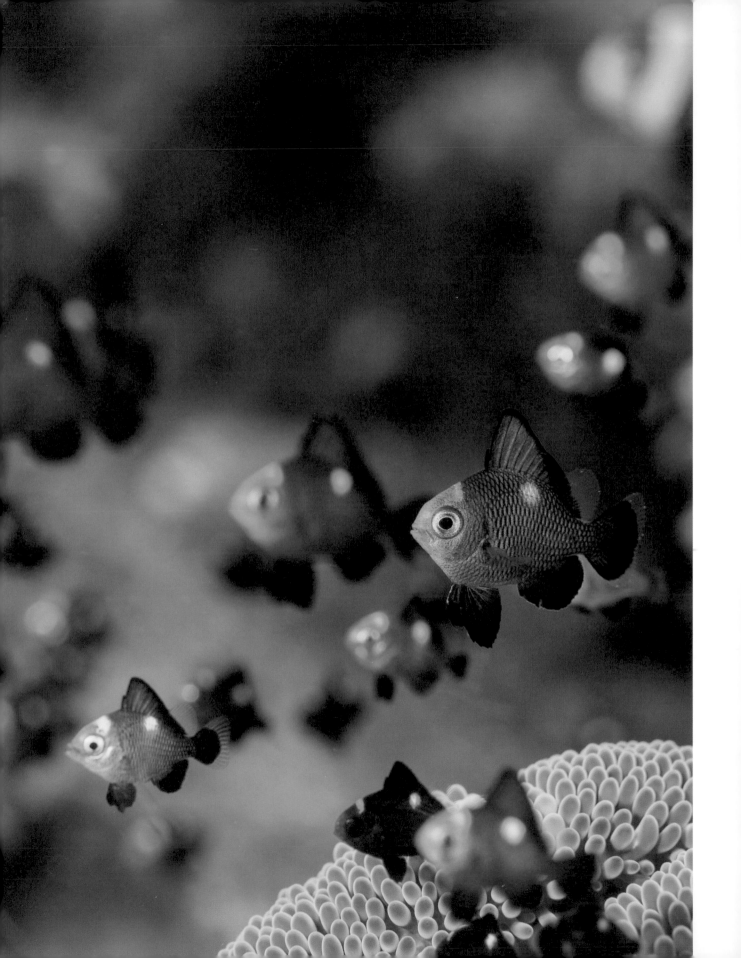

other species. For their size, anemonefish have the longest known lifespan of all damselfishes; their natural death rate is low. While other damsels of a similar size live for five to ten years on average, clownfish can live up to thirty-five years (although, the higher end of some estimates suggest they could live up to ninety years).[89]

While this symbiosis is fundamental for both anemone and anemonefish, there is a third symbiont that is the final link in the chain. To maximize energy cycling, exactly like reef-building hard corals, the anemone's cells contain microscopic algae, zooxanthellae of the genus *Symbiodinium*. As in corals, the zooxanthellae use the sun's light to photosynthesize and produce energy that is used by the coral. In return, the coral provides the alga with its own waste products, which act as a fertilizer to fuel the alga's growth. Together, the anemone, zooxanthellae, and fish forge an exceedingly close relationship that benefits all.

SOCIAL HIERARCHY

Anemonefish live in small discrete groups that rarely stray more than a few feet away from their hosts. Living in permanent groups such as this can be socially uncomfortable and begs the question as to how their society is organized. In fact, the social structure of these groups is one of the most well studied and fascinating aspects of anemonefish biology.

While diving on the reefs of Southeast Asia, I have come across anemones as small as an Oreo cookie with a single teeny tiny anemonefish inhabiting them. Other times, groups of up to six anemonefish inhabit a single large anemone with a diameter of a foot and a half. Once settled, anemonefish usually live in isolated groups that do not subsequently interact with other such groups. The opportunity to join an anemone happens only at the end of the pelagic larval phase, so this is an extremely crucial time in the fish's life.

Established social groups consist of a monogamous breeding pair and up to four nonbreeding subordinates. The breeding pair is comprised of a large female and a smaller male. The nonbreeders are a group of progressively smaller individuals. Their sizes are determined by the order in which they arrived at the anemone. Nonbreeders do not assist the breeding process in any way, nor do they hinder the reproductive potential of the breeding pair. It is this that permits the breeders to tolerate their presence, but only up to a certain point.

OPPOSITE: Juvenile three-spot dascyllus seek protection around an anemone. Raja Ampat, West Papua, Indonesia.

Things suddenly change when the female dies. Her death carries profound consequences for the whole group and catalyzes a chain of events most certainly omitted from the animated version of anemonefish lives. Almost immediately, the reproductive male, the next largest in the group, begins an irreversible process of changing sex to become female. The largest of the nonbreeding individuals also starts to change: its sperm-producing cells activate, promoting the fish to the role of the group's reproductively active male. The social group dynamics of anemonefish have been described as a queue system.[90] The fish passively move on up the social ranks, simply by outliving their older and more dominant group mates. At this point there is a vacancy at the bottom of the chain and a new pelagic larval recruit will often be admitted to the group. Prior to this, resident fish regulate the admittance of new members, which puts a cap on the numbers of individuals in the group. The total number of anemonefish is largely determined by the size of the anemone. Unsurprisingly, larval fish would rather join a smaller group, as this means that they are joining a shorter queue and will most likely be able to reproduce sooner. However, on tropical reefs, all anemones tend to be inhabited, so there is rarely an opportunity to be choosy.

As it happens, sex change is rather common on coral reefs. Many fishes have separate sexes, which is known as "gonochorism," while other species can be both sexes at the same, producing sperm and eggs simultaneously. They are known as "hermaphrodites." Others change sex during their lifetimes, a process known as "sequential hermaphroditism." The most widespread form of sequential hermaphroditism on coral reefs appears to be protogyny, in which a fish starts out life as a female and becomes male later in life. Wrasses, parrotfishes, and even some damselfishes display this kind of change. The male-to-female change observed in anemonefish is known as "protandry."

ABOVE: Saddleback anemonefish tending to its eggs. Anilao, Luzon Island, Philippines.

OPPOSITE TOP: Lord Howe Island's McCulloch's anemonefish. Lord Howe Island, New South Wales, Australia.

OPPOSITE BOTTOM: McCulloch's anemonefish tending to mature eggs. Lord Howe Island, New South Wales, Australia.

The World Beneath

In anemonefishes, the female tyrannically controls sex change in her subordinates through aggression. The reigning female has the highest levels of stress hormones, with levels decreasing down the chain according to rank. High levels of these hormones transform male hormones into female hormones and kick-start the body's morphological changes. After the female's death, the male immediately becomes more aggressive and dominant, changing the hormone levels within his body and initiating the cascade of change; it takes around six weeks for the male to transition to becoming a sexually active female and develop functional ovaries.

The matriarch's aggression also suppresses the growth of other members of the group, resulting in the development of well-defined size boundaries between individuals adjacent in rank. The female is generally 1.6 times larger than the male, and is the largest individual in the group. Her size guarantees that she will be able to produce a generous clutch of eggs. After the female dies, each individual ascends one rank and grows a defined amount to fill the next stage in the queue.[91] On average, there is usually a one centimeter difference between the size of the reproductive male and the largest nonbreeder, so after the largest nonbreeder transitions to becoming sexually active, the next nonbreeder in the queue grows too.

Social rank is very important in anemonefish society. Researchers have found that an individual's social rank has the greatest influence on the likelihood of death.[92] The well-defined size discrepancy between ranks helps to reduce conflict and competition between individuals. Should there be social unrest, the more dominant individual may kill or evict the usurper from the anemone, which leads to almost certain death. Such conflict is generally avoided when the size differences between ranks are maintained.

MAKING BABIES

Once a stable hierarchy has been established in a group of anemonefish, it isn't long before they start to get busy. Pair bonding is more drawn out for newly formed pairs (in which the male has just transitioned) than for veteran pairs. The male initiates courtship through displays and jaw clicking. He then begins nipping at the substrate where the eggs will be deposited, as well as at the tentacles that are adjacent to this area, causing them to shrink away. The male will often suffer tissue damage to the lips and face from clearing the area where the pair decides to nest. Female aggression can be high at this time and can cause stress to the male. Much

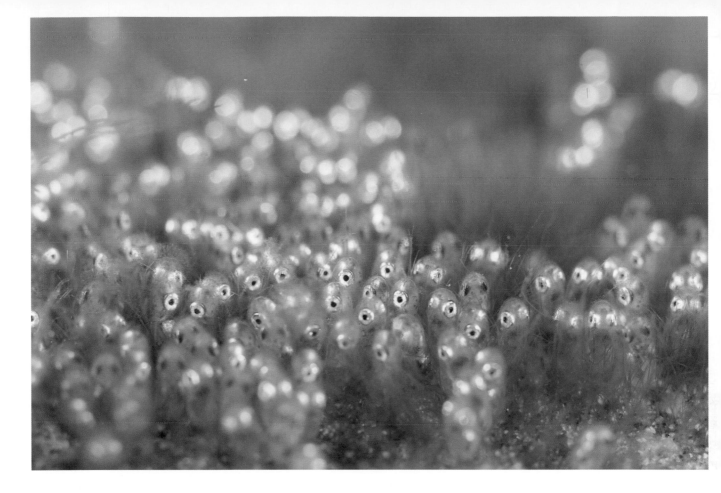

ABOVE: Anemonefish eggs about to hatch, with fry's eyes visible inside. Raja Ampat, West Papua, Indonesia.

like a stressed person bites their nails, males bite at the substrate in an effort to release these frustrations.

Anemonefish need a hard surface onto which they can lay their eggs, and sometimes their host anemone lives on the soft expanse of a sandy patch. In this case, the fish must deposit their clutch on a nearby shell, coconut, or piece of wood which they may have to physically move closer. Under very rare circumstances an anemone can change location by detaching its foot and being carried away by currents, but it seems that this is unlikely to happen frequently enough to benefit a group of anemonefish in need of a nesting surface.

Egg laying can happen at any time of day for some species of anemonefishes, while others are limited to the two or three hours after sunset.[93] When newly laid, anemonefish eggs are bright orange in color, but they darken as they develop until soon before hatching it is possible to see the eyes of the fry inside the eggs. The whole egg-laying process takes around ninety minutes, and the subsequent care is largely carried out by the male. This division of labor allows the female to spend precious time replenishing her resources, so she's ready for the next clutch. The

egg-sitting male is very attentive, fanning the eggs with his pectoral fins and closely checking the clutch for dead eggs (which he eats) and checking for disease or fungus that could spread and spoil healthy eggs. Fanning helps to oxygenate the eggs and the egg-sitting male amps up this activity in the moments before hatching. At this time, the fry are at their most active in the eggs; their movements in combination with the development of their large silver eyes catch the attention of their parents.

The incubation period is determined by water temperature, and although tropical anemonefishes can breed year-round, those in cooler waters tend to lay eggs only during the six or so months of warmer water. Hatching is timed to coincide with the full and new moons when the spring tides bring the highest high tides and the lowest low tides. The resultant tidal changes cause the strongest currents of the month and therefore the most effective dispersal of fry from the nest. Most tropical anemonefish species lay two clutches per month, and an experienced pair can produce 7,000 to 18,500 eggs per year depending on the species. Although this sounds like a lot, it is likely that, assuming a stable population, just a couple will reach adulthood and replace their parents.

FRAGILE RELATIONS

While diving on healthy remote coral reefs, you would be forgiven for thinking that anemonefish populations are very stable and don't face significant threats. There are thirty species of anemonefishes currently named, but only sixteen have been evaluated for the International Union for the Conservation of Nature (IUCN) Red List of Threatened Species. The Red List is the global standard in evaluating the conservation status of a species. The sixteen anemonefishes that have been evaluated are all listed as "Least Concern," but, worryingly, some of the most potentially at-risk species are yet to be evaluated.

Isolated in the subtropical Pacific, five hundred miles northeast of Sydney, lies the tiny island of Lord Howe. It is a quarter the size of Manhattan and was formed by a massive volcanic eruption seven million years ago. Ancient and remote, Lord Howe Island hosts various endemic organisms found nowhere else on earth. Among these are 113 plant species and almost one thousand insects, including a critically endangered four-inch-long black stick insect that was thought extinct for almost a century but rediscovered on a small satellite islet in 2001. The reefs around the island host sixteen endemic fishes including Coleman's pygmy

seahorse, three-striped and Lord Howe Island butterflyfish, double-header wrasse, plus half-banded and Ballina angelfish. There is also an indigenous anemonefish.

With arguably the smallest geographic range of any anemonefish, McCulloch's anemonefish calls Lord Howe, and a few other isolated oceanic Australian islands, home. The fish was scientifically described in 1929, and despite its potential conservation concern, its risk of extinction has yet to be evaluated. While most other anemonefishes are much more widespread, they are all habitat specialists and rely on healthy anemones for their continued survival. McCulloch's lives with only one anemone host, which, along with its limited geographic range and small local population, puts it at an elevated risk of extinction.[94] Anemonefishes have received some of the most extensive and focused research for a coral reef fish, yet there is still much to learn.

The popularity of anemonefishes is widespread, but as is often the case with celebrities, extreme popularity can lead to downfall. Even before Nemo became a global phenomenon, clownfish were the most popular ornamental marine fish of the 1,471 species that were traded globally between 1997 and 2002.[95] The Philippines, Indonesia, and the Solomon Islands sourced 80 percent of traded wild-caught marine fish during that period, resulting in the export of a total of 145,000 wild-caught clownfishes. Although anemonefishes are one of the relatively few commercially captive-bred fish in the trade, the demand is high enough that many have still been taken from the wild. Pressures on wild populations are so severe that they have become locally extinct on some reefs. Anemones and anemonefishes comprised almost 60 percent of the trade's catch in one region of the Philippines during the four-month period from January to April 2002 alone, when seventeen hundred anemonefishes were caught.[96] Clearly this degree of fishing pressure on such long-lived, socially complex fish has the potential to severely deplete their populations.

WHITE OUT

Symbiosis is the key innovation that has fostered the evolution of the extraordinary biodiversity on coral reefs. Sadly, however, this relationship has the potential to catastrophically break down and bring the ecosystem to a halt. We have experienced three devastating global mass bleaching events in the years since 1998.[97] These not only affect corals, but other coral reef invertebrates such as giant clams, sponges, soft

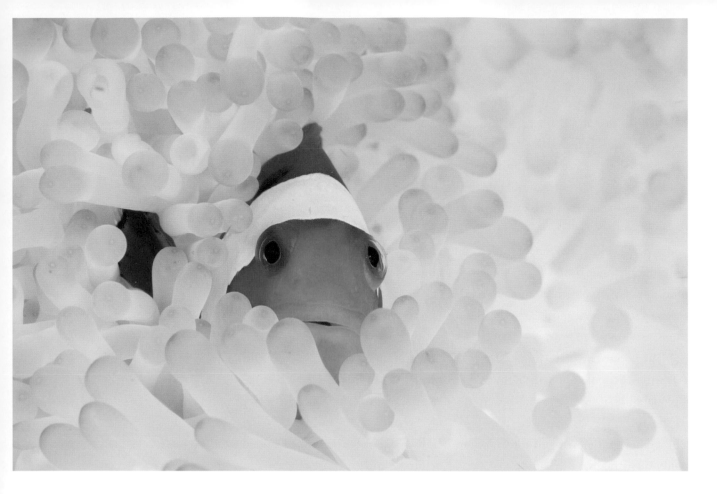

ABOVE: False clown anemonefish in bleached anemone. Raja Ampat, West Papua, Indonesia.

corals, and anemones too. A variety of localized influences can trigger bleaching, but widespread bleaching events can be linked directly to elevated sea temperatures.

Bleaching involves the breakdown of the symbiosis between single-celled algae and their invertebrate host. The algae are expelled from their host's cells, and without the pigments the algae harbor, the host turns a ghostly white. Bleaching has been recorded in all ten of the anemones that anemonefisheses inhabit and across the geographic range of their cohabitation.[98] There is a huge amount of variation in the geographic patterns of bleaching, patterns that are not yet fully understood. The species of anemone, depth, and geographic location all seem to influence the risk of an anemone bleaching. Breakdown of the symbiosis has implications for the health of the anemone, as the intracellular algae provide certain chemicals that are used in an array of metabolic processes. Bleaching doesn't always result in the death of the anemone, but in extreme or extended cases of sea temperature increase, death is certainly a risk. If the temperature change is less severe, the host may bleach and remain alive, reacquiring a healthy algal population at a later stage.

Anemones may naturally live for more than one hundred years and have very

The World Beneath

few natural predators, which makes them exceedingly vulnerable to increases in the frequency and severity of bleaching events. In a French Polynesian study, half of the anemones in the study area bleached due to elevated sea temperatures.[99] In southern Japan, 17 percent of one anemone species died shortly after bleaching. This figure reached 25 percent for another species of anemone, which hadn't had a single natural mortality in the preceding six years. A study in Papua New Guinea found that 35 percent of recorded anemones were bleached.[100] Few died as a result of the bleaching, but those that were bleached were reduced in size by a third.

Just as the symbiosis between the anemone and its intracellular algae breaks down during bleaching, the symbiosis between the anemone and anemonefish also suffers. Half of the cinnamon anemonefish population perished in an area of the Great Barrier Reef that was devastated by a bleaching event during parts of 2016 and 2017.[101] Generally, anemonefish mortality isn't this high; however, bleaching certainly affects the fish's overall health. Researchers have recorded greatly reduced egg production, ranging from one-third to almost 75 percent fewer eggs from those anemonefish living in bleached hosts.[102] They have also been found to be much more stressed when inhabiting bleached anemones, which may account for their poor fertility. They seem to sacrifice their reproductive potential for survival. Even after normal temperatures have returned, it takes the fish three to four months to recover their normal productivity.

Stressed anemonefish will take desperate measures to survive. Singapore's dramatically elevated water temperatures in 2016 caused a tomato anemonefish despite having only been recorded with a single species of anemone before, to suddenly begin cohabiting with a false clownfish in a different anemone species altogether.[103] In 1998, a mass bleaching event in Japan wiped out so many anemones that several years later, a desperate Clark's anemonefish lived alone in a soft coral for at least the twenty months of a study.[104] Larval anemonefishes actively avoid settling on an anemone that has bleached, so the long-term effects on the demographics of anemonefishes could be profound.[105]

With bleaching events forecast to become more frequent in the coming years and decades due to climate change, populations of anemones and anemonefishes are likely to decline significantly if they cannot acclimate or adapt to rising sea temperatures in some way. Around the world, fifty-one species of fishes have part of their life cycle linked to an anemone, so the impacts of bleaching aren't limited to anemonefishes alone.

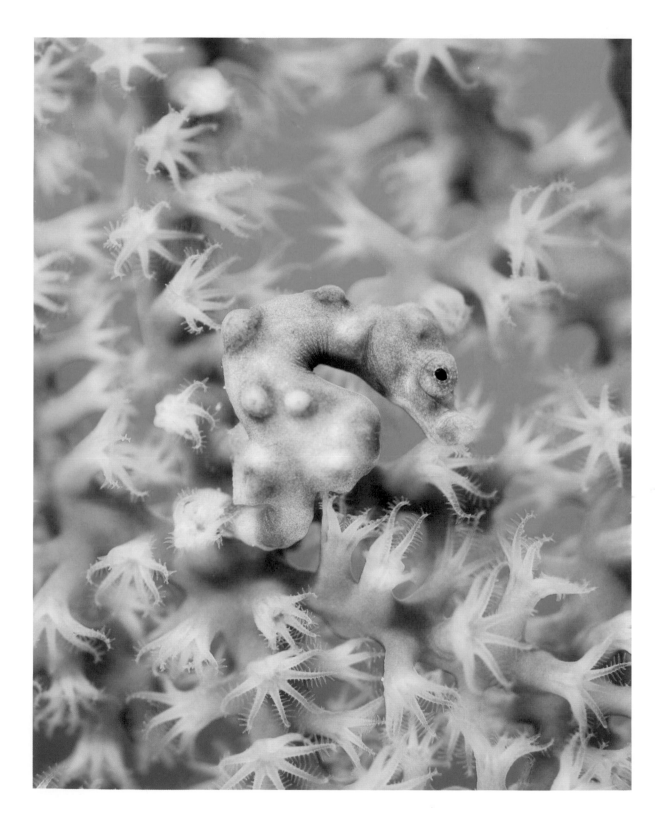

Chapter 7:

Pygmy Seahorses: Tales from the Stables

As the first blue hues crept into the otherwise lightless black sky, I carefully continued down the slippery ladder. Donning full scuba gear and tank—with a clipboard, fins, and underwater camera somehow all wedged, clipped, or balanced around my body—I sank into the inky, inscrutable water. Earthly burden lifted, I joined the weightless and serene world of the coral reef at dawn.

Swimming across the shallow reef flats of the tropical Indonesian lagoon, the atmosphere felt both eerie and tranquil in equal measure. As I passed the jetty, I steeled myself for the mutual startling that the resident sleeping turtle and I shared each morning. Jolted out of his repose, he barreled past at great speed and disappeared into open water. Nearby, a parrotfish remained deep in slumber inside its protective mucus cocoon, while some of the early-to-rise reef top fishes began their morning ablutions.

Crossing the reef crest, with the sun rising behind me, I dropped down the coral wall, still in blackness save for a school of bioluminescent flashlight fish, whose symbiotic bacteria emitted an incongruous glow from specialized sacs

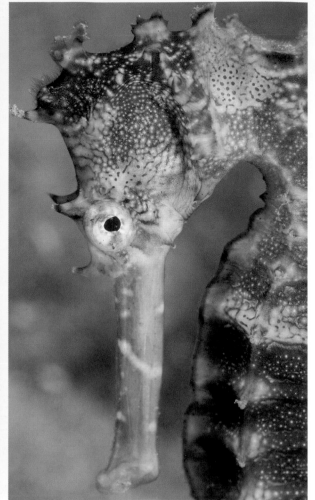

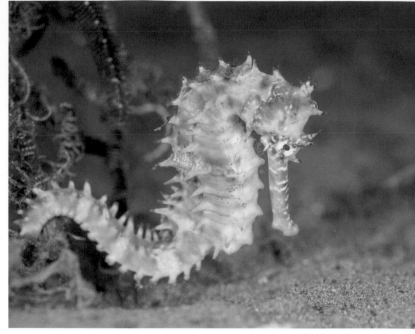

ABOVE LEFT: Thorny seahorse. Ambon, Indonesia.

ABOVE RIGHT: Thorny seahorse. Dumaguete, Negros Island, Philippines.

OPPOSITE, TOP TO BOTTOM:
Soft coral pipefish. Raja Ampat, West Papua, Indonesia.

Galaxea coral pipefish dwarfed by individual coral polyps. Triton Bay, West Papua, Indonesia.

Caledonian pipefish, known from just a few scattered locations around the Coral Triangle. Triton Bay, West Papua, Indonesia.

beneath their eyes. My presence scared off these skittish biological lanterns, leaving the reef uncharacteristically quiet as I descended into the dark. My goal at this unsociable hour was to become one of the privileged few who have ever witnessed the birth of a pygmy seahorse. Enigmatic, charismatic, and poorly known, these miniature fish had been reluctant to give up their secrets, until now.

Embarking on the doctoral research that culminated in my thesis, "The Biology and Conservation of Gorgonian-Associated Pygmy Seahorses," I could never have foreseen what fascinating subjects they would make.[106] In this first research into the biology of pygmy seahorses, I set out to explore their private lives. Male pregnancy had already been confirmed for pygmies from museum specimens, but their natural behaviors on the coral reefs of Southeast Asia had remained a mystery since their rather accidental discovery in 1970. I couldn't have predicted, therefore, that my notes on the species would read more like a novel of the Fifty Shades series than a scientific record, revealing many of these mysterious animals' darkest secrets.

A FAMILY AFFAIR

The Syngnathidae family is a large and varied assemblage of fishes that are found throughout all the world's oceans. Meaning "fused-jaw," it is the scientific grouping that gathers the seahorses with their relatives the pipefishes, seadragons, pipehorses,

and pygmy pipehorses. Several hundred species exist within this diverse group of fishes, from the glorious leafy sea-dragon that floats among the kelp forests of southern Australia, to the miniature thread pipehorse, which only stretches across the length of a quarter and whose body seems as thick as a few braided hairs. Unsurprisingly, given the miniscule size of some of these animals, new species discovery occurs unabated. In fact, syngnathid research remains at the cutting edge of new discoveries in the ocean. The thread pipehorse wasn't named until 2007; even more recently, in 2015, the scientific community was shocked by the discovery of a third seadragon species, found off Western Australia. The ruby seadragon, known only from being caught in trawlers, now joins the always fantastical-looking leafy and weedy species.

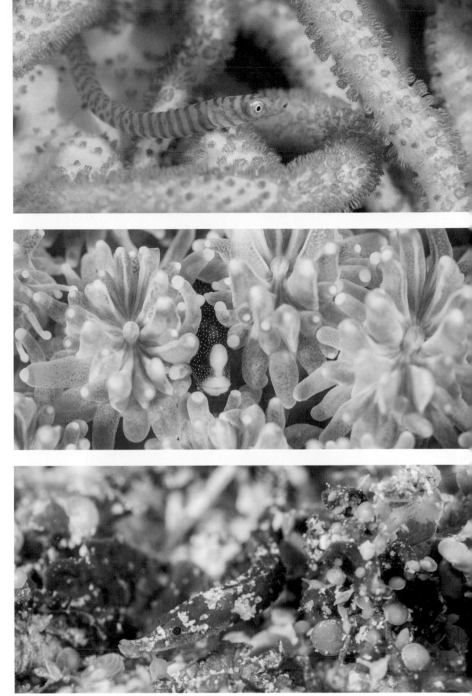

The syngnathid family's many species have in common a few morphological features that demonstrate their shared evolutionary heritage: tube-like snouts that end in a puckered mouth, and hard bony plates instead of fishy scales. And across all the species, it is the male who broods the eggs.

As with the discoveries of many marine species, a majority of new syngnathid discoveries are small, well-camouflaged, and very habitat-specific. In 2008, Lynne Van Dok first spotted a strange bright pink pipefish while diving in a remote corner of Papua New Guinea. For the following seven years, Lynne travelled around the Coral Triangle searching

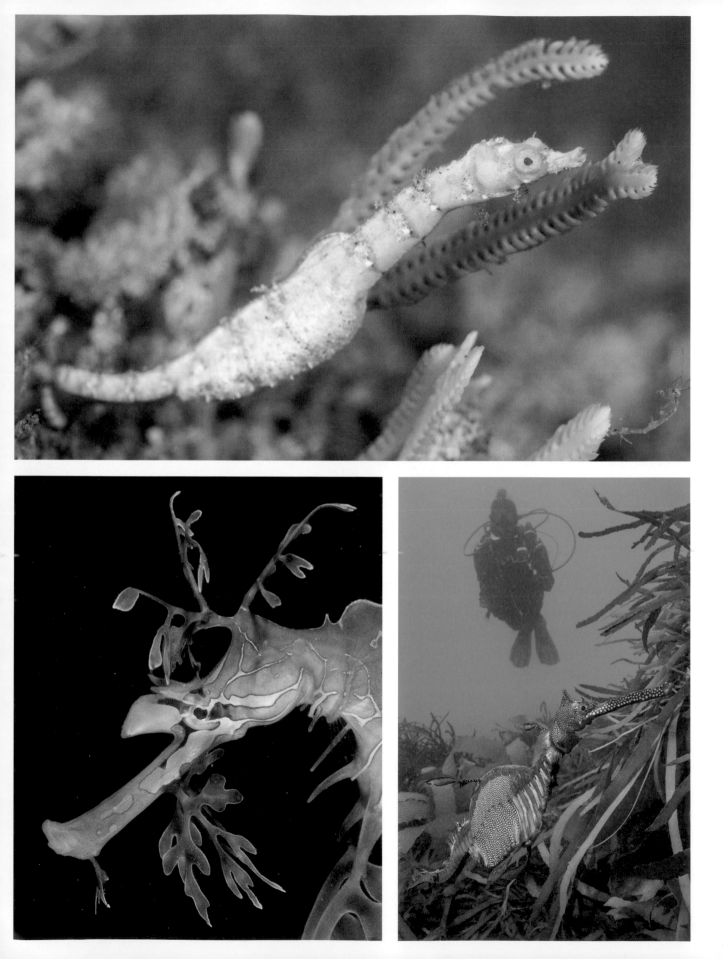

for more of these cryptic critters. The size of a toothpick, the pipefish lives on steep walls where a tiny and equally gaudy sponge grows in small clumps. To the naked eye, it is almost impossible to distinguish the pipefish from its habitat, so without Lynne's eagle eyes, this fish may never have come to the attention of scientists. It was only in 2015, after the scientific team involved in its description collected specimens, that they gave it the scientific name *Festucalex rufus*.

I have been lucky enough to see several of these little gems. The first was in the Solomon Islands, where I had been tipped off by some buddies that Lynne had spotted some in the area. On the day of the sighting, my buddy Sam was poring over the reef wall at sixty feet below the surface when suddenly his head shot up and he gestured me over to see a patch of the pink pencil-like sponges where a tiny worm-like pipefish wiggled between the towering fronds. I spent as much time as I could underwater (well, as much time as I could at that depth without getting too much nitrogen building up in my blood), in hopes of spotting its partner. From experience I knew that such habitat specialists tend to live in male-female pairs, and in due time, I found the male counterpart a foot away. These fish are so rare and their environmental needs so specific that learning exactly where the animal lives makes finding them much simpler.

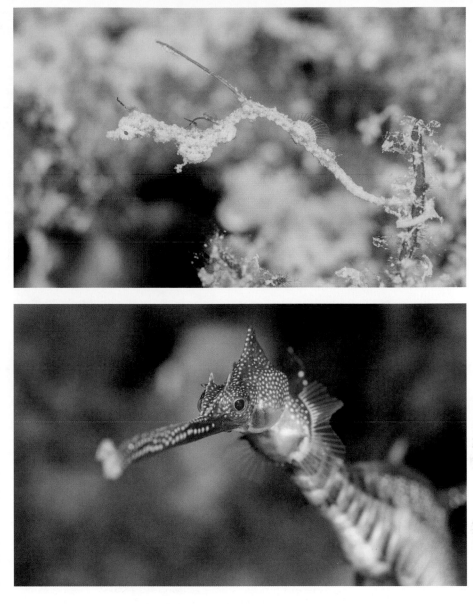

Above, Top to Bottom: Thread pipefish, just two centimeters long, described in 2007. Cebu, Philippines.

Weedy seadragon. Victoria, Australia.

Opposite Top: Male short pouch pygmy pipehorse. Dumaguete, Negros Island, Philippines.

Opposite Bottom Left: Leafy seadragon head detail. South Australia.

Opposite Bottom Right: Weedy seadragon and diver. Tasmania, Australia.

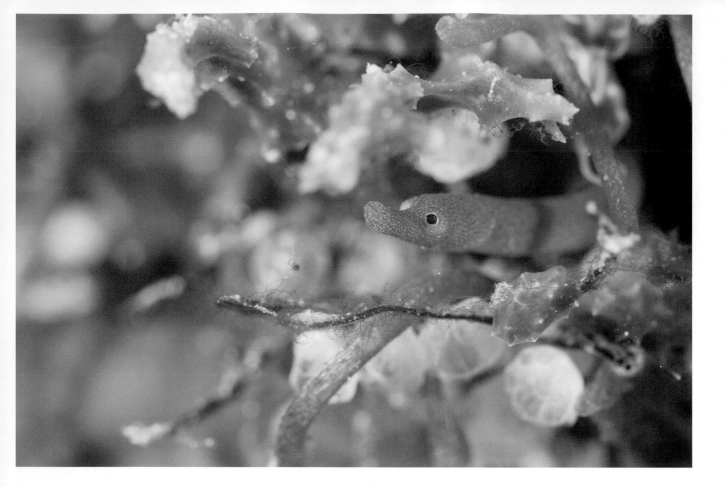

HIPPOCAMPUS

It's easy to list any number of unusual features possessed by seahorses: a horse-like head, the puckered mouth, eyes that move about independently, a monkey-like prehensile tail. Or the strange processes of their reproduction, where the extraordinary devotion of the fathers and strict pair monogamy remain unique in the animal kingdom.

As of this writing, there are forty-two species of seahorses recognized by the IUCN, but this number is constantly in flux. Presently, all seahorses belong to the genus *Hippocampus*, which derives from the Greek term for "horse-like sea monster." Historically, there has been considerable inconsistency over the number of recognized seahorse species. Over the past two hundred years, 140 species names have been proposed in the scientific literature for members of the genus *Hippocampus*.[107] The genus ballooned in 2009, when one author suggested eighty-three species; however, after serious revision, it was lowered substantially.

Some of the difficulties in seahorse identification result from the huge variation present within a given species. Males tend to have longer tails and shorter bodies

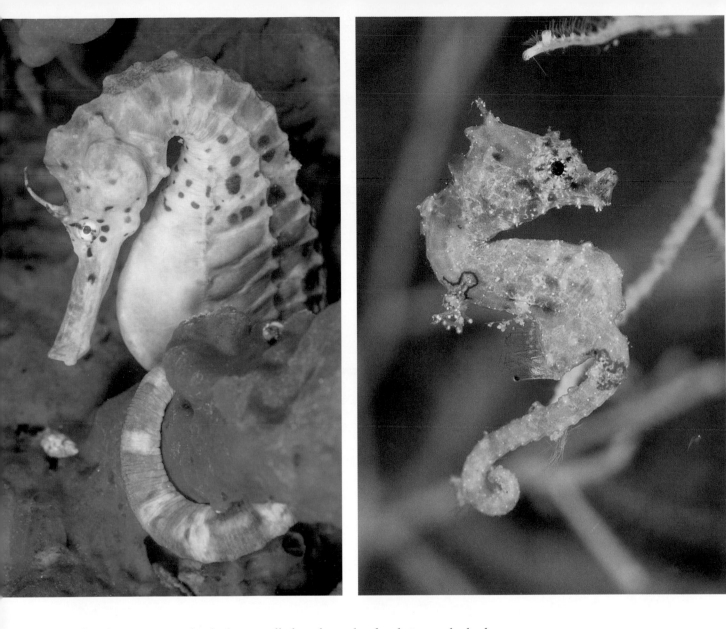

than females. Younger individuals generally have larger heads relative to the body. They can also have more spines, are generally slimmer, and have more prominent crowns than adults.[108] In addition, their colors vary dramatically, depending on local environmental cues as simple as the color of a sponge that they live close to. Local conditions also influence the prominence of the spines as well as how filamentous the skin appears, with a covering of thin threads sometimes giving a hairy appearance. This ability to perfectly tailor their appearance helps to obscure the animals from predators, but also muddies the classification situation for taxonomists.

The highest number of seahorse species is found around Australia and Asia, but seahorses are by no means restricted to tropical waters. Seahorses have even

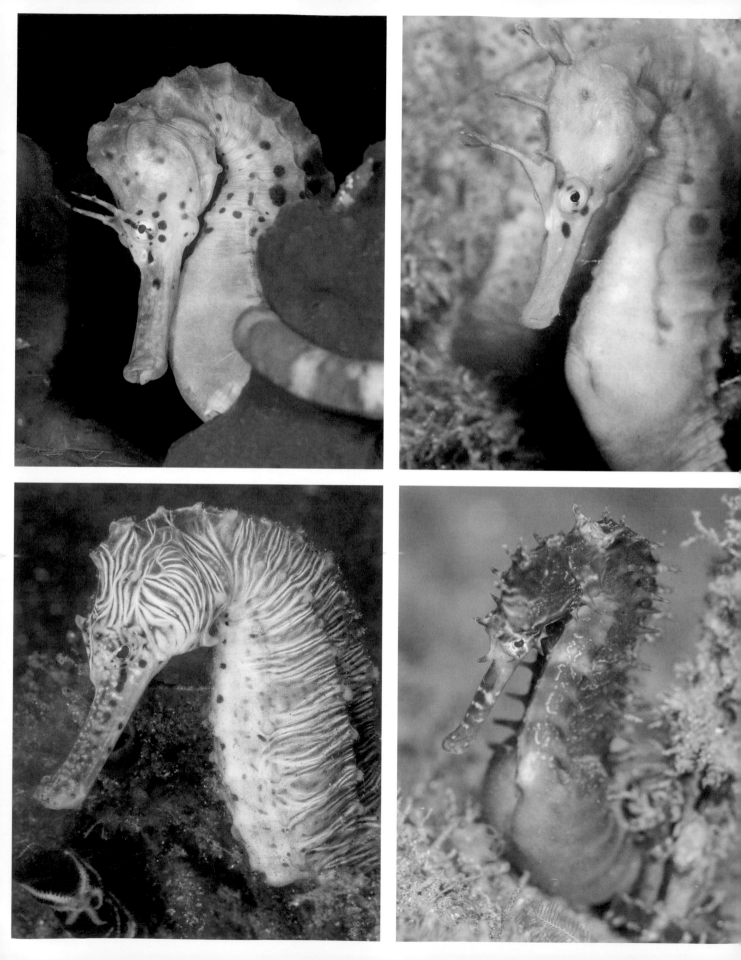

been discovered living in the Thames Estuary, only five miles from the British Parliament in London. They are found throughout the world's oceans, inhabiting all but polar regions. The vast majority of seahorses aren't found on coral reefs, but prefer seagrass meadows, mangrove forests, and muddy or silty bottoms. The largest species, the potbellied seahorse, often found around jetties in southern Australia and New Zealand, reaches a foot in length, and the smallest, Satomi's pygmy seahorse, barely stretches across a dime.

OPPOSITE TOP, LEFT AND RIGHT: Color variation in potbellied seahorses. Victoria, Australia.

OPPOSITE BOTTOM, LEFT TO RIGHT: Three-spot seahorse, rare zebra form. Lembeh Strait, Sulawesi, Indonesia.

Pregnant male thorny seahorse. Dumaguete, Negros Island, Philippines.

THE BIOLOGY OF FATHERHOOD

The most well-known and fascinating aspect of seahorse reproduction is male pregnancy. Male seahorses aren't the only animals that put a great deal of effort into raising their young, but they are the only ones that become pregnant, subject to all aspects of the phenomenon—even stretch marks. The direct transfer of unfertilized eggs from the female into the male's brood pouch affords him confidence in his paternity. The male nourishes his offspring inside the pouch and maintains a perfect developmental environment. Unlike other animals, where promiscuity is rife, the male seahorse is 100 percent sure that each of the offspring he carries is his own, with no risk of cuckoldry. This explains the extreme lengths to which male seahorses are willing to go in raising their young. It is certainly in his best interests to raise as many young as possible so that he can pass his genes on to the next generation. Brood sizes vary hugely within the group: larger species can produce more than one thousand fry in a single clutch, but the smallest pygmy seahorses can give birth to just half a dozen.

Every day, seahorse pairs meet at dawn, dusk, or both, depending on the species, to perform courtship rituals. These critical times allow the bonding pair to synchronize their reproductive cycles, a process that provides the female with the assurance she needs to hydrate their clutch of eggs—a necessary step before they are ready to be transferred to her mate. Once it has begun, egg hydration is an irreversible process, so it is important for the female to be confident that her partner is willing and able to accept them. If she does not transfer the clutch at the end of the few days' hydration process, the eggs can foul and damage her reproductive organs. Even without sickness, the wastage of such large amounts of scarce resources can take its toll. Synchronization is beneficial as it increases the pair's overall productivity. Pairs that have been forced to switch mates under laboratory

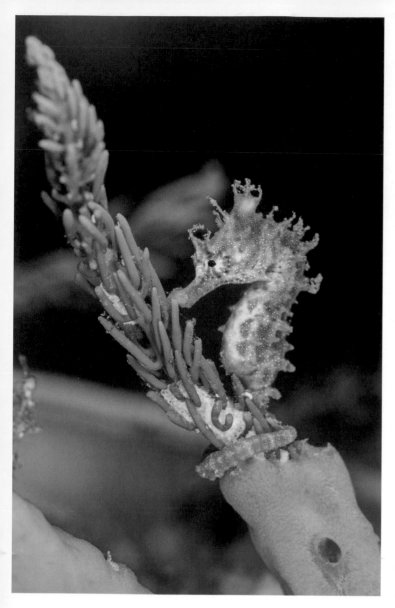

conditions have gone on to produce fewer young over the next couple of broods.[109] Monogamy is a more stable and sustainable option in the long-term.

Despite many aquarium studies in which seahorses have been offered multiple mates, there has never been a case of a male or a female seahorse re-mating with another individual for the duration of the male's pregnancy period. Seahorses usually prefer to remain with the same mate for a season, or even a lifetime. Males shut their brood pouch after mating, since intrusion of saltwater damages the eggs within, and this is thought to prevent males accepting eggs from several females. Moreover, the energy required by a female to produce a new brood is considered to prevent her from re-mating after transferring eggs to her partner. This has led to seahorses forming enduring bonds that can last for life. The true romantics of the ocean, some may never re-mate, even after their long-term partner dies.

DWARVES AND PYGMIES

There is a strange pattern that emerges when you look at the forty-two IUCN-recognized seahorse species. Many larger species measure over ten centimeters in total length, but around a dozen species measure five centimeters or less. This propensity toward dwarf forms appears to have developed through the seahorse's preference for a mate of around the same size.[110] Smaller males tend to mate with smaller females and the same goes for larger partners. Selecting a mate of a similar size allows both parties to raise as many young as possible. If a large male mated with a small female, there would be wasted space in his pouch. In reverse, if a small male mated with a large female, there would be insufficient space in his pouch to accommodate her full clutch of eggs and some would go to waste. Over time, the preferential mating of smaller seahorses with other smaller seahorses has pushed their sizes to extreme limits and resulted in the formation of very small species.

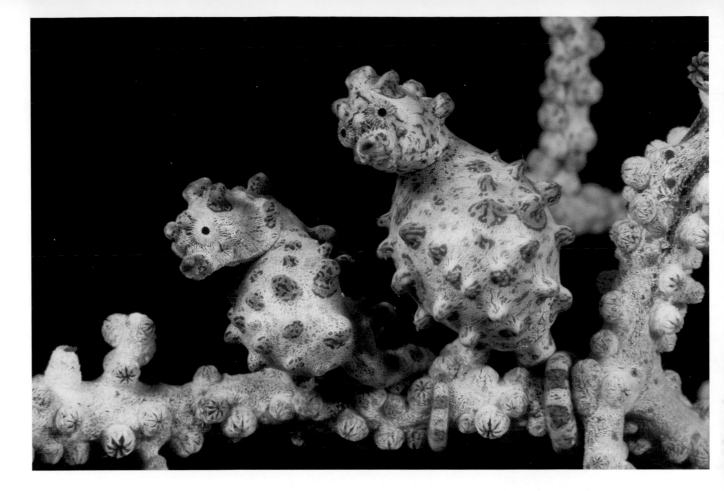

ABOVE: Two Bargibant's pygmy seahorses. Wakatobi, Sulawesi, Indonesia.

In southern Australia, around the jetties of the Mornington Peninsula outside Melbourne, two seahorse species can be found. The aforementioned potbellied is the world's largest at a foot in length, while the short-head seahorse measures at under 10 cm. Despite their divergent sizes, they are sister species, each other's closest relatives.

In 1969, a new and unique seahorse was discovered by accident when a diver, Georges Bargibant, was collecting a gorgonian coral for the Nouméa Aquarium in New Caledonia. Gorgonian corals are the coral reef's equivalent of oak trees: they may live for over a hundred years and provide habitat for many animals. Generally flat, bright red, pink, or yellow in color and often about half the size of a table tennis table, gorgonians comprise a massive colony of polyps that open at certain times of day, usually when the local currents are strongest, to filter feed particles from the water. As Georges spent some time before heading back to the boat with the gorgonian that he had collected, while peering at the bright pink coral he suddenly spotted two odd little creatures clinging to its surface. He had discovered the first-known pygmy seahorses.

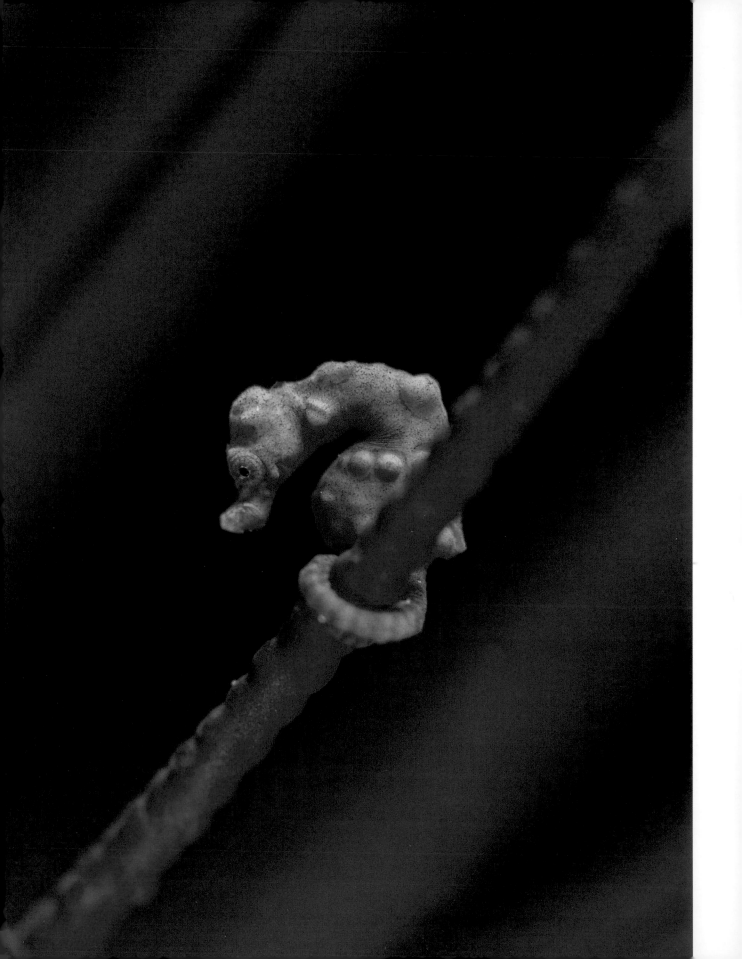

A year later, the tiny seahorse, measuring just one inch long, was named in his honor as *Hippocampus bargibanti*. Like the gorgonian corals that they inhabit, the seahorse is covered in large tubercles that mimic the closed polyps of the coral. Despite its comedic pucker and striking appearance, the fish disappeared into obscurity until divers began to spot them in the mid-1990s. I first became aware of them in 1999 when I missed seeing a pair found by our group's guides on a trip to Papua New Guinea. It wasn't until 2002 that my good friend Yann Alfian, an Indonesian dive guide with an eye for the microscopic, showed me my first pair in Indonesia's Komodo National Park.

The large numbers of divers and budding underwater naturalists that have begun to explore shallow tropical reefs over the past twenty years have generated a flurry of new pygmy seahorse discoveries since the beginning of the

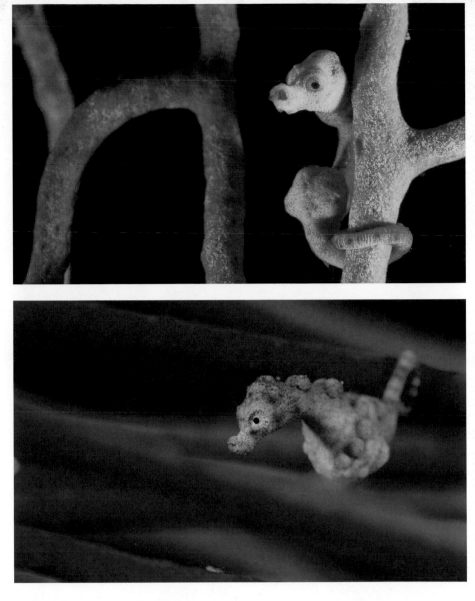

twenty-first century. In 2003, Denise's pygmy seahorses joined Bargibant's as another gorgonian-living species, but one with a broader range of ecological tolerances than Bargibant's. My own research found that Bargibant's is only found on the *Muricella* species of gorgonians, for which it is highly adapted. On the other hand, I have found that Denise's pygmies inhabit at least ten different types of gorgonians.[111] Denise's pygmies are much more variable in their appearance too. Some are yellow; others red, white, or pink. They also vary in surface texture, from smooth to exceedingly bumpy, depending entirely on the specific gorgonian that they happen to inhabit.

In 2003, Coleman's pygmy seahorse from Lord Howe Island, off the east coast of Australia, joined the ranks, and 2008 marked the arrival of Pontoh's, Satomi's,

ABOVE TOP: Female Denise's pygmy seahorse, described in 2003. Milne Bay, Papua New Guinea.

ABOVE BOTTOM: Denise's pygmy seahorse on a whip coral. Wakatobi, Sulawesi, Indonesia.

OPPOSITE: Denise's pygmy seahorse on a whip coral. Wakatobi, Sulawesi, Indonesia.

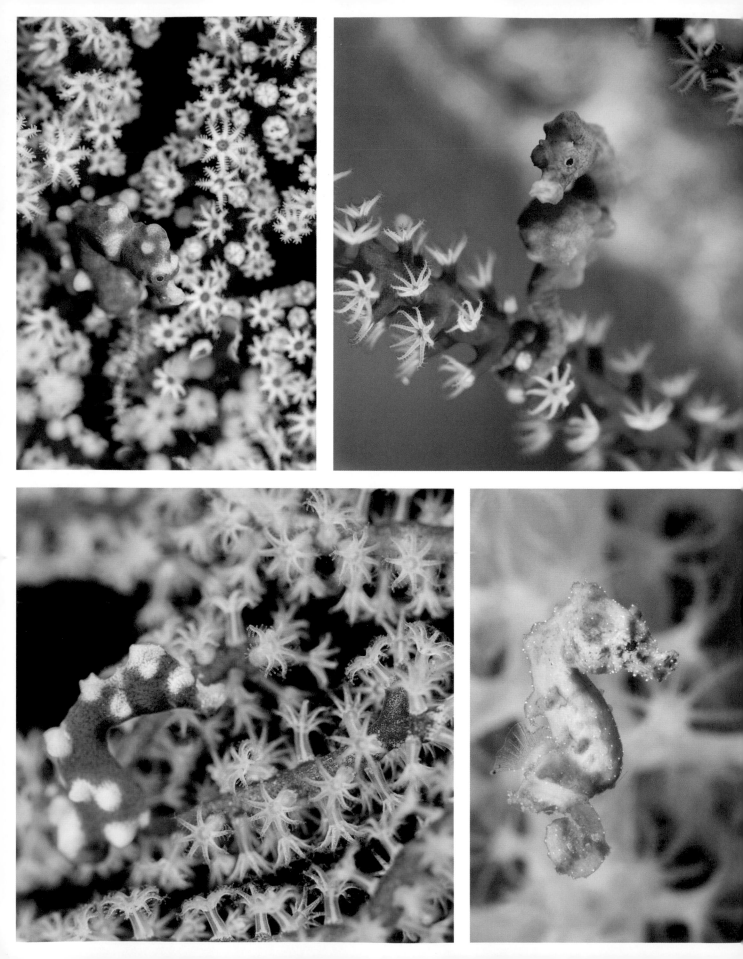

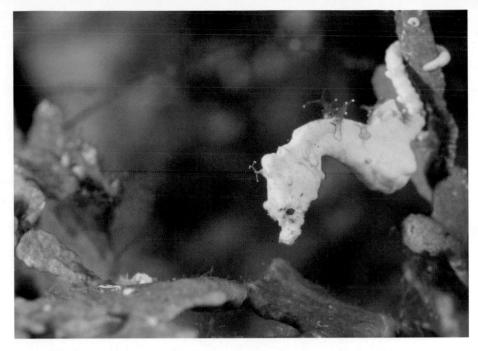

and Severn's pygmy seahorses. These four species were all fundamentally different from Bargibant's and Denise's species, as they were generally not found living with a particular kind of coral, but inhabiting algal tufts and filamented reef invertebrates. Their laissez-faire attitude to habitat preferences makes these fishes particularly difficult to locate, and as a result, they have yet to be the focus of any scientific study. In fact, just like many seahorse species before them, Severn's was merged with Pontoh's under the scientific name *Hippocampus pontohi* in 2016 when it was found that they represented just one species. It turns out that color had been the primary motivation for granting them different names, with brown individuals considered to be Severn's and white ones considered to be Pontoh's.

In 2009, the Walea soft coral pygmy seahorse was named. This enchanting fish lives only on the beige soft corals in an area of central Indonesia called the Gulf of Tomini, roughly equivalent in size to half of Maine. This combination of habitat specificity and a very small natural range puts the Walea species at a real risk of extinction. For now, though, on the reefs of the Gulf of Tomini it hops from one frond of soft coral to another, its comically long tail adapted for holding thick branches of the coral. When swimming, the seahorse coils it up into a little ball, like an eighteenth-century lady holding her gown as she runs.

True pygmy seahorses have several morphological adaptations for their small size that distinguish them from other seahorses. They have a single gill opening behind the head and they brood their young within the trunk, rather than in a pouch on the tail like their larger kin. Dwarf seahorses, on the other hand, are identical to the larger species in every way except their size. They have paired gill openings rather than single gill openings and their brood pouch is located on the tail, rather than within the trunk. The pygmies split from this main lineage of seahorses early on in seahorse evolution.

ABOVE: Pontoh's pygmy seahorse, white variation, described in 2008. Wakatobi, Sulawesi, Indonesia.

OPPOSITE TOP, LEFT TO RIGHT: Female Denise's pygmy seahorse, described in 2003. Milne Bay, Papua New Guinea.

Denise's pygmy seahorse on a whip coral. Wakatobi, Sulawesi, Indonesia.

OPPOSITE BOTTOM, LEFT TO RIGHT: Denise's pygmy seahorse variation. Wakatobi, Sulawesi, Indonesia.

Swimming Walea soft coral pygmy seahorse, described in 2009. Tomini Gulf, Sulawesi, Indonesia.

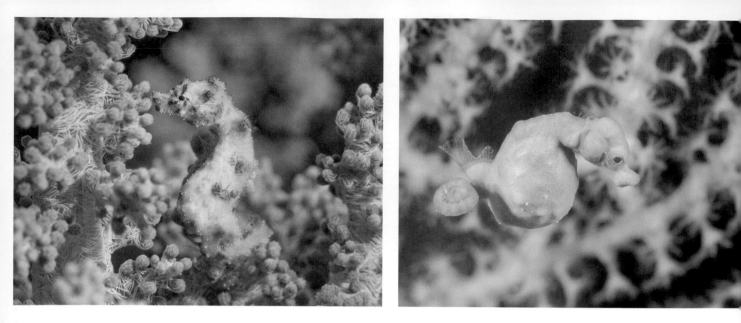

PRIVATE LIVES OF PYGMIES

ABOVE LEFT: Walea soft coral pygmy seahorse, described in 2009. Tomini Gulf, Sulawesi, Indonesia.

ABOVE RIGHT: Heavily pregnant male Denise's pygmy seahorse swimming to his birthing site. Wakatobi, Sulawesi, Indonesia.

OPPOSITE TOP, LEFT TO RIGHT: Male Denise's pygmy seahorse giving birth to two fry. Wakatobi, Sulawesi, Indonesia.

Male Denise's pygmy seahorse giving birth. Wakatobi, Sulawesi, Indonesia.

OPPOSITE BOTTOM, LEFT TO RIGHT: Male Denise's pygmy seahorse giving birth, with newborn baby visible. Wakatobi, Sulawesi, Indonesia.

Male Denise's pygmy seahorse immediately after giving birth, bearing stretch marks. Wakatobi, Sulawesi, Indonesia.

Using as little light as I am able to in order to watch the events unfolding before me, I see the rotund pregnant male pygmy seahorse risk his life by releasing his vice-like grasp on the gorgonian to fight the current and swim to where it strikes with most force. There, he reattaches to the gorgonian, and, once he is confident that he has a strong hold, he begins to go into labor.

Just moments before, after a ten-minute swim against the current along the dark and gloomy reef wall, I had arrived at the gorgonian home of my pygmies. I immediately began to seek out each one of the four residents, which I could identify individually by color and size, before beginning observations that I scribbled on A4 waterproof paper. Early on in my research, peer pressure from my dive guide friends had morphed my rigid scientific-minded nomenclature of the four fish from 1, 2, 3, and 4 to Tom, Dick, Harry, and Josephine. The group's exploits certainly seemed to warrant proper names. This unusual conjugal situation—Josephine and three males— gave me a unique opportunity to observe whether the fabled seahorse monogamy, one of the fundamental quirks of their reproduction, could endure such temptation.

The gorgonian buzzed with activity soon after my arrival. Tom, with a belly swollen like a miniature basketball, swam out from the little nook he shared with his gorgonian-mates, to an exposed edge of the expanse. Without much ado, he bent over, expelling numerous tiny black specks into the ocean. These specks, of course, were the brood of young that he had been nurturing in his pouch for the past two weeks. Another couple of contractions and the baby seahorses were released into the water. Before being carried off in the current, the babies uncurled to reveal their heritage; they resembled darkened miniature versions of their parents.

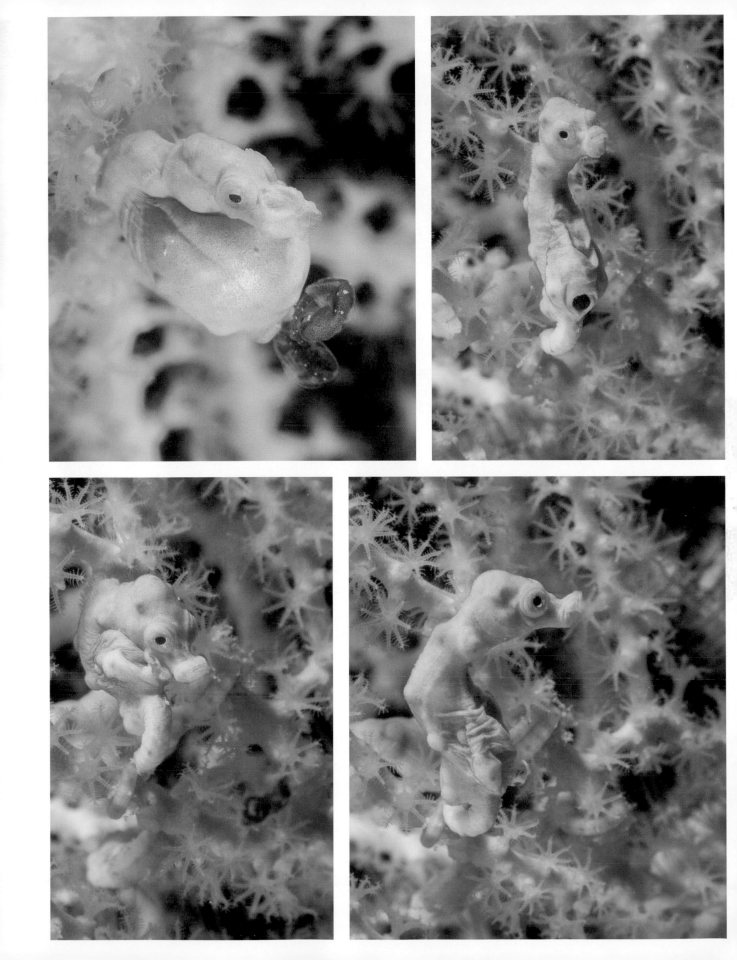

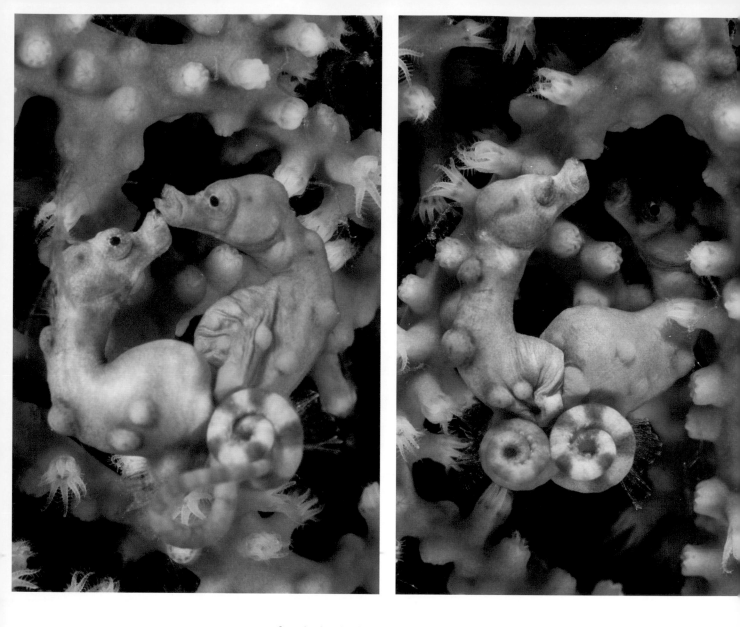

ABOVE LEFT: Mating Denise's pygmy seahorses. The female on the left is full of eggs; the male is empty, having just given birth. Wakatobi, Sulawesi, Indonesia.

ABOVE RIGHT: Mating Denise's pygmy seahorses forty-five seconds later. The female on the left has transferred the eggs and the male is now full of fertilized eggs. Wakatobi, Sulawesi, Indonesia.

After the birth, the newborn seahorses set off on their own and would never see their parents again, instead spending a couple of weeks at the whim of ocean currents before finding a gorgonian of their own on which to settle. My research showed that after they find a suitable gorgonian, they need only five days to change their dark free-floating coloration to match their new gorgonian home in color and surface texture.

Tom was visibly drained after the birth. His previously rotund physique heaved with stress and exhaustion, now he was surely the only male in the animal kingdom with stretch marks. This would be the only moment of rest for Tom; his day had just begun. No sooner had he given birth than he headed back to the little

nook where the other three rested. Josephine immediately noticed his return, and side-by-side, the two began an age-old ritual of mirrored movements and quivers. After conveying to Josephine that he had given birth and was receptive to mating, the pair slowly loosened their grip of the gorgonian and hovered above it. They intertwined their tails, holding together their tiny genital openings. Josephine's belly, swollen with eggs, gradually shrank as she pushed the clutch of unfertilized eggs into Tom's pouch. His deflated and wrinkled belly became correspondingly plumper as the eggs entered his pouch and he fertilized them, ensuring him certainty over his fatherhood. The pair's reproductive synchrony, ensured by daily courtship dances, allowed Tom and Josephine to re-mate so soon. Forty-five seconds later, the pair went their separate ways; Tom, presumably, needing a rest.

During my research I discovered a terrible truth: not all seahorses are the portraits of domestic bliss that we assumed. I regularly found the three males, Tom, Dick, and Harry, involved in brawls. Seahorse brawling is a surprisingly comedic affair that involves their most prized appendage: the tail. In one skirmish, Dick grasped Tom around the base of his tail and shoved him off the gorgonian while the hapless Tom thrashed around in disapproval. Harry seized the opportunity and grasped Dick around the neck with his tail too. Since both the bigger males were being held, neither wanted to lose face and let go. The tussle lasted a good several minutes and Tom was left with a sprained tail for days!

Behind these brawls, of course: the lovely Josephine. During my research the cause of the turmoil became clear. Josephine was mating with both Tom and Dick. With a gestation period of twelve days, Josephine would mate with one of the males after he gave birth, and then mate with the other six days later, while the first male was only halfway through his pregnancy. Both males were always pregnant and Josephine was constantly hydrating eggs for them. She conducted twice daily dances with both males to keep tabs on their due dates. This is the first time a seahorse has been found to engage in polygamy. In fact, in this case since it was the female mating with two males, it is technically known as "polyandry," from the Greek meaning "many men." Poor Harry never did get a second look during my study, being much smaller than the other two males and presumably failing to gain traction in the wrestling matches.

My research required that I next turn my attention to a female-biased ménage à trois. I had already seen that under the circumstances of a male-biased sex ratio, the female (in this case, Josephine) was able to produce clutches of eggs just days

apart in order to impregnate two males (Tom and Dick). Subsequently, I was intrigued to find out whether a single male would accept eggs from two females. Luckily, at my study site there was no shortage of pygmies and I soon found a perfect group: Brad, Jennifer, and Angelina.

I spent many hours with the trio, observing and recording their every interaction. I found that Brad and Jennifer shared a core area on one side of the gorgonian, while Angelina slept on the other side of the gorgonian. A "core area" is the protected area of the gorgonian where they carried out their social bonding dances, mated, and slept. Tom, Dick, Harry, and Josephine all slept together in one small core area.

During my research, Brad and Jennifer raised several broods together, but all the while Brad was also flirting with Angelina. Each morning, after bonding dances with Jennifer, Brad would leave their core area and swim directly to the other side of the gorgonian where Angelina bided her time. Angelina and Brad then carried out the same social bonding dances, but they never mated. In the world of pygmy seahorses, it is always best to keep your options open in case something were to happen to a partner. Unlike the pugnacious males, the two females eschewed violence, instead electing cool indifference.

Broadening my search further, I found another group of pygmies along the reef. On a bright red gorgonian, three pairs shared a home. This offered the opportunity to investigate how bonded pairs interacted with each other. Would jealousy feature in a male pygmy seahorse's behavior when he was happily partnered? Mapping home ranges and recording social interactions led me to conclude that it would not. On a gorgonian as big as a thirty-four-inch television screen, these individuals spent their entire lives confined to an area as small in some cases as three adjoining Post-it Notes, while the largest spanned the area of a double-page spread in a magazine. Males generally used less space than females, which is probably due to the difficulty of travelling when inflated with young. When happily settled with a single partner, males appeared to pay no attention to other males, even though their home ranges often overlapped. Hunting for prey to fuel their constant egg production and pregnancy is a full-time pursuit, so they searched for and grazed on the miniscule crustaceans that live on the surface of the gorgonian.

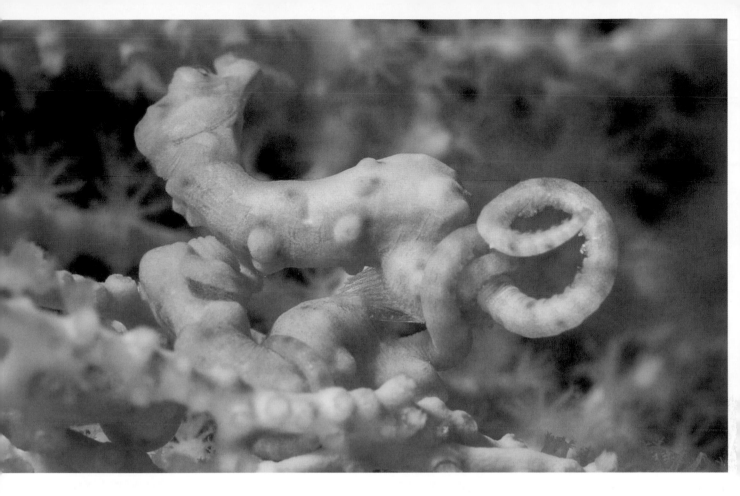

PYGMY ECOLOGY

After studying the pygmies' private lives in depth, I embarked on a mission to discover more about their general biology. Their camouflage seems to prevent them from having any committed predators, although the long-nosed hawkfish, another gorgonian-living fish, has been known to occasionally feast upon a pygmy treat. Pygmies are short-lived, probably living twelve to eighteen months, which also explains why they are so keen to produce as many babies as possible during their short but full lives.

To get an idea of their numbers, I surveyed an area of local reefs equivalent to the size of a soccer field. I found many fewer pygmies than you would expect to find if searching for their larger cousins. In the whole area, I only found twelve Bargibant's and forty-one Denise's pygmies, despite scouring every gorgonian in a range of different depths and locations.

Although the *Muricella* homes of Bargibant's pygmies are much rarer (I found just twenty-five in my study area), this species of pygmy is exceedingly highly specialized to inhabit them, so one-fifth had seahorses living on them. Comparatively,

ABOVE: Three male Denise's pygmy seahorses fighting with their tails. Wakatabi, Sulawesi, Indonesia.

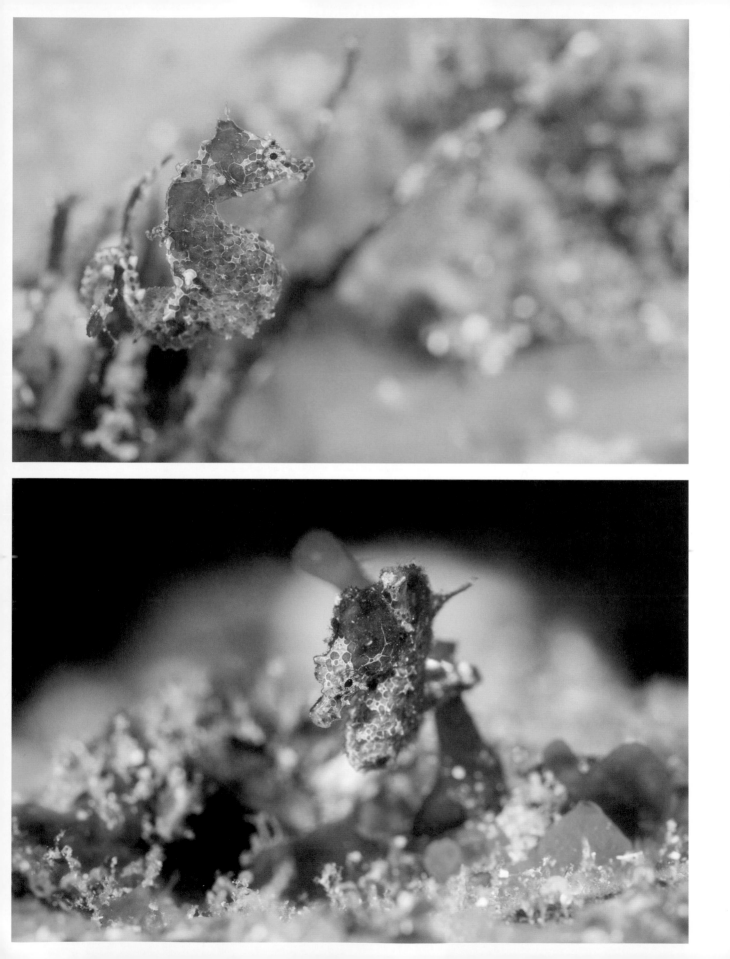

Denise's species is much less picky about the gorgonians that it inhabits, but at a cost of being less well specialized for any given type. As a result, they inhabited less than 8 percent of the almost three hundred possible gorgonians I counted. In terms of their conservation, this situation puts Bargibant's pygmy seahorses in a precarious position. Just as certain gorgonians of the Mediterranean have experienced huge die-offs,[112] there is always the risk that *Muricella* may be infected by a disease and perish en masse. This would clearly lead to the local extinction of the seahorses too. Denise's pygmy, on the other hand, is less picky and thereby more capable of surviving a similarly precarious situation. If one of the gorgonian species that Denise's pygmy inhabits were to die off, then it could move to another type. In slightly different ways, each of these animals is the epitome of a habitat specialist but sadly as we have learned these are often the first to be lost.

As we approached the end of a decade without a new pygmy seahorse discovery, a meeting of the world's seahorse researchers in Tampa in 2017 started the ball rolling again. There, I gave the keynote speech on syngnathid diversity, and showed an image of a pygmy seahorse I had seen in Japan. Afterward I spoke with a colleague about this pygmy, which I was sure was new and, despite being known by the Japanese dive community, had not been named. Taxonomy is a discipline unto itself, and teamwork was the best approach to get this pygmy a name. I had first become aware of it almost fifteen years earlier, but diving in Japan is very difficult logistically for a non-Japanese speaker, so I hadn't been able to study it as much as I would have liked.

After heading to Okinawa for a conference of fish biologists in 2013, I had decided it would be rude to not head north and at least try to find this tiny beauty, so I flew to Hachijō-jima, an island 175 miles south of Tokyo, and a forty-five minute flight. The island's twin volcanoes jut abruptly out of the blue Pacific Ocean, which I soon found to be full of amazing and unique fishes and other animals. Here, with my fantastic guide Kotaro, I saw my first Japanese pygmy, the "japapigu," which is the name used locally for the seahorse. Over five days, I found a total of thirteen; however, when I returned with a team of four highly experienced divers in 2015, our exhaustive searches yielded only one. This illustrated to me how population fluctuations could easily lead to the disappearance of an animal we hadn't even added to the catalog of life. This motivated me more than ever to help assign it a name.

In August 2018, our paper officially naming the Japanese pygmy seahorse as *Hippocampus japapigu* was released through the collaboration of colleagues from

OPPOSITE, TOP AND BOTTOM::

Japanese pygmy seahorse, *Hippocampus japapigu*, which colleagues and I described in 2018. Hachijō-jima, Japan.

OPPOSITE, TOP AND BOTTOM:

Japanese pygmy seahorse, *Hippocampus japapigu*, which colleagues and I described in 2018. Hachijō-jima, Japan.

Japan, Australia, the United States, and myself, a Brit.[113] Although superficially similar to Pontoh's pygmy seahorse, genetic analysis showed that these tiny fish split from the other pygmies around eight million years ago. Who knows what other parts of the ocean may conceal other equally unique and diminutive syngnathids.

CONSERVATION

The information we have accumulated about seahorses is slowly beginning to paint a clear picture of their biology. What's certain is that the group faces grave threat. In 2002, along with two shark species, seahorses were the first fishes to be added to the Convention on the International Trade in Endangered Species of Wild Fauna and Flora (CITES). This bold and controversial step, pioneered by the conservation organization Project Seahorse, offered these species protection against overexploitation in trade. The demand comes from the Chinese traditional medicine trade where they are highly prized and believed to alleviate certain lung ailments, throat infections, insomnia, and abdominal pains.[114] They are also collected for aquaria and as curios. Still, it is estimated that some thirty-seven million seahorses each year are caught as bycatch in fishing trawlers alone.[115] I always avoid eating shrimp due to the way they are caught: for every kilogram of trawl-caught shrimp, ten kilograms of other marine life is caught that is often dumped, dead, back into the sea. Seahorses are among the huge variety of different species that are incidentally caught as bycatch, and it is certainly taking its toll on their populations.

Despite such huge pressure on seahorses, we still know relatively little about them. Of the forty-two species listed by the IUCN, seventeen are listed as "data deficient," meaning we don't know enough about them to even guess how threatened they might be. Of the twenty-five species for which we have sufficient information, twelve are classified as vulnerable to extinction and two are endangered. Clearly, we need to gather more information about them. Project Seahorse's iSeahorse program has paved the way for citizen scientists to log seahorse sightings. Almost half of registered seahorse sightings have added previously unknown information in some form and 15 percent have extended the known geographic range for the species. While seahorses have fascinated humans since the time of the ancient Greeks, the true natures of these enigmatic creatures have amazingly only begun to be revealed in the last few decades.

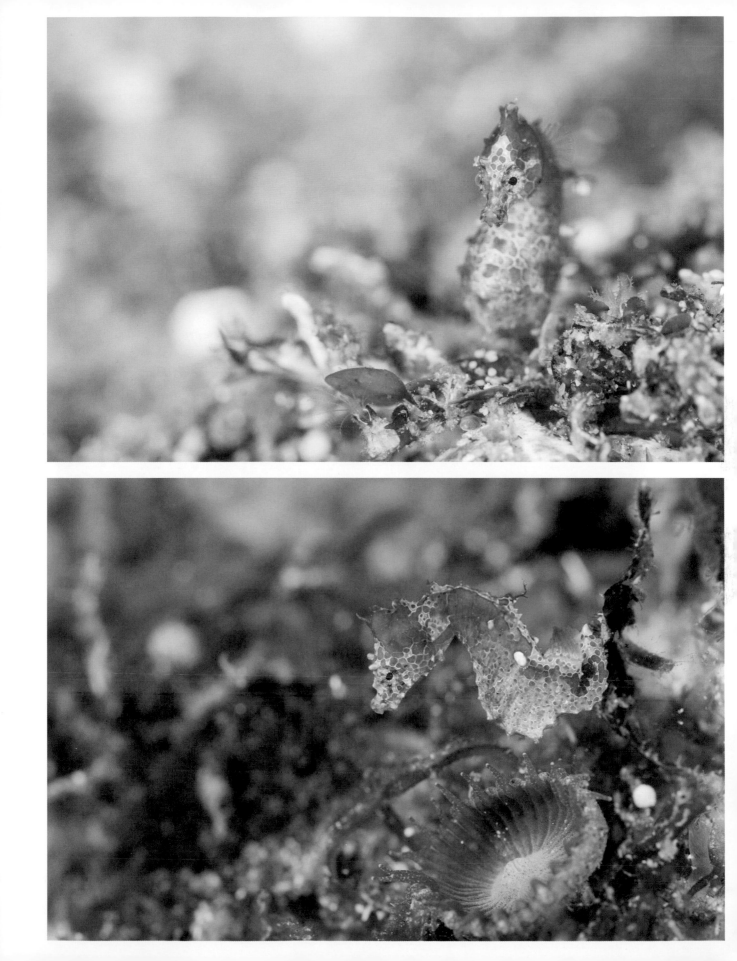

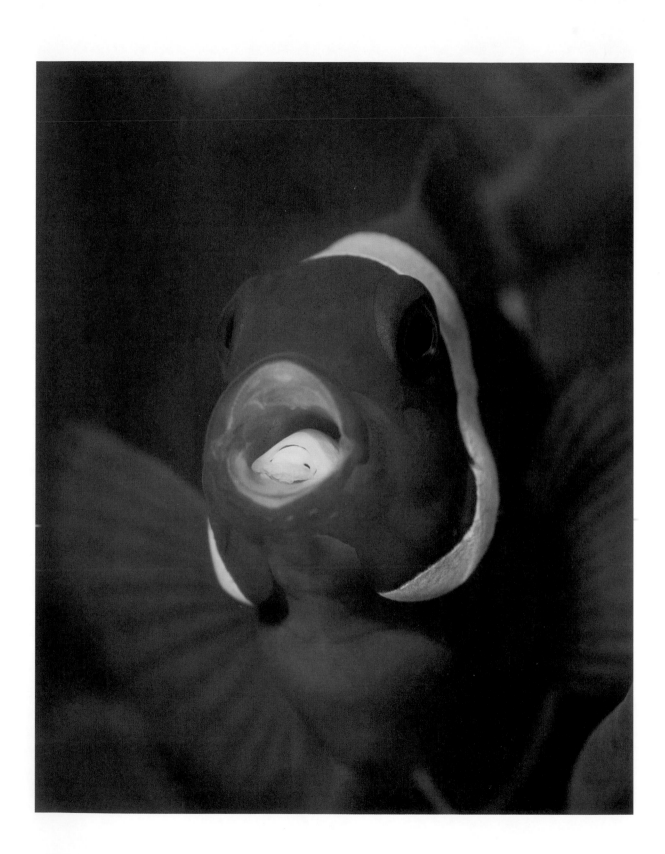

CHAPTER 8:

PARASITES
RULE THE REEF

A s the crew of the *Nostromo* huddle round the writhing body of John Hurt's character Kane, the angry chomping young alien shockingly and violently bursts from his stomach, in one of cinema's most iconic scenes. For several days prior, having implanted an egg, the "facehugger" had clung to Kane's face; in its next stage the newborn parasite emerged through his chest, before finally transforming into the alien incarnation that rampages around the ship, mercilessly hunting Sigourney Weaver. Despite being based on a parasitic life cycle, Hollywood certainly employed its fair share of artistic license. Luckily, not all parasites are as horrifying as this, but seemingly without exception they make our skin crawl. Like spiders, slugs, and snakes, we consider them the lowest of the low in the animal kingdom. They're creepy crawlies that spread disease and exploit other creatures, which is probably why calling someone a parasite is so derogatory. In fact, the term "parasite" was first used in ancient Greece to mean "hanger-on" and was later adopted by biologists to describe this diverse group of animals.

Parasites live in or on a host organism and obtain nutrients from the host at the host's expense. Like mutualism and commensalism, parasitism is a symbiotic long-term relationship between two species. But in this relationship there is a cost borne by the host that benefits the parasite. Unlike a traditional predator-prey relationship, the parasite won't kill the host (immediately, anyway) because the survival

OPPOSITE: Spine-cheek anemonefish with tongue-biter isopod parasite so large the fish is unable to close its mouth. Lembeh Strait, Sulawesi, Indonesia.

of both organisms are intrinsically linked. There's a real simplicity and finesse to the life histories of parasites that perfectly fits Darwin's theory of natural selection.

Humans, like all animals, can be stricken with parasites. We are the victims of a huge variety of species, from liver flukes to intestinal worms, giardia, hair lice, and mosquito-borne dengue and malaria; the latter is thought to kill more than one million people a year around the world. In fact, humans can harbor some 430 different species of parasites. Perhaps because they cause us such misery, we seem to have a morbid fascination with them. Aside from *Alien*, other movies, including *The Thing* and *Star Trek II: The Wrath of Khan,* are all based on the parasite–host relationship.

The diversity of parasites is astonishing: scientists believe that there may be at least one species of parasite for every nonparasitic species on the planet.[116] Even parasites get parasites. Because they're so maligned, there has been relatively little research on many of the species, beyond those that are most costly to us medically and economically. Parasites have a huge impact on agriculture and aquaculture. They can be particularly damaging in areas that have moved toward high-intensity monocultures, where one species is farmed intensively, providing a veritable feast for that species' parasites. Parasitic infections affect the growth, reproduction, and survival of farmed species and cost us millions, if not billions, of dollars each year.

Due to the clandestine nature of parasites, we typically only glimpse a fraction of their diversity. Of the many cryptic and tiny organisms, parasites are among the most difficult to examine. Parasites can be classified in a number of ways, but the biggest distinction lies in whether they live outside or inside the host. External parasites such as lice, ticks, copepods, and isopods are known as ectoparasites. Inside the hosts are the endoparasites that we generally can't see, such as flukes, tapeworms, and hookworms. Parasites needn't be just microscopic organisms either; a parasitic tapeworm the length of a Boeing 737 was found inside the gut of a sperm whale.

Logic suggests that a greater diversity of potential hosts would attract a higher diversity of parasites. Since coral reefs are the pinnacle of oceanic biodiversity, it follows that they would have the highest number of parasite species in marine ecosystems. Some 30 to 50 percent of known animal species are thought to be parasitic at some point in their life cycle, feeding on and adapting to their hosts. At present, since we haven't even begun to describe all the nonparasitic life on Earth, it is impossible to begin to estimate the total number of parasite species. Much like

habitat-specific commensal symbionts, such as the giant clam shrimp and its host, most parasites are very specific about the animals that they associate with.

THE PARASITE STORY

While it may sound rather macabre, the simplicity and single-mindedness of parasites is truly fascinating. My interest in parasites was first piqued during a dive in Indonesia after noticing a large gray isopod parasite attached to the head of a small damselfish. The parasite was so big that it was very prominent on the fish and I thought about the costs the poor fish must incur lugging this hefty hitchhiker around. After noticing this parasite, it suddenly seemed like every individual of that particular species of damselfish on the reef was infected by these isopods, the same gray parasite attached at the same location on the head, and always the same side of the head. Once my eyes were opened to parasites, I began to see them everywhere—the different species, hosts, and colors.

Parasites evolved from free-living ancestors; there are examples of parasites from almost all animal lineages. There are parasitic plants, insects, worms, crustaceans, fish, and even mammals, such as the vampire bat. Fossil evidence shows parasites have been part of the planet's ecology for millennia. Parasitism is believed to have evolved when free-living ancestors gained some advantage through a close association with another species. By further exploiting the association, this developed over time to the point that the host was at a disadvantage.

Some parasites pass directly between hosts, while others use a complex series of intermediate hosts, known as "vectors," to navigate through the turns and stages of their life cycle. Each part of the life cycle has some advantage to the parasite. Sometimes a parasite will even manipulate the host into increasing the chances of transmission to the next phase. If the parasite life cycle involves their current host being eaten by a specific predator, the parasite can alter the host's behavior to increase the chance of predation. Infected fish are thus subject to the will of parasites—like piscine zombies—their instincts overwritten by the hostile force.[117] In schooling situations, infected fish are often found at the periphery of shoals where predators are more likely to take them. One experiment found that parasitized fish were thirty times more likely to be preyed upon than unparasitized ones. In another study, parasitized fish were more likely to be caught by predators due to swimming closer to the surface than uninfected fish.

Sometimes separate shoals of parasitized fish develop when infected individuals are eschewed by uninfected compatriots. Uninfected potential hosts also change their own behavior to avoid becoming infected by a potentially life-altering parasite infection. They might choose to live in a different habitat where parasite prevalence is lower or avoid preying on infected animals.

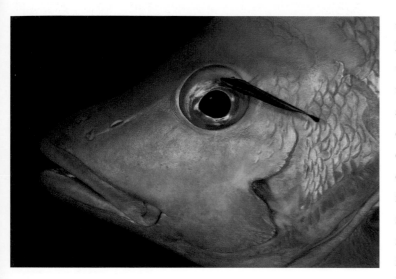

ABOVE: Paddle-tail snapper being cleaned by a juvenile cleaner wrasse. Wakatobi, Sulawesi, Indonesia.

In an even more sinister turn, it has been found that parasitic infection can lead to castration of the host. This benefits the parasite as it releases resources that the host would otherwise expend in reproduction. Certain fishes don't move into their terminal sexual phase if infected with parasites, as gonad development is suppressed by the infection. The small dogfish, a type of shark, suffers from an unusual kind of parasitic barnacle that has lost the usual filter feeding mode of the typical barnacle. The parasitic barnacle sends roots into the shark's body and sucks out nutrients, which also leads to castration.[118] However, it is not a hopeless case. As is the case with similar biological arms races, host species can fight back. Species commonly subjected to parasitic castration tend to mature at an early age to allow a window for reproduction before their parasites sterilize them.[119]

THE CAR WASH

Because parasitism is so common on coral reefs, there's a big market for extermination services. Around 130 species of marine fishes act as cleaners at some point in their life, often during juvenile stages, by approaching an infected fish and eating the exoparasite off of its host. Unrelated groups of cleaning fishes will frequently use the colors blue and yellow to advertise their role in the community. These colors were found to be the most conspicuous when contrasted with the reef and could be spotted by prospective clients some way off.[120] Much like a barbershop advertising its services with a red, white, and blue banded pole, the vivid colors of a cleaner fishes serve to draw customers to their services.

Blue-streak cleaner wrasses, *Labroides dimidiatus*, illustrate just how fundamental parasites are to coral reef ecology. A mated pair of cleaner wrasses will carry

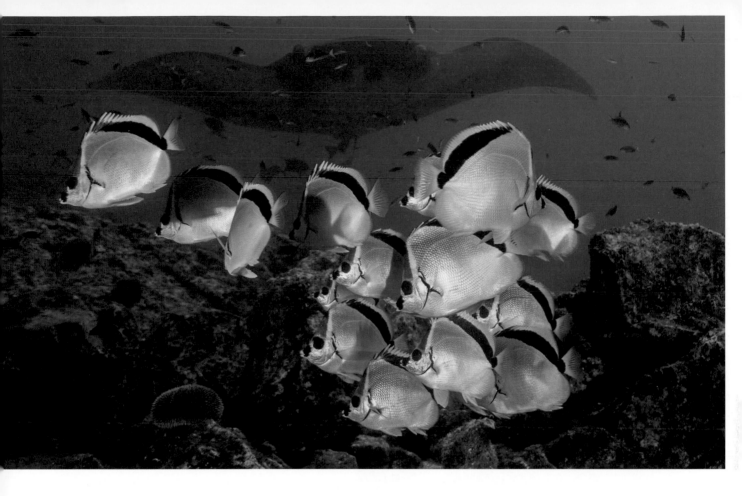

ABOVE: Barber butterflyfish awaiting arrival of an Oceanic manta client. Socorro Island, Mexico.

out their cleaning work in a specific location on the reef known as a "cleaning station," and will defend it against other cleaners. Much as we know the locations of our local supermarket, gas station, and post office like the back of our hands, the same can be said for coral reef fish and their cleaning stations. In this mutualism, the cleaners gain nutritional benefits from eating the parasites, while the clients get rid of their interloping parasites and damaged tissues.

Cleaner wrasses are constantly cleaning or otherwise advertising their services during daylight hours. Local residents visit them multiple times during the day, and almost all fish visit a cleaning station at some point. This work is so valuable that some medium- to large-sized fish visit them on average every five minutes during daylight hours, racking up almost 150 visits in a day. The particularly pesky gnathiid larvae that parasitize reef fish engorge quickly and drop off after several hours, so it is vital that the parasite be removed as quickly as possible. An individual cleaner wrasse can serve over two thousand clients in a day, removing on average one parasite from every other client that visits.[121]

I have spent a great many dives just watching the antics at cleaning stations. I

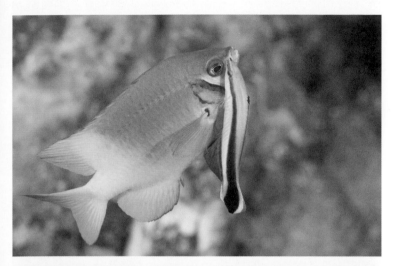

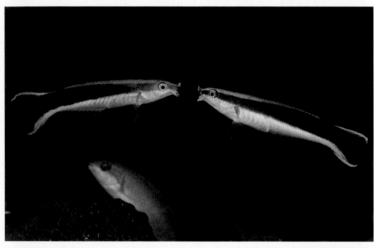

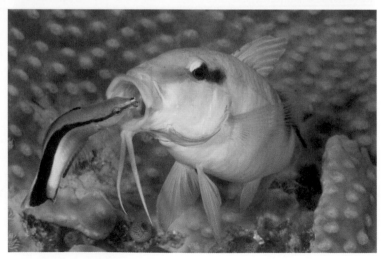

find a quiet position a short distance away to avoid disturbing the animals and watch as the fish start arriving for their daily routine. At first, they are tentative, but then they start arriving en masse and forming orderly queues. Sometimes a whole school of fusiliers will arrive and form a ball just above the sea bottom, all vying for the attention of the two frenetic cleaners. Much like at a beauty salon, some clients are fussier than others. If a client seems to want a full makeover and the cleaner doesn't have time, the cleaner will just potter off to its next client while the desperate first client waits with its fins held wide open ready for the cleaning.

The interaction between the cleaner wrasse and the client fish is rather intimate. The cleaner is allowed access to very vulnerable soft tissues that the client would ordinarily protect, such as the gills and around the eyes. Conversely, the cleaner could be putting itself at risk by entering the mouth of a large predatory fish that would usually predate upon fish of a similar size. To counteract potential threats, cleaner wrasses touch the client with their pelvic and pectoral fins as tactile stimulation to ensure an enduring positive interaction.[122] The cleaner's touch seems to encourage clients to spend more time at the cleaning station. The cleaner makes a greater number of these sensual touches on predatory fish than it does non-predatory fish. This seems to suggest that the cleaner is making an effort to avoid conflict between itself and a potentially dangerous client. Furthermore, the cleaner's touching of predatory fish seems to reduce their aggression toward other prey fish using the same cleaning station.[123] Cleaning stations may act as a temporary safe haven from predation.

Fish take on a distinctive posture during their time at cleaning stations. Usually the only time you'll

catch a fish with all its fins open is when it's displaying to members of its own species, but at cleaning stations it is common for fish to posture with their fins open as parasites love to nestle inside the folded fins of host fish. In the Maldives, I spent some time watching a gray reef shark cleaning station, where several six-foot-long sharks were queuing up to be cleaned. Sharks tend to be negatively buoyant and sink when they stop moving. It was amusing to watch the sharks at the cleaning station with their mouths wide open, sinking from the tail down as the cleaner wrasses performed their own brand of dentistry. The sharks could only hold their stance for a short time before needing to swim off and readjust their posture. Many sharks need to have water flowing over their gills to get oxygen, so it must be an unusual and possibly uncomfortable sensation for them to stop at a cleaning station.

The action of cleaner wrasses is key in maintaining high species diversity on coral reefs. Studies of reefs where cleaner wrasses were absent or removed showed that the number of species significantly reduced over a period of four to twenty months.[124] It has also been shown that the parasite infection of reef fish increases fourfold within twelve hours of cleaner wrasse removal. Where cleaner wrasses were added to sites where none had previously been, it took just a few weeks for fish diversity to increase.

Mitigating the negative impacts of parasites seems to be a very important consideration in the lives of reef fishes. However, despite client fish visiting cleaning stations almost obsessively throughout the day, they remain vulnerable at night when most gnathiid feeding occurs. Many fish are covered in a thin layer of mucus, which generally acts to reduce abrasions and prevent sun damage. Amazingly, however, some parrotfishes and wrasses produce a mucus cocoon in which to sleep. This was long thought to prevent predators from being able to smell them as they slept, but the cocoon has since been discovered to act like a mosquito net against parasite attack. Where cocoons were removed, the infestation rate of these fish was much higher.[125]

ABOVE TOP: Stocky anthias being cleaned by a juvenile blue-streak cleaner wrasse. Alor, Indonesia.

ABOVE BOTTOM: Ryukyu fairy wrasse with fins open being cleaned. Wakatobi, Sulawesi, Indonesia.

OPPOSITE TOP: Yellowtail damselfish being cleaned by a blue-streaked cleaner wrasse. Wakatobi, Sulawesi, Indonesia.

OPPOSITE MIDDLE: Cleaner wrasses settling a territorial dispute. Raja Ampat, West Papua, Indonesia.

OPPOSITE BOTTOM: Blue-streak cleaner wrasse cleaning the mouth of a goatfish. Bangka Island, Indonesia.

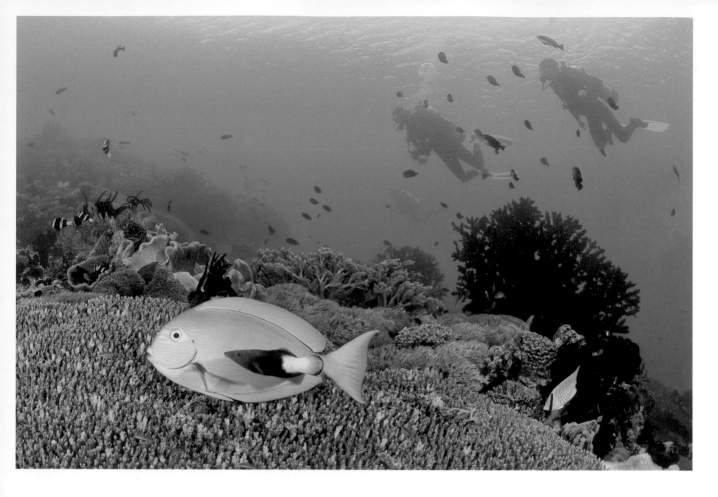

The use of the equivalent of mosquito nets by sleeping reef fish also highlights a secondary impact of gnathiid parasites. In the tropics, humans began using mosquito nets to avoid being irritated by mosquito bites, but more importantly they reduce contact with mosquitoes carrying the potentially fatal malarial parasite. Unexpectedly, it was discovered that gnathiids, just like mosquitoes, carry a blood-borne parasite that infects their hosts. The fish equivalent of malaria is called "haemogregarines" and can cause anemia and death.[126] Clearly it is in the best interests of the fish to avoid at all costs gnathiids and the parasites they are potentially carrying.

As in any relationship, there is potential for deception of some kind to occur between the cleaner and the client at the cleaning station. Sometimes the blue-streak cleaner wrasses like to cheat, preferring to eat the client's healthy mucus and scales rather than their parasites. It is clearly in the best interests of the client that the cleaner acts honorably and doesn't take advantage of it whilst it is being cleaned. This is encouraged through repeat custom by the client to build up trust over time. If a cleaner cheats and takes a bite out of a regular client, then the client

chases it off as punishment and is wary to return. Next time when the client visits, the cleaner is encouraged to provide better service to avoid punishment. Onetime clients are more likely to respond to cheating by swimming off and patronizing another cleaning station instead.[127] Through honest interactions, the cleaner builds rapport with repeat clients, and also tries to build trust with new clients through better, more authentic initial interactions. Interestingly, if there are other client fish looking on while the cleaner cleans another fish, the cleaner is much more likely not to cheat, as if a prospective client who witnesses a cleaner cheating will be much more likely to avoid it in the future. Without Yelp or the Better Business Bureau, fish must rely on a consumer savvy built by instinct, observation, and interaction.

The interactions between client and cleaner appear to differ depending on the species of cleaner in question. A close relative of the blue-streak cleaner, the bicolor cleaner wrasse, *L. bicolor*, is a larger species and has a larger home range. Rather than clients coming to the small service area of the blue-streak's cleaning station, the bicolor cleans clients throughout its home range. This suggests that bicolor cleaners are less likely to have repeat clients, so building up a rapport doesn't carry the same importance, and it becomes easier to cheat.[128] Rather than waiting for clients to come to a cleaning station, as happens in a blue-streak patch, the bicolor wrasse actively seeks out new clients. Because the clients are less likely to know the cleaner and have repeat interactions, especially when the cleaner is roving over a large area, bicolor cleaners lean toward parasitism, rather than mutualism, preferring to eat the client's healthier tissues and mucus rather than its parasites.

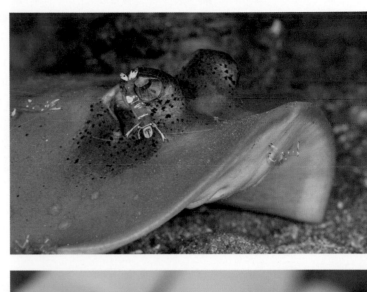

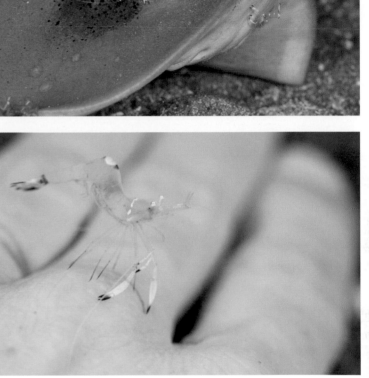

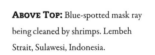

ABOVE TOP: Blue-spotted mask ray being cleaned by shrimps. Lembeh Strait, Sulawesi, Indonesia.

ABOVE BOTTOM: Shrimp manicure. Lembeh Strait, Sulawesi, Indonesia.

Fake It till You Make It

Cleaner wrasses have an incomparably intimate interaction with their clients, which must make predatory fish—who want the same access to *their* prey—quite envious. The blue-stripe fang blenny mimics juvenile cleaner wrasses in order to get close to its meals. Instead of cleaning parasites from fish, this aggressive trickster darts in and bites a chunk of flesh or scales from unsuspecting "clients." Another mimic, the false cleaner fish, also mimics the blue-streak cleaner wrasse, but it uses its advantage to garner protection, rather than prey. This doppelganger favors eggs and worms rather than fish.

Besides cleaner wrasses, there are many other hygiene-obsessed organisms, including many species of shrimps. I have spent lots of time exploring shallow tropical sandy expanses, which, due to a lack of coral reef structures and an insufficient numbers of clients, don't offer suitable habitats for cleaner fish. Parasites are still a problem for the large puffer fish and stingrays that frequent this kind of habitat, so it seems that crustacean cleaners have stepped up in their stead. In the absence of cleaner wrasses, large fishes employ the services of shrimps that live on anemones and strange tube anemones which advertise their services by clapping together their claw arms. When client fish arrive at these unconventional cleaning areas, a dozen small transparent shrimp appear out of the safety of the anemone's stinging tentacles to pick off small parasites or damaged tissue from the client. I have even dared to offer my own hand to these cleaners, who eagerly removed skin from my cuticles in an impromptu manicure.

Parasite Types

Given their intimate location, internal parasites are difficult to see but easy to fear. Perhaps it is their very obscurity that lends an extra level of terror to their insidious reputation. After all, we fear most the things we cannot see: the bogeyman under the bed, the monster who lurks in the dark recesses of the closet. Under the cover of shells, scales, and skin, these covert parasites spread, spawn, and sustain themselves at the expense of their living host. On a few occasions, I have caught a glimpse through the transparent hard upper shell, the carapace, of a crustacean and seen a little-known parasitic fecampiid worm living inside. The parasite looks like a pink intestine, taking over any pocket of free space within the shrimp. For the fecampiid, the shrimp is nothing more than an eating machine. The parasite does

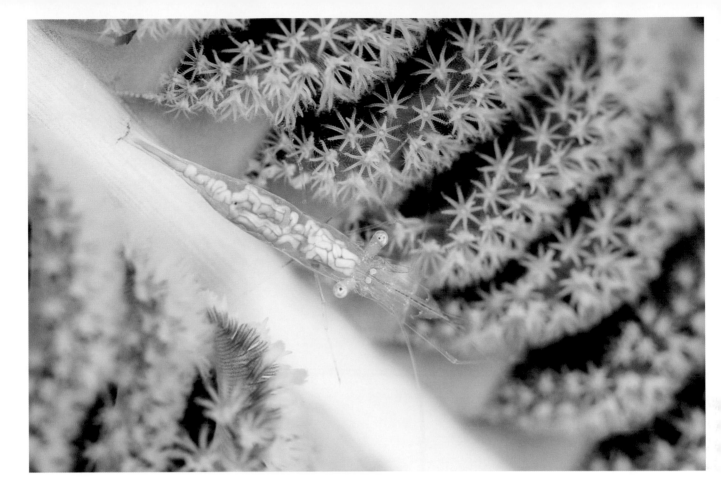

not need the shrimp to reproduce, so it sterilizes the animal. It also does not need the shrimp to grow or develop sexually, since these processes might distract from the ever-important task of consumption. This relationship does not endure; it erodes the very life force of the shrimp. Fecampiid worms, unlike parasites we have discussed before, are thought to be parasitoids: exacting and unremitting intruders that ultimately kill their host.[129] There is little known about fecampiids and after I captured images of some them, I sent my images to experts at London's Natural History Museum; they believe the images are almost certainly of a not-yet-identified species of fecampiid.

Around 10 percent of all insects are believed to be parasitoids, most of which are wasps. They lay their eggs inside the bodies of other organisms, where they hatch and devour the internal organs one by one, starting with the nonessential organs before pupating within the host and killing it when they emerge. There are even some parasitoids, hyperparasitoids, that lay their eggs in the grubs of other parasitoids. In this case, these Russian dolls of grubs develop inside another grub that is already developing within the initial host.

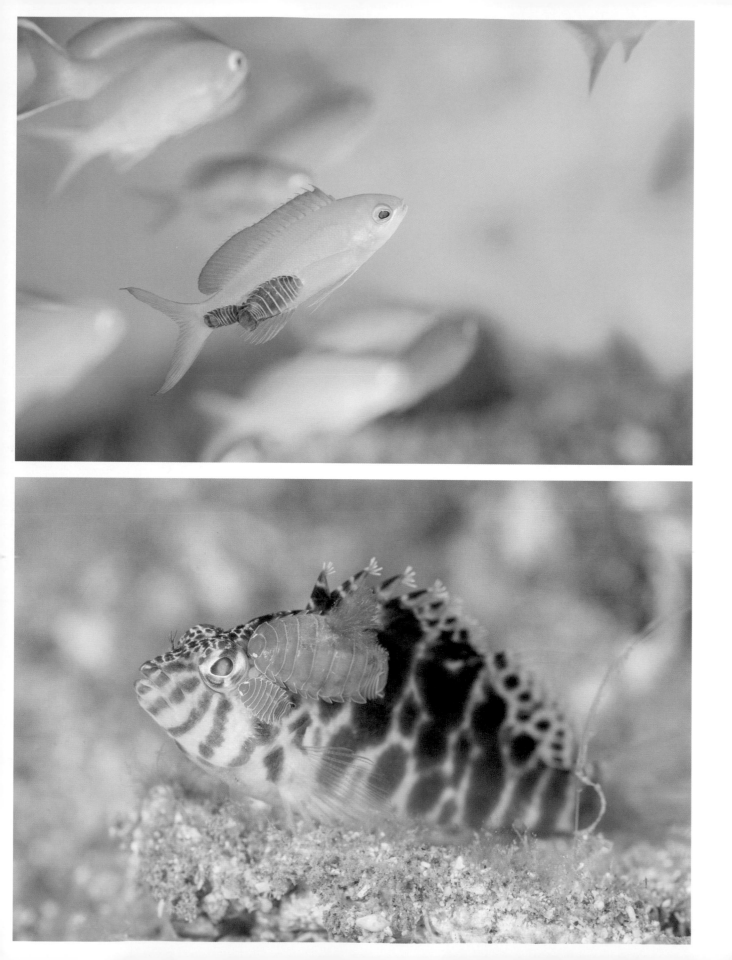

While we rarely see internal parasites, there are external parasites that we see often; the most commonly found on coral reefs are isopods and copepods, both of which develop long-lasting relationships with their hosts. Since my obsession with parasites began, I have found many that seem to be new to science. I guess divers aren't as interested in finding new parasites as they are in finding fishes, crustaceans, and conventionally cute animals like pygmy seahorses and nudibranchs.

There are many types of isopod crustaceans, and not all are parasitic. Perhaps you've seen a pill bug in your garden, rummaging in rotting wood. In the deep sea, giant isopods can reach twenty inches in length. Parasitic isopods, on the other hand, range in size from one to five centimeters, with females generally outsizing the males. Like many parasites, they're very specific about the host species they'll infect, as well as their attachment site on the body. There are several main kinds of parasitic isopods and they all have their partialities: scale-attaching, flesh-burrowing, mouth-living, and gill-attaching. Although they rarely kill the host, they can cause localized lesions, reduced growth, and behavioral changes—perhaps, most devastating of all, they have also been found to castrate their host.[130]

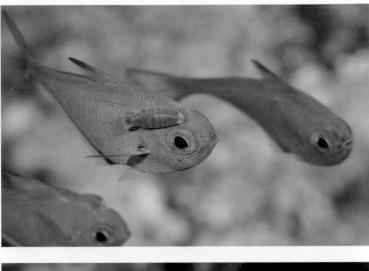

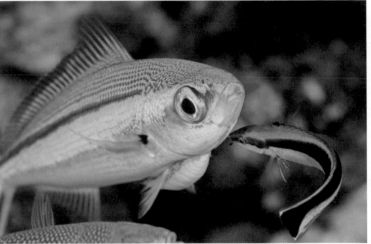

In my hunt for parasitic isopods, I have been lucky enough to come across various forms, again several of which seem to have been previously unknown. At a cleaning station in West Papua, a school of fusiliers came in and queued to be cleaned. Among them I noticed numerous individuals with large isopods, about an inch in length, underneath the chin. Fusiliers have adapted to feeding on plankton in the blue water off the reef, doing their best to avoid predators in this exposed habitat. They travel in dense schools and employ countershading as camouflage, their top half darker than the lower half. This camouflage protects them from predators that swim above since the dark coloration blends into the deep blue of the sea. When viewed from below, the pale belly blends in with the bright sky above. Many

ABOVE TOP: Sweeper and isopod. Raja Ampat, West Papua, Indonesia.

ABOVE BOTTOM: One stripe fusilier with an undescribed isopod parasite much too large to be removed by a cleaner wrasse. Raja Ampat, West Papua, Indonesia.

OPPOSITE TOP: Anthias infected with a male-female pair of isopod parasites. Alor, Indonesia.

OPPOSITE BOTTOM: Blotched hawkfish with a male-female pair of isopod parasites. Sangeang Island, Indonesia.

Parasites Rule the Reef

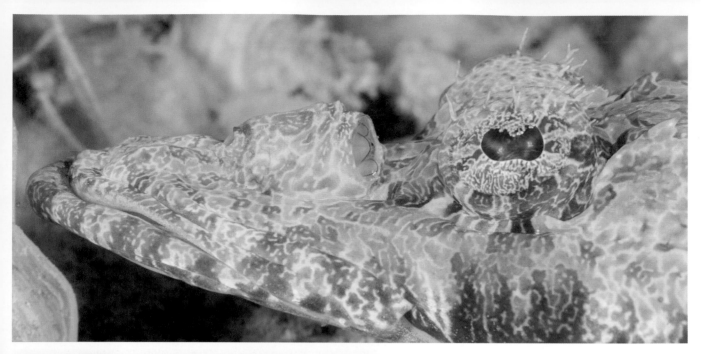

fishes use countershading for camouflage and it is common in predators such as sharks, allowing them to sneak up on prey. The isopods, clinging to the bellies of the fish, blended into the sheet-white coloration of their attachment locations.

I had never seen an all-white isopod before, but it follows that selective pressure and natural selection would cause the parasite to conform in color to its host. If the parasite was black or gray, it would appear conspicuously on the fish—a living beauty mark, a sizable freckle to draw a predator's attention. The host fish would lose the advantage of its all-white camouflage; predators could identify and follow this fish in the school and spot it against the pale blue water. If the fish gets eaten by a predator, the parasite gets eaten too. And if the parasite gets eaten, it will not get to pass on its genes. Blending in with the host becomes a matter of biological imperative; the all-white color owes to the selective pressure faced by generations of isopods. I was able to photograph some of these isopods and an expert in the field who had never seen such a parasite before made it clear that the animals I photographed were likely members of yet another species to be added to the tally of unknown ones.

Another surprising (and seemingly undescribed) isopod that I found in the Philippines was attached to a flathead fish. I came across the large flathead,

The World Beneath

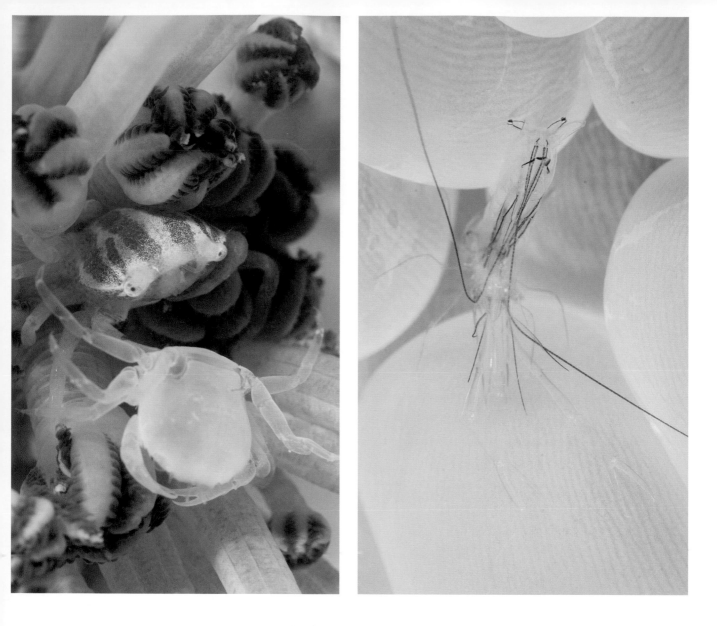

commonly also known as a crocodilefish, due to its superficially similar shape to the large reptiles, sitting out on the reef top. The fish was about two feet in length, and I noticed its nostril was enormously swollen. On closer inspection, I saw the tail of an isopod poking out of the nostril's opening. Apparently, this isopod preferred to infect the fish as a larva, crawling into the nostril and feasting on the blood of its unsuspecting host. As the isopod grows, the skin around the nostril stretches to accommodate it, becoming both safe haven and cafeteria.

One of the best known and most macabre of isopods, however, is the cymothoid tongue-biter. When small, the parasite crawls through the gill arches and into the fish's mouth, where it attaches to the tongue. Over time it devours

The World Beneath

the tongue and takes its place in the mouth, enacting the only example of anatomical replacement by another organism in the natural world. The fish can use the new tongue-shaped parasite as a prosthetic to grip and swallow prey. I have seen these tongue-biters in the mouths of anemonefish; sometimes they are so large that the fish can't properly close their mouths.

The life cycle and reproduction of isopods is fascinating. Like kangaroos, females carry eggs and developing young in a pouch under their bodies, which is called a "marsupium." Once the young hatch, they undergo a few molts of the outer layer of their skin, called the "exoskeleton," before leaving this protective enclave. Whilst the freshly exposed skin beneath is soft and supple they suck in a little seawater and expand slightly, before the skin hardens to serve its protective function. They leave the pouch as active swimmers but after a short while must attach to a host of their own and return to a sedentary lifestyle. Because of this small window for attachment, some sites seem completely infested by parasites. Every individual in a given school can become infected, since larvae leave the pouches of mature females en masse and infect as many of the local fish as possible.

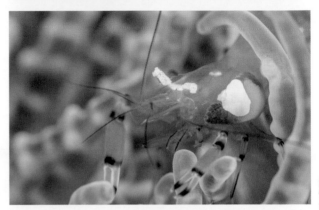

Over the years, on numerous occasions, I had seen a colorful imperial shrimp, a white mottled Coleman shrimp, or orange *Leander plumosus* shrimp, with a huge bulge on the side of the head, but the pigments of the shrimp's carapace thwarted me from investigating the isopod I knew to be residing inside. While diving in Bali in 2016, I found a glass anemone shrimp with a transparent carapace and a noticeable bump on the side of its head. Because

the shrimp was just an inch long, I couldn't see much with the naked eye. But I took several images and through the magnification of my computer screen, I saw the tail of the isopod and a large clutch of eggs. Unlike other isopods that brood their young in a marsupium, these eggs were laid directly against the inside of the shrimp's exoskeleton. It became an exercise in patience to gather more information about this elusive parasite, but a year later I was rewarded with another glass anemone shrimp. This shrimp hosted a brood that had hatched and undergone several molts. I could clearly see a pair of beady little eyes on each of the four miniature

ABOVE, TOP TO BOTTOM: Glass anemone shrimp with an isopod on the side of the head. Bali, Indonesia.

Glass anemone shrimp with an isopod on the side of the head and a clutch of eggs against the inside of the carapace. Bali, Indonesia.

Glass anemone shrimp with an adult isopod and four juveniles. Bunaken Island, Indonesia.

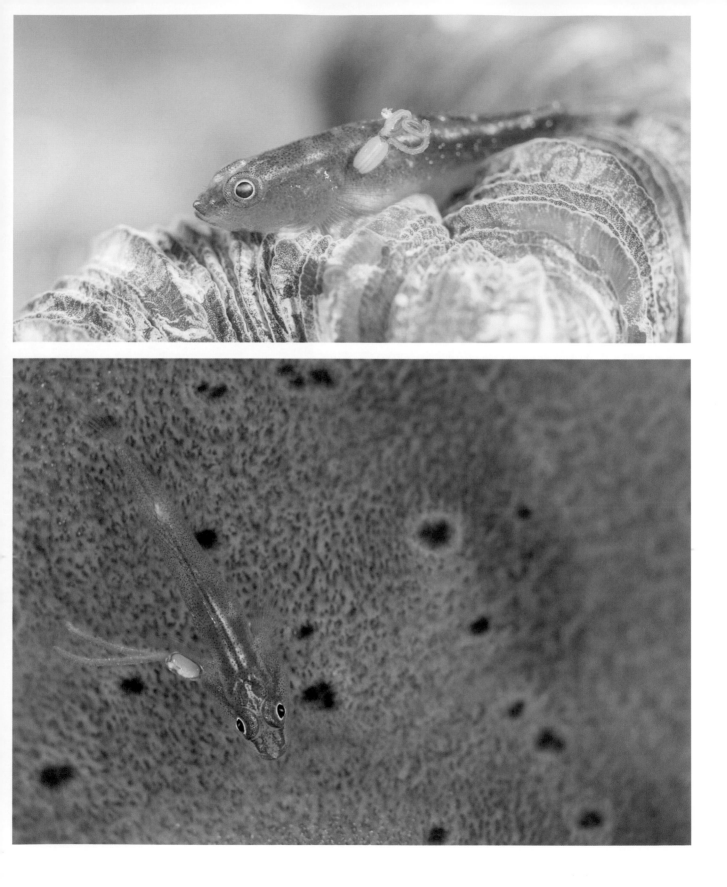

The World Beneath

baby isopods squished between their mother and the exoskeleton of the shrimp. At just a few millimeters long, it wouldn't be long until they left the safety of this host, possibly through the gills, to find homes of their own.

Almost as widespread as isopod parasites are copepods: a widespread group of around thirteen thousand crustacean species found in many niches across the world's aquatic ecosystems. Parasitic copepods feed directly on the blood of their hosts, as well as their mucous and tissues. Large females are usually the most conspicuous, as they have prominent eggs coils coming off their bodies, whereas the male is usually too small to be seen with the naked eye. However, not all of the thirteen thousand copepod species are parasitic. They inhabit a variety of ecosystems; some live on the seafloor, while some float freely in the open ocean pelagic zone. Among the latter is the sea sapphire. I had long wondered about the fish-scale-like iridescent blue flecks that I often saw while swimming away from the reef into blue water at the end of a dive. It wasn't until I had the opportunity to observe them up close that these microscopic creatures truly revealed themselves to me.

In a rarely visited northern region of Raja Ampat in Indonesian West Papua, I visited a bay where prevailing currents had trapped huge numbers of pelagic sea squirts, known as "salps." I was at the end of my dive, completing a safety stop at around fifteen feet to help off-gas some of the nitrogen that had accumulated in my blood. As I hovered in the water, my friend Wendy pointed out a three-inch-long salp drifting toward me. I peered inside the gelatinous body of the salp and to my surprise I noticed half a dozen of the iridescent specks that I had previously only seen floating in blue water. Each measured just a few millimeters in length and all were shimmering shades of blue, green, and turquoise. I took several images and once I was back on the boat looked at them on the big screen. Suddenly it became clear that these glittering gems were copepods.

When I began to research these copepods, also known as "sappharinas," I learned that the iridescent shimmering individuals were males. The few plain-looking animals residing in the salps were females. Typically, males float freely in the water column while the females reside inside the salps. When the mood strikes, male sappharinas enter the salps and mate with the females. The role of the male's color in the mating process isn't yet fully understood, but it likely helps a male and female pair up.[131] Their skin is comprised of multilayered hexagonal plates separated by just a tiny fraction of a millimeter. This separation distance varies between species; the species I observed in Indonesia has plates that were separated by the

OPPOSITE TOP: Goby with copepod and twin egg coils. Wakatobi, Sulawesi, Indonesia.

OPPOSITE BOTTOM: Goby on the mantle of a giant clam with copepod and twin egg coils. Raja Ampat, West Papua, Indonesia.

The World Beneath

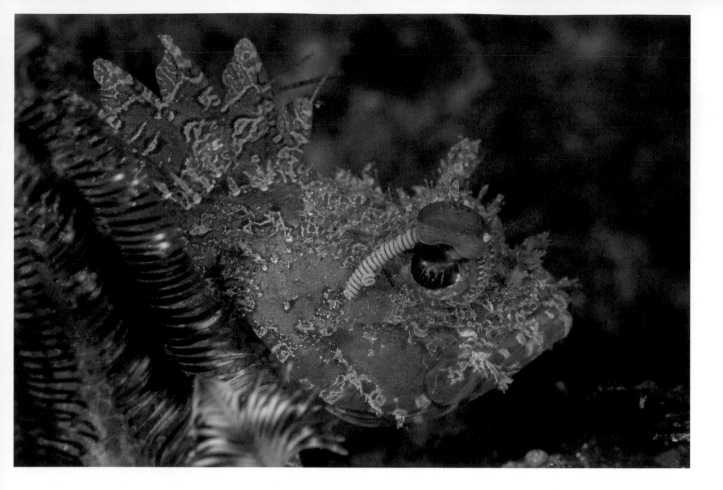

same distances as a wavelength of blue light. Blue light passes through these spaces uninterrupted, whereas other wavelengths of light are lost, resulting in the eponymous shimmer. Just by shifting slightly the angle at which light strikes, the animal can become transparent, obscured and protected from potential predators.[132]

Parasites infect a wide range of species, and we are only slowly acquainting ourselves with their range. Examining an image at 100 percent magnification, I spotted an unexpected copepod on a photo I took of a Pontoh's pygmy seahorse. This is the first known pygmy seahorse parasite. These seahorses are only three-quarters of an inch long, so it stands to reason that their parasites would be even tinier and invisible to the naked eye. The seahorses themselves have been the focus of very little research, my own being the only major study on their biology, so it is unsurprising that their parasites would be unknown. The tiny copepod, after all, was just a speck on the seahorse's flank.

I found another copepod in Osezaki, a protected bay in the chilly waters just south of Tokyo, that sits with Mount Fuji looming on the horizon. At sixty feet below the water's surface, a scorpionfish camouflaged itself among a patch of organic

debris. Looking closer, I noticed a large, broad bean-shaped copepod attached directly to the fish's eyeball. The scar tissue on the eye was visible, in addition to a bright pink egg sac densely coiled and coming off the parasite toward the fish's tail. Just visible to the naked eye, a tiny white barnacle grew on the surface of the parasite. It is quite possible, given how host-specific many of these parasites are, that the copepod attached to the eye of the scorpionfish may only attach in that one location, and the barnacle growing on its surface may only grow on the surface of these copepods.

I hope that learning more about parasites has meant that they have grown on you a little too (interest-wise, not physically). Despite the morbid fascination they inspire, parasites have the dubious honor of being the only group of animals that scientists are working to eradicate, rather than conserve. On coral reefs, they are easily overlooked, but once they take hold of you, they never let go. As one of the planet's richest ecosystems, coral reefs likely contain more species of marine parasites than anywhere else on Earth. As much as they might make you squirm, they too contribute to the extraordinary diversity that makes coral reefs one of the most biodiverse ecosystems on the planet.

The more we learn, the more we realize the ubiquity of parasites and the insidiousness of their actions on organisms across the tree of life. It has been suggested that the evolution of the peacock's highly ornamented and colorful tail was driven by parasites. Males with bright colors are believed by females to be less likely to have a heavy parasite load than their drab competitors. Although parasites are unlikely to explain the kaleidoscope of patterns found on coral reef fish, this is certainly the most colorful ecosystem on the planet for a reason, one we will explore in the next chapter.

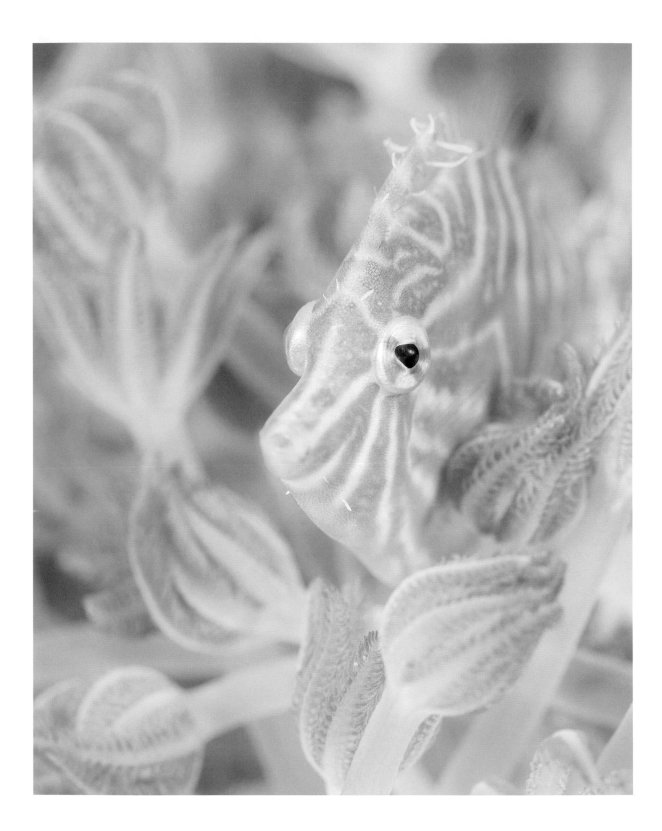

COLORS
OF THE REEF

Scarlet red soft corals nestle between baby blue sponges and pink *Tubastrea* corals. A yellow crinoid, the shade of a daffodil, perches atop the mélange. Above the reef, a rainbow of fishes, some of which change color at the drop of a hat, parade their turquoise, shimmering white, and cerulean displays. On the reef, a pair of yellow-rimmed panda butterflyfish swim over cerise corals and past a riotously colorful fairy wrasse. Even the smallest tangerine-colored sea slug is arresting in its beauty. Amphipod crustaceans, smaller than peppercorns, don bands of bright orange and blue, like sprinkles on a cupcake. It's easy to forget that this kaleidoscope of color isn't made for our benefit alone. Biological imperative, rather, compels each organism to appear the way it does. The reasons are many, but appreciating how marine creatures perceive each other is often key to understanding the purpose of their coloration.

Since the Cambrian explosion around 540 million years ago, when the first complex eyes evolved and the oceans suddenly became filled with an enormous diversity of visually orientated organisms, sight has been used for a wide variety of purposes. Today, vision drives mate selection and species recognition, communicates health, fosters social interactions, maintains territories, and aids in prey detection, and predator evasion through mimicry and crypsis.

We perceive just 40 percent of the light that reaches the Earth from the Sun,

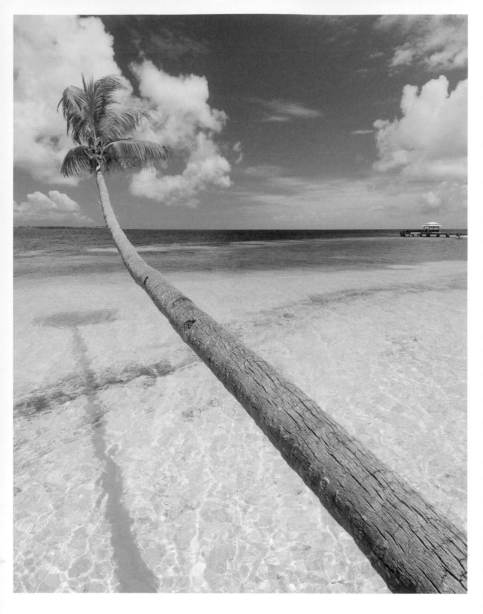

which we call the "visible spectrum." The visible spectrum is comprised of the colors of the rainbow, each of which carries a slightly different wavelength. Red light has the longest wavelength, and thus has the least energy within the visible spectrum. Violet is the most energetic and has the shortest wavelength. The remainder of the light that reaches Earth is invisible to us and is comprised of infrared energy (50 percent), ultraviolet (UV; 9 percent), and X-rays or microwaves (1 percent). The visible spectrum is sandwiched between high-energy, short-wavelength UV and low-energy, long-wavelength infrared, neither of which we can see. The high energy of UV light can be damaging to living tissues and DNA due to the penetrative ability of the high-energy waves; this is the reason we use sunscreen. Infrared, on the other hand, is not damaging but produces warmth through the energy it transfers.

As land-living animals, visible light reaches us after passing through space and the Earth's atmosphere; however, in the marine environment, light must also pass through the water column. Light that passes through the water surface and isn't reflected into the atmosphere is absorbed by the water column in differing amounts according to depth.

Where the ocean is devoid of all other materials, such as sediments that make it brown, phytoplankton, which make it green, or blooms of certain algae, which can make it appear red, the water appears as we know it best: blue. The water column quickly absorbs both long wavelength light at the red end of the visible color spectrum, and short wavelength violet and UV. The remaining light is mostly

blue, which penetrates most deeply into the water, giving the ocean its trademark hue. At shallow depths, or in small volumes such as the contents of a glass, the liquid appears clear since there aren't enough water molecules to absorb the light. Imagine the gradually sloping sands around a coral atoll that start in shallow water and lead into the abyss. The white sand is immediately apparent in the shallows where all light reaches the substrate, but gradually progresses from light to dark blue with the distance from shore and increasing depth.

EYE SPY

Marine creatures experience the reef differently than we do, and it is important for us to consider the ocean's colors and shapes through their eyes, not our own. Some fishes see wavelengths of light that we do not; some see color; some see ultraviolet. The visual acuity of reef fish makes the reef appear significantly less colorful for them than it does for us.

Humans have two types of classic photoreceptors, called "rods" and "cones." Rods play a very limited role in our perception of color but are extremely light-sensitive and afford us night vision, which is why we see little color in dim light. We perceive color vision, finer detail, and faster resolution using cones. Like certain fishes, we have trichromatic color vision, with three types of cone cells that each detect different wavelengths of light in the visible spectrum. Color blindness occurs where one of these cones doesn't function correctly. There are also dichromatic fishes, with only two types of color photoreceptors. Most spectacular among reef inhabitants is the mantis shrimp, which currently holds the record by possessing twelve different color receptors.[133] At least some fish have ultraviolet-sensitive cones, and this seems especially common in coral reef fish since they live in clear, UV-intense waters. The function of UV vision could include improved hunting, navigation, recognition of UV color patterns in other members of their own species, social signaling, or the avoidance of areas with high levels of damaging UV exposure.[134]

Our understanding of UV signaling and vision in fish is still in its relative infancy.[135] We know that many reef fish possess color patterns visible only in UV, which are invisible to us under natural light conditions. Certain damselfishes have extensive UV patterning over the face and fins, which they seem to flaunt during antagonistic displays with fish that enter their territory. It is thought that around half of all reef fish have UV light sensitivity, so it seems that there may be a

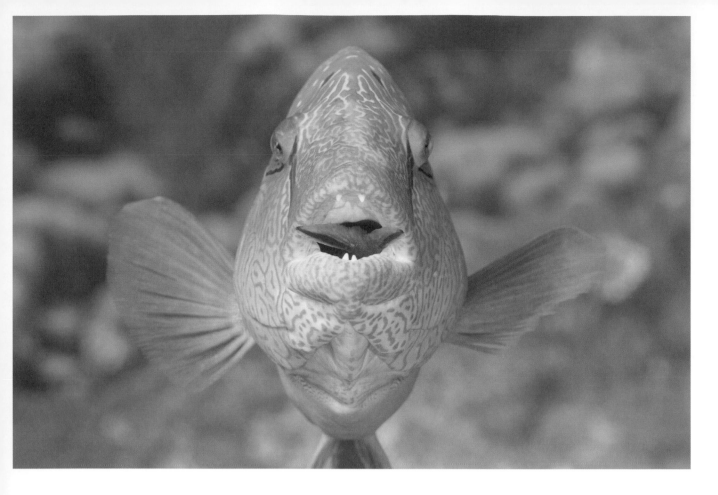

ABOVE: The green colors of Napoleon wrasses allow them to blend into mid-water tones, and in this case catch a damselfish. Raja Ampat, West Papua, Indonesia.

OPPPOSITE TOP TO BOTTOM:
A rare blue-line octopus from a short stretch of the east Australian coast. Nelson Bay, New South Wales, Australia.

Greater blue-ringed octopus showing off full colors. Lembeh Strait, Sulawesi, Indonesia.

Southern blue-ringed octopus swimming. South Australia.

potential for its use in signaling. Given the fact that many predatory fishes cannot see in UV, it seems that UV patterning may be a secret signaling channel used between non-predatory species.

COLOR AND ITS PURPOSE

Although most reef fish appear vibrant to us, many of them utilize their coloration as camouflage. Parrotfishes, for example, rely on unique pigments in their skin to blend into the hard corals that they feed upon. Green fishes, such as certain wrasses, become camouflaged when viewed horizontally in shallow water over the reef flats. Yellow fishes, on the other hand, such as certain damselfishes, many butterflyfishes, and even a yellow phase of the trumpet fish, disappear against typical reef colors of soft and hard corals. These yellow fishes seem particularly conspicuous to human eyes as we are adept at distinguishing yellow against a green background, but to other fish, these shades are difficult to discriminate. Blue fishes, as expected, fade into the expanse of deep water.

Many reef fishes are endowed with strikingly complex patterns and colors. It is hard to believe that this might confer them with camouflage. The adult emperor angelfish, for example, has vivid yellow and blue stripes over the latter two-thirds of its body as well as a bright mustard yellow tail, with dark saddles around the neck and over the eyes. To our visual system these fish are conspicuous from far across the reef, but many fish are unable to resolve these patterns over long distances. This affords the angelfish with camouflage against predators, unless at very close quarters.[136] At close range, they are extremely conspicuous. Suddenly the blue and yellow bands that previously camouflaged the fish provide a strong color contrast. This may act as aposematic coloration, which, like a bee's distinctive yellow and black stripes, informs a predator that an organism is potentially dangerous. In the case of angelfish, large spines on the cheeks make them hazardous for predators to swallow. They are territorial, moving around the reef in pairs; perhaps their coloration warns possible interlopers of their territory. When threatened, the emperor angel often hides among branching corals, and it has been suggested that the blue and yellow stripes act to obscure its outline in the coral, effectively camouflaging it.

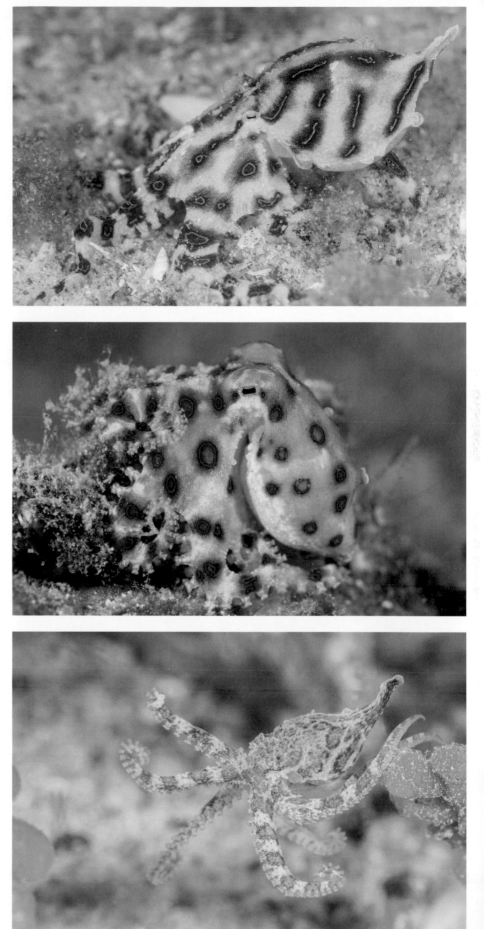

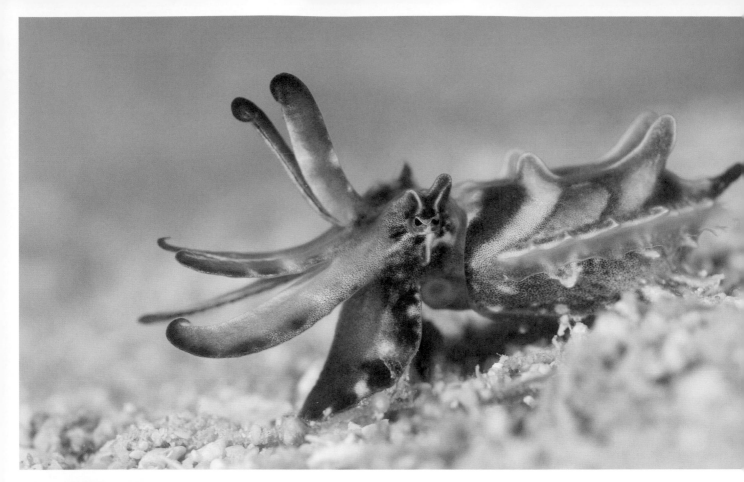

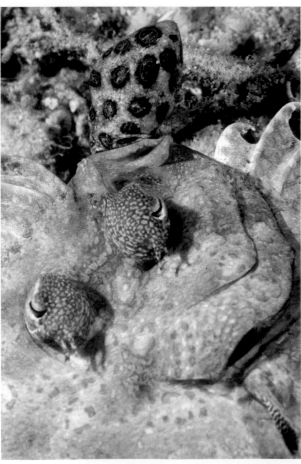

Fish colors and patterns have evolved over millions of years, driven by interactions both within and outside their species. When communicating with other species, color may offer a warning to predators through aposematic, or warning, coloration, or help camouflage an animal through disruptive camouflage, crypsis, mimicry, or countershading. Aposematic coloration is common on the reef, since there are many species that have evolved venom to protect themselves against predators. Why produce these costly chemicals, depleting vital energy stores, if by not showing them off you end up getting eaten before the predator realizes its deadly error? Other animals, however, remain camouflaged where possible and keep their vivid displays concealed until they sense a real threat, including the blue-ringed octopus, poison ocellate octopus, flamboyant cuttlefish, and flasher scorpions. Both of these octopuses and the cuttlefish contain tetrodotoxin, a deadly nerve blocker produced by symbiotic bacteria, in their bite or

The World Beneath

within their flesh. These animals usually remain well camouflaged as they go about their business on the reef, but when a predator approaches, they flash the vivid aposematic colors that advertise their danger.

I had longed to see a blue-ringed octopus for years, but one thousand dives later I still hadn't been lucky enough to find one. I visited a remote island in southeast Sulawesi, Indonesia, where I heard that they had sometimes been spotted in the early morning in the shallow lagoon. These animals are very small, just the size of an adult's thumb, but despite the odds, early each morning for two weeks I jumped into the water to hunt for one of these elusive cephalopods. Finally, on the last morning I spotted one swimming in mid-water, its body covered in bright blue rings. Unusual, I thought, since they usually only show these colors off when in danger. Suddenly, I understood why. A peacock flounder swam in an undulating fashion up from the sand and chomped down on the octopus, with only the cephalopod's head bobbing from the flounder's mouth. The fish immediately spat out the octopus, realizing its grave error too late, I presumed. However, seconds later the flounder was back for more. It approached the octopus again, this time swallowing it whole. I was sure that the flounder would die and spent the next twenty minutes watching, waiting for the deadly nerve blocker to take hold. But the fish appeared fine. In the Caribbean, these flounders have been observed feeding on puffer fish that contain the same tetrodotoxin that blue-ringed octopuses carry in their flesh, so perhaps they have a mechanism that inhibits the toxin's fatal course of action.

The bullseye electric ray, native to the tropical East Pacific, takes a less subtle approach. As the name suggests, the ray has the capability to generate an electric charge through a pair of kidney-shaped organs near its eyes. These organs are used to subdue prey, but also to thwart attacks from predators. I came across one of these while diving in the Sea of Cortez between Baja California and the mainland of Mexico. The ray was a foot and a half in length and just sitting out on the open sand. Its namesake bull's-eye caught my attention. Concentric rings of black, yellow, and dusky gray surrounded a golden center. Otherwise, the ray blended into the sand. As I approached, the ray lifted its tail end off the sand to show off its design.

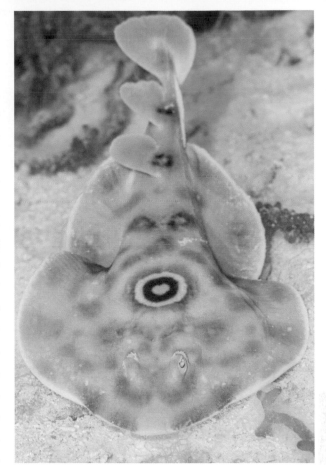

ABOVE: Bullseye electric ray displaying its warning coloration. Sea of Cortez, Mexico.

OPPOSITE TOP: Flamboyant cuttlefish. Puerto Galera, Mindoro Island, Philippines.

OPPOSITE BOTTOM: Blue-ringed octopus being eaten by a flounder. Wakatobi, Sulawesi, Indonesia.

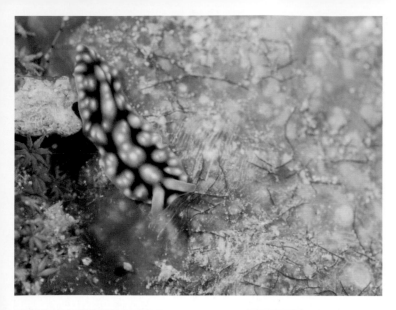

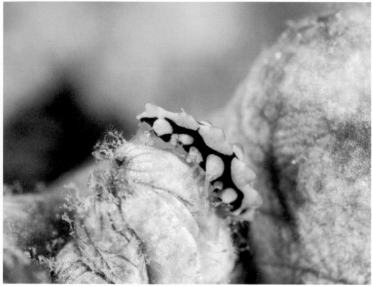

Clearly, it is beneficial for predators to learn the signs of a potentially deadly meal compared to a more palatable alternative. Predators avoid species known to be noxious, and therein lies the potential for other species to exploit the situation. Harmless species that mimic dangerous species are known as "Batesian mimics." Those mimics that resemble the model most closely are more likely to survive and pass on their genes. Over generations, and through selective adaptation, the mimicry becomes extremely accurate. The banded snake eel mimics the banded sea krait, a type of highly venomous sea snake belonging to the same family as the cobra. The snake eel is so similar to its model that it even hoodwinks divers. The banded snake eel is so secure in its mimicry that it spends its days swimming openly and hunting fearlessly around the reef, chipper and secure in its disguise. Meanwhile, other snake eels that don't mimic toxic species are confined to the cover of darkness before emerging to hunt.

Phyllidia nudibranchs are a common genus of sea slugs on coral reefs. In fact, they may be one of the most commonly spotted groups, and divers often ignore them as a result. Predators avoid these nudibranchs due to the toxic secretions that they produce from the sponges they prey on. As a result, many other species mimic them across various animal groups, including other slugs and flatworms. One of the slugs, *Paradoris liturata*, belongs to a different group of slugs that have their gills on the back rather than under the mantle like *Phyllidia*. To complete the charade, when a predator approaches, the *Paradoris* mimic internalizes its gills so they are hidden to underscore its likeness to the noxious *Phyllidia*. Perhaps the most surprising mimic, however, is the juvenile form of a sea cucumber, which mimics these toxic nudibranchs while it is small enough to get away with it.

Another example of Batesian mimicry is the striking and aptly named comet-fish. The comet is a pitch-black fish covered in a vivid constellation of white spots.

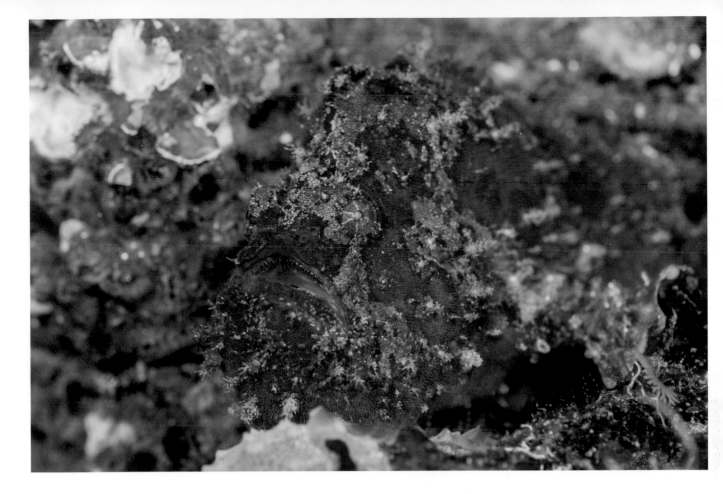

It has a relatively small body and disproportionately large fins that extend out around all but the head of the fish. The fins form an oval, water-droplet-like shape that reaches a point at the tip of the tail. Just beneath this, there is a mouth-like cut in the fin. Above the fin is a white rimmed spot that resembles an eye. Together, these features combine to make the fish appear like a large white-mouthed moray eel: a formidable predator on the reef. When threatened, the fish hovers face down in a hole, so only the eel-like tail extends beyond.

In stark contrast to Batesian mimicry, aggressive mimicry occurs when a predator mimics a harmless model, like a wolf in sheep's clothing. One of the most well-known examples is the frogfish. The animal uses protective resemblance to make itself appear exactly like a sponge, rock, or other natural feature of the habitat. Unlike some other fishes, frogfish cannot change their color quickly, requiring a couple of weeks to adjust in color. As a result, if they encounter a rich hunting ground they will remain motionless and feed off unsuspecting fish for as long as their bad behavior is rewarded. They attract prey to a close striking distance with "bait" at the tip of their lure that mimics a harmless shrimp or worm. They wiggle

Colors of the Reef

225

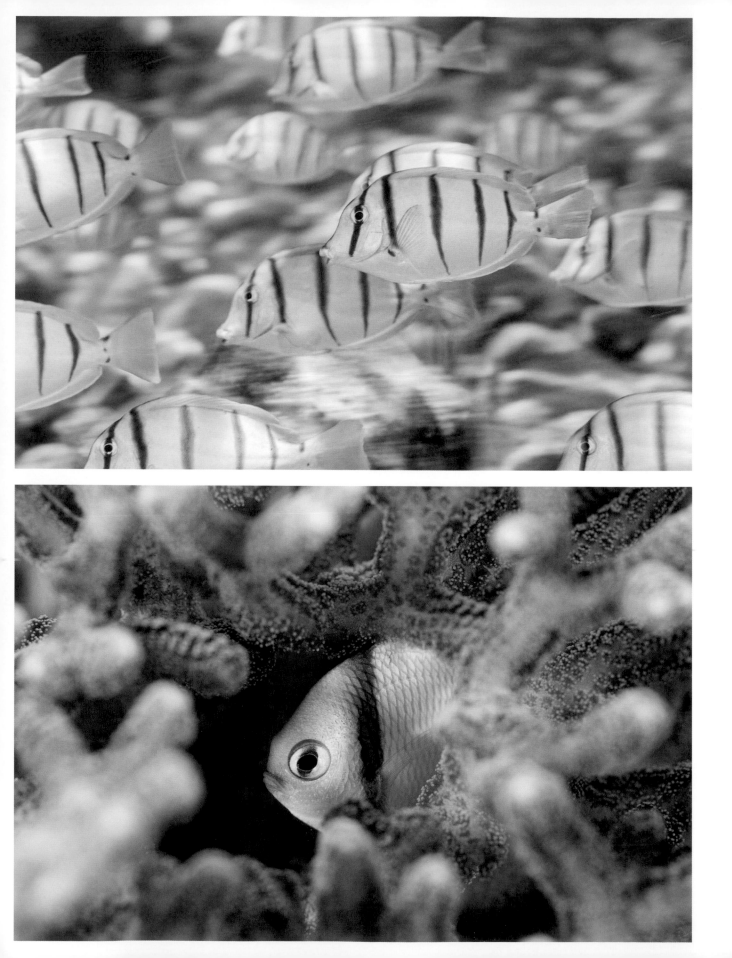

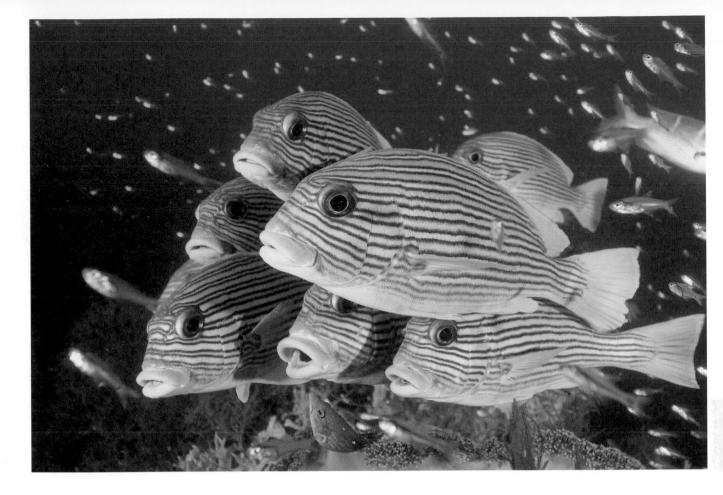

the lure to draw in unsuspecting prey looking for a snack. Sadly, the story seldom ends well for the misled fish.

Marine organisms display several types of camouflage. Disruptive camouflage either breaks up the outline of an animal, making it harder for a predator to pinpoint it against the background, or blends a group of individuals by using strongly contrasting light and dark patterns. On land there are very well-known examples of this: the striped zebra and tiger; in the shallows of coral reefs, we have convict surgeonfish, cream-colored fish with narrow black bands across the body that recall their eponymous convict's garb. In their case, the pattern helps to blend individuals with other members of the school. The various species of black and white dascyllus damselfishes use their contrasting black and white bands to break up their outline while feeding and hiding among the branches of hard corals. While vertical stripes help to muddy a fish's outline among other members of a school, horizontal stripes impact a predator's ability to judge a fish's speed when it is swimming in a school. The Australian stripey and the oriental sweetlips are two reef species that use horizontal stripes to their advantage within a school.

ABOVE: Schooling ribbon sweetlips. Raja Ampat, West Papua, Indonesia.

OPPOSITE TOP: School of convict surgeonfish. Banda Sea, Indonesia.

OPPOSITE BOTTOM: Reticulated dascyllus hiding in a hard coral. Raja Ampat, West Papua, Indonesia.

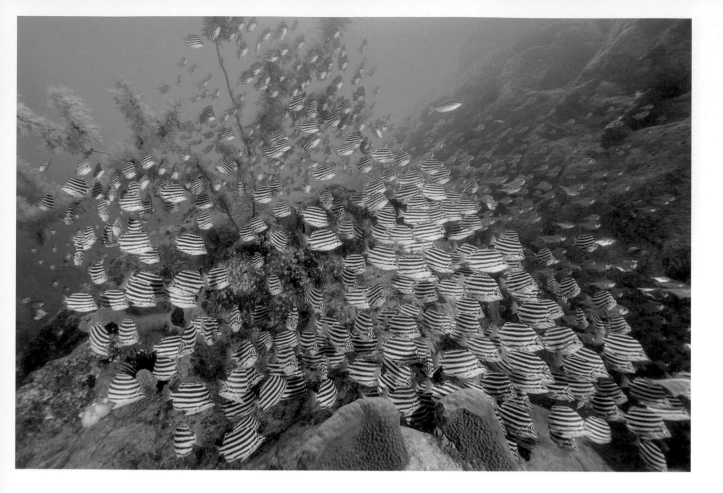

False eyespots that mimic real eyes are widespread on coral reefs. Not only do they make an animal appear larger than it actually is, but they serve to confuse predators in attack. The fake eyespot is usually located on or near the fish's tail, so the predators may assume it will swim in a different direction or pattern. If the predator does make contact, the damage is relegated to a less vital part of the body. False eyespots commonly occur in juvenile fish, with irises that reflect the color of their bodies; these juvenile fish can minimize the appearance of their true eyes. Many butterflyfishes have a black line through their eye as a means of camouflage, in addition to a fake eyespot toward the tail.

Camouflage by resembling the surroundings is very common in the marine environment too. Cryptic species that blend into their environs have been the source of many new discoveries over recent decades. Not only can their camouflage be exceptionally deft, but many are exceedingly small, which makes it hard for divers to find them, even with our advanced visual acuity. On the larger size of the spectrum, at over a foot and a half long, stonefish are well-known as masters of camouflage, and this is probably the reason that they are often accidentally

The World Beneath

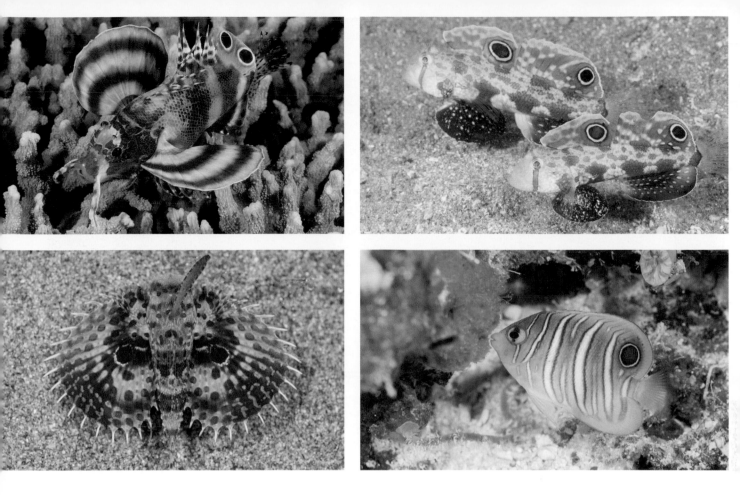

trodden on by unwary swimmers. They are widespread in the tropical Indo-Pacific, where they sit in prominent locations appearing almost exactly like the coral rocks they rest on.

Another of my favorite camouflage artists on coral reefs is the seldom-encountered cryptic sponge shrimp. Although they are common in the right habitat, they resemble their sponge homes so well that they're almost impossible to spot if you haven't seen one before. The surface of the shrimp is pitted to match the holes on a sponge, and of course, their color matches identically. They also hold themselves very close to the surface of the sponge, so there is no shadow created between themselves and the sponge, only a very slight fringe breaking up their outline against the background.

One of the world's true masters of camouflage is the leafy seadragon of southern Australia. It uses various tricks from the repertoire of marine camouflage artists to allow it to vanish into its environment. It lives in algal and kelp beds, where its color matches the algae in which it's found. The seadragon has skin filaments and paddles that are almost identical to those of the algae, and this helps to disrupt its

ABOVE TOP, LEFT TO RIGHT:

Twin spot lionfish with a pair of fake eye spots near the tail. Wakatobi, Sualwesi, Indonesia.

Pair of crab-eyed gobies. Milne Bay, Papua New Guinea.

ABOVE BOTTOM, LEFT TO RIGHT:

Juvenile flying gurnard with fake eye spots. Bali, Indonesia.

Juvenile regal angelfish with a large fake eye spot on the dorsal fin. Cebu, Philippines.

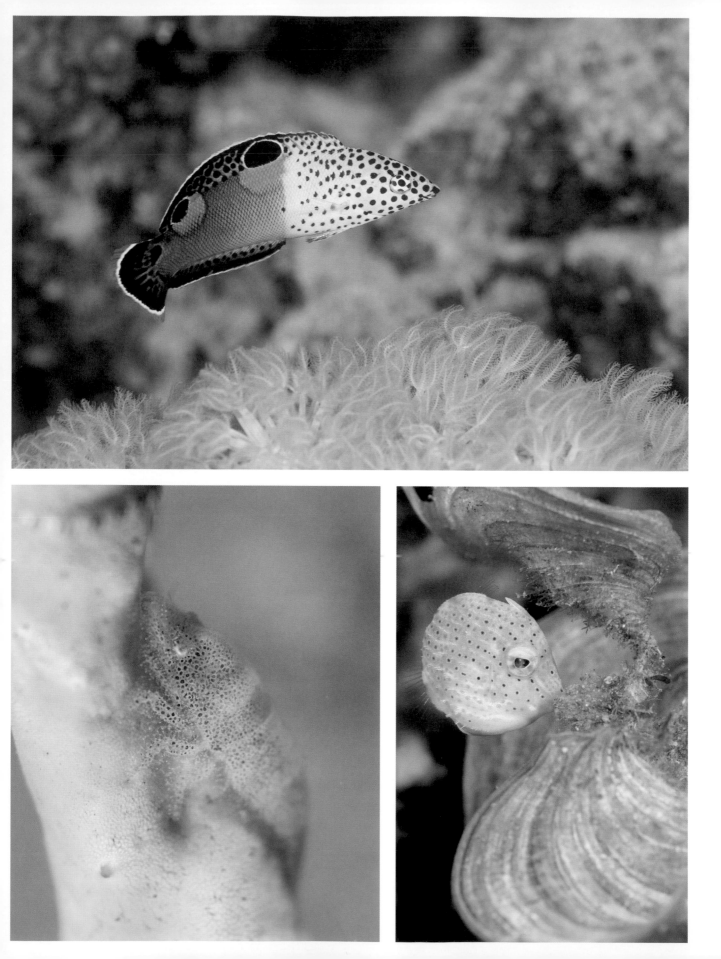

outline from the background. Finally, its behavior mimics the movement of the algae undulating in the swell. It doesn't tend to swim directionally; rather, it floats with the swell and surges back and forth, making slow progress in the opposite direction from predators or toward prey.

Of course, octopuses are also renowned for their camouflage abilities; they modulate almost instantaneously to the local environment. Vital for this performance is a complex visual system, advanced skin functions, and the mental capacity to process this information. Not only is their color effortlessly controlled by the contraction or relaxation of the muscles surrounding their chromatophores, or pigment-bearing cells, but they can also change their surface texture to match their habitat in a fraction of a second. The chromatophores connect directly and link uninterruptedly to nerve centers, allowing messages to be translated instantaneously.[137] However, even this process may be too slow to account for the speed of octopus color change. Recent evidence suggests that the octopuses may have light-sensitive pigments, called "opsins," in their chromatophores that can react to differences in color of the substrate without the cephalopod actually *seeing* it with its eye.[138]

ABOVE: Perfect camouflage of a flounder. Dumaguete, Negros Island, Philippines.

OPPOSITE TOP: Juvenile clown coris with a pair of fake eye spots. Egyptian Red Sea.

OPPOSITE BOTTOM LEFT: Cryptic sponge shrimp. Raja Ampat, West Papua, Indonesia.

OPPOSITE BOTTOM RIGHT: Puffer filefish hiding among algae. Raja Ampat, West Papua, Indonesia.

As we found with the parasitic isopod on the chin of certain fusilier fishes, camouflage is even possible in the open ocean through countershading. This is actually very common in pelagic species, which are those found in the open ocean. The grading from a pale underside to a darker top is used by both predators and prey to conceal for ambush or evasion, respectively. The system works by having different colors match the different backgrounds when viewed from either above or below. Almost all open-ocean sharks have countershading. Some deep-sea squids even go one step further by actively emitting light through special photophores, light-emitting cells, on their undersides. In the deep ocean this prevents them from casting a dark shadow as they approach their prey, allowing them to approach much closer before striking.

Through natural selection, some parasites have developed colors that allow them to blend in with the coloration of their host, although many don't bother. Gnathiids are one of the most bothersome of fish parasites and engorge with blood fairly quickly and then drop off. Since they only remain attached for a few hours, they don't try and camouflage; instead they darken in color as they fill with

blood. As we learned, these gnathiids are the main reason for fish to visit cleaning stations. While being cleaned, clients open their fins to allow cleaners access to the recesses where parasites hide. In another client adaptation, some change color while being cleaned. I have noticed that when cleaner wrasses approach certain surgeonfishes and unicornfishes, these clients transform from dark in color to very pale blue. It seems that this may help create greater contrast between the client and any parasites, making the job of removal simpler for the cleaners. It is easier to spot a blood-darkened parasite when it lies against a pale background.

BUCKING THE TREND

Given that there appear to be very specific reasons for each reef fish's coloration and pattern, it is surprising that polymorphisms exist. Polymorphism is the phenomenon in which a single species can exist in a variety of color forms. These sometimes occur in different geographical locations, but they can also be found on the same reefs. One example is the dusky dottyback (*Pseudochromis fuscus*), whose common name is rather misleading given that it is found in six different color forms, including yellow, gray, pink, and orange. However, having carried out genetic studies on this species from New Guinea to the Great Barrier Reef, researchers found that some color forms are genetically distinct from others and that geographic location also plays a part.[139] So, rather than being a great example of a single species with differing color forms, this dottyback likely represents a group of several distinct species that science has yet to recognize. This is another example of how much we still have to learn about the oceans. The dusky dottyback is still considered by science as one species, so no special conservation efforts would currently be implemented if one of the color morphs were to be at risk.

The Red Sea's freckled hawkfish (*Paracirrhites forsteri*) is found in four color morphs varying from dusky to red and black, as well as a starkly contrasting white and red phase with a yellow dorsal stripe.[140] Some explanations for polymorphism have included geographic variation, habitat specificity, aggressive mimicry, and color difference between sexes. In the case of the freckled hawkfish, all four of the morphs have been found living on the same reefs and sometimes sharing the same coral head, where they perch ready to ambush unsuspecting prey. Certain morphs, however, were generally found deeper than others. Darker forms were more likely to avoid predators by darting into dead rather than live corals, which is where

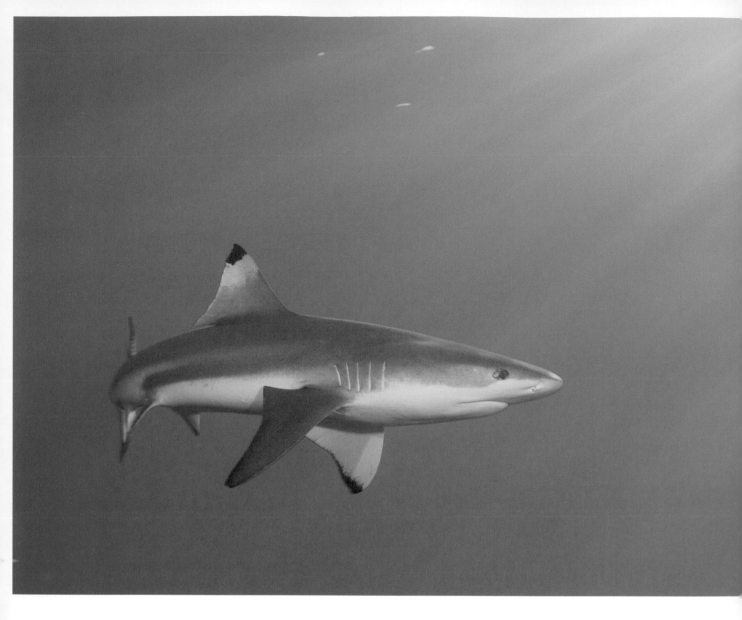

lighter color forms sought protection. This shows that there seems to be some ecological advantage to having several polymorphisms within a single species.

Another source of unexpected color variation among reef fish is freak genetic mutation. Albinism is a well-known condition in the animal kingdom, recorded in pure white gorillas, lions, alligators, and humpback whales. This phenomenon of color mutation also occurs on the reef. Often, genetically isolated populations have higher incidences, such as the queen angelfish of Saint Paul's Rock, which lies almost six hundred miles off the Atlantic coast of Brazil. There, a limited gene pool of angelfish has resulted in high instances of genetic mutation leading to color variation. Pure white, golden, blue, and piebald, differently colored, individuals

represent at least 1 percent of the population.[141] Although this sounds like relatively few, it is a dramatically higher proportion than expected.

In the many thousands of hours I have spent underwater, I have been lucky enough to spot a few unusual color-mutated fish. In the Solomon Islands, I found a mottled white, yellow, and black individual of the ordinarily black three-spot dascyllus. In Papua, I spotted several melanistic Cenderawasih long-nosed butterflyfishes. "Melanistic" means that the black pigment, melanin, is produced in excess, in this case creating a pure black fish. Normally, these fish have a black top half of the head and a white chin, with the rest of the body bright yellow. The black form is quite striking, but common enough that it must not affect the survivability of the fish. Melanism is fairly common in the natural world. The black panther is a good example, being a melanistic form of the jaguar. Melanistic deer, penguins, squirrels, and giraffes have all been recorded in nature too.

In the chilly waters of Alor on the south coast of Indonesia, I was exploring the reef one day when my buddy called me over. There, in a cave, was a beautiful adult male bicolor anthias. While these fish ordinarily have a bright red dorsal half and bright pink underside, this fish had a ghostly white belly. As he displayed his form for a harem of female onlookers, the white of his lower half extended above his scarlet red eye, giving the fish a slightly sinister, bloodthirsty appearance.

Coloration isn't only used in interactions between different species; it also plays an important role in signaling between members of the same species. Sexually mature fish often use coloration to maintain territories by advertising their dominance over a certain area of reef. From a distance, the adult emperor angelfish's pattern helps it to blend into the background to avoid predation, but at closer proximity it is used in territorial displays to keep trespassers out of its territory. The same coloration process is thought to occur in butterflyfish, which have striking patterns that advertise to members of their own species the presence of an established territory. This largely avoids the need for physical aggression. Butterflyfish are generally monogamous specialist coral eaters that due to limited food supplies maintain specific territories. In contrast, less-picky planktivores, those fish that eat small planktonic animal and vegetable matter floating past in the water column, are much more likely to live in gregarious schools without maintaining territories or strict social systems.

The fact that adult reef fish can be quite aggressive in the defense of a territory poses a challenge for juveniles arriving from the open ocean after their larval stage and wanting to settle. There is no nepotism among reef fish, especially since juveniles float away from the reef on which they are born. Adults know that newly arriving juveniles are extremely unlikely to be their own kin. It makes sense then that, in the interests of protecting limited food supplies, they defend their territories against juveniles as they would against other adults. Nature has worked a way around this problem by painting the young with entirely different colors, patterns, and even body shapes compared to sexually mature adults, so that when juveniles arrive on the reef, adults don't see them as competitors for food and other resources.[142] Both juveniles and adults are then able to live together harmoniously until the fish reaches maturity. In some cases, the physical appearance of juveniles is so different from adults that early natural historians believed them to be completely different species.

ABOVE: Bicolor anthias with pigment mutation. Alor, Indonesia.

OPPOSITE TOP: Line-up of blunthead batfish. Raja Ampat, West Papua, Indonesia.

OPPOSITE BOTTOM: Juvenile pinnate batfish. Raja Ampat, West Papua, Indonesia.

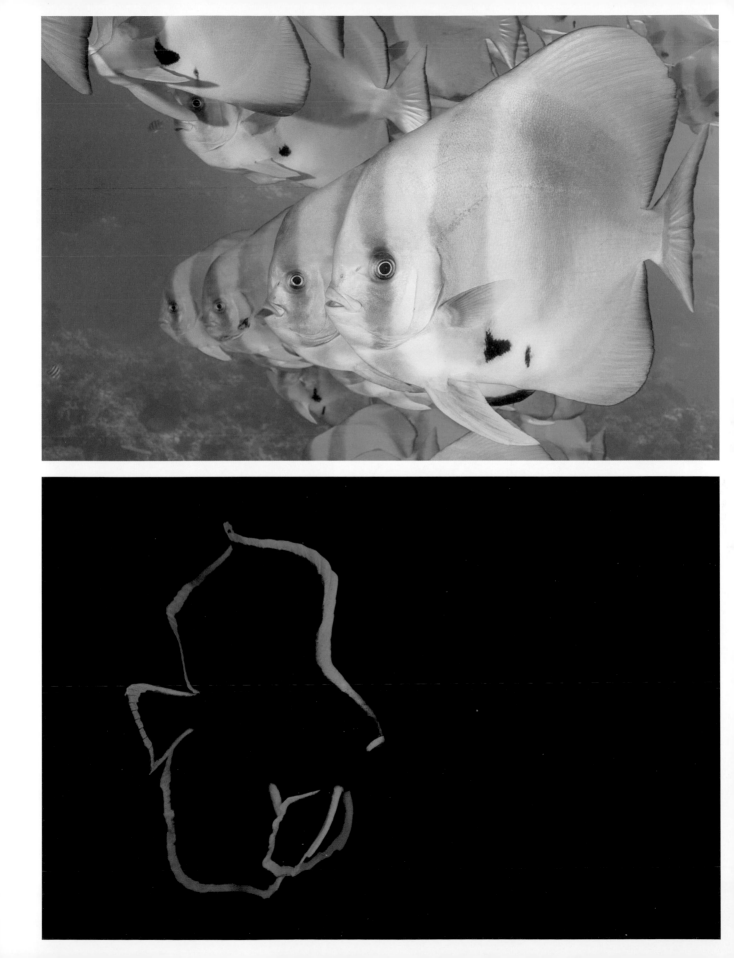

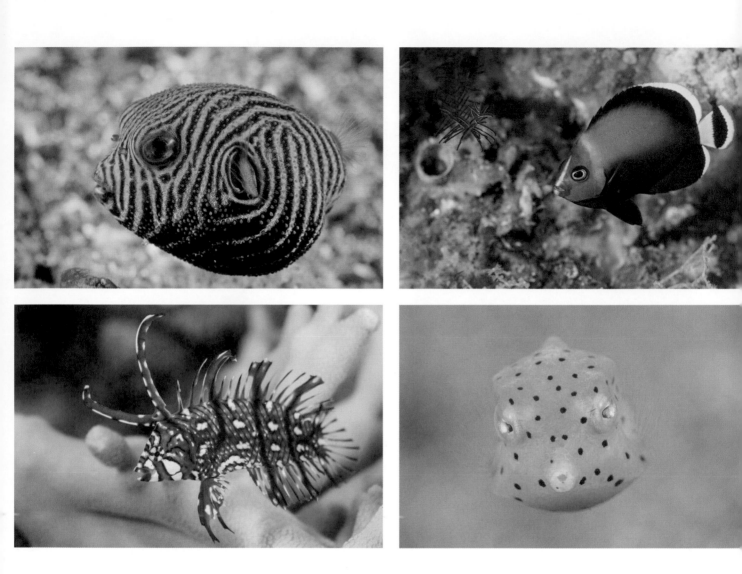

I became interested in the color changes of reef fish after noticing a particularly stunning damselfish in southeastern Indonesia. The adult Cross's damsel is a fairly nondescript, dark brown fish found only in the east of Indonesia and I am ashamed to say that for a while I never gave them more than a fleeting thought. It turns out I had been hasty in my dismissal; these fish live out their lives like the Ugly Duckling, except in reverse. When I was exploring the shallows in front of a remote village on the Indonesian island of Wetar (which I later learned was a terrible idea since two people had apparently been taken by an enormous saltwater crocodile there just weeks before), I spotted a bright orange fish just an inch or so in length. It was the brightest orange I recall having seen on a reef fish, with a neon blue stripe down the

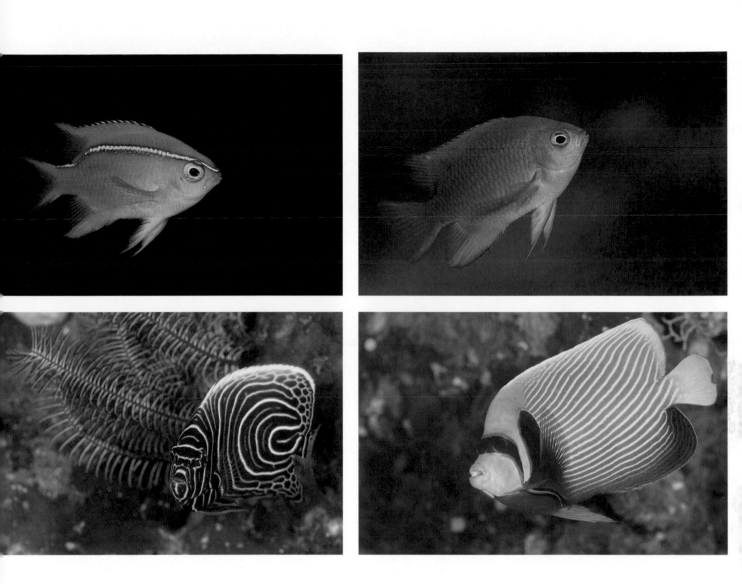

length of the body and the same blue tipping on the fins. I must admit that I had to check the identification of this little beauty when I got back to the boat. It was indeed a juvenile Cross's damsel: the same species as the drab brown adults I had often dismissed. Some of the most dramatic color changes occur among damselfishes.

I was lucky enough to return to the exact same spot three months later and decided to go in search of my stunning little friend again. I have pretty good underwater navigation skills and managed to re-locate the distinctive rock next to which the little fish had been living. Lo and behold, there it was! But, it had grown another inch and instead of the bright colors I encountered before, it had now become mossy green, with just a couple of hints of orange still remaining. It was

ABOVE TOP, LEFT TO RIGHT:

Juvenile Cross's damselfish.
Wetar Island, Indonesia.

Adolescent Cross's damselfish.
Wetar Island, Indonesia.

ABOVE BOTTOM, LEFT TO RIGHT:

Juvenile emperor angelfish. Bali,
Indonesia.

Adult emperor angelfish. Alor,
Indonesia.

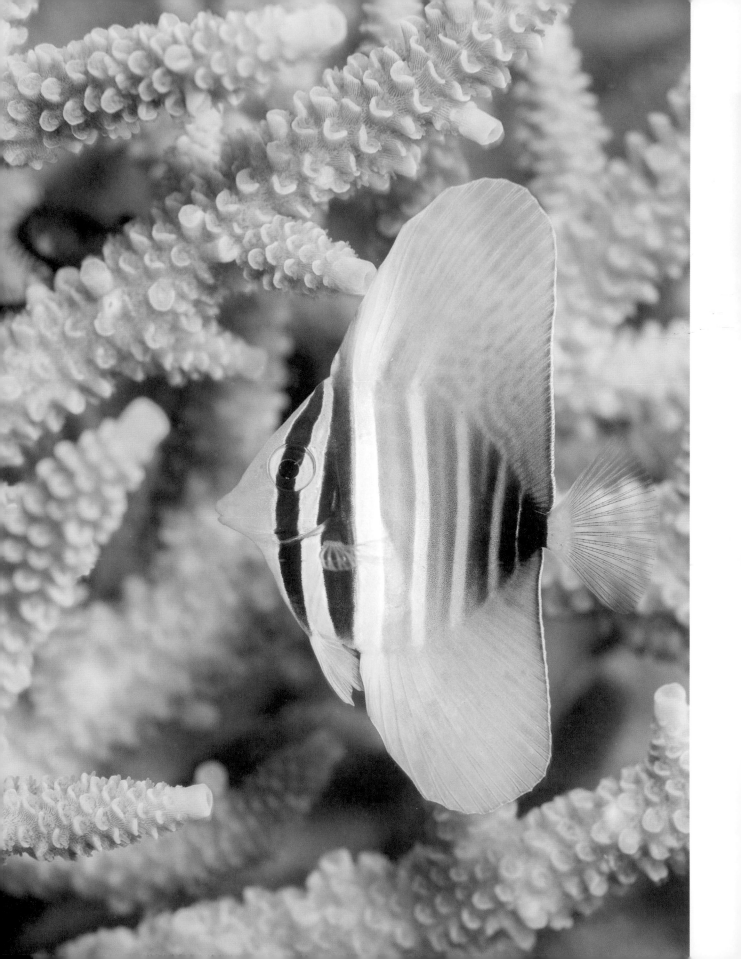

fascinating to see in action this transition from juvenile to adult; this encouraged me to investigate more fish that demonstrate similar transformations and learn their fascinating stories.

The juvenile-to-adult change in fish occurs in a variety of ways across a wide swath of reef species, including the mimic surgeonfish. The adult mimic surgeon is orange-brown in color, with an orange trailing edge to the tail; however, in its juvenile form it appears uncannily like the pearl-scaled angelfish in both behavior and coloration. These similarities allow the juvenile surgeon to feed within the territories of another species: the jewel damselfish. Mimic surgeons and jewel damsels have very similar diets, whereas pearl-scaled angels don't. It seems that the mimicry of juvenile surgeons allows them to freely exploit a competitor's resources without repercussions.

Some of the most dramatic and different transformations between juvenile and adult reef fish take place among the batfish or spadefish. Although the adults are all rather similar large silvery discs, which affords them amazing camouflage in the blue water where they live, they each have very different juvenile forms that inhabit the reef itself. One of these, the pinnate batfish (*Platax pinnatus*) is jet black, with a bright orange outline. Especially when small, it has an exaggerated undulating swimming style that mimics an almost identically colored flatworm. The flatworm is strongly toxic and avoided by most predators. The same flatworm is also mimicked by a juvenile sole, so it's unpalatability must be well-recognized among predatory fishes.

ABOVE LEFT: Juvenile mimic surgeonfish. Cebu, Philippines.

ABOVE RIGHT: Pearl scale angelfish. Cebu, Philippines.

OPPOSITE: Juvenile sailfin tang. Raja Ampat, West Papua, Indonesia.

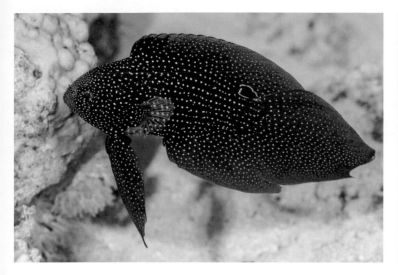

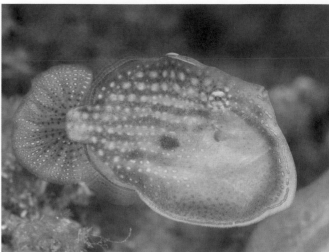

A rare sighting of a
cometfish out of the shadows.
Egyptian Red Sea.

ABOVE RIGHT: Displaying male
pygmy leatherjacket. South Australia.

Rather than mimicking a toxic species, the juvenile circular batfish (*Platax orbicularis*) choses to hide in plain sight by mimicking a dead leaf. Since it's uncommon to see a dead leaf on a reef, these fish tend to hide in very shallow water where leaves are more likely to fall. I have seen them in water just a couple of inches deep. Presumably, this is more likely to bring them into contact with land-living predators, but their camouflage is really quite incredible and they seem to have everyone tricked. The third batfish with an entirely different juvenile color is the Batavia batfish (*Platax batavianus*); it has starkly contrasting black and white stripes up and down its body. They are usually found near crinoids, from which they are almost impossible to distinguish. As well as having a disruptive coloration, the ends of the fins are feathered, much like the arms of the crinoid, and serve to physically break up the fish's outline too.

Mimicking another species for nefarious reasons seems to be particularly common in groupers. When young, these piscivores mimic other smaller reef fish, which allows them to get closer to their prey. The juvenile blue-spotted grouper was once believed to be a different species and uncannily mimics the yellowtail damselfish. The juvenile masked grouper mimics an anthias and the juvenile slender grouper mimics a wrasse. This aggressive mimicry allows the mimics to get closer to their prey by appearing harmless. In all cases, the juvenile grouper is found in the same habitat as the fish it chooses to mimic, even if the adult tends not to be.

We all know about the colorful displays of peacocks and male birds-of-paradise, but some reef fishes can be equally ostentatious. A couple of years ago, I

The World Beneath

was diving in the chilly waters off Adelaide in South Australia. I came across a disc-shaped fish called a southern pygmy leatherjacket, which is only found in southern Australian waters and reaches just a few inches in length. As I watched the beige fish, I couldn't help but gasp when it suddenly extended a huge flap from its chin that almost doubled the fish's size. The fish also suddenly developed bright blue spots on its side and along the edge of the body, and the tail began to shimmer with a burst of color encompassing all hues of blue. The flap, or "dewlap" as it is more formally known, is used either in sexual display or to show off to other males, as was the case here. Just as this fish exploded with color, another fish that I hadn't noticed before darted up from the rubble and opened a shimmering dewlap of its own. The two raced back and forth in front of me, side by side, comparing notes about who had the biggest and most colorful dewlap.

While many fish change sex throughout their lives, they also change color as a result of this development. These changes are usually hormonal, and as you might expect, males tend to be more colorful. Sexually active "terminal" males are the biggest, brightest males that have reached the end of the road in their sexual fluidity. Fish pigments are located in chromatophores, which can expand or contract rapidly, allowing fish to change color very quickly when compared with hormonal changes, which are more gradual. Many male fish will become particularly flushed with bright colors during their displays, as it would be disadvantageous and rather conspicuous to be so adorned all the time while going about their day-to-day activities. Some of the most stunning of all the reef's male displays are performed by the fairy and flasher wrasses. Over the past decade, both groups have swelled in number through new discoveries, often because scientists and divers have become more observant of their subtle differences in color during nuptial displays. These fascinating fishes will be the focus of the next chapter.

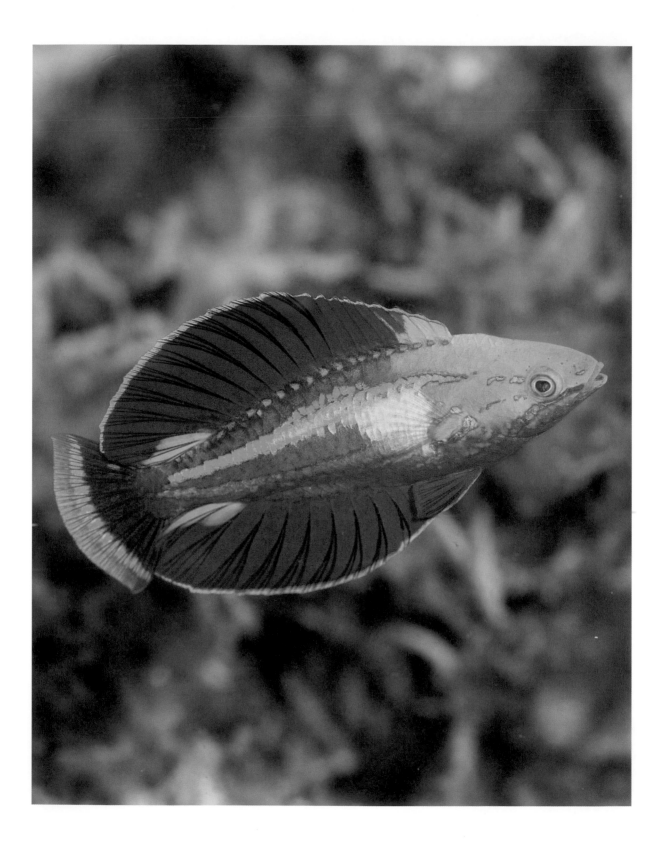

The World Beneath

Chapter 10:

Flashers and Fairies

In April 2014, I joined an expedition with my friends Ned and Anna to a little-known bay on the southern coast of Indonesia. For decades, Ned and Anna have been making new and astute observations of reef animals that have directly informed scientists. No signs of human life surrounded our liveaboard vessel in the remote reaches near the island of Alor, just the area's ubiquitous smoking volcanoes. As we puttered along the reef in a loose group, along with another good friend, the amazing dive guide Yann Alfian, Anna suddenly called us all over to point out a few colorful but tiny fish that seemed to be enjoying themselves.

The fish were teardrop-shaped, just a few inches long, and were showing off some of the most amazing colors I had ever seen in nature, although they were clearly recognizable as a type of flasher wrasse. The head was bright mustard yellow, although a vivid hot flash of pink ran along the belly from the chin down to the tail. The flank bore an electric pale blue stripe, above which darker blue spots formed a boundary between the body and the large dorsal fin. The large and imposing dorsal and anal fins were scarlet but edged with bright blue. All in all, a very memorable fish and I was certain I had never seen them before. By the looks of Ned and Anna's dumbstruck enjoyment, I could tell they hadn't either. We were all swept up in a flurry of excitement but each of us managed to capture some images.

OPPOSITE: Displaying male Alfian's flasher wrasse, described in 2015. Alor, Indonesia.

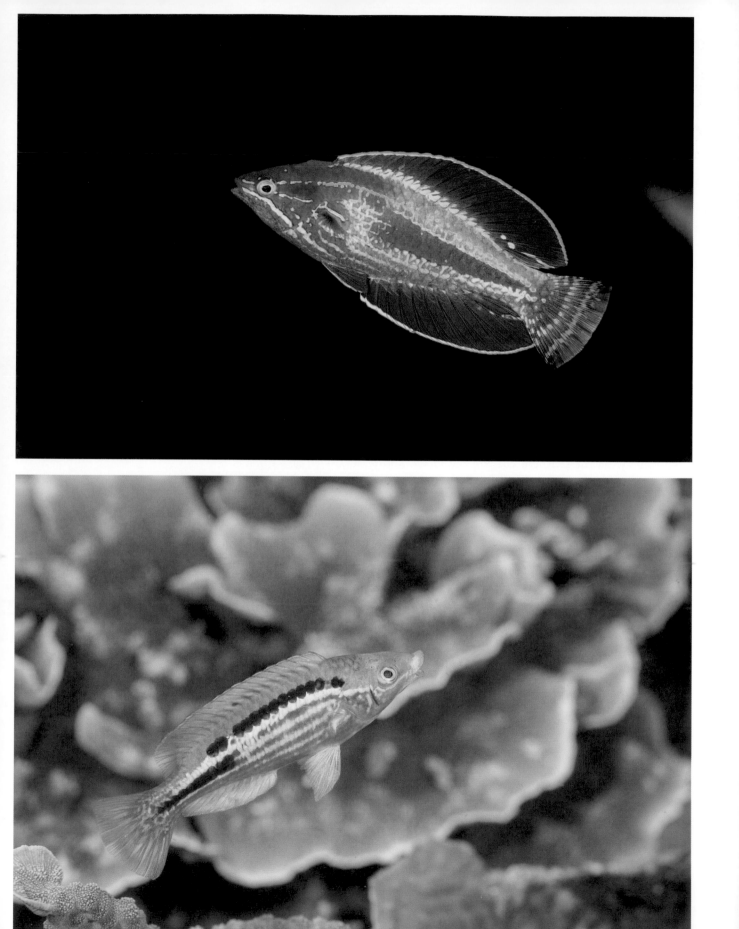

After the dive, Anna sent some of Ned's images to their friend Dr. Gerry Allen, one of the world's foremost experts on this beautiful animal group (even in these remotest corners of the Earth, there is often data connectivity!). Gerry instantly replied that this fish was almost certainly a new species. We dived the same spot again and gathered as much information and as many images as we could. Just two years later, at Anna's request, Gerry went on to name the new species as Alfian's flasher wrasse, *Paracheilinus alfiani*, in honor of our friend and guide, Yann. This lovely fish has now become the latest member to join the celebrated group of stunning flasher wrasses.

WRASSEDEMONIUM

Wrasses comprise one of the most species-rich groups of coral reef fishes, beaten only by the gobies and sea basses. There are some five hundred and fifty or so species of wrasses populating tropical and temperate coastal areas around the world.[143] With so many species and sixty genera, it is no wonder that two genera, the fairy and flasher wrasses (*Cirrhilabrus* and *Paracheilinus*) eluded my attention until only a few years ago. Indeed, scientists in general had underrated them until recent decades. I always seem drawn to animals that are tough to appreciate, whether secretive, rare, found only in an obscure corner of the globe, or living in an unusual kind of habitat. These fish check every box. They are also some of the most striking of all the earth's creatures and even rival the birds-of-paradise, which is no easy feat.

A group of generally smallish fish most commonly found in shallow inshore locations, wrasses tend to hover at around eight inches long, although the biggest species, the Napoleon wrasse, can reach almost seven and a half feet in length and weigh close to two hundred pounds. Wrasses have a variety of feeding predilections, from small crustaceans, to mollusks, plankton, and simple algae grazers. It is believed that wrasses share a common ancestor with parrotfishes, cichlids, and damselfishes. There are fairly good fossils of wrasses that date back at least fifty million years, although genetic evidence suggests an older origin of around seventy million years.[144] In such a rich group, it's unsurprising that they have developed a vital role in the ecology of coral reefs and fill a range of niches.

Many are generalists, but the distinctive morphology of the jaw has allowed specialists to evolve too, and the slingjaw wrasse takes jaw morphology to the extreme.

OPPOSITE TOP: Displaying male Renny's flasher wrasse. Komodo Island, Indonesia.

OPPOSITE BOTTOM: Displaying male Filipino purple-stripe form of Lubbock's fairy wrasse. Dumaguete, Negros Island, Philippines.

OPPOSITE TOP: Displaying male Nursalim flasher wrasse. Triton Bay, West Papua, Indonesia.

OPPOSITE BOTTOM: Displaying male Walton's flasher wrasse. Cenderawasih Bay, West Papua, Indonesia.

I have long been fascinated by these fish, which have the highest jaw protrusion of any fish, seemingly almost half as long as the body. However, in my opinion the most spectacular of all wrasses, and probably of all coral reef fishes, are the fairy and flasher wrasses. In terms of aesthetics, the two genera are equally stunning, and their behavior and morphology indicate a very close evolutionary relationship. Many new members of both types have been discovered over the past few decades and they have now swelled to become some of the most species-rich genera among the wrasses.

FLASHER AFICIONADO

Witnessing a male flasher wrasse in mid-nuptial display for the first time suddenly got me hooked. I had heard of people hunting for them while I was busy with my pygmy seahorse research, but I was otherwise distracted—mired in the daily domestic disputes and dramas of my little research subjects.

Years later, I found myself in the dwindling late afternoon light, sixty feet deep on a rubble slope. Although I hadn't gone looking for them specifically, this happened to be the perfect time of day and habitat for flasher wrasse spotting. As I swam along the slope, I came across a mass of small fish just two inches long with some brighter individuals whizzing around and through them as if possessed. The majority of individuals among this great cloud of fish were slightly smaller pale pink fish, and I assumed these to be the females. Above and among these, the rainbow-colored, energetic males dashed through the throngs while most of the females continued to absentmindedly graze on passing zooplankton. Occasionally, one of the ostentatious males would catch a female's eye and they would pair off. They would rise up above the rest of the group, gingerly at first and then, with a speedy dash, release a little cloud of sperm and eggs. Afterward, the pair would return to the shoal, the relatively loose aggregation of fish. The female was done for the evening, but the male immediately went back to displaying to court further suitors.

Although their numbers have been swelling over the past couple of decades, the first flasher wrasse species was named as recently as 1955 from a single specimen collected in the Red Sea. At this point the new genus, *Paracheilinus*, was also created and to this day contains all flasher discoveries. For the next nineteen years, until 1974, the Red Sea's eightline flasher was alone in the genus. At this point, Dr. Allen began his journey of discovery with these fishes. He published a review of the genus and described the filamented flasher from Papua New Guinea.[145] Just

The World Beneath

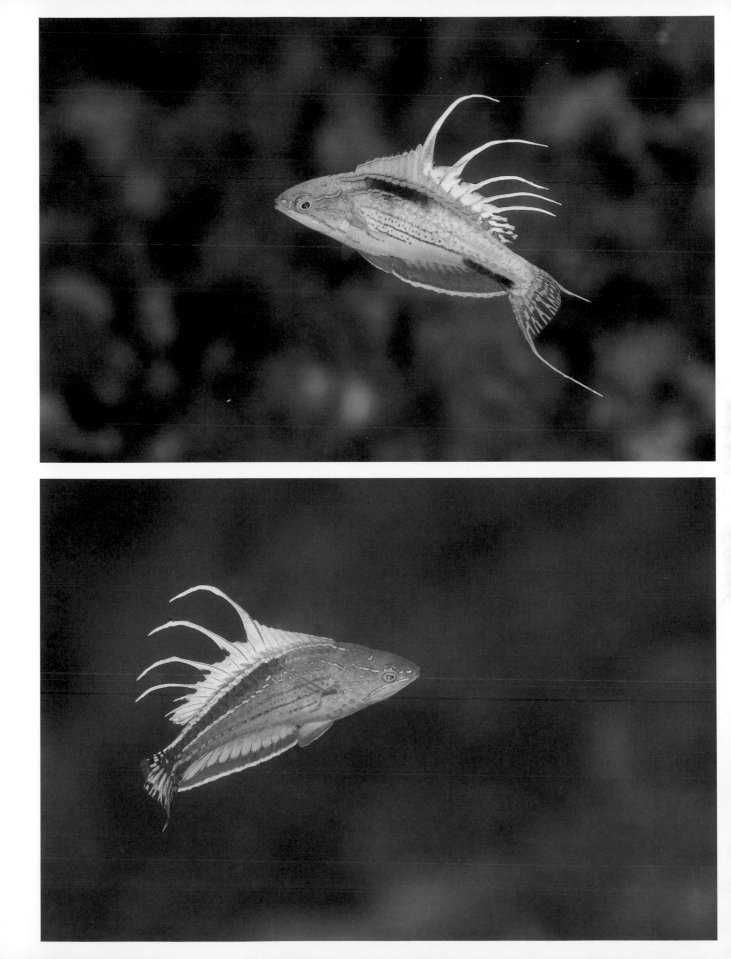

three years later, another two species were added and from there, the number of described species has gradually increased over the years. Alfian's flasher, named in 2016, was the twentieth member to join the group; half of these have been named since 1999.

By far the country with the highest number of flashers is Indonesia, which harbors eleven species throughout its waters. Many of these are microendemics and are only found in a very small geographic area. The Nursalim flasher, for example, is known only from Triton Bay on Papua's southwest coast; Walton's from Cenderawasih Bay on Papua's north; the Togian flasher from the Gulf of Tomini of central Sulawesi; Alfian's flasher has still only been found in the small bay where we first discovered it. In neighboring Komodo Island, just 250 miles to the west, is another distinct species that was named just a couple of years prior to Alfian's. There has been some controversy over whether this Komodo species, named Renny's flasher, is the same as Alfian's, given their close proximity and physical similarity. Prior to seeing Renny's firsthand, I had my doubts as to whether these were too similar to be classified as distinct species, but in late 2017 I visited Komodo and had the opportunity to see Renny's for myself. The male Renny's bright displays were distinctive, and the fish themselves were much larger than Alfian's. Sometimes observing an animal in its natural habitat can add so much more value and information than merely studying preserved bodies in a glass jar or, in my case, from just reading the original paper describing the species.

FAIRIES

Not to be outdone, the fairy wrasses have among them some equally stunning members. Fairy wrasses are often found in habitats very similar to those of flashers and their behaviors have much in common. Stunningly colored males develop outlandish colors and patterns to entice smaller, more muted females. In some tropical equatorial areas, they probably breed year-round, but some large fairies found in subtropical Japan likely adhere to a defined breeding season during the warmer summer months. This group has also grown exponentially in number over the past decades, from just six valid species known before the 1960s to around fifty-nine species now. In 1853, a full two hundred years before the first flasher wrasse, peacock fairy, was named and described, it became the first official member of the genus *Cirrhilabrus*. Today, new species are being discovered far more often, with

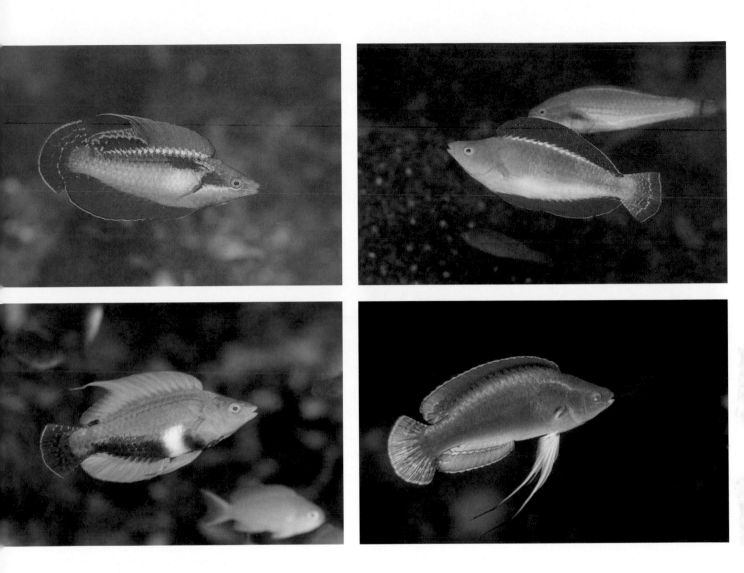

at least twenty added since the turn of the century. This is a group to which citizen scientists have made valuable contributions by discovering new species.

I always try to keep up-to-date on the latest descriptions, since like flashers, many fairies can only be found in very small areas of the ocean. Opportunities to see them remain rather limited and it's best to take advantage of them when you can. During a visit to West Papua's Cenderawasih Bay in 2013, seeing the endemic Cenderawasih fairy wrasse, first described in 2006, was high on my wish list. I applied my knowledge of other members of the group, that I had already seen, to try and track down this elusive species. I went deeper than I normally would on a site with a rich coral plateau, and lo and behold, the wrasses appeared. They

ABOVE TOP, LEFT TO RIGHT:

Displaying male Tonozuka's fairy wrasse. Raja Ampat, West Papua, Indonesia.

Displaying male redfin fairy wrasse. Dumaguete, Negros Island, Philippines.

ABOVE BOTTOM, LEFT TO RIGHT:

Displaying male Javan fairy wrasse. Alor, Indonesia.

Displaying male peacock fairy wrasse. Izu Peninsula, Japan.

ABOVE: Male Cenderawasih fairy wrasse, described in 2006. Cenderawasih Bay, West Papua, Indonesia.

OPPOSITE TOP: Male Humann's fairy wrasse, described in 2012, being cleaned. Alor, Indonesia.

OPPOSITE BOTTOM: Two young Walton's flasher wrasses, described in 2006, displaying. Cenderawasih Bay, West Papua, Indonesia.

weren't forming large clouds like the flashers; rather, the males darted about from place to place low on the reef. I had arrived a little too early in the day to witness their mating behaviors, but when a male did occasionally display, I had the feeling that an interior designer would have scoffed at the jarring color palette. His head was bright salmon pink, all the fins including the tail edged with iridescent blue, the dorsal fin was dusted with daffodil yellow, and five or so black blotches punctuated a vivid mustard yellow smear down the side. In nature, these colors somehow seem to complement each other perfectly. I was still buzzing as I swam into the shallows, overjoyed at having finally seen this wonderful fish. Several years later I saw this wrasse in Raja Ampat to the west, at least two hundred miles outside its expected range, so I guess naming it the "Cenderawasih fairy wrasse" was a little premature—no surprise, given how much we still must learn about many of these species.

A few years before Anna discovered Alfian's flasher wrasse, she discovered a new fairy wrasse too. In 2012, it was officially named Humann's fairy wrasse, after Anna's long-time collaborator Paul Humann. On the same expedition where she

The World Beneath

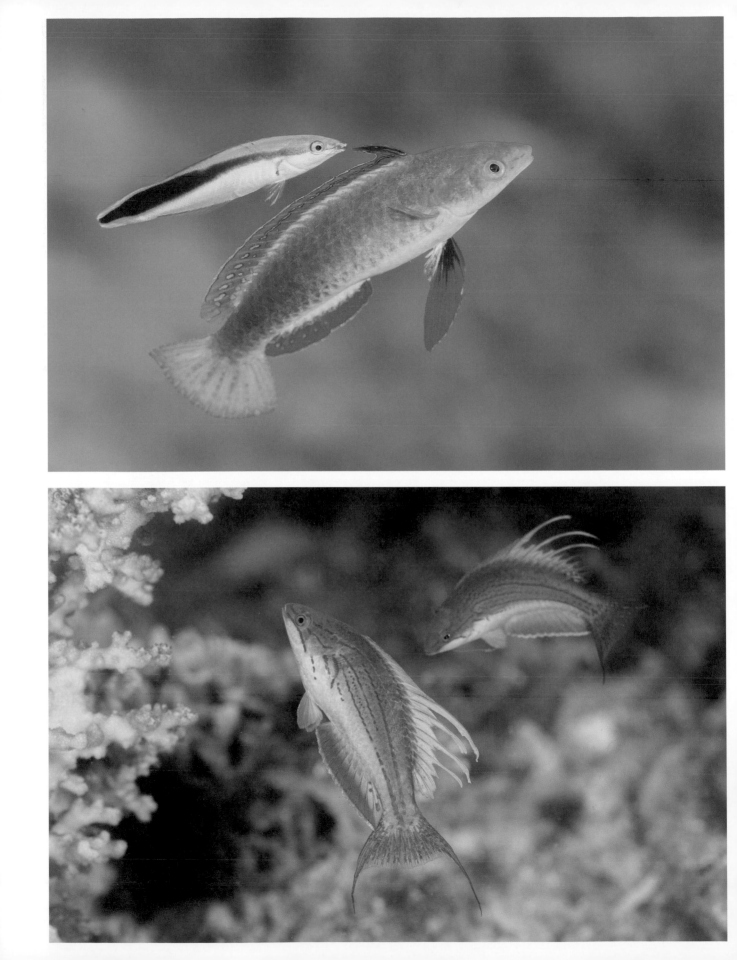

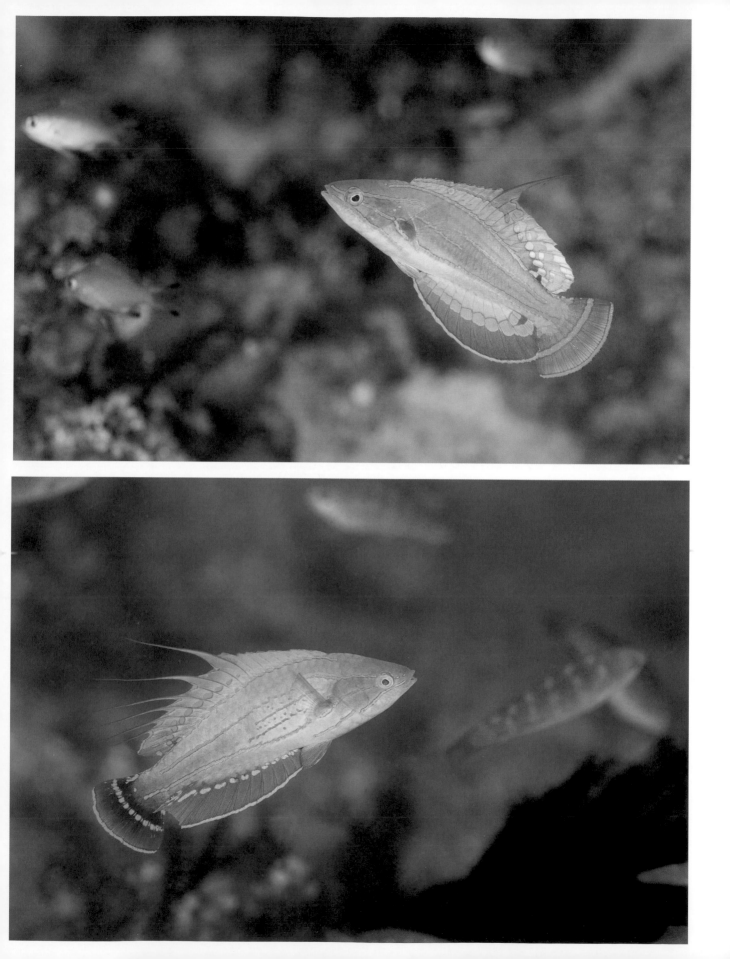

discovered Alfian's wrasse, we returned to the location where Anna had first seen these fairies. She hadn't returned since the wrasse had been named, so it became a priority for us to try and spot one. It turns out that the males of this species are rather frantic, and unlike other fairy species where the male tends to stick around his small harem of females, the Humann's species preferred to whiz from one group of females to another, all over the reef. After spending the whole dive trying to capture an image, I noticed that the male was rather vain and keen to stay in tip-top condition, so he visited a cleaning station frequently. On our second dive, I decided to stalk the cleaning station and wait for his vanity to supersede his sexual urges. Every seven to eight minutes, he returned to the cleaning station and it was here that I was finally able to capture an image of this elusive new species.

SHOW-OFFS

Evident in the biology of both fairy and flasher wrasses is the importance of their sexual displays. Both groups are protogynous, which means they initially become sexually mature as females and later change sex to become males. Sexually mature females tend to be pale pink in color. Initial phase males usually spawn in aggregations, but the terminal males are the true show-offs in terms of brilliance of color and pattern. Terminal males tend to dominate a harem of females and are definitely the star of the show. It is the specific color and pattern of the terminal males that tend to be considered characteristic for each species, since the females are generally very similar and in fact can be almost impossible to distinguish to species level with the naked eye.

Vivid ornamentation of males in the natural world is usually a result of a branch of evolution first identified by Darwin: sexual selection. Sexual selection is most often driven by female preference for certain male characteristics, which in this case include bright colors, extended filaments on males' fins, and in some cases elaborate swimming techniques. Sexual selection also occurs between members of the same sex, who compete for access to mates. Females are believed to choose males with more ornamention as this advertises their health and vigor, possibly even illustrating a resistance to parasites, which, as we have learned, are pervasive on the reef.

Through sexual selection, Darwin attempted to explain traits that didn't appear to make sense under the umbrella of natural selection. Natural selection

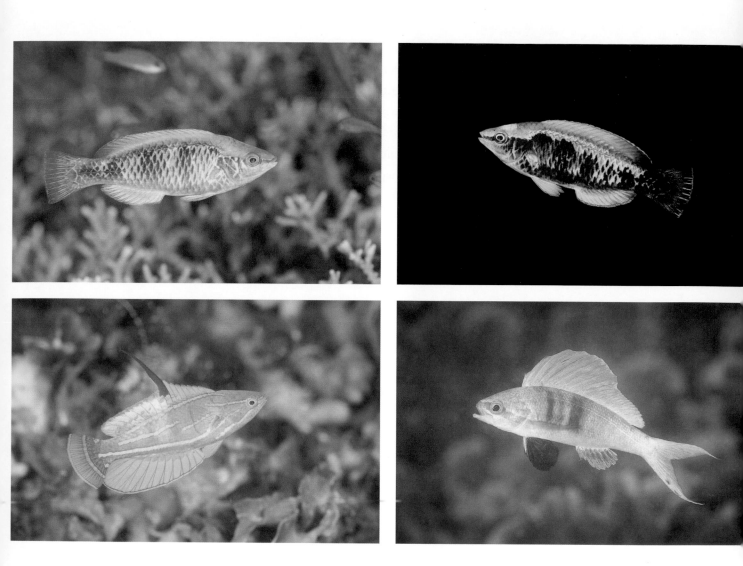

ABOVE TOP, LEFT TO RIGHT:

Male Indonesian yellow-back form of Lubbock's fairy wrasse. Alor, Indonesia.

Male Indonesian yellow-back form of Lubbock's fairy wrasse in nuptial display. Alor, Indonesia.

ABOVE BOTTOM, LEFT TO RIGHT:

Displaying male yellowfin flasher wrasse. Bali, Indonesia.

Displaying male sailfin anthias. Triton Bay, West Papua, Indonesia.

predicts that those organisms best adapted to their environment will be those most likely to survive and pass on their genes. However, certain traits like a stag's enormous and cumbersome antlers would seem to make him more likely to fall foul of predators. A conflict arose in Darwin's mind. What role would these features play in an understanding of evolution informed by the primacy of survival? Sexual selection theory very neatly explains the phenomenon of extreme male ornamentation. Although decorated males are indeed more likely to be predated upon, the most elaborate and vigorous males are also more likely to pass on their genes before perishing—having been chosen by females as desirable mates early on. These fish are very much the piscine equivalent of the antlered stag.

In the heat of their displays, male flashers seem to egg each other on. When one male sees another displaying, his hormones seem to go through the roof. This is true both within and between species. Males size each other up by showing off their full color displays and race through the water alongside each other. Whether showing off to other males or females, their color change is quite dramatic, and thanks to chromatophores, their skin cells can change color almost instantaneously. It's almost unbelievable in some cases that you're looking at the same fish. Probably the most exceptional displays that I have witnessed were at an aptly named site called Flasher Beach in Triton Bay on the southern coast of West Papua. There, mixed clouds of three Indonesian endemic species—blue, Nursalim, and yellowfin flashers—all vie for female attention. As if this wasn't enough of a macho display, there were also male sailfin anthias displaying there too. It was a sexual frenzy, this mélange of hundreds of fish. The flashers all had their colors dialed up to full intensity and the male anthias had erected their huge sail-like dorsal fins and flashed them from red to pure white, something I had never seen before.

THE MÉLANGE

There were, however, a few fish in this orgy that stood out as different to the four main types. I noticed three male flashers that didn't quite look like the others, but somehow shared certain features with them. As I looked closer it became apparent that these were in fact hybrids: one of the males was clearly a mix of the blue and Nursalim species, while the two others were a mix of yellowfin and Nursalim. This was very curious, given that hybrids tend to be quite rare in nature (although I have since seen hybrids a few times where these large groups of flashers congregate). They have highly synchronized spawning behaviors that seem to encourage accidental hybridization during the sexual frenzy.

In general terms, when species crossbreed, their offspring become infertile (as with the mule—the infertile offspring of the horse and the donkey), but in the case of these flashers we are unsure whether they would be able to breed or not. Sometimes, where the geographic ranges of two species meet, a boundary can form called a "hybrid zone." There has long been debate among evolutionary biologists about the role zones play in a species' biology. Do they encourage evolutionary novelties, or are they dead ends? Botanists hold a rather different view to animal biologists, the former believing that crossbreeding is important in the creation of new races, and the

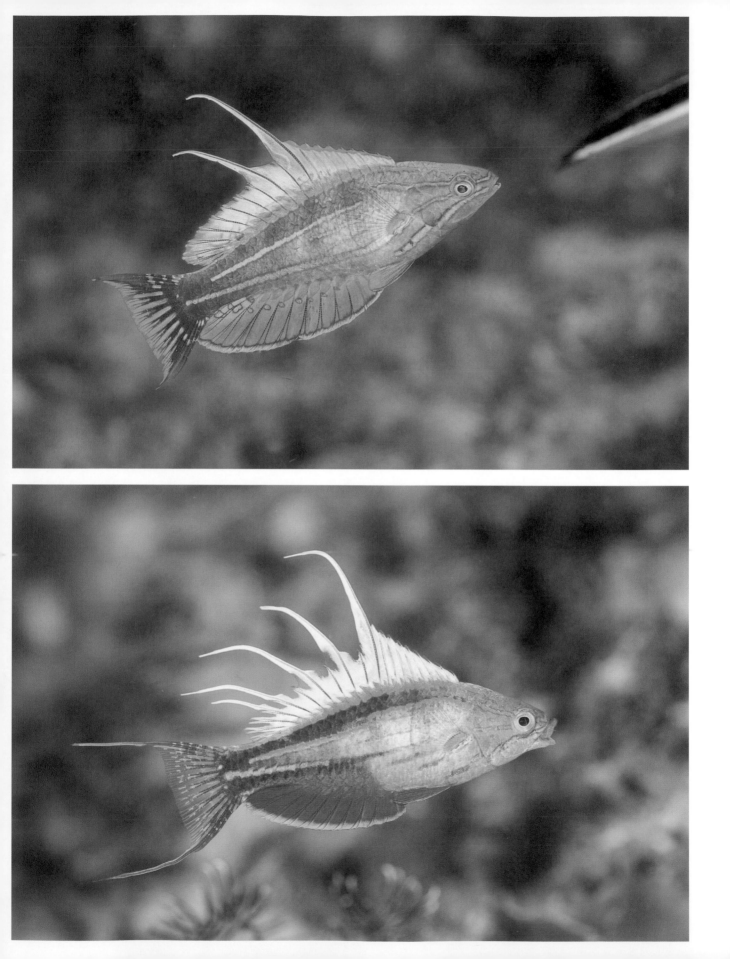

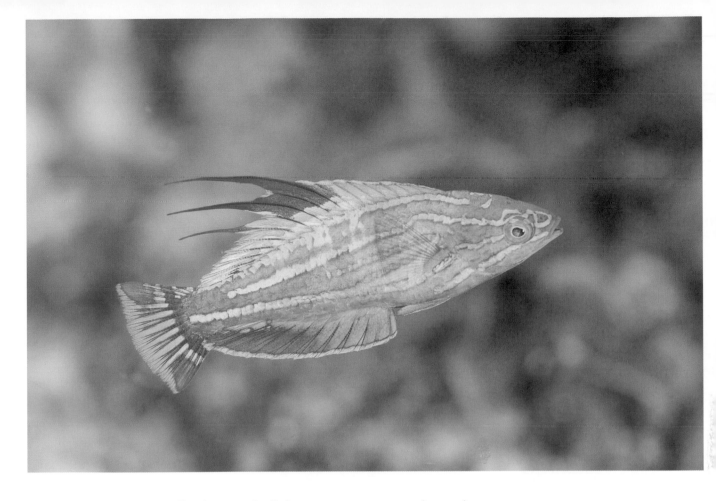

latter arguing the opposite.[146] Either way, the flasher wrasses are an unusual example of an animal that easily forms hybrids where populations of different species coexist.

The question of hybridization in flasher wrasses brings to light a recurring problem within the taxonomy of both flashers and fairies. Humans like to put animals into boxes, which we call "species," however, this isn't necessarily the reality of nature. We might imagine that it's easy to look at an organism and know immediately which species it belongs to, but sometimes scientists struggle to fundamentally define what a "species" actually is.[147]

As new species continue to be named, it has become increasingly difficult to know where to draw the line between populations and species boundaries. Over the last couple of decades, we have developed the immense potential of genetic analysis to confirm or refute our suspicions in distinguishing different species. Traditionally, we have assumed that, for two species to look visually distinct, a significant amount of time would have passed since their divergence and detectable changes would also have accumulated in their genes. In fact, the flashers and fairies sit at an uneasy new frontier where many fishes that look very different to each

ABOVE: Displaying male hybrid flasher wrasse (likely Walton x yellowfin). Cenderawasih Bay, West Papua, Indonesia.

OPPOSITE TOP: Displaying male hybrid flasher wrasse (likely Nursalim x yellowfin). Triton Bay, West Papua, Indonesia.

OPPOSITE BOTTOM: Displaying male hybrid flasher wrasse (likely Nursalim x blue). Triton Bay, West Papua, Indonesia.

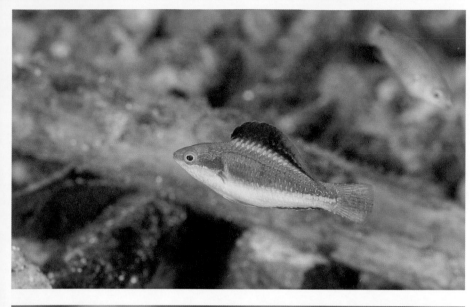

other are genetically almost identical, changes in their own genetic makeup seemingly not keeping pace with the evolution of their colors and patterns. This conflict has come to a head around the newly named Marinda's fairy wrasse, where there has been some controversy, based on the lack of genetic differences between it and the similar Conde's fairy wrasse, over the validity of identifying this as a new species.

I was diving in the Solomon Islands when I came across a tiny fairy wrasse that I wasn't familiar with. I swam over a coral head and in front of me was an expanse of sand with some tree trunks and leaf litter. I was hunting for cryptic animals among the organic matter, when a frantic tiny fairy wrasse caught my eye. I had never seen a displaying male fairy wrasse that was so small before and immediately knew it was something different. The male had an extremely

ABOVE TOP: Marinda's fairy wrasse. Solomon Islands.

ABOVE BOTTOM: Conde's fairy wrasse. Raja Ampat, West Papua, Indonesia.

high and somewhat curtailed black dorsal fin, also unlike anything I had seen before. As soon as I was back in the virtually connected world I did some research and found that just a few weeks before, the new Marinda's fairy wrasse had been described. The controversy, however, arose from the similarity of this new species with Conde's fairy found in almost exactly the same geographic region. As one of the few people to have seen both species in the wild, I am sure that these are distinct. I had seen Conde's fairy wrasse in Raja Ampat, West Papua and in comparison, the dorsal fin had significantly less black and was much more "normal" in shape. So, whilst genetically these two species are very similar, they look and behave rather differently.

The World Beneath

Several recent studies have found that closely related species, such as Marinda's and Conde's fairy wrasses, are likely to have split very quickly from each other in recent history, their evolution driven by strong sexual selection.[148] Such strong sexual selection can result in the development of hugely divergent male color patterns with the passage of just a short amount of time. Where large groups of females choose from relatively few breeding males, males face huge selection pressure, which produces unbelievably bright and complex male patterns as well as exaggerated fins. Where sexual selection has so quickly driven the evolution of these different male color patterns there is limited opportunity for the rest of the genome to catch up. Ordinarily there would be other neutral genetic mutations that simply accumulate with the passage of time, and it is these that we detect through genetic analysis. Since we only analyze relatively small sections of a species' genome when carrying out these tests, we may not pick up the relatively few genes involved in color and the genome at large appears very similar between the two species. It may be that as the costs decrease and make it more affordable to analyze a larger proportion of the genome, we will indeed find the differences reflected in the genome that are evident in the physical attributes of these species. In the case of Marinda's and Conde's, there was no observable difference in the genetic analysis conducted. Species such as these can challenge our definition of a species since they are clearly no longer interbreeding and therefore must be distinct.

Although flasher and fairy wrasses may seem like an obscure group of fishes, they possess many biological quirks and illustrate how much we still need to learn about the oceans. Of course, plenty of other new and little-known groups of animals populate our tropical shallow seas too. If they inhabit an ecosystem as imperiled as coral reefs, they inherently face the threat of extinction. Our goal in conservation must be to protect as many species, both well-known and obscure, as possible.

The World Beneath

CORAL REEFS IN THE TWENTY-FIRST CENTURY

In 1998, the world looked on in horror as coral reefs around the globe began to turn ghostly white and die. I was diving in the Maldives as this ecological disaster unfolded, but at the time, I didn't fully comprehend what was happening to the reefs. Few people did. I took some of my first underwater images during that trip on a simple point-and-shoot camera, and knowing what we know now, it's shocking to look back and see these reefs in their death throes. We were experiencing the first recorded global coral bleaching event: it went on to kill 16 percent of all the world's hard corals.[149]

I returned to the Maldives sixteen years later in 2014 and felt absolutely devastated when I jumped in for my first dive. The once bustling reefs had become a shadow of their former selves, and my heart ached for the loss of life. Many of those corals that had bleached in 1998 subsequently died. Researchers have since found that parts of the Indian Ocean lost 90 percent of their corals that year thanks to sea temperatures three to five degrees Celsius above normal.[150] The architectural shapes and structures formed by the diverse branching, plate, and vase corals had eroded down to stumps on the tops of the towering coral reef monoliths, locally known as "thilas." Where the biologically diverse reefs once stood, algal-covered

OPPOSITE: A reef top barren, many years after being devastated by coral bleaching. Maldives.

OPPOSITE TOP: A healthy reef top with a school of bigeye trevally. Solomon Islands.

OPPOSITE BOTTOM: A bustling, healthy reef top with an immense school of silversides. Raja Ampat, West Papua, Indonesia.

bedrock now stretched in huge expanses. Of course, some sites have recovered better than others, and more resilient types of corals remain, but there is no doubt that the reefs have undergone a fundamental change. The year 1998 was the warmest year the Earth had experienced since records-keeping began 150 years earlier, and the impacts were clear.[151] Since 1998, there have been two subsequent global coral bleaching events and the latest, in 2016 and 2017, hit the Maldives with particular force. One wonders how much more destruction the reefs can bear.

Coral reefs live in places that few of us are lucky enough to enjoy firsthand. As a result, it can be hard to relate to how incredible they are. There isn't an ecosystem on Earth that compares in terms of the number and diversity of species you can experience. From one spot you can look up and see sharks, schools of barracuda, and trevally swimming overhead. You can look out across the reef where dozens of reef fish flit about conducting their business. Or, look down at the countless sessile invertebrates, sponges, tunicates, corals, and echinoderms, and see where tiny pygmy seahorses and cryptic pipefish live on a more miniature scale. This all depends on the fragile alliance between scleractinian corals and humble algae. Throughout this book we have learned about the myriad of amazing creatures that require healthy coral reefs for their very survival. Many readers will be surprised that so many are still being discovered on such a regular basis, and not just the tiny animals hiding away in the shadows and crevices, but fish that flash kaleidoscopic colors to announce themselves. If we lose coral reefs, we lose them all.

The Caribbean is a case study on how coral reef ecosystems can change over time. At this point almost all pristine Caribbean reefs are relegated to the history books of the late 1970s,[152] when several species of hard, or scleractinian, corals dominated and were the primary builders of reef structure.[153] *Acropora* branching corals dominated the shallows of the Caribbean for at least half a million years until the 1980s, when they virtually vanished over a ten-year period. Today, macroalgae dominate and corals are only just maintaining a foothold. The Caribbean suffered a perfect storm of reduced herbivore numbers at a time when human-produced nutrient runoff from shore acted as a fertilizer for these large fibrous algae, and their populations skyrocketed. Once these algae reach a certain size, they are tough and largely inedible for most herbivores even if their populations recover. With time, algae overshadow corals and prevent new ones from settling; in this way, the shift to algal dominance becomes permanent.

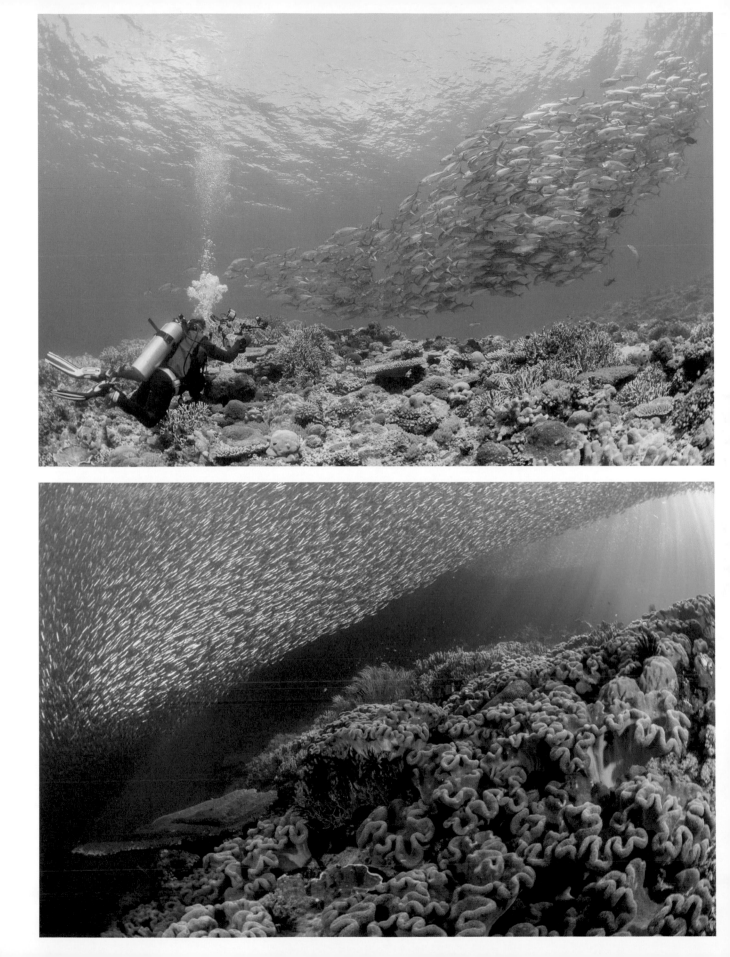

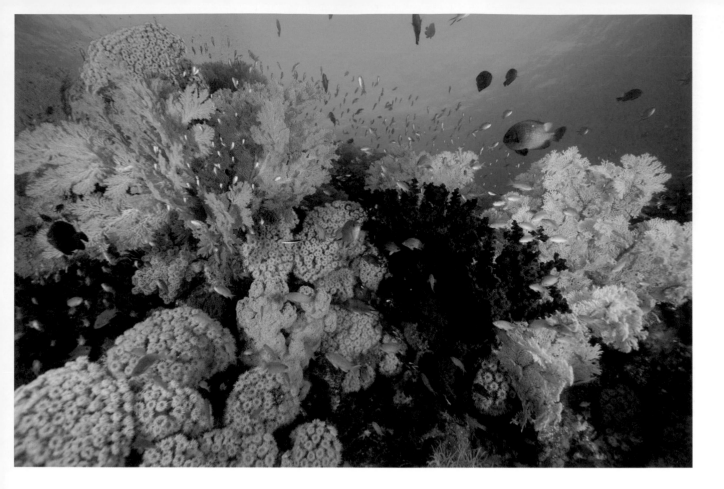

At the same time, major outbreaks of disease resulted in the widespread death of corals and urchins. White-band coral disease killed off huge stands of *Acropora* branching corals and a second pathogen in 1983 and 1984 resulted in the widespread die-off of the previously ubiquitous *Diadema* urchins; there was a 98 percent mortality rates once they were infected by the pathogen, and millions of them died from it.[154] Overfishing of large algae-eating fishes, such as parrotfish, also contributed to the lack of mouths capable of grazing away the proliferating algae. The final nail in the coffin for the last remaining Caribbean corals may be widespread coral bleaching, which in 2005 affected 95 percent of coral colonies in some areas. In the US Virgin Islands, over 50 percent of corals died due to bleaching and subsequent disease.[155]

The World Beneath

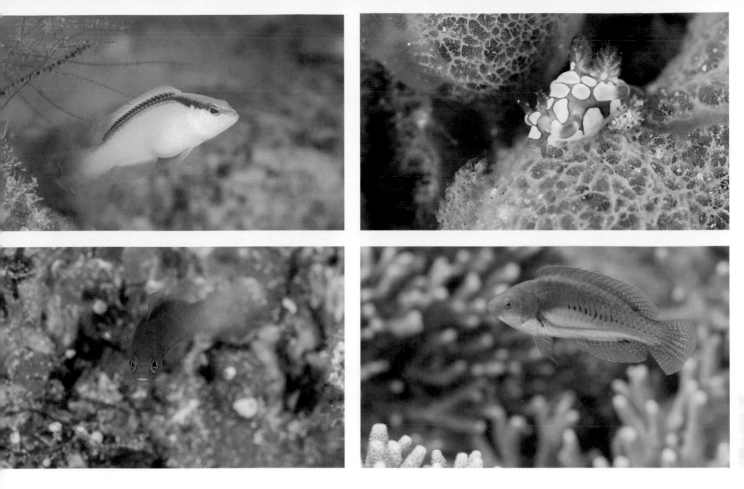

BLEACHED

"Coral bleaching" is a term that is often referred to in the media, but few people actually understand how it is caused and what it means. At a basic level, bleaching happens when the coral-algal symbiosis breaks down. The algae, more correctly known as "zooxanthellae," are beige in color and provide the coral with its color until they leave. The term "bleaching" refers to the coral after the algae have left, so the remaining coral is stark white or very pale in color. Anemones and other organisms with zooxanthellae can bleach too. There are various reasons why the algae may leave, but it is generally a result of environmental stress such as increased temperatures, pollution, or elevated nutrient and light levels.

The coral-algal symbiosis allows corals to flourish in the clear nutrient-poor waters of the tropical shallows. Algae, or zooxanthellae, provide corals with sugars produced through photosynthesis and in return the coral provides the algae with its own waste products as a fertilizer. The fact that a coral has bleached doesn't necessarily mean that it has died, although if the water becomes too hot too quickly then corals can die even before having the chance to bleach. After bleaching, some corals

ABOVE TOP, LEFT TO RIGHT:

Zippered dottyback, described in 2008. Triton Bay, West Papua, Indonesia.

Two nudibranchs (sea slugs), *Trapania scurra*, described in 2008. Triton Bay, West Papua, Indonesia.

ABOVE BOTTOM, LEFT TO RIGHT:

An undescribed Papuan dottyback. Triton Bay, West Papua, Indonesia.

An undescribed fairy wrasse from Cenderawasih Bay, West Papua, Indonesia.

can live without algal symbionts for a limited amount of time by feeding on plankton that they catch using the ring of tentacles that surround each polyp. However, at this time, the coral is still very much in danger. Without the algae, ongoing stresses that the coral experiences make it vulnerable to infection, and subsequent mortality. Should conditions improve, new zooxanthellae may populate the coral and it can begin to recover. The biggest danger sign following a bleaching event is when the corals start turning rich brown in color. This suggests that the living coral has died and algae are beginning to grow over the coral skeleton. There is no possible recovery for the coral at this stage.

The most widespread coral bleaching events have been a result of rising sea surface temperatures caused by human-induced climate change.[156] An increase of two degrees Celsius above the expected average temperature for the water at a given time of year is enough to cause bleaching; in some cases, reefs have had to endure temperatures higher than this for many months. In fact, just one degree Celsius above normal temperatures for a month is enough to trigger mass bleaching. Over the past eighteen years, global warming has resulted in three planetwide bleaching events: in 1998, 2010, and 2015/2016. Incidences of large-scale coral bleaching were first recorded in the 1980s, but in 1998 the extent and impact of the first global bleaching event resonated throughout the world. The effects of the most recent global mass-bleaching event in 2015/2016 are still being collated, but it was the longest, most widespread, and most severe global bleaching event ever recorded, with many areas experiencing multiple mass-bleaching events during this period.[157] Impacts from across the world are extremely sobering, including catastrophic damage to the iconic Great Barrier Reef and Hawaiian reefs.[158]

The 2015/2016 bleaching event resulted in the unprecedented ecological collapse of the coral reefs on Australia's Great Barrier Reef north of Port Douglas.[159] [160] This northern section of the reef was hit the worst and accounted for 75 percent of coral mortality on the Barrier Reef.[161] During the peak of temperature extremes, tens of millions of corals died over a two- to three-week period. Eighty percent of 522 reefs surveyed were severely bleached, and less than 1 percent of the corals remained unbleached. Nearly a third of all the Great Barrier Reef's corals died in 2016 alone, and human-induced climate change is estimated to have made this catastrophic coral mortality 175 times more likely. The most terrifying projections suggest that by 2034, the Great Barrier Reef will be hit by bleaching events of this same severity every two years.

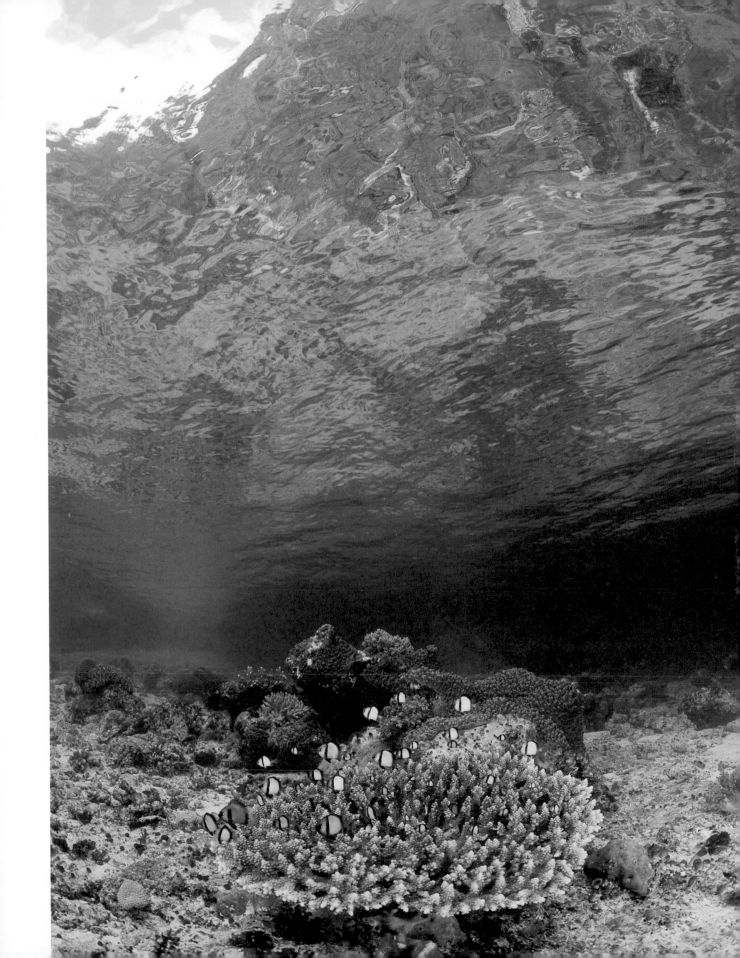

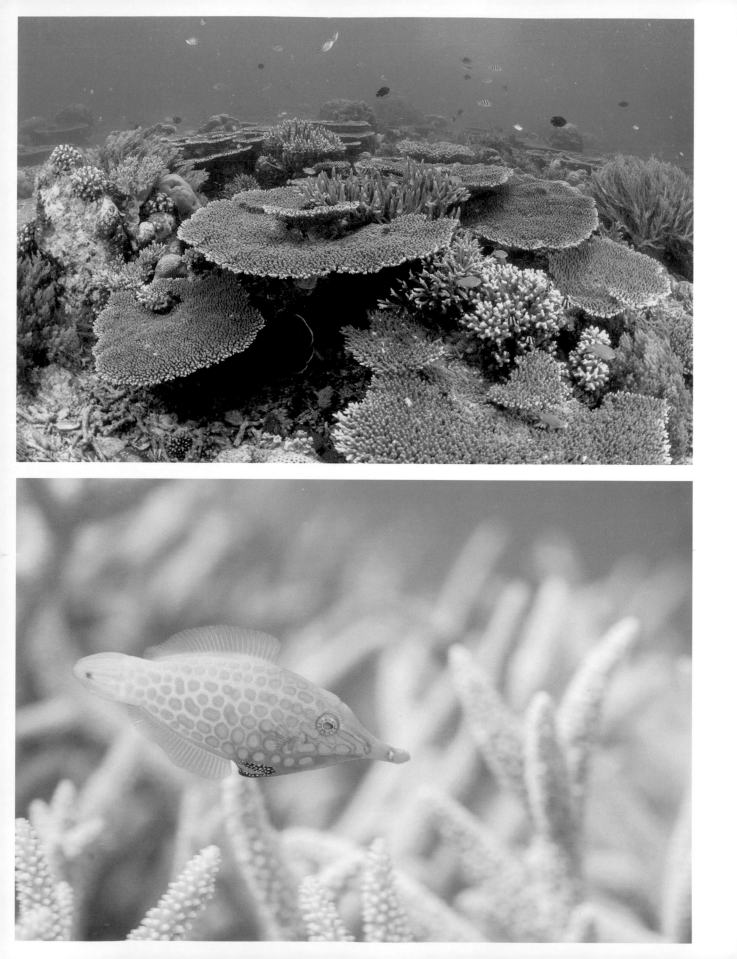

Certain types of corals are more likely to die because of bleaching, particularly branching and plate forming types, which are those that form much of the reef's three-dimensional structure. Given that these corals can be pushed to regional extinction following a particularly severe bleaching event, there are huge implications for the future of the reef and its composition. Mature and diverse coral reef communities take many years to establish, and bleaching events can reduce these areas to a shadow of their former glory very quickly. Suddenly, creatures that rely on those corals are left without a home. Often, on a healthy reef crest, you'll see great clouds of planktivorous fish that simply rely on the physical structure of branching corals to hide when predators pass by. Species such as these may endure beyond the life of the coral, but as the skeleton begins to crumble and erode, they too will disappear. Specialized corallivores that feed directly on coral polyps, such as butterflyfish and longnose filefish, will find their food source vanished. What about all the other organisms that we have learned about in previous chapters? Science knows very little about them, and they are hard to include in predictions. Still, most groups of reef fish decline in number after a bleaching event due to loss of habitat. Predictions from many scientific authorities suggest that these global bleaching events will increase in frequency and severity in coming decades to the extent that coral reefs as we know them may not endure beyond 2050 or even sooner.[162] How old will you be in 2050? What age will your children be?

Mass coral bleaching events result directly from human-induced climate change.[163] As we continue to burn fossil fuels, carbon dioxide in the atmosphere increases, which in turn traps heat in our atmosphere. For global temperatures to remain below two degrees Celsius above preindustrial levels, we will need to leave 80 percent of known coal reserves, 50 percent of gas reserves, and 30 percent of oil reserves unburned.[164] In 1910, atmospheric levels of carbon dioxide were at 300 parts per million and have now surpassed 400 ppm, which is higher than they have been for at least eight hundred thousand years (although some data suggest it may be more like twenty million years). Human impact has already been so far-reaching on the climate and environment that geologists widely believe that we have now entered a new geological era that they propose should be named the Anthropocene.[165] Our dominance over the Earth's environments is now clear enough to observe in the soils around us that will become the rocks memorializing our existence long after we are gone. These strata will

OPPOSITE TOP: A diverse hard coral garden. Raja Ampat, West Papua, Indonesia.

OPPOSITE BOTTOM: Longnose filefish only eat coral polyps, so require plentiful hard coral growth. Fiji.

contain human-made products, such as concrete and bricks, as well as our roads and cities, polluted soils and muds, plastics, and radiation from the waste of power plants and atomic bombs.

TOXIC SEAS

Coral bleaching isn't the only consequence linked to increasing atmospheric carbon dioxide concentrations. Over recent years, the danger of ocean acidification has become apparent. More than 30 percent of the carbon dioxide we emit is absorbed by the oceans, which makes them more acidic when carbon

The World Beneath

dioxide reacts with water, producing carbonic acid.[166] Further reactions of the carbonic acid act to mop up vital carbonate ions from seawater, which then reduces their availability to the marine organisms that rely on them to form calcium carbonate for shells and other structures, including the skeletons of corals. Due to high atmospheric carbon dioxide concentrations, the oceans now have carbonate ion concentrations that are lower than they have been at any point in the past 420 thousand years.[167]

Laboratory experiments show that the problem of ocean acidification is potentially far-reaching and could impact any creature that creates a calcium carbonate structure, including a range of mollusks, from planktonic to reef-living,

ABOVE: An endemic Cenderawasih damselfish, described in 2012, guards and tends to her eggs on a discarded single-use plastic bottle. Manokwari Harbor, West Papua, Indonesia.

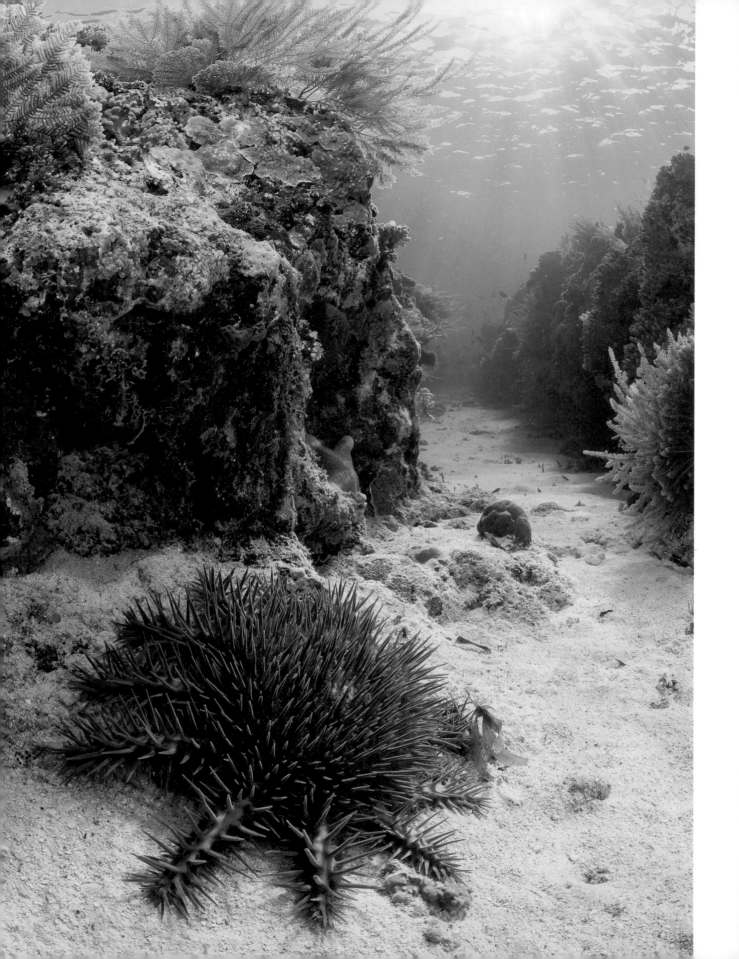

as well as echinoderms and corals. The impact on marine organisms is predicted to become more widespread as this threat grows. Once atmospheric carbon dioxide concentrations reach 560 ppm, coral growth could be reduced by 40 percent.[168] Corals have been experimentally shown to completely lose their skeletons in acidic water, but they are able to regrow them when returned to normal seawater, which, at least, offers a ray of hope if we manage to curb carbon dioxide emissions. Year by year, corals grow on the deceased carbonate skeletons of their forbears, so the continued formation of these carbonate skeletons is fundamental for future reefs.

OPPOSITE: A crown-of-thorns sea star on a reef. Wakatobi, Sulawesi, Indonesia.

The quality of ocean water is not only being impacted by climate change but also land management practices, with the greatest dangers coming from rapidly increasing fertilizer use and land clearing. As we know, the symbiosis between coral and algae evolved due to the paucity of nutrients in the nutrient desert of clear blue tropical waters. When conditions shift due to human interference, this partnership can break down. Deforestation has a direct influence on the survival of local offshore coral reefs. Forests and other natural vegetation are currently being cleared at a rate of 1 percent of the Earth's surface each year; this contributes to our forests shrinking at a global rate of ten billion trees per year.[169] Those huge areas of suddenly exposed soil without roots to bind them together means that large amounts of topsoil wash off the land and into coastal waters. This quickly smothers inshore reefs and can kill corals. Those reefs that aren't directly smothered can also suffer due to increased turbidity preventing vital light from reaching them.

A further issue with land clearing is that the cleared areas are often subsequently planted with crops, which then need fertilizing. Nitrogen-based fertilizer use has increased more than six-fold since the 1960s.[170] Like the soils, these fertilizers are washed out onto the reef. Free-living macroalgae, rather than corals, tend to benefit most from this situation and soon the fertilized algae smother and dominate corals. The Great Barrier Reef has suffered over the years thanks to the huge amounts of fertilizer used to grow extensive coastal sugarcane crops. The nutrient load of the waters flowing out to sea is estimated to be seven to ten times higher than would be expected without agricultural runoff.

An unexpected knock-on effect of these high nutrient levels appears to be plagues of crown-of-thorns sea stars. These large sea stars occur naturally on coral reefs in low numbers but are voracious corallivores. They are venomous, and few predators are able to negotiate their spines; however, they are ordinarily found in

Coral Reefs in the Twenty-First Century

such low densities that the reef is able to absorb their impact as part of its natural processes. It appears that increased nutrient levels around the Great Barrier Reef have resulted in blooms of phytoplankton, which is the food of larval crown-of--thorns sea stars. With a doubling of phytoplankton, there is tenfold growth and survival of larval crown-of-thorns sea stars.[171] Localized currents collect these larvae and when they are old enough to settle on the reef they are deposited in large numbers. Huge outbreaks, with estimates of millions of individuals, have devastated large areas of the Barrier Reef, adding to pressure on the reef ecosystem from coral bleaching.[172] Adult sea stars often hide in the reef during the day, making a physical cull ineffective, but it is thought that reducing nutrient levels to improve the water quality of the reef is the best way to reduce them.

Fertilizers are not the only treatment used to enhance the growth of crops. On the Barrier Reef, pesticides are starting to have an impact on the reef too, where they are being washed into the sea from farmland. Even very small amounts of herbicides can affect the productivity of marine plants and corals, and these are now also being detected on the reef.[173] Of course, the Great Barrier Reef isn't the

only location that these impacts are being detected, but it is where much of the data is collected. This is a worldwide phenomenon that is just another of the many dangers impacting coral reefs.

As we have seen, even naturally occurring coral reef species, such as the crown-of-thorns sea star, can run amok when a system gets out of sync. However, where non-native species are introduced to reefs, the threat looms larger. Without their own predators, competitors, or even parasites, non-native species have a huge advantage over indigenous ones. There have been many examples of alien species impacting temperate marine ecosystems and causing huge economic impacts, including zebra mussels in the Great Lakes and Japanese sea stars in southern Australia; the latter is just one of about 250 invasive marine species that have been detected in Australian waters.[174] There have been similar impacts in the tropics when reef species have been moved from their native homes to new shores.

HOME AWAY FROM HOME

The most well-known and devastating example of alien impacts on coral reefs has been the lionfish's introduction into the Caribbean. Lionfish, native to the Indo-Pacific, were introduced into Floridian waters in the early 1990s, most likely from aquarium captives. Surveys from the Bahamas showed the arrival of a single individual in 2005, but by 2007 over one hundred individuals were recorded and their spread has been almost viral ever since. They are already abundant and widespread, with little chance of being eradicated, having reached Bermuda to the east, Rhode Island to the north, and Brazil to the south.[175] They pose a potentially major threat to native species, due to their predation of reef fish and competition with other predators. They hunt using oversized and filamented pectoral fins to herd and corner prey before a rapid strike. West Atlantic fishes are naive to this approach, having never experienced it before, so predation success is much higher than on the lionfish's native Indo-Pacific reefs.

The presence of lionfish on Caribbean reefs has been linked to dramatic declines in the diversity and abundance of herbivorous fishes, which in turn is another cause of algal proliferation on Caribbean reefs. Predators such as sharks and groupers seem to naturally avoid lionfish, although populations sometimes seem to stabilize thanks to widespread cannibalism within lionfish groups and through some native predators beginning to learn to eat these new invaders. It

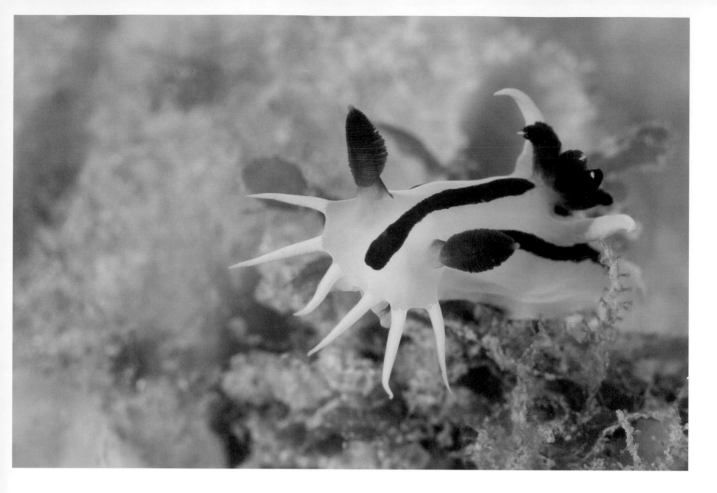

seems that continuing a targeted fishery for adult lionfish may allow the system to recover and ultimately for a greater number of species to coexist.

Humans have had a huge part to play in the migration of marine species around the planet. Marine creatures are often unintentionally transported in the ballast water of huge container ships. There are extensive networks of these around the globe, linking trade hubs in Europe, the United States, Asia, and beyond. These large container ships take on ballast water for stability in one port, and as they add or remove cargo they adjust the volume of ballast water they are carrying. This water may be taken onboard in one part of the world and emptied in another, thereby transporting larval marine creatures in the ballast water from one part of the world to another.[176] When emptied into a new part of the ocean, without any of their natural predators or competitors, their numbers can balloon. Before too long they can become part of the local ecosystem, and it is then all but impossible to remove them.

One of my favorite sites to dive in Australia is a bay a few hours' drive north of Sydney. Often while diving there I have come across a stunning little black, white, and yellow sea slug named *Polycera capensis*. After seeing a few of these

nudibranchs and very much appreciating their unusual yellow oral tentacles that stick out from the front of the animal, it suddenly struck me as strange that there would be a "cape" slug in eastern Australia. The name "*capensis*" generally refers to the South African cape, so I decided to do a little digging on the name. It turns out that this species was another species most likely transported in the ballast waters of ships from its native Africa. Since 2014 it has also been found in waters sufficiently warm enough to sustain it near Tasmania. This is just one more example of an alien species becoming established and, like many such species, it is not yet known what impact this species could have on native Australian marine life.

Another way that we have helped move marine creatures around the globe is through the building of shipping channels. The Suez and Panama canals have shortened trade routes and saved millions of dollars annually by avoiding the circumnavigation of continents, but at the same time they have linked bodies of water that have previously been separated by millions of years of evolution. We currently know of about 350 nonindigenous species that have entered the Mediterranean Sea from the Red Sea through the Suez Canal since its opening in 1869, and many are having huge impacts on local flora and fauna.[177] Among the voluminous number of examples, a goatfish has replaced local mullets, non-native prawns have replaced native varieties, and an introduced oyster completely replaced a native species along the Israeli coast within a decade. A Red Sea jellyfish now produces such dense summer blooms in the eastern Mediterranean that they clog fishing gear and power plant intakes. The non-native jellies are also venomous, with a sting that can be painful for months, so they have huge impacts on tourism as well as local access to the ocean. Passage of marine organisms through the Panama Canal have been numerous but luckily not as extensive as those through the Suez. Since its opening in 1910, passage through the Panama Canal has included freshwater lock systems, which have prevented many, but not all, marine invaders from crossing.

TAKE, TAKE, TAKE

In some parts of the world where we have introduced species they have wrought havoc, but in others we are harvesting native species beyond levels that are sustainable for their populations, causing ecosystem-wide catastrophes. Fish caught on or near coral reefs are a major source of food for a billion people around the world and account for around 10 percent of the world's fisheries' catch, so it is clearly

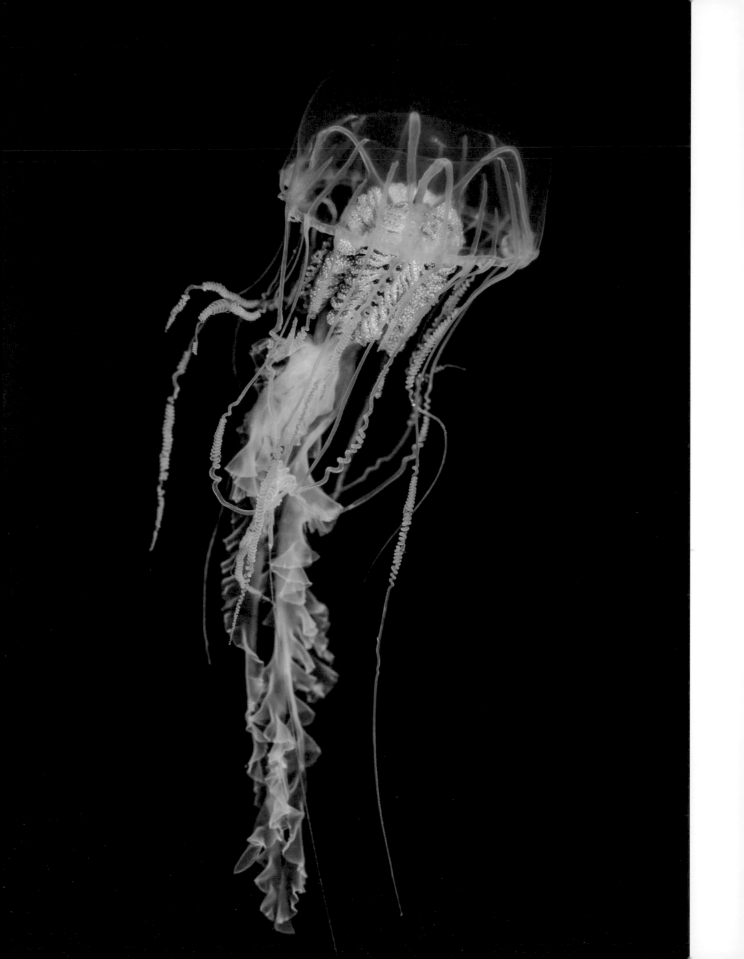

important to manage these fish stocks in order to provide this critical resource to some of the poorest parts of the world. However, it appears at present that coral reef fish are being caught at rates 64 percent higher than can be sustained in the long-term. The situation is particularly grave around densely inhabited islands such as Sri Lanka, Madagascar, the Philippines, and Trinidad and Tobago.[178] Small-scale subsistence fishing of coral reefs in the Western Pacific has been taking place for forty thousand years without known major ecological impacts, so sustainable fishing levels are attainable if the industry is managed responsibly.[179]

Sadly, there are many unsustainable fisheries in our tropical oceans; one of the most heartbreaking and wasteful is for shark fins. During my experience of Southeast Asian reefs over the past twenty years, I have witnessed firsthand the impact that shark finning has had on shark populations. In 1999, I visited Kavieng on the island of New Ireland, in a remote corner of east Papua New Guinea. During the trip I had two of my most incredible shark encounters ever. While diving a site called Chapman's Reef, we had quite a hairy entry, with strong currents forcing us to swim straight down from the surface to sixty feet below as quickly as we could. Once safely down, we could shelter from the raging current behind some large coral rocks and watch the action take place around us. A huge school of several hundred bigeye trevallies stuck closely together all around us, knowing what lurked just off the reef.

After twenty minutes or so, the rest of the divers surfaced, but my father and I stayed a little longer to enjoy the show. With just the two of us left on the site, the lurking predators felt slightly braver. Suddenly, without warning, a feeding frenzy began before our eyes. Several gray reef sharks appeared at high speed out of nowhere. One came in right over our heads so quickly it was merely a blur. They stole the startled trevallies straight from the school, and, in a flash of silvery bodies, they were gone again as quickly as they came. I haven't seen such an abundance of gray reef sharks on a reef in Southeast Asia since.

Just the next day, we dived Valerie's Reef, which was known for its resident group of silvertip sharks. These hefty sharks reach ten feet in length and several of them swam all around our group of divers, completely dwarfing us. It was truly humbling to be in such close proximity to these magnificent animals without feeling any sense of danger from them. I have never felt threatened by a shark's behavior, so long as we treat them with respect. In fact, it is humans that these sharks should have been afraid of. Soon after these encounters, a dedicated longline

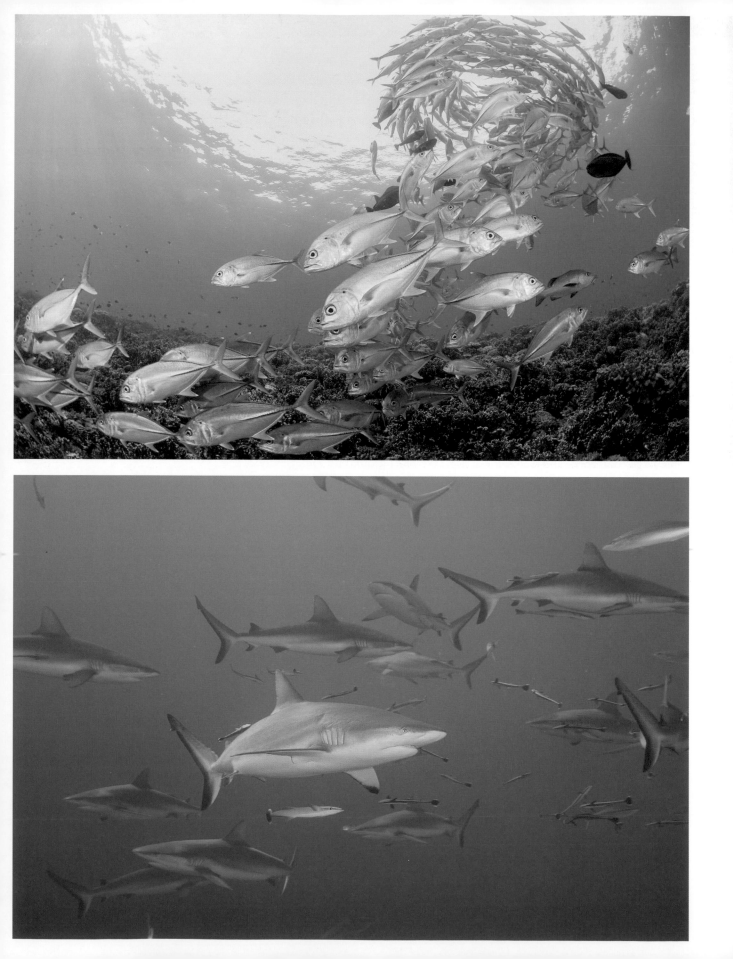

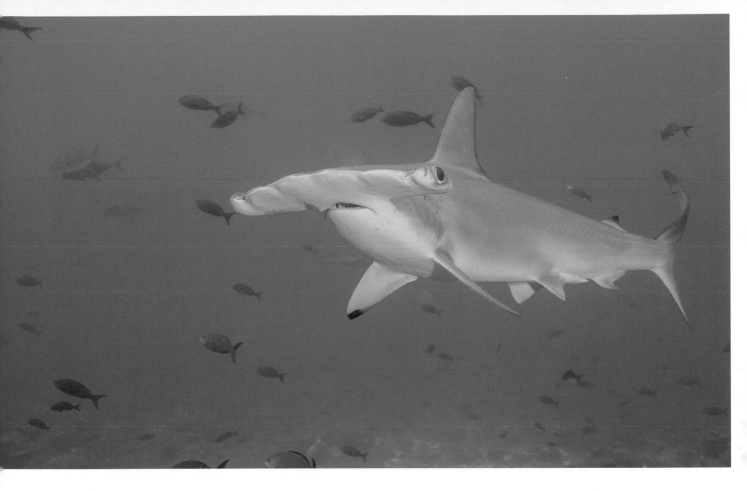

shark fishery opened in this area of Papua New Guinea. In just a year, the graceful silvertips of Valerie's Reef were killed. Thankfully this fishery was closed in 2014, so there may be a chance some sharks will return.

Global shark fisheries have been relentless in supplying the insatiable demand for shark fin soup, an Asian delicacy. Sharks are caught in huge numbers on longlines, which in open seas can extend for over sixty miles, with thousands of baited hooks hanging from a single line. In many cases, fisheries cut off the valuable fins and discard the shark's body; because of its bulk and the space required to store it, the fin-less body is often tossed back into the ocean.

Whilst diving in the enormously well-protected Galapagos Islands just last year, two magnificent silky sharks swam past me in pursuit of some schooling fish and I was shocked to see that they were both missing their dorsal fins. In fact, these were the lucky ones. Usually the sharks asphyxiate and die on the longlines before being freed. Many other species are also caught as incidental bycatch on longlines, such as sea turtles, albatrosses, and dolphins. Conservative estimates indicate that 1.4 million tons of sharks are caught per year, or around

ABOVE: Scalloped hammerhead shark populations have reduced by 75 percent in the Atlantic. Galapagos Islands.

OPPOSITE TOP: Schooling bigeye trevally. Solomon Islands.

OPPOSITE BOTTOM: Gray reef sharks are now very scarce, or locally extinct, across much of Asia. Great Barrier Reef, Australia.

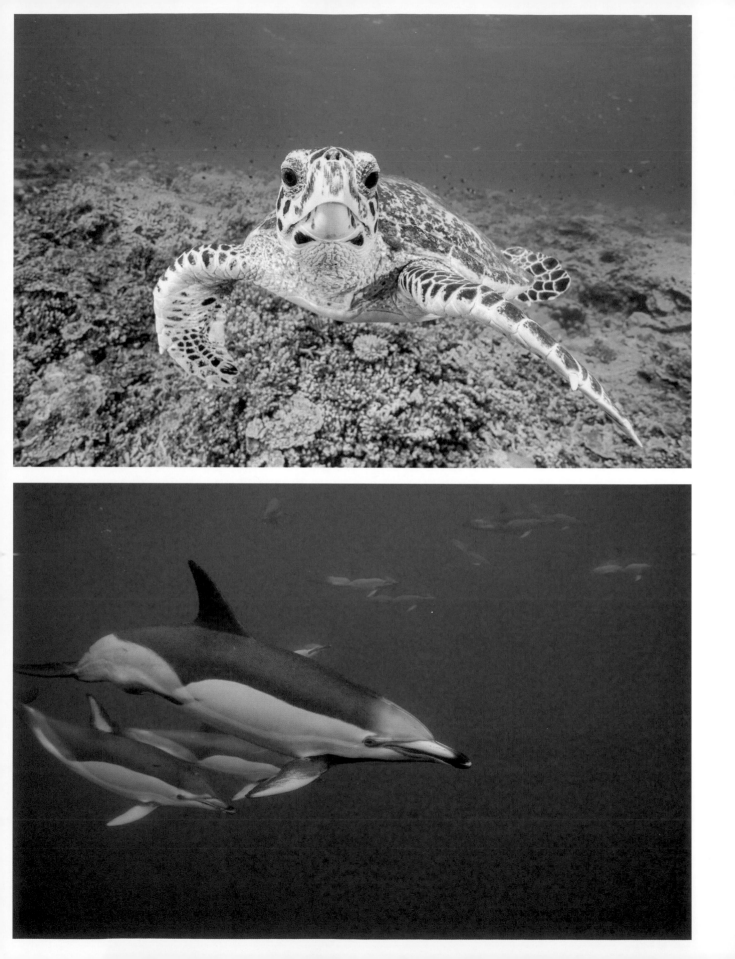

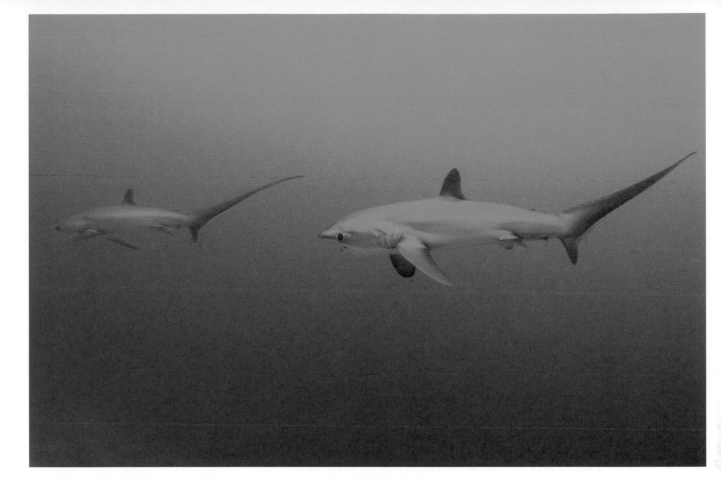

one hundred million individual sharks; however, some numbers suggest the figure could reach up to 270 million.[180] To put this into perspective, the human population of the United States is around 325 million. In the Northwest Atlantic, populations of great white, thresher, and scalloped hammerhead sharks are thought to have been reduced by more than 75 percent in the past fifteen years.[181] Furthermore, Atlantic populations of Oceanic whitetip sharks are listed as critically endangered, facing an extremely high risk of extinction, and yet continue to be hunted. Despite these extremely disturbing statistics, we have very poor data on how many sharks remain and whether they will be able to recover from this decimation. Some shark populations are thought to have been reduced by 90 percent; however, we lack accurate baseline information from yesteryear to found this on, which could mean that they're even closer to extinction than we realize. Whatever the case, sharks will struggle to rebound from such heavy fishing pressure in our lifetime, particularly with such small broods and late sexual maturity.

ABOVE: Populations of the majestic thresher shark have plummeted in the Atlantic. Cebu, Philippines.

OPPOSITE TOP: Sea turtles fall foul of longlines. Tubbataha Reef, Philippines.

OPPOSITE BOTTOM: Dolphins become incidental bycatch in longline fisheries. Azores Islands, Portugal.

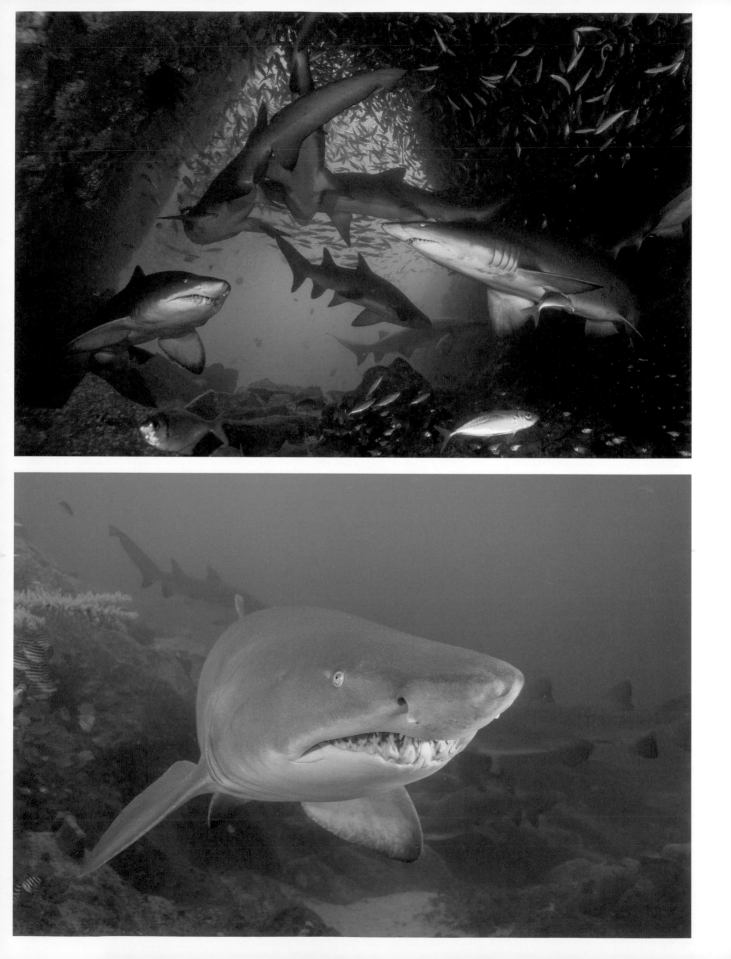

A Wasteland for Dummies

Coral reef fish are threatened not only by overfishing itself, but also the destructive fishing techniques used to catch them. Cyanide and dynamite fishing are the most destructive practices, killing many other creatures as collateral damage. Cyanide fishing tends to be used in the live fish food trade, in which species of grouper and Napoleon wrasse are particularly targeted. Target fish are squirted with cyanide, subsequently stunned, and caught alive—a practice that in the process kills an area of coral, as well as the other organisms that inhabit it. Much more widespread and damaging than cyanide fishing is dynamite or blast fishing. Risking their own loss of life and limb, fishers use homemade bombs to kill fish, which then float to the surface, making them easily collectible in relatively large numbers. The blasts have the side effect of also shattering coral skeletons, leaving in their wake large expanses of coral rubble.

These extensive rubble barrens move and shift slightly with currents and swells, which perpetually prevents a solid surface on which corals and other organisms can thrive. Almost nothing grows in these fields and few fish populate them. It has been estimated that they may take anywhere from several decades to centuries to return to productive and biodiverse coral reefs.[182] A single blast in the middle of a rich coral reef structure can destroy an area of four to six feet; however, these limited blasts are much less damaging in the long term. Within five years these blast craters can return to normal, but when expansive barrens are formed they still show no signs of recovery many years later.[183] It seems that being surrounded by healthy corals encourages the regeneration process.

In response to degraded reefs around the world, artificial ones are being created. These artificial reefs can come in the form of concrete blocks that form a stable substrate onto which corals and other organisms can settle, or metal frames, which in some cases have been enhanced with an electric current running through them to promote coral settlement. The devices seem to attract fish by providing the complex habitat structures that they prefer, and colonization can begin within months, going through a succession of growth from the early barren structure to more diverse species assemblages as time goes by. The information we now lack is whether these artificial reefs will in the long-term go on to become equally as diverse as their natural counterparts.

As much damage as we are causing to coral reefs and the animals that inhabit them, we are also creating a huge humanitarian, as well as economic, disaster by

doing away with all those services that coral reefs provide us for free. Most fundamentally, many of the remote oceanic countries such as Tuvalu, the Marshall Islands, Kiribati, and the Maldives directly rely on corals to generate the very ground that they were founded on. The Maldives has one of the highest population densities in the world with around four hundred thousand people living on twenty-six atolls, its highest altitude just eight feet above sea level. Kiribati reaches just six feet above sea level and its 110-thousand-strong population lives scattered through thirty-three low-lying atolls.[184] Without coral reefs these islands wouldn't exist. The continued growth of corals is of paramount importance; otherwise, these islands will erode away, or be swallowed by rising seas.

Corals physically generate limestone as a feature of their growth, and the fringing reefs that surround many islands are critical in protecting the shoreline from erosion and damage when storms strike. Corals also promote the growth of seagrass beds and mangrove forests, which are very important in coastal protection. Mangrove forests are a fascinating place to explore. The complex webs of tree roots that they produce are very solid and can buffer even the most vicious climatic onslaughts. These services alone are valued in the tens of millions of dollars: for instance, an artificial breakwater replacing a coral reef in the Maldives cost twelve million dollars.[185] Many of the world's poorest communities cannot afford such luxuries and rely on the structures formed naturally by coral reefs; however, these need to be maintained if they are to continue to provide protection.

Not only have coral reefs provided the pharmaceutical industry with many novel chemicals that have been useful in the development of anticancer, antiretroviral, antimicrobial, anti-inflammatory, and anticoagulant drugs, but reef-related tourism provides billions to the global economy. The Great Barrier Reef alone is thought to generate between seven hundred million and 1.6 billion dollars annually in recreational income.[186] Thankfully, some countries are beginning to recognize the greater value of healthy, living reefs and their inhabitants as opposed to their dead counterparts. In Indonesia, manta rays were declared off-limits to fishers after data showed that they are worth two thousand times more alive than dead. A single manta ray is estimated to be worth one million dollars in tourism revenue, compared to less than five hundred dollars if caught and sold.[187]

Palau declared its waters a shark sanctuary in 2009, having already banned commercial finning in 2003. The money generated from tourists paying to dive in shark-inhabited water is a major contributor to the small country's economy,

generating eighteen million dollars annually, which equates to 80 percent of the GDP, and totaling 1.2 million dollars in local salaries and 1.5 million dollars in taxes to the government.[188] Shark finning would produce nowhere near this amount of revenue; the same populations of sharks are considered to be worth less than eleven thousand dollars dead. The declaration of Palau's waters as a shark sanctuary encouraged the creation of ten more sanctuaries around the world, covering six million square miles, or 3 percent of the world's ocean area. Countries joining the declaration included the Maldives, Honduras, Bahamas, British Virgin Islands, and New Caledonia. It is fantastic that there is such momentum across the world to conserve these magnificent animals. The framework must now be set in place to monitor and regulate these sanctuaries to ensure they serve their purpose.

These sanctuaries now cover enormous bodies of water but mostly protect open ocean and are targeted toward sharks. In addition to these, a similar area has been set aside globally for Marine Protected Areas (MPAs): the national parks of the oceans. It is thought that 18 percent of the world's reefs fall within this global network of MPAs, although these vary quite widely in their efficacy. It seems that

ABOVE: The decapitated heads of two sharks under a fishing jetty. Ambon, Indonesia.

OPPOSITE TOP: Mangrove forests are a vital and free source of coastal defense. Solomon Islands.

OPPOSITE BOTTOM: Mangroves provide vital habitat for many organisms. Raja Ampat, West Papua, Indonesia.

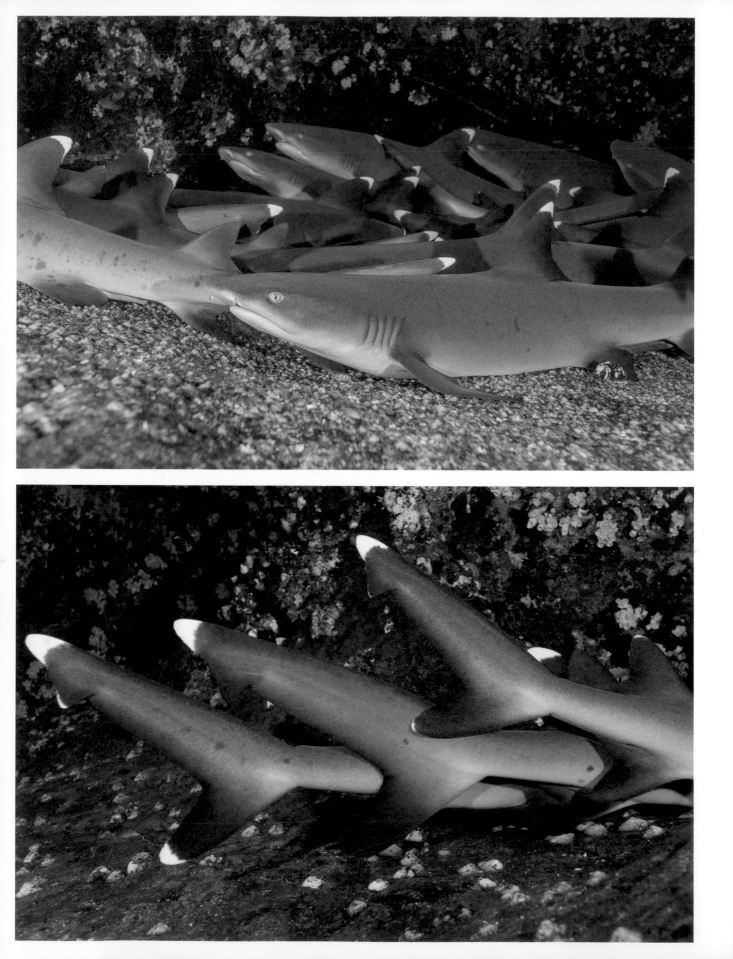

a reef's general resilience to degradation is primarily based on its having healthy populations of large herbivorous and predatory fishes. When readjusted for policies and systems that specifically protect these fishes, just 1.4 percent of reefs fall within the jurisdiction of no-take MPAs that completely protect these fishes from fishing.[189] Again, good management and enforcement are always vital in making an MPA effective. Just 0.1 percent of the world's coral reefs are protected within MPAs that are managed in such a way that they are both no-take and do not suffer from poaching. Research suggests that an extremely effective way to protect reefs would be a global network of MPAs, each around four square miles in size and placed nine miles apart, to allow topping up from other local reefs and maintain connections between each. This sounds ambitious and would require an additional 2,559 MPAs around the world; however, they would protect an achievable 5 percent of the world's coral reefs and make real strides toward their protection.

Coral reefs are at a tipping point. Catastrophic bleaching events have devastated even remote and well-protected reefs within World Heritage Sites such as the northern Great Barrier Reef. In fact, all twenty-nine of the World Heritage Sites that contain coral reefs are expected to cease as functioning ecosystems by the end of this century if we continue as we have been.[190] We need to stop ignoring incontrovertible science; there is little need for further research into the causes of decline in coral reefs. Human-induced climate change *is* the cause. Funding for research would be best spent on implementing renewable energy sources. We need to start increasing the use of renewable energy and phasing out the use of coal, with an immediate reduction in greenhouse gas emissions. Can we consciously bequeath to future generations a world without the wonder of coral reefs? We can make immediate changes that will benefit the reefs of the future, but we must take unprecedented action—now, and together.

So, as I imminently leave to explore a rarely visited cluster of tiny coral atolls one hundred nautical miles north of remotest Papua, I wonder how long such places will continue to exist. How much longer will anemonefish be able to play and fight and mate, nestling in colorful anemones? How much longer will anemones be able to grow on coral rock? I think of marvelous pygmy seahorses, dazzling flasher wrasses, and cardinalfish with mouths full of quizzical fry. I think of the children of the future, like my godson Joey, who will marvel at the fourteen-hundred-mile-long Great Barrier Reef and the towering underwater monuments that once stood, all built by a humble relative of the jellyfish.

OPPOSITE TOP: A healthy shark population. Socorro Islands, Mexico.

OPPOSITE BOTTOM: Fins are much better on a shark. Socorro Islands, Mexico.

Coral Reefs in the Twenty-First Century

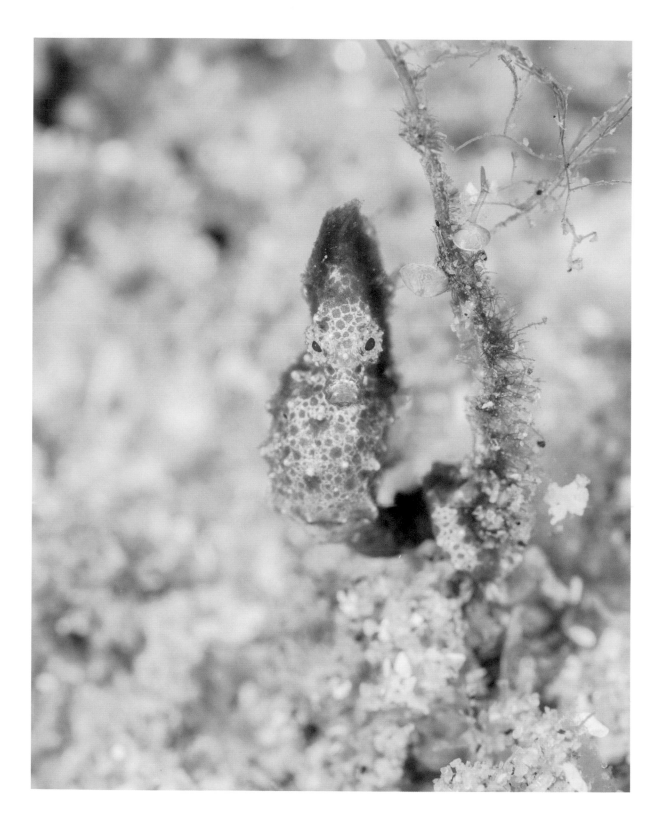

The World Beneath

EPILOGUE

everal months after finishing the manuscript for this book I went to South Africa to dive with a colleague, Louw, from the IUCN Seahorse, Pipefish and Seadragon Specialist Group, of which we are both members. She works on the country's endemic and endangered Knysna seahorse found in only a couple of estuaries on the south coast. She had been to South Africa's subtropical northeast region several months prior, having heard about a potentially new species of pygmy pipehorse, a member of the same group as one I was able to observe in New Zealand. She was unable to find the pipehorse, as poor weather conditions severely limited the diving window. However, whilst there someone showed her an image of something very unexpected, which is why I ended up in South Africa in October 2018.

The last thing I expected to hear from Louw was that there may have been a pygmy seahorse sighting in South Africa. The new Japanese pygmy seahorse that I named with colleagues in August 2018 was the farthest from the Coral Triangle (Indonesia, Philippines, Papua New Guinea, Solomon Islands, Malaysia, and East Timor) that any pygmy had been recorded. All the previously known pygmies were found only in the Coral Triangle and its surrounds, as far as Australia and a few scattered Pacific Islands. However, a new pygmy seahorse anywhere in the Indian Ocean would be quite a coup. This would be like finding

OPPOSITE: A newly discovered pygmy seahorse from South Africa.

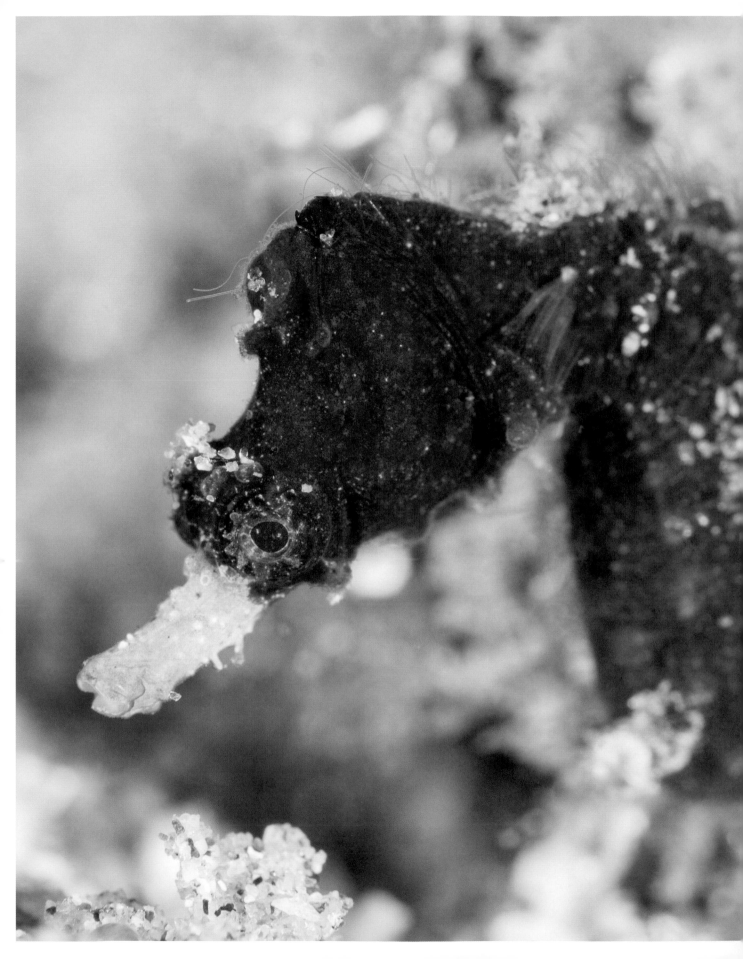

a kangaroo in Norway! So, as soon as I was able, off I went to South Africa. Louw and I met with Savannah, who had made this startling discovery, and on our first dive, despite a great deal of trepidation, we saw them: a pair of South African pygmy seahorses swaying contentedly in the surge. I went on to find a tiny baby too, just a centimeter long, so we also know this is a breeding population of a hitherto unknown species; the first pygmy seahorses from the Indian Ocean ever to be recorded. In the coming months, we will be working together to name this amazing fish, while learning more about its biology and behavior. In fact, on our very last dive we also found the new pygmy pipehorse that started this whole adventure. This too looks likely to be a new species. Once again, these discoveries show us just how much there is still to learn about our oceans and their precious inhabitants.

OPPOSITE: A likely new species of pygmy pipehorse from South Africa.

The World Beneath

OPPOSITE: A large frogfish comes
eye to eye with a juvenile hogfish.
Dumaguete, Negros Island, Philippines.

NOTES

1 Rafael de la Parra Venegas et al., "An Unprecedented
Aggregation of Whale Sharks, *Rhincodon typus*, in Mexican Coastal
Waters of the Caribbean Sea," *PLoS ONE* 6, 4 (April 2011).

2 Michael Benton and Richard Twitchett, "How to Kill
(Almost) All Life: the End Permian Extinction Event," *Trends in
Ecology & Evolution* 18, 7 (2003): 358–365.

3 Wolfgang Kiessling et al., "An Early Hettangian Coral Reef
in Southern France: Implications for the End-Triassic Reef Crisis,"
Palaios 24 (2009): 657–671.

4 George Stanley Jr. and Peter Swart, "Evolution of the
Coral-Zooxanthellae Symbiosis during the Triassic: a Geochemical
Approach," *Paleobiology* 21, 2 (1995): 179–199.

5 C. Hearn, M. Atkinson, and J. Falter, "A Physical Derivation
or Nutrient-Uptake Rates in Coral Reefs: Effects of Roughness and
Waves," *Coral Reefs* 20 (2001): 347–356.

6 Michael Huston, "Variation in Coral Growth Rates with
Depth at Discovery Bay, Jamaica," *Coral Reefs* 4 (1985): 19–25.

7 Heike Wagele and Geir Johnsen, "Observations on the
Histology and Photosynthetic Performance of 'Solar Powered'
Opisthobranchs (Mollusca, Gastropoda, Opisthobranchia)
Containing Symbiotic Chloroplasts or Zooxanthellae,"
Organisms, Diversity and Evolution 1 (2001): 193–210.

8 Ken Ridgway and Katy Hill, "Marine Climate Change in
Australia: Impacts and Adaptation Responses," Report Card 5 (2009).

9 T. Wernberg et al., "Impacts of Climate Change in a Global
Hotspot for Temperate Marine Biodiversity and Ocean Warming,"
Journal of Experimental Marine Biology and Ecology 400 (2011): 7–16.

10 K. Ridgway, "Long-Term Trend and Decadal Variability
of the Southward Penetration of the East Australia Current,"
Geophysical Research Letters 34, 13 (2007).

11 Craig Johnson et al., "Climate Change Cascades: Shifts in
Oceanography, Species' Ranges and Subtidal Marine Community
Dynamics in Eastern Tasmania," *Journal of Experimental Marine
Biology and Ecology* 400 (2011): 17–32.

12 S. Ling, "Range Expansion of a Habitat-Modifying Species Leads to Loss of Taxonomic Diversity: a New and Impoverished Reef State," *Oecologia* 156 (2008): 883–894.

13 J. Cortes, "Biology and Geology of Eastern Pacific Coral Reefs," *Coral Reefs* 16 (Supplement 1) (1997): S39–S46.

14 Andrew Bruckner, "Galapagos Coral Reef and Coral Community Monitoring Manual," *Khaled bin Sultan Living Oceans Foundation Publication* 10 (2013).

15 Anshika Singh and Narsinh Thakur, "Significance of Investigating Allelopathic Interactions of Marine Organisms in the Discovery and Development of Cytotoxic Compounds," *Chemico-Biological Interactions* 243 (2016): 135–147.

16 Mauro Maida, Paul Sammarco, and John Coll, "Effects of Soft Coral on Scleractinian Coral Recruitment. I: Directional Allelopathy and Inhibition of Settlement," *Marine Ecology Progress Series* 121 (1995): 191–202.

17 Mary Elliot, "Profiles of Trace Elements and Stable Isotopes Derived from Giant Long-Lived *Tridacna gigas* Bivalves: Potential Applications in Paleoclimate Studies," *Palaeogeography, Palaeoclimatology, Palaeoecology* 280 (2009): 132–42.

18 P. Buston and M. Garcia, "An Extraordinary Life Span Estimate for the Clown Anemonefish *Amphiprion percula*," *Journal of Fish Biology* 70 (2007): 1710–1719.

19 D. Brown et al., "American Samoa's Island of Giants: Massive Porites Colonies at Ta'u Island," *Coral Reefs* 28, 3 (2009): 735.

20 Andrew Hoey and David Bellwood, "Limited Functional Redundancy in a High Diversity System: Single Species Dominates Key Ecological Process on Coral Reefs," *Ecosystems* 12 (2009): 1316–1328.

21 Michael Crosby and Ernst Reese, "A Manual for Monitoring Coral Reefs with Indicator Species: Butterflyfishes as Indicators of Change on Indo-Pacific Reefs." Office of Ocean and Coastal Resource Management, National Oceanic and Atmospheric Administration, Silver Spring, MD (1996).

22 H. Fukami et al., "Ecological and Genetic Aspects of Reproductive Isolation by Different Spawning Times in Acropora Corals," *Marine Biology* 142 (2003): 679–684.

23 Charles Boch et al., "Effects of Light Dynamics on Coral Spawning Synchrony," *Biological Bulletin* 220 (2011): 161–173.

24 Jasper de Goeij et al., "Surviving in a Marine Desert: the Sponge Loop Retains Resources Within Coral Reefs," *Science* 342, 6 (2013): 108–110.

25 Patrick Lemaire, "Evolutionary Crossroads in Developmental Biology: the Tunicates," *Development* 138 (2011): 2143–2152.

26 Fredrik Moberg and Carl Folke, "Ecological Goods and Services of Coral Reef Ecosystems," *Ecological Economics* 29, 2 (1999): 215–233.

27 Rebecca Fisher et al., "Species Richness on Coral Reefs and the Pursuit of Convergent Global Estimates," *Current Biology* 25, 4 (2015): 500–505.

28 Alasdair D. McIntyre, ed., *Life in the World's Oceans: Diversity, Distribution and Abundance* (Blackwell Publishing, 2010): 65–74.

29 Renema, Willem, ed., *Biogeography, Time and Place: Distributions, Barriers and Islands* 29 (Springer Science and Business Media, 2007): 117–178.

30 Gerald Allen, "Conservation Hotspots of Biodiversity and Endemism for Indo-Pacific Coral Reef Fishes," *Aquatic Conservation: Marine and Freshwater Ecosystems* 18, 5 (2008): 541–556.

31 J. Veron et al., "Delineating the Coral Triangle," *Galaxea, Journal of Coral Reef Studies* 11, 2 (2009): 91–100.

32 A. Green and P. Mous, "Delineating the Coral Triangle, its Ecoregions and Functional Seascapes," Version 5.0. TNC Coral Triangle Program Report 1, 08 (2008).

33 J. Veron et al., "Delineating the Coral Triangle," *Galaxea, Journal of Coral Reef Studies* 11, 2 (2009): 91–100.

34 J. Veron et al., "Delineating the Coral Triangle," *Galaxea, Journal of Coral Reef Studies* 11, 2 (2009): 91–100.

35 Hedley Grantham et al., "A Comparison of Zoning Analyses to Inform the Planning of a Marine Protected Area Network in Raja Ampat, Indonesia," *Marine Policy* 38 (2013): 184–194.

36 Gerald Allen and Mark Erdmann, "Reef Fishes of the Bird's Head Peninsula, West Papua, Indonesia," *Check List* 5, 3 (2009): 587–628.

37 Gerald Allen and Mark Erdmann, *Reef Fishes of the East Indies,* Volume II. Tropical Reef Research, Perth, Australia (2012): 425–856.

38 Gerald Allen et al., "*Hemiscyllium halmahera*, a New Species of Bamboo Shark (Hemiscylliidae) from Indonesia," *Aqua, International Journal of Ichthyology* 19 (2013): 123–136.

39 Gerald Allen, "Conservation Hotspots of Biodiversity and Endemism for Indo-Pacific Coral Reef Fishes," *Aquatic Conservation: Marine and Freshwater Ecosystems* 18, 5 (2008): 541–556.

40 Joseph DiBattista et al., "On the Origin of Endemic Species in the Red Sea," *Journal of Biogeography* 43, 1 (2016): 13–30.

41 Nicholas Casewell et al., "The Evolution of Fangs, Venom, and Mimicry Systems in Blenny Fishes," *Current Biology* 27, 8 (2017): 1184–1191.

42 Luke Tornabene et al., "Support for a 'Center of Origin' in the Coral Triangle: Cryptic Diversity, Recent Speciation, and Local Endemism in a Diverse Lineage of Reef Fishes (Gobiidae: Eviota)," *Molecular Phylogenetics and Evolution* 82 (2015): 200–210.

43 Paul Barber, "The Challenge of Understanding the Coral Triangle Biodiversity Hotspot," *Journal of Biogeography* 36, 10 (2009): 1845–1846.

44 Paul Barber, M. Moosa, and S. Palumbi. "Rapid Recovery of Genetic Diversity of Stomatopod Populations on Krakatau: Temporal and Spatial Scales of Marine Larval Dispersal," *Proceedings of the Royal Society B: Biological Sciences* 269, 1500 (2002): 1591–1597.

45 Alejandro Vagelli and Mark Erdmann, "First Comprehensive Ecological Survey of the Banggai Cardinalfish, *Pterapogon kauderni,*" *Environmental Biology of Fishes* 63, 1 (2002).

46 Alejandro Vagelli, "The Reproductive Biology and Early Ontogeny of the Mouthbrooding Banggai Cardinalfish, *Pterapogon kauderni* (Perciformes, Apogonidae)," *Environmental Biology of Fishes* 56, 1–2 (1999): 79–92.

47 Willem Renema et al., "Hopping Hotspots: Global Shifts in Marine Biodiversity," *Science* 321, 5889 (2008): 654–657.

48 Alain Dubois, "Describing a New Species," *Taprobanica: The Journal of Asian Biodiversity* 2, 1 (2011): 6–24.

49 J. Stevens, "Whale Shark (*Rhincodon typus*) Biology and Ecology: a Review of the Primary Literature," *Fisheries Research* 84, 1 (2007): 4–9.

50 Shang Yin Vanson Liu et al., "Genetic Diversity and Connectivity of the Megamouth Shark (*Megachasma pelagios*)," *PeerJ* 6 (2018): e4432.

51 Christine Huffard et al., "The Evolution of Conspicuous Facultative Mimicry in Octopuses: an Example of Secondary Adaptation?" *Biological Journal of the Linnean Society* 101, 1 (2010): 68–77.

52 Luiz Rocha, Richard Ross, and G. Kopp, "Opportunistic Mimicry by a Jawfish," *Coral Reefs* 31, 1 (2012): 285.

53 James Thomas, "*Leucothoe eltoni* sp. n., a New Species of Commensal Leucothoid Amphipod from Coral Reefs in Raja Ampat, Indonesia (Crustacea, Amphipoda)," *ZooKeys* 518 (2015): 51–66.

54 Luiz Rocha et al., "Mesophotic Coral Ecosystems are Threatened and Ecologically Distinct from Shallow Water Reefs," *Science* 361, 6399 (2018): 281–284.

55 Richard Pyle, Brian Greene, and Randall Kosaki. "*Tosanoides obama*, a New Basslet (Perciformes, Percoidei, Serranidae) from Deep Coral Reefs in the Northwestern Hawaiian Islands," *ZooKeys* 641 (2016): 165–181.

56 Luiz Rocha et al., "*Roa rumsfeldi*, a New Butterflyfish (Teleostei, Chaetodontidae) from Mesophotic Coral Ecosystems of the Philippines," *ZooKeys* 709 (2017): 127–134.

57 Greg Rouse, Josefin Stiller, and Nerida Wilson, "First Live Records of the Ruby Seadragon (*Phyllopteryx dewysea*, Syngnathidae)," *Marine Biodiversity Records* 10, 1 (2017): 2.

58 Nicolas Hubert et al., "Cryptic Diversity in Indo-Pacific Coral-Reef Fishes Revealed by DNA-Barcoding Provides New Support to the Centre-of-Overlap Hypothesis," *PLoS ONE* 7, 3 (2012): e28987.

59 Andrea Marshall, Leonard Compagno, and Michael Bennett, "Redescription of the Genus Manta with Resurrection of *Manta alfredi* (Krefft, 1868) (Chondrichthyes; Myliobatoidei; Mobulidae)," *Zootaxa* 2301 (2009): 1–28.

60 Tom Kashiwagi et al., "The Genetic Signature of Recent Speciation in Manta Rays (*Manta alfredi* and *M. birostris*)," *Molecular Phylogenetics and Evolution* 64, 1 (2012): 212–218.

61 William White et al., "Phylogeny of the Manta and Devilrays (Chondrichthyes: mobulidae), with an Updated Taxonomic Arrangement for the Family," *Zoological Journal of the Linnean Society* 182, 1 (2017): 50–75.

62 Shaun Wilson et al., "Habitat Utilization by Coral Reef Fish: Implications for Specialists vs. Generalists in a Changing Environment," *Journal of Animal Ecology* 77, 2 (2008): 220–228.

63 Douglas Boucher, Sam James, and Kathleen Keeler, "The Ecology of Mutualism," *Annual Review of Ecology and Systematics* 13, 1 (1982): 315–347.

64 Hiroki Hata and Makoto Kato. "A Novel Obligate Cultivation Mutualism Between Damselfish and *Polysiphonia* Algae," *Biology Letters* 2, 4 (2006): 593–596.

65 Andrew Thompson, Christine Thacker, and Emily Shaw, "Phylogeography of Marine Mutualists: Parallel Patterns of Genetic Structure Between Obligate Goby and Shrimp Partners," *Molecular Ecology* 14, 11 (2005): 3557–3572.

66 Janie Wulff, "Mutualisms Among Species of Coral Reef Sponges," *Ecology* 78.1 (1997): 146–159.

67 Robert Poulin and Serge Morand, *Parasite Biodiversity* (Smithsonian Institution Scholarly Press, 2005).

68 Florian Wehrberger and Juergen Herler, "Microhabitat Characteristics Influence Shape and Size of Coral-Associated Fishes," *Marine Ecology Progress Series* 500 (2014): 203–214.

69 Juergen Herler, Sergey Bogorodsky, and Toshiyuki Suzuki, "Four New Species of Coral Gobies (Teleostei: Gobiidae: Gobiodon), with Comments on their Relationships Within the Genus," *Zootaxa* 3709.4 (2013): 301–329.

70 Philip Munday, Lynne van Herwerden, and Christine Dudgeon, "Evidence for Sympatric Speciation by Host Shift in the Sea," *Current Biology* 14, 16 (2004): 1498–1504.

71 D. Brown et al., "American Samoa's Island of Giants: Massive *Porites* Colonies at Ta'u Island," *Coral Reefs* 28, 3 (2009): 735.

72 S. McMurray, James Blum, and Joseph Pawlik, "Redwood of the Reef: Growth and Age of the Giant Barrel Sponge *Xestospongia muta* in the Florida Keys," *Marine Biology* 155.2 (2008): 159–171.

73 Brendan Roark et al., "Extreme Longevity in Proteinaceous Deep-Sea Corals," *Proceedings of the National Academy of Sciences* 106, 13 (2009): 5204–5208.

74 Valerie Syverson, "Predation, Resistance, and Escalation in Sessile Crinoids." Doctoral Thesis, University of Michigan (2014).

75 Hsin-Drow Huang, Daniel Rittschof, and Ming-Shiou Jeng, "Multispecies Associations of Macrosymbionts on the Comatulid Crinoid *Comanthina schlegeli* (Carpenter) in Southern Taiwan," *Symbiosis* 39, 1 (2005): 47–51.

76 Dimitri Deheyn, Sergey Lyskin, and Igor Eeckhaut, "Assemblages of Symbionts in Tropical Shallow-Water Crinoids and Assessment of Symbionts' Host-Specificity," *Symbiosis* 42, 3 (2006): 161–168.

77 Emmett Duffy, Cheryl Morrison, and Rubén Ríos, "Multiple Origins of Eusociality Among Sponge-Dwelling Shrimps (Synalpheus)," *Evolution* 54, 2 (2000): 503–516.

78 Gerald Allen, "Review of Indo-Pacific Coral Reef Fish Systematics: 1980 to 2014," *Ichthyological Research* 62, 1 (2015): 2–8.

79 Andrew Negri et al., "Understanding Ship-Grounding Impacts on a Coral Reef: Potential Effects of Anti-Foulant Paint Contamination on Coral Recruitment," *Marine Pollution Bulletin* 44, 2 (2002): 111–117.

80 P. Barth et al., "From the Ocean to a Reef Habitat: How Do the Larvae of Coral Reef Fishes Find Their Way Home? A State of Art on the Latest Advances," *Vie et Milieu* 65, 2 (2015): 91–100.

81 Rebecca Lawton, Morgan Pratchett, and Michael Berumen, "The Use of Specialisation Indices to Predict Vulnerability of Coral-Feeding Butterflyfishes to Environmental Change," *Oikos* 121, 2 (2012): 191–200.

82 Ricardo Beldade et al., "Spatial Patterns of Self-Recruitment of a Coral Reef Fish in Relation to Island-Scale Retention Mechanisms," *Molecular Ecology* 25, 20 (2016): 5203–5211.

83 Jelle Atema, Michael Kingsford, and Gabriele Gerlach, "Larval Reef Fish Could Use Odour for Detection, Retention and Orientation to Reefs," *Marine Ecology Progress Series* 241 (2002): 151–160.

84 Jeffrey Leis, Hugh Sweatman, and Sally Reader, "What the Pelagic Stages of Coral Reef Fishes are Doing out in Blue Water: Daytime Field Observations of Larval Behavioural Capabilities," *Marine and Freshwater Research* 47, 2 (1996): 401–411.

85 William Brooks and Richard Mariscal, "The Acclimation of Anemone Fishes to Sea Anemones: Protection by Changes in the Fish's Mucous Coat," *Journal of Experimental Marine Biology and Ecology* 80, 3 (1984): 277–285.

86 Bruno Frédérich et al., "Iterative Ecological Radiation and Convergence during the Evolutionary History of Damselfishes (Pomacentridae)," *The American Naturalist* 181, 1 (2013): 94–113.

87 Anita Nedosyko et al., "Searching for a Toxic Key to Unlock the Mystery of Anemonefish and Anemone Symbiosis," *PLoS ONE* 9, 5 (2014): e98449.

88 Sally Holbrook and Russell Schmitt, "Growth, Reproduction and Survival of a Tropical Sea Anemone (Actiniaria): Benefits of Hosting Anemonefish," *Coral Reefs* 24, 1 (2005): 67–73.

89 Peter Buston and M. García González, "An Extraordinary Life Span Estimate for the Clown Anemonefish *Amphiprion percula*," *Journal of Fish Biology* 70, 6 (2007): 1710–1719.

90 Peter Buston, "Social Hierarchies: Size and Growth Modification in Clownfish," *Nature* 424, 6945 (2003): 145–146.

91 Miyako Kobayashi and Akihisa Hattori, "Spacing Pattern and Body Size Composition of the Protandrous Anemonefish *Amphiprion frenatus* Inhabiting Colonial Host Anemones," *Ichthyological Research* 53, 1 (2006): 1–6.

92 Peter Buston, "Mortality is Associated with Social Rank in the Clown Anemonefish (*Amphiprion percula*)," *Marine Biology* 143, 4 (2003): 811–815.

93 Robert Ross, "Reproductive Behavior of the Anemonefish *Amphiprion melanopus* on Guam," *Copeia* 1978, 1 (1978): 103–107.

94 J. Hobbs, J. Neilson, and J. Gilligan, "Distribution, Abundance, Habitat Association and Extinction Risk of Marine Fishes Endemic to the Lord Howe Island Region." Report to Lord Howe Island Marine Park (James Cook University, 2009).

95 Colette Wabnitz et al., "From Ocean to Aquarium: the Global Trade in Marine Ornamental Species." UNEP World Conservation Monitoring Centre. Cambridge, UK (2003).

96 Craig Shuman, Gregor Hodgson, and Richard Ambrose, "Population Impacts of Collecting Sea Anemones and Anemonefish for the Marine Aquarium Trade in the Philippines," *Coral Reefs* 24, 4 (2005): 564–573.

97 Terry Hughes et al., "Spatial and Temporal Patterns of Mass Bleaching of Corals in the Anthropocene," *Science* 359.6371 (2018): 80–83.

98 Anna Scott and Danielle Dixson, "Reef Fishes Can Recognize Bleached Habitat during Settlement: Sea Anemone Bleaching Alters Anemonefish Host Selection," *Proceedings of the Royal Society B: Biological Sciences* 283 (2016): 2015–2694.

99 Ricardo Beldade et al., "Cascading Effects of Thermally-Induced Anemone Bleaching on Associated Anemonefish Hormonal Stress Response and Reproduction," *Nature Communications* 8, 1 (2017): 716.

100 P. Saenz-Agudelo et al., "Detrimental Effects of Host Anemone Bleaching on Anemonefish Populations," *Coral Reefs* 30, 2 (2011): 497–506.

101 Anna Scott and Andrew Hoey, "Severe Consequences for Anemonefishes and their Host Sea Anemones during the 2016 Bleaching Event at Lizard Island, Great Barrier Reef," *Coral Reefs* 36, 3 (2017): 873.

102 Ricardo Beldade et al., "Cascading Effects of Thermally-Induced Anemone Bleaching on Associated Anemonefish Hormonal Stress Response and Reproduction," *Nature Communications* 8, 1 (2017): 716.

103 D. Taira et al., "First Record of the Host-Specific Anemonefish *Amphiprion frenatus* Inhabiting *Heteractis magnifica* during a Mass Bleaching Event," *Bulletin of Marine Science* 94, 1 (2018): 123–124.

104 M. Arvedlund and A. Takemura, "Long-Term Observation in Situ of the Anemonefish *Amphiprion clarkii* (Bennett) in Association with a Soft Coral," *Coral Reefs* 24, 4 (2005): 698.

105 Anna Scott and Danielle Dixson, "Reef Fishes Can Recognize Bleached Habitat during Settlement: Sea Anemone Bleaching Alters Anemonefish Host Selection," *Proceedings of the Royal Society B: Biological Sciences* 283 (2016): 2015–2694.

106 Richard Smith, "The Biology and Conservation of Gorgonian-Associated Pygmy Seahorses," Doctoral dissertation, University of Queensland, Australia (2010).

107 Sara Lourie, Riley Pollom, and Sarah Foster, "A Global Revision of the Seahorses *Hippocampus* Rafinesque 1810 (Actinopterygii: Syngnathiformes): Taxonomy and Biogeography with Recommendations for Further Research," *Zootaxa* 4146, 1 (2016): 1–66.

108 Sarah Foster and Amanda Vincent, "Life History and Ecology of Seahorses: Implications for Conservation and Management," *Journal of Fish Biology* 65, 1 (2004): 1–61.

109 C. Kvarnemo et al., "Monogamous Pair Bonds and Mate Switching in the Western Australian Seahorse *Hippocampus subelongatus*," *Journal of Evolutionary Biology* 13, 6 (2000): 882–888.

110 Adam Jones et al., "Sympatric Speciation as a Consequence of Male Pregnancy in Seahorses," *Proceedings of the National Academy of Sciences* 100, 11 (2003): 6598–6603.

111 Richard Smith, Alexandra Grutter, and Ian Tibbetts, "Extreme Habitat Specialisation and Population Structure of Two Gorgonian-Associated Pygmy Seahorses," *Marine Ecology Progress Series* 444 (2012): 195–206.

112 Marc Bally and Joaquim Garrabou, "Thermodependent Bacterial Pathogens and Mass Mortalities in Temperate Benthic Communities: a New Case of Emerging Disease Linked to Climate Change," *Global Change Biology* 13, 10 (2007): 2078–2088.

113 Graham Short, Richard Smith, and David Harasti, "*Hippocampus japapigu*, a New Species of Pygmy Seahorse from Japan, with a Redescription of *H. pontohi* (Teleostei, Syngnathidae)," *ZooKeys* 779 (2018): 27–49.

114 K. Kumaravel et al., "Seahorses—A Source of Traditional Medicine," *Natural Product Research* 26, 24 (2012): 2330–2334.

115 Julia Lawson, Sarah Foster, and Amanda Vincent, "Low Bycatch Rates Add up to Big Numbers for a Genus of Small Fishes," *Fisheries* 42, 1 (2017): 19–33.

116 Ryan Hechinger and Kevin Lafferty, "Host Diversity Begets Parasite Diversity: Bird Final Hosts and Trematodes in Snail Intermediate Hosts," *Proceedings of the Royal Society B: Biological Sciences* 272, 1567 (2005): 1059–1066.

117 Iain Barber, Danie Hoare, and Jens Krause, "Effects of Parasites on Fish Behaviour: a Review and Evolutionary Perspective," *Reviews in Fish Biology and Fisheries* 10, 2 (2000): 131–165.

118 Tommy Leung, "Evolution: How a Barnacle Came to Parasitise a Shark," *Current Biology* 24, 12 (2014): R564–R566.

119 Kevin Lafferty and Armand Kuris, "Parasitic Castration: the Evolution and Ecology of Body Snatchers," *Trends in Parasitology* 25, 12 (2009): 564–572.

120 Karen Cheney et al., "Blue and Yellow Signal Cleaning Behavior in Coral Reef Fishes," *Current Biology* 19, 15 (2009): 1283–1287.

121 Alexandra Grutter, "Parasite Removal Rates by the Cleaner Wrasse *Labroides dimidiatus*," *Marine Ecology Progress Series* 130 (1996): 61–70.

122 Redouan Bshary and Manuela Würth, "Cleaner Fish *Labroides dimidiatus* Manipulate Client Reef Fish by Providing Tactile Stimulation," *Proceedings of the Royal Society B: Biological Sciences* 268, 1475 (2001): 1495–1501.

123 Karen Cheney, Redouan Bshary, and Alexandra Grutter, "Cleaner Fish Cause Predators to Reduce Aggression Toward Bystanders at Cleaning Stations," *Behavioral Ecology* 19, 5 (2008): 1063–1067.

124 Redouan Bshary, "The Cleaner Wrasse, *Labroides dimidiatus*, is a Key Organism for Reef Fish Diversity at Ras Mohammed National Park, Egypt," *Journal of Animal Ecology* 72, 1 (2003): 169–176.

125 Alexandra Grutter et al., "Fish Mucous Cocoons: the 'Mosquito Nets' of the Sea," *Biology Letters* 7, 2 (2010): 292–294.

126 Nico Smit et al., "Hematozoa of Teleosts from Lizard Island, Australia, with Some Comments on Their Possible Mode of Transmission and the Description of a New Hemogregarine Species," *Journal of Parasitology* 92, 4 (2006): 778–788.

127 Ana Pinto et al., "Cleaner Wrasses *Labroides dimidiatus* Are More Cooperative in the Presence of an Audience," *Current Biology* 21, 13 (2011): 1140–1144.

128 Jennifer Oates, Andrea Manica, and Redouan Bshary, "Roving and Service Quality in the Cleaner Wrasse *Labroides bicolor*," *Ethology* 116, 4 (2010): 309–315.

129 Armand Kuris, Mark Torchin, and Kevin Lafferty, "*Fecampia erythrocephala* Rediscovered: Prevalence and Distribution of a Parasitoid of the European Shore Crab, *Carcinus maenas*," *Journal of the Marine Biological Association of the United Kingdom* 82, 6 (2002): 955–960.

130 Kevin Lafferty and Jenny Shaw, "Comparing Mechanisms of Host Manipulation Across Host and Parasite Taxa," *Journal of Experimental Biology* 216, 1 (2013): 56–66.

131 Yuval Baar, Joseph Rosen, and Nadav Shashar, "Circular Polarization of Transmitted Light by Sapphirinidae Copepods," *PLoS ONE* 9, 1 (2014): e86131.

132 Dvir Gur et al., "Structural Basis for the Brilliant Colors of the Sapphirinid Copepods," *Journal of the American Chemical Society* 137, 26 (2015): 8408–8411.

133 Justin Marshall and Kentaro Arikawa, "Unconventional Colour Vision," *Current Biology* 24, 24 (2014): R1150–R1154.

134 Karen Cheney and Justin Marshall, "Mimicry in Coral Reef Fish: How Accurate is This Deception in Terms of Color and Luminance?" *Behavioral Ecology* 20, 3 (2009): 459–468.

135 G. Losey et al., "Visual Biology of Hawaiian Coral Reef Fishes. I. Ocular Transmission and Visual Pigments," *Copeia* 2003, 3 (2003): 433–454.

136 Justin Marshall, "Communication and Camouflage with the Same 'Bright' Colours in Reef Fishes," *Philosophical Transactions of the Royal Society of London B: Biological Sciences* 355, 1401 (2000): 1243–1248.

137 Roger Hanlon, "Cephalopod Dynamic Camouflage," *Current Biology* 17, 11 (2007): R400–R404.

138 Desmond Ramirez and Todd Oakley, "Eye-Independent, Light-Activated Chromatophore Expansion (LACE) and Expression of Phototransduction Genes in the Skin of *Octopus bimaculoides*," *Journal of Experimental Biology* 218, 10 (2015): 1513–1520.

139 Vanessa Messmer et al., "Phylogeography of Colour Polymorphism in the Coral Reef Fish *Pseudochromis fuscus*, from Papua New Guinea and the Great Barrier Reef," *Coral Reefs* 24, 3 (2005): 392–402.

140 Darren Coker, Veronica Chaidez, and Michael Berumen, "Habitat Use and Spatial Variability of Hawkfishes with a Focus on Colour Polymorphism in *Paracirrhites forsteri*," *PLoS ONE* 12, 1 (2017): e0169079.

141 Osmar Luiz-Júnior, "Colour Morphs in a Queen Angelfish *Holacanthus ciliaris* (Perciformes: Pomacanthidae) Population of Saint Paul's Rocks, NE Brazil," *Tropical Fish Hobbyist* 51, 5 (2003): 82–90.

142 Hans Fricke, "Juvenile-Adult Colour Patterns and Coexistence in the Territorial Coral Reef Fish *Pomacanthus imperator*," *Marine Ecology* 1, 2 (1980): 133–141.

143 P. Parenti and J. Randall, "A Checklist of Wrasses (Labridae) and Parrotfishes (Scaridae) of the World: 2017 Update," *Journal of the Ocean Science Foundation* 30 (2018): 11–27.

144 Mark Westneat and Michael Alfaro, "Phylogenetic Relationships and Evolutionary History of the Reef Fish Family Labridae," *Molecular Phylogenetics and Evolution* 36, 2 (2005): 370–390.

145 Gerald Allen, "A Review of the Labrid Genus Paracheilinus, with the Description of a New Species from Melanesia," *Pacific Science* 28, 4 (1974): 449-455.

146 Richard G. Harrison, ed., *Hybrid Zones and the Evolutionary Process* (Oxford University Press, 1993).

147 Kevin De Queiroz, "Species Concepts and Species Delimitation," *Systematic Biology* 56, 6 (2007): 879–886.

148 Gerald Allen, Mark Erdmann, and Muhammad Dailami, "*Cirrhilabrus marinda*, a New Species of Wrasse (Pisces: Labridae) from Eastern Indonesia, Papua New Guinea, and Vanuatu," *Journal of the Ocean Science Foundation* 15 (2015): 1–13.

149 Ove Hoegh-Guldberg, "Climate Change, Coral Bleaching and the Future of the World's Coral Reefs," *Marine and Freshwater Research* 50, 8 (1999): 839–866.

150 Clive Wilkinson et al., "Ecological and Socioeconomic Impacts of 1998 Coral Mortality in the Indian Ocean: an ENSO Impact and a Warning of Future Change?" *Ambio* 28, 2 (1999): 188–196.

151 Gerald Bell et al., "Climate Assessment for 1998," *Bulletin of the American Meteorological Society* 80, 5 (1999): S1–S48.

152 Terence Hughes, "Catastrophes, Phase Shifts, and Large-Scale Degradation of a Caribbean Coral Reef," *Science* 265, 5178 (1994): 1547–1551.

153 John Pandolfi and Jeremy Jackson, "Ecological Persistence Interrupted in Caribbean Coral Reefs," *Ecology Letters* 9, 7 (2006): 818–826.

154 R. Bak, M. Carpay, and E. De Ruyter Van Steveninck, "Densities of the Sea Urchin *Diadema antillarum* before and after Mass Mortalities on the Coral Reefs on Curaçao," *Marine Ecology Progress Series* 17, 1 (1984): 105–108.

155 Clive Wilkinson and David Souter, eds, *Status of Caribbean Coral Reefs after Bleaching and Hurricanes in 2005*, Global Coral Reef Monitoring Network, Townsville, Australia (2008).

156 Andrew Baker, Peter Glynn, and Bernhard Riegl, "Climate Change and Coral Reef Bleaching: an Ecological Assessment of Long-Term Impacts, Recovery Trends and Future Outlook," *Estuarine, Coastal and Shelf Science* 80, 4 (2008): 435–471.

157 Terry Hughes et al., "Global Warming and Recurrent Mass Bleaching of Corals," *Nature* 543, 7645 (2017): 373–377.

158 Courtney Couch et al., "Mass Coral Bleaching Due to Unprecedented Marine Heatwave in Papahānaumokuākea Marine National Monument (Northwestern Hawaiian Islands)," *PLoS ONE* 12, 9 (2017): e0185121.

159 Kuʻulei Rodgers et al., "Patterns of Bleaching and Mortality Following Widespread Warming Events in 2014 and 2015 at the Hanauma Bay Nature Preserve, Hawaiʻi," *PeerJ* 5 (2017): e3355.

160 Terry Hughes et al., "Global Warming Transforms Coral Reef Assemblages," *Nature* 556, 7702 (2018): 492–496.

161 Terry Hughes et al., "Global Warming Transforms Coral Reef Assemblages," *Nature* 556, 7702 (2018): 492–496.

162 J. Veron et al., "The Coral Reef Crisis: the Critical Importance of <350 ppm CO2," *Marine Pollution Bulletin* 58, 10 (2009): 1428–1436.

163 Ruben Van Hooidonk et al., "Local-Scale Projections of Coral Reef Futures and Implications of the Paris Agreement," *Scientific Reports* 6 (2016): 39666.

164 Christophe McGlade and Paul Ekins, "The Geographical Distribution of Fossil Fuels Unused When Limiting Global Warming to 2 C," *Nature* 517, 7533 (2015): 187–190.

165 Jan Zalasiewicz et al., "The New World of the Anthropocene," *Environmental Science and Technology* 44, 7 (2010): 2228–2231.

166 Kenneth Anthony et al., "Ocean Acidification Causes Bleaching and Productivity Loss in Coral Reef Builders," *Proceedings of the National Academy of Sciences* 105, 45 (2008): 17442–17446.

167 Ove Hoegh-Guldberg et al., "Coral Reefs under Rapid Climate Change and Ocean Acidification," *Science* 318, 5857 (2007): 1737–1742.

168 Ove Hoegh-Guldberg et al., "Coral Reefs under Rapid Climate Change and Ocean Acidification," *Science* 318, 5857 (2007): 1737–1742.

169 Thomas Crowther et al., "Predicting Global Forest Reforestation Potential," *bioRxiv* (2017): 210062.

170 Katharina Fabricius, "Effects of Terrestrial Runoff on the Ecology of Corals and Coral Reefs: Review and Synthesis," *Marine Pollution Bulletin* 50, 2 (2005): 125–146.

171 Jon Brodie et al., "Are Increased Nutrient Inputs Responsible for More Outbreaks of Crown-of-Thorns Starfish? An Appraisal of the Evidence," *Marine Pollution Bulletin* 51, 1–4 (2005): 266–278.

172 Robert Endean, "Crown-of-Thorns Starfish on the Great Barrier Reef," *Endeavour* 6, 1 (1982): 10–14.

173 Stephen Lewis et al., "Herbicides: a New Threat to the Great Barrier Reef," *Environmental Pollution* 157, 8–9 (2009): 2470–2484.

174 J. McDonald, "The Invasive Pest Species *Ciona intestinalis* (Linnaeus, 1767) Reported in a Harbour in Southern Western Australia," *Marine Pollution Bulletin* 49, 9–10 (2004): 868–870.

175 Mark Albins and Mark Hixon, "Invasive Indo-Pacific Lionfish *Pterois volitans* Reduce Recruitment of Atlantic Coral-Reef Fishes," *Marine Ecology Progress Series* 367 (2008): 233–238.

176 Nicholas Bax et al., "Marine Invasive Alien Species: a Threat to Global Biodiversity," *Marine Policy* 27, 4 (2003): 313–323.

177 Bella Galil et al., "'Double Trouble': the Expansion of the Suez Canal and Marine Bioinvasions in the Mediterranean Sea," *Biological Invasions* 17, 4 (2015): 973–976.

178 Katie Newton et al., "Current and Future Sustainability of Island Coral Reef Fisheries," *Current Biology* 17, 7 (2007): 655–658.

179 Jeremy Jackson et al., "Historical Overfishing and the Recent Collapse of Coastal Ecosystems," *Science* 293, 5530 (2001): 629–637.

180 Boris Worm et al., "Global Catches, Exploitation Rates, and Rebuilding Options for Sharks," *Marine Policy* 40 (2013): 194–204.

181 Julia Baum et al., "Collapse and Conservation of Shark Populations in the Northwest Atlantic," *Science* 299, 5605 (2003): 389–392.

182 Helen Fox et al., "Experimental Assessment of Coral Reef Rehabilitation Following Blast Fishing," *Conservation Biology* 19, 1 (2005): 98–107.

183 Helen Fox and Roy Caldwell, "Recovery from Blast Fishing on Coral Reefs: a Tale of Two Scales," *Ecological Applications* 16, 5 (2006): 1631–1635.

184 UN Climate Change Website for the Pacific:
http://cop23.com/fj/kiribati.

185 Fredrik Moberg and Carl Folke, "Ecological Goods and
Services of Coral Reef Ecosystems," *Ecological Economics* 29, 2
(1999): 215–233.

186 Liam Carr and Robert Mendelsohn, "Valuing Coral Reefs: a
Travel Cost Analysis of the Great Barrier Reef," *AMBIO: A Journal
of the Human Environment* 32, 5 (2003): 353–357.

187 Mary O'Malley, Katie Lee-Brooks, and Hannah Medd, "The
Global Economic Impact of Manta Ray Watching Tourism," *PLoS
ONE* 8, 5 (2013): e65051.

188 G. Vianna et al., "Socio-Economic Value and Community
Benefits from Shark-Diving Tourism in Palau: a Sustainable Use
of Reef Shark Populations," *Biological Conservation* 145, 1 (2012):
267–277.

189 Camilo Mora et al., "Coral Reefs and the Global Network of
Marine Protected Areas," *Science* 312 (2006): 1750–1751.

190 Scott Heron et al., "Impacts of Climate Change on World
Heritage Coral Reefs: a First Global Scientific Assessment," (2017).
Paris, World Heritage UNESCO Centre.